The Ecstatic Quotidian

Literature and Philosophy

A. J. Cascardi, General Editor

This series publishes books in a wide range of subjects in philosophy and literature, including studies of the social and historical issues that relate these two fields. Drawing on the resources of the Anglo-American and Continental traditions, the series is open to philosophically informed scholarship covering the entire range of contemporary critical thought.

Already published:

The Ecstatic Quotidian

Phenomenological Sightings in
Modern Art and Literature

Jennifer Anna Gosetti-Ferencei

The Pennsylvania State University Press
University Park, Pennsylvania

Library of Congress Cataloging-in-Publication Data

Gosetti-Ferencei, Jennifer Anna.
 The ecstatic quotidian : phenomenological
 sightings in modern art and literature /
 Jennifer Anna Gosetti-Ferencei.
 p. cm.—(Literature & philosophy)
Includes bibliographical references and index.
ISBN-13: 978-0-271-03228-3 (pbk : alk. paper)
1. Aesthetics.
I. Title.

BH39.G653 2007
111'.85—dc22
2007025801

For Milan, again,
and for Arthur Ferencei

Contents

Acknowledgments

The author would like to thank some people who helped to bring this book into being. Michael Richards at The Pennsylvania State University Press first drew editorial support for this book in an enthusiastic and careful reading. Sandy Thatcher, the director of the Press, gave helpful advice. Material for some chapters appeared in earlier formulation in articles in the following journals: *Philosophy Today, Journal of the Association for the Interdisciplinary Study of the Arts, Analecta Husserliana* (volumes 82, 87, 92), and *Phenomenological Inquiry*, and *The German Quarterly* (volume 80:2). The author is grateful for their kind permission, and to Kluwer Academic Publishers and Springer Academic Publishers for the *Analecta Husserliana*, to reprint material in whole or part. Thanks to The Metropolitan Museum of Art, New York, for permission to use the Cézanne image on the front cover. Gary Backhaus gave a critical reading of an early draft of the manuscript. T. J. Reed generously read a later draft of the manuscript and provided excellent suggestions. Ritchie Robertson's insightful discussions of modern literature proved most helpful during the final revisions. Arthur Ferencei afforded the author the privilege of an intimate witnessing of childhood experience, essential to the insights in chapter 2.

Introduction

This book is devoted to an examination, through art, literature, and phenomenology, of that which is, by definition, the most ordinary and habitually unnoticed. The "quotidian" is the sense of life built up in daily experience, by everyday habits, by the sedimentation of ordinary expectations of the world, but also by the tensions between the regularity of the familiar and necessary innovation. The quotidian is that background in contrast to which new discoveries emerge and we are surprised; and more pointedly, it is a necessary condition for surprise, the regularity in contrast to which something new and unexpected occurs. Unfamiliarity, wonder, and mysteriousness are both embedded in and turnings-away from familiarity and predictability. These turnings-away, our stepping outside of the ordinary, do not leave it behind, but draw energy and vivacity from this deviation.

It is not in denigration of everyday life—not to "repudiate the ordinary" as Stanley Rosen describes philosophies that befriend disruption of the ordinary (Rosen 2002, 291), and not only to "*problematize* everyday life" as Michael Gardiner summarizes a tradition of its theorization (Gardiner 2000, 6)—but with appreciation of it, that the notion of the "ecstatic quotidian," the stepping outside or "ecstasis" of the ordinary feeling of the self's familiarity with the world, is here presented. Not only the fantastical which, as in surrealist renderings, has left the everyday behind, but also the tension between everydayness and ecstasis, become essential in manifestations of modernism, reflected in the interweaving expressions of literature, visual art, and phenomenology. A more intimate link between the quotidian and the ecstatic than a transparent opposition would seem to be nonsensical, yet their coupling is a persistent theme in modern art and literature. An intimacy between

the quality of life and ecstasis that can occur with reflection on it is suggested, amplified, and defended, if not sometimes radically exaggerated, in works of modern literature and painting, through which writers and painters embrace the paradox of seeing the everyday for its very everydayness and, yet, discerning within it latent possibilities of transformation. Of course, to look at the everyday with intensity and scrutiny is to already have stepped outside of it, to live primarily the reflection upon the quotidian rather than the quotidian itself. The quotidian usually remains hidden. In §129 of *Philosophische Untersuchungen*, Wittgenstein writes:

> Die für uns wichtigsten Aspekte der Dinge sind durch ihre Einfachheit und Alltäglichkeit verborgen. (Man kann es nicht bemerken,— weil man es immer vor Augen hat.) Die eigentlichen Grundlagen seiner Forschung fallen dem Menschen gar nicht auf. Es sei denn, daß ihm *dies* einmal aufgefallen ist.—Und das heißt: das, was einmal gesehen, das Auffallendste und Stärkste ist, fällt uns nicht auf.

> [The aspects of things that are most important for us are hidden because of their simplicity and familiarity. (It goes unnoticed— because it is always before one's eyes). The real foundations of his enquiry do not strike a person at all. Unless *that* fact has struck him some time before.—And this means: we fail to be struck by that which, once seen, is most striking and most powerful.] (Wittgenstein 1953/2001, 43)

While in everyday life we necessarily fail to be struck by what is so familiar, the fact of things' familiarity to us becomes a subject of intense study in modern art and literature, for which not the content, but the very fact and structure, of experience are thematic. In modern art and literature, from the late nineteenth (perhaps as early as the French poet Charles Baudelaire) to the mid-twentieth century, quotidian life has been a subject of fascination, even if this fascination necessarily changes the everyday quality of the world. But quotidian life is also a persistent theme in phenomenology, which studies the structure of appearance or phenomena. Rosen has argued, to some extent justifiably, that phenomenological treatment among other philosophical approaches can reduce everyday life to concepts which "leave out everything that is characteristic of life" (Rosen 2002, 272). Yet the efforts and strategies of phenomenology have been various, from Edmund Husserl's scientific description to Martin Heidegger's early formal indication and later poetic studies (Rosen concentrates mostly on *Sein und Zeit)*, to Maurice Merleau-Ponty's

studies of perception through art, not to mention Gaston Bachelard's poetic phenomenology and Jean-Paul Sartre's literary-phenomenological writings. Phenomenologists moving beyond Husserl's scientific philosophy have been innovative in their attempts to address quotidian experience without reducing its content. In the main, their methods converge in the area of literary-aesthetic considerations of quotidian life. Thus one does not have to choose between repudiating everyday life for the aesthetic realm and reducing it to scientific concepts which rob it of all vitality. For in modern art and literature, and phenomenological responses to it, everyday life has become the subject of aesthetic attention; and the phenomenological approach, at least to some extent, has learned from its presentations of what is so elusive to conceptual thought.

Whereas Rosen, despite acknowledging the illustrative uses of literature in addressing the relation between ordinary life and extraordinary discourse used to express it, rejects the blurring of art and philosophy (Rosen 2002, 234–35), post-Husserlian phenomenological discussions have invited consideration of quotidian life specifically through art and literature. For phenomenology the world is not simply there to be described, but is to be described as constituted for a living consciousness. This constitution of the world can be examined, among other ways, through its analogies with artistic and poetic constitution, though those come to challenge claims about the universality of egological structures of constitution and essences discerned. This need not to affirm any radical skepticism about the nature of truth or objective reality, nor is it the purpose of this study to refute skepticism altogether. The primary concern here is not to critique the everyday, as has been worked out by Henri Lefebvre, Agnes Heller, Michel Foucault, and other post-Marxist and cultural studies approaches to particular features of everyday life, such as the micropractices of institutions, the organization of social space, the regulation of labor, production and consumption, the discipline of the human body, and so on. Rather, the aim of the present study is both more limited in scope and also more affirmative, as it seeks to illuminate common structures between phenomenological studies and literary-aesthetic evocations of the quotidian and the resonances between their departures from everydayness, in order to show to what extent literary-aesthetic and phenomenological reflections upon the everyday are not only analogous but in some ways interimplicating. For even Husserl acknowledged the need for the productive and fictive imagination, as well as the need for literary description, when pursuing the task of describing experience, even if the phenomenologist's creative impulses are to be held in check.

The intimacy between the object of reflection, the everyday quality of life,

and the act of reflection, is affirmed when writers and painters look for the origins of artistic creativity within the quotidian experience. Thus the most commonplace activities become the focus of intense literary and aesthetic study, including ordinary perception of objects, play and boredom, scribbling and musing, habit and challenges to its expectations, the ordinary activity of looking. Without disparaging it, works of art and literature challenge the seeming stability and nontransitoriness of the quotidian as an illusion of habit, often drawing upon more fluid relations to reality experienced in childhood—which Proust, Rilke, Frost, Twombly, Klee, among others have evoked, and Bachelard, Merleau-Ponty, and Benjamin have studied explicitly. While the exposure of the quotidian as latently mysterious or provocative of unfamiliarity is aligned with existentialism and its anxieties about contingency, a glance beyond the absurdities evoked by Sartre, not to mention Kafka, toward other figures of modern art and literature, opens up the affirmative side of this exposure. In the modern aesthetic the occurrence of ecstasis—starting with what Shklovsky identified as "defamiliarization"—liberates ordinary expectations from the fallenness of habit.

The tone of these studies and evocations differs both from the valuable socio-political critique of the everyday, and from affirmations of the ordinary which regard the ordinary outside of any concern for fallenness. Theoretical critiques of everyday life often neglect to take into account the density and structure of individual experience and consciousness in favor of determining how the individual as social being is caught up and performs within abstract relations of power, commodification, regulations and proliferations of production, consumption, and desire. While not disallowing for renewal of quotidian life, theorists like Henri Lefebvre focus largely on its alienated and abstracted aspects, such as captured in Baudrillard's analysis of the world of simulacra (which will be useful in discussing mimesis in art in the final chapter); the world is seen as a "false world" (Lefebvre 1991, 35), and the utopian objective is to "annihilate" and "oppose" everyday life even as it is to "reorganize" it (Lefebvre 1984, 36–37). While excellent in many respects, Rosen's account, by contrast, is insufficient to address the specific concerns that arise in reflection upon particularly modern everyday life. For whatever alienation may be felt, the ordinary has not only to do with the inadequacy of our accounts of it, but with the tensions or entropy within everyday lived experience. For modern artists and writers, not to mention philosophers of modernity, everyday life has been both a source of wonder and interest as well as the context of fallenness or alienation. In modernism—and given the reliance here on literature, the visual arts, and philosophical studies of culture, this term will be necessarily used in a broad sense—there is much ambivalence about everyday life.

Philosophers, writers, and artists—from the early nineteenth century to the period of the Second World War and its aftermath—have been both affirmative of the everyday—which in the course of the secularization of culture no longer needed to be considered secondary to a transcendent source of meaning—and skeptical of its codification due to mass production, urbanization, uprootedness from village or regional culture, from nature and more natural experiences of time, space, and physical life. Alienation from everyday life might lead to a repudiation of it, but it could also involve a desire for its renewal or revivification, to which many modern writers and artists have been devoted. Some writers and artists have seen this alienation as a source of distress, while others have hailed it as a liberation from the assumption that everyday life is invulnerable to conscious alteration. This ambivalent situation is a matter not only for social-political critique, but for uniquely aesthetic and literary reflection. There are, it seems, sources within everyday life, even when it is alienating, for imaginative renewal, creativity, and wonder, all of which can contribute to a revitalized experience of the world. This affirms Heller's assertion not only that art draws its resources from the quotidian, where "preconditions, the embryonic outlines of the aesthetic way of looking at things, are inherent in the heterogeneous complex of everyday thought" but also that "aesthetic experience in some form or other, is always present in that complex" (Heller 1984, 107–8). Regularity and fascination need not be mutually exclusive, but are coupled in the works of certain modern painters and poets as well as in phenomenology, where they are bound by a tension that, in various reflections, is pulled in one direction or the other, and at different strands of their connection. Yet while Heller looks to pre-modern models for an alternative, the works described here draw their possibilities from the very modern configurations of quotidian life which promote and provoke their reflections.

The subjects of this study are not representative of modern art and literature as a whole. Rather, selected works of art and literature are shown to illustrate one or more aspects of the tension between the quotidian and its ecstatic transformation, as it is reflected upon thematically and with respect to the constitution of experience. These are examined not in order to give a history of the quotidian in modern art, but to show the connections between artistic literary study of the quotidian and phenomenological reflection on the nature of experience of the everyday. The aim is to discover in what ways a thematic reflection evoked by some modern works brings them into a region of phenomenological consideration of everyday life, and how phenomenology, in turn, is indebted to the literary-aesthetic imagination. The meditations from Husserl to Heidegger, Sartre and Merleau-Ponty, Bergson and Bachelard

will be invoked as well as the pragmatist aesthetics of John Dewey, which has much in common with the phenomenological approach to art. Although recent studies of wonder and imagination by Peter de Bolla (2001) and Philip Fischer (1998) are helpful for thematizing the aesthetic-ecstatic quotidian, the present study will depart in critical respects from their analyses. Phenomenological sightings in modern art and literature, as the subtitle indicates, are primarily of and into artworks and works of literature, thus diverging from other approaches to the everyday. But phenomenology is not applied as a method investigation to literary aesthetic works; rather it is invoked where its themes and method coalesce with the artistic and the poetic. It must also be shown how literature and art elude phenomenological accounts.

The triad of phenomenological sightings, modern art, and literature is wonderfully illustrated in the writings of the German poet Rainer Maria Rilke, whose phenomenological-poetic investigations of intentionality—or relation of objects to the structures of consciousness—are expressed in poetry that has been, in turn, profoundly inspired by his study of visual works of art. Although Rilke is by no means representative of modernism, his works voice many of its concerns and thus figure prominently in this study. Heidegger's investment in Rilke, and Merleau-Ponty's in Cézanne, make it all the more remarkable that the painter most important in Rilke's poetic-phenomenological discoveries was Cézanne, by whom a similar form of objectivity was sought. For modern art, this seems to involve rendering visible the world being seen, that is, an attention to the processes of perception. Reflective absorption in the perceptual world leads to consideration of the structure of everydayness, which is then transformed by the poetic or aesthetic intensity with which it is considered. Rilke discovers a heightened intimacy by way of analogies between the inner life and the inner space of things in the world— for which he coined the word *Weltinnenraum*. In his interpretation of Cézanne this relationship is rendered through dynamic tension between the structure of things seen and the means, such as color, a trembling line, a non-scientific precision, by which they emerge in living vision. Rilke's work appears in several chapters of this book. In his *Sonnets to Orpheus* (*Sonette an Orpheus*) and *The Notebooks of Malte Laurids Brigge* (*Die Aufzeichnungen des Malte Laurids Brigge*), for example, ecstatic exposure of the everyday takes the form of a tense oscillation between anxiety and adoring affirmation of the world. That Rilke's work is complemented by similar oscillations in other writers, for example Robert Frost's poetry and the poetically dense and elaborate prose of Marcel Proust, as well as that of Hugo von Hofmannsthal, and the phenomenological fiction of Sartre, suggests that this tension is not unique to a single literary genius, but rather characteristic of modern literary preoccu-

pations. For phenomenology, and its elaboration in existentialism, affirmation and *Angst* are the twin effects of this reflection on the modern subject. That Cézanne's work, for its part, has been linked to both a groundbreaking way of making the world visible and to the very different transformations introduced by cubist and subsequent abstract art, reflect these possibilities inherent in his rendering visible, to some extent discovering, the structure of modern vision. The fact that the subject matter often consists of ordinary objects of domestic life in still lifes, or familiar landscapes, is not merely a vestige of generic traditions, but part of the fascination with seeing itself.

If descriptions of everydayness necessarily depart from it, this may be due not only to the nature of language or representation but to awakening, intense seeing, being drawn into mystery, to uncanniness. All the experiences, which can be called "ecstatic," are also made possible in the initial motivations and movements of phenomenology, which attempts a reflective reach to the beginnings in consciousness of the world's emergence as a world experienced. Analysis of poems, novels, and paintings in this book are governed by an attempt to grasp everydayness phenomenologically, though without strict adherence to any given set of phenomenological principles, for those come to be challenged by the very works they illuminate. Consideration of both the persistent entropy of everydayness that makes it monotonous and the extraordinary intensity of moments which counter this tendency leads to literary questioning of the phenomenological method as well as an indication of limits of scientific phenomenology in capturing the possibilities of ecstasis, or even of everyday life itself.

Chapter 1 situates art and literature, the aesthetic and the poetic, within an account of everydayness that engages the thought of Husserl, Heidegger, and Dewey. It is the aesthetic which offers a departure from the ordinary constitution of the lived world, which consummates its inherent possibilities for harmony, unity, and maximal significance of experience. Contrary to Dewey's account of the consummatory experience of art, aesthetic departure represents a counter-direction to the slackness and monotony of ordinary life, that is, its tendency to lapse into a state of "fallenness" or inertia. The aesthetic or poetic approach highlights a rupture caused by recognition of the fragility (by Sartre thought as contingency) of the world's appearance. This contingency invites reflection that tends to court notions of void, of nothingness, and of *Angst*. Sartre's literary presentations, alongside others, present poetic or aesthetic creativity as a way out of a paralyzing anxiety; but it remains to be shown how literature and art provide a productive engagement with, even establishment of, new ways of being and dwelling.

There is, moreover, within us a residuum of that phase of human experience wherein fragility of appearances is coupled not merely with worry but

with creative play. Chapter 2 focuses on childhood experience, which the adult must remember, and somehow retain or revivify. Such revivification, insofar as possible, is a source for re-imagining the structure of the given, for breaking through the sedimentation of adult expectations of the world. This is not to denigrate mature reflective experience in favor of an idealized naïve perception, but rather to examine why modern writers and thinkers continually evoke childhood experience as a source for understanding the vital possibilities of everyday life. Recaptured, albeit mediated, in the poetics of Rilke and Frost, in the early sections of Proust's major novel, and in studies of childhood perception by Benjamin, Bachelard, and Merleau-Ponty, childhood experience has repeatedly been drawn upon in modern works. The topic of childhood will be revisited in Chapter 6 in the context of Cy Twombly's abstract paintings composed of childish scribbles that can be seen in terms of the tension between everydayness and the ecstatic on the cusp of language. Freud's psychoanalytic formulation of the relationship between childhood and artistic activity will be shown to be inadequate to capture the rich source of experience that characterizes childhood and the literary retrieval thereof.

Husserl admitted that the imagination, productive of fiction, is essential to the phenomenological task. Chapter 3 draws on the origins of scientific phenomenology in Husserl and shows how his phenomenology, as a description of experience and its relation to consciousness, requires literary description, and is given analogous renderings in the work of modern poets and writers. The relation between poetic and phenomenological description is investigated in light of their common departure from the "natural attitude." While experience and its structures are described and examined in both literature and phenomenology, questions and presumptions about the being of what is experienced are put in abeyance. The poetical consciousness at work in Rilke, as first established by Käte Hamburger's studies, reflects the consequences of the phenomenological reduction, wherein the world is retained as phenomenon correlate to the intentionality of consciousness. Rilke's understanding of the intimacy between objects and seeing consciousness, the fantastical analysis of ordinary objects in the prose-poems of Ponge, and the nearly obsessive description of quotidian life seen up close in Robbe-Grillet's narratives, all present ecstatic transformations of this break with the natural attitude that is part of the phenomenological approach to objectivity. From the naïveté of the natural attitude to the phenomenal objectivity of things, poetic and phenomenological descriptions follow interimplicating procedures. This chapter presents an analysis of these analogous descriptions, but it also shows, in contrast to Hamburger's thesis, the literary-poetic means by which writers

call into question the viability of the scientific aims of phenomenology proper. Despite Husserl's acknowledgment that fiction is necessary source for the phenomenologist, some aspects of his philosophy have been challenged by writings that most closely parallel phenomenological discovery, straining phenomenology's claim that the essence of what is can be grasped and expressed univocally.

The mysterious is a notion that arises in correlation with the fragility of the quotidian look of the world, and it is the subject of chapter four. Husserl's descriptions of what constitutes a world, with its inner horizons of what is perceived and known and its outer regions of the unperceived and unknown, resonate with poetic intimations of the power that resides within everydayness and informs the way ordinary things admit a horizon, suggesting another side of reality, unseen within our habitual quotidian regard. The poetry of both Rilke and Robert Frost intimates another side of things beyond the world's inner horizons, suggesting not so much a radical mysticism, but a view that the mysterious and unknown remains relevant to our everyday life, as a potential halo surrounding the most ordinary things and experiences. When the mysterious is acknowledged, the ordinary look of things is radically transformed; for these poets this means that they are seen more truly in a reality of greater and more intensely magnified dimensions than our ordinary habits of perception allow.

The deeper connections between language and seeing are the subject of chapters five, six, and seven, which are devoted to the medium of painting. Chapter 5 examines the means by which poetical images are related to painterly images, disclaiming traditional aesthetics which has always separated them. The divide, which art theorists have maintained since at least Gotthold Ephraim Lessing, is thrown into question by the appropriation of modes of painterly seeing by poetic writers. At the center of this revolution of the traditional aesthetics is Rilke's fascination with Cézanne's paintings, from which he claims to have learned a grasp of objectivity, a truer vision of the world than ordinary seeing affords, a vision that is enacted in his poems. This is presented in light of Cézanne criticism and his influence on modern art, and the relation of abstraction to a perception of reality, truer, for Cézanne, than established perspectival renderings and what he considered artificial realism. The aesthetic objectivity so won, as discussed in Merleau-Ponty's phenomenology, is understood through strategies of painterly practice and the way they make apparent the invisible structures of seeing. With Cézanne not only what is seen, but how it is seen, becomes the subject of painting. Informed by this view, Rilke's poetic images in language present a challenge to the theoretical

divide that assigns in strict division the art of painting to experience of virtual space and poetry to that of time, allowing only for poetry to occasionally try to imitate painting. A phenomenological approach to the aesthetic experience can help overcome major aspects of this division and show how painting and poetic images in concert can contribute to the study, and here also ecstatic transformation, of the given of quotidian life.

Painting again is the subject of chapter 6, in which the ecstasis of vision is considered as a form of silence. In light of the previous discussion of the tutelage Rilke's poetry found in Cézanne's images, other works of modern art are examined in a contrasting maximization of the visual sense at the expense of language. Both Heidegger's interpretations of van Gogh and Merleau-Ponty's interpretations of Cézanne and other painters, treat painting as a form of language, albeit radically reconceived as disclosure and revealing in Heidegger's view and the expression of gestural-embodied life in Merleau-Ponty's. This chapter is devoted to how certain forms of aesthetic ecstasis—the feeling of stepping-outside of ordinary vision in a heightened contemplation or cognitive stimulation—evade the linguistic analogy. Color Field painters like Morris Louis, Barnett Newman, and Mark Rothko realize an ecstatic silence of vision. These paintings refuse anything like linguistic expression, in contrast to counterparts in abstract expressionism. Situated between this silence and the echoes and residues of gesture and writing are the works of Schiele and Twombly. Their images evoke a suspension of legibility or ironization of gesture. Phillip Fischer highlighted a particular ecstasis in Twombly's work, effected by the double recognition in viewing both an ordinary object (like a blackboard with chalk scribbles) and of the surface of a painting as painting. Yet Twombly's paintings also bring to the surface of the work a subterranean consciousness of pre-linguistic experience, associated with childhood, which grants a special quality to everyday experience and the transport from everyday experience. In Schiele's paintings, an ironic mimesis of gesture renders them uniquely visual by canceling expression and evoking the figure's feeling of loneliness through the paradoxical isolation of desirous seeing.

The quotidian in visual art is perhaps nowhere more explicit than in trompe l'œil painting, a style that became particularly strong at the end of the nineteenth century. In the twentieth century, it was adopted by René Magritte and Andy Warhol. A hint of it can also be found in Twombly's work. Chapter 7 examines trompe l'œil paintings that deceive the eye into registering the actual presence, rather than painterly semblance, of usually very ordinary objects of quotidian usage. The metaphysics of trompe l'œil is a teasing and sometimes ironic play with the familiarity of everydayness, in which the viewer experiences at first an undisturbed practical relation to objects which,

as discussed in chapter 1, constitute the quotidian world. If the trompe l'œil highlights the viewing subject's relation to ordinary things, it is also challenged thereby, inasmuch as it is exposed as constituted by the attitudes of looking and is vulnerable to transformation. The persistence of trompe l'œil as a genre, albeit relatively uncelebrated, in Western art since at least the time of Plato, makes it all the more remarkable that a work similar to trompe l'œil, Andy Warhol's *Brillo Box,* presenting the humblest of domestic objects, could usher in a revolution in art. Whereas Arthur Danto celebrates Warhol's work as ushering in the end of art—after which anything can be art—its resonance with trompe l'œil suggests a persistent self-reflective tension within the act of painting itself, which finds unique expression in the modern fascination with quotidian objects. Within the broader framework of this chapter, attention will be paid to mimetic gestures in contemporary art to determine how mimesis contributes to productive reflections on quotidian life.

The epilogue poses questions about the desirability and quality of ecstasis available in the fast-paced presentday quotidian life, with its hyper-stimulation of the senses, and all the troubles, burdens, and denials that have intervened since Husserl's *The Crisis of the European Sciences.* These entail not only a confrontation with technology and its imbalanced development, but with new dimensions of illness, inequity, terrorism, and destruction. While art and literature are not only to change the world, as Sartre would have it, they also inevitably reflect the world and they do affect our expectations of it, our possibilities for understanding it. The individual experience that is expanded through art and literary experience need not be dismissed for its possible insignificance on a political scale, since it is also a source for critique, differentiation, and resistance of grand or overpowering political ideologies and movements. To illuminate the quotidian in this way may be a claim and defense of its worth, but one must also pose questions about the relation between reflection upon quotidian life and life as it is lived and a renewed capacity for preservation and transformation. The question that then arises for contemporary art is whether a provocation of ecstasis, as an aesthetic departure from reflection on everydayness, can be a source for revitalization of the everyday that opens new expressions of the feeling of life and new possibilities for its reconfiguration.

The Quotidian and Literary-Phenomenological Departures from Everydayness

Initial Considerations: The Quotidian in Phenomenology and Literature

In ordinary life, the familiarity of things, by its very nature, does not come to our notice. Only when we are surprised, when things are not as we expected, do we become aware of our expectations explicitly. Such awareness modifies everydayness. Because of this modification, as the philosopher Ludwig Wittgenstein has written, "unfamiliarity is much more of an experience than familiarity." The unfamiliar negates a previously intact state of things; unfamiliarity is felt in surprise (Wittgenstein 1965, 127). The surprising modification needed brings the everyday to notice arises with modern aesthetic and poetic treatment. Aesthetic "defamiliarization," as Shklovsky describes it, played out in dramatic episodes in literature, also occurs in recounting the experience of ordinary perception and ordinary things (Shklovsky 1965, 12). Gertrude Stein finds noble subjects in the "blind glass" of a carafe, in a box, a plate, a chair, a "substance in a cushion." Kafka relates being overwhelmed by the solidity of a glass on the table. Sartre turns to phenomenology when he realizes (in the course of a conversation with Raymond Aron who had just returned from visiting Husserl's lectures) that an apricot cocktail could be the subject of philosophical inquiry. Objects of such ordinariness become existential provocations in his literary writing. He proposes the fragility of appearances as a manifestation of freedom, since they are contingent upon a subject and thus vulnerable to transformation by that subject's engagement with the world. Ponge dedicates his language to the most ordinary of domestic objects (cigarette, orange, sponge) and finds in them resources for an elemental mythol-

ogy. Proust's discovery of time through memory in his novel, *A la recherche du temps perdu*, is framed by an obsessively detailed description of the narrator's surroundings, his readings, his everyday habits. Robbe-Grillet turns description of ordinary surroundings (room, streets, villa, garden) into the total substance of his novels. Rather than leaving the everyday for more heroic or tragic events, modern literature, among other preoccupations, gives recognition to everydayness in such a way that it is seen as experience. From literary exploration of quotidian emanate, at first glance paradoxically, ecstatic experiences. Phenomenology will be enlisted here to describe this seeming paradox in respect to some texts of modern literature, selected for their express attention to everyday experience. Yet literary and aesthetic recognition of the quotidian also contains significant parallels to its phenomenological study. It will be seen in what sense these approaches to the everyday implicate each other.

Phenomenology is a descriptive philosophy which attempts to get at the essence of what is through description of the structure of its appearance. It seeks to grasp the things themselves not as philosophical constructs but as objects of consciousness. For the phenomenologist the world is, in the wake of the initial reduction, the "phenomenal world." To describe everyday experience is to begin to study its manifestation as appearance; for everydayness is not a quality of the world, but of consciousness and its habitual orientation. To recognize in the everyday a world of phenomena is to emerge from a pre-phenomenological naiveté, from what Husserl has called the "natural attitude," for which "the world is simply there, it exists in a literal or a figurative sense." [Die Welt ist für mich einfach da, im wörtlichen oder bildlichen Sinne 'vorhanden'] (Husserl III, 57; 1982, 51).

The ordinary unreflectiveness of quotidian experience is analogous to the natural attitude. As Husserl states in *Cartesianische Meditationen* (*Cartesian Meditations*):

> Daily practical living is naïve. It is immersion in the already given world, whether it be experiencing, or thinking, or valuing, or acting. Meanwhile all those productive intentional functions of experiencing, because of which physical things are simply there, go on anonymously. The experiencer knows nothing about them, and likewise nothing about his productive thinking. The numbers, the predicative complexes of affairs, the goods, the ends, the works, present themselves because of the hidden performances; they are built up, member by member; they alone are regarded.

> [Das tägliche praktische Leben ist naiv, es ist ein in die vorgegebene Welt Hineinfahren, Hineindenken, Hineinwerten, Hineinhandeln.

Dabei vollziehen sich alle die intentionalen Leistungen des Erfahrens, wodurch die Dinge schlechthin da sind, anonym: der Erfahrende weiß von ihnen nichts, ebenso nichts vom leistenden Denken; die Zahlen, die prädikativen Sachverhalte, die Werte, die Zwecke, die Werke treten dank den verborgenen Leistungen auf, Glied für Glied sich aufbauend; sie sind allein im Blick.] (Husserl 1993, 152–53; I, 179)

In ordinary experience we take the world unreflectively as an actual world out there; and so pre-phenomenological reflection accepts the world as "actual being" (wirkliches Sein) as the object of its knowledge (Husserl III, 10; 1982, 5). The ecstatic reflection on the quotidian in literature is analogous to phenomenological rendering of the world not as simply there, but as the correlate of conscious experience. Departing from Husserl and scientific phenomenology, other phenomenologically sensitive philosophers, among them Heidegger, Merleau-Ponty, Sartre, and Bachelard, turned to literary description, not only for inspiration but for guidance in their efforts to bring lived experience to the forefront of thought. Whereas Husserl expresses ambivalence about literary imaginings and its language (an ambivalence to be discussed in chapter 3), others rely extensively on literature and art. In discussing what he calls *durchschnittliche Alltäglichkeit* (average everydayness) in *Sein und Zeit* (*Being and Time*), Heidegger argues that a study of the world in its existential-phenomenological structures cannot be fully accomplished in philosophical language alone. Both Heidegger and Sartre have interpreted literature as evidencing a kind of proto-phenomenological reduction, getting to the essence of things by allowing the seemingly self-evident structure of the appearance of the everyday to shift out of focus, to break down, to be called into question. For Heidegger such calling into question belongs to the same task as understanding the being of one for whom its own Being is a question. This self-understanding of *Dasein*, too, will be described in terms of a stepping-outside of self or ecstasis. To grasp what Dasein essentially is, Dasein must recognize its temporal *ek-stasis*, its being not accounted for merely in the static present but determined by the open and vital temporality of future, past, and present. This requires breaking out of the average everyday in order to lay bare how the structure of Being is opened up by human existence. To what extent Heidegger is able to account for the experience of everyday life depends in part on what is included in (or excluded from) the realm of Dasein's concerns. Merleau-Ponty seeks to grasp a world he saw as "inexhaustible," a reality "full of reserves," by turning to literary description and aesthetic depiction and to

overcome a prosaic vision of the world in which this inexhaustibility is
dimmed (Merleau-Ponty 1993, 65).

In literary phenomenology, quotidian experience emerges from a state of
unexamined self-evidence and is made apparent through imaginative descrip-
tion. If, while seeing, we could discern the very structure of vision, the seen
would appear to us quite differently; so too the manifestation of everydayness
illuminates the expectational horizons and performances of consciousness by
which the world appears to us as it does. The emergence of everydayness
as phenomenon exposes it as a manifestation of reality—not its definitive
nature—that is constituted by the intentionality of consciousness, with its
habitual expectations. In the exposure of everydayness, our naive acceptance
of a world as simply being there gives way to reflection on the nature of its
constitution. The analogous moment in modern literary consciousness seems
to rely on what is a fundamentally imaginative assumption: within everyday-
ness, within the everyday life world, is harbored a theoretical-reflective la-
tency, a vulnerability to thematization and alteration. This alteration goes
beyond Shklovsky's defamiliarization. Not only does the familiar or quotidian
become strange, familiarity itself becomes thematic as that from which one
can be estranged.

Habit, Everyday Experience, and Aesthetic-Existential Departures from the Everyday

Everydayness is not a primitive substrate of material life upon which higher
culture is built up. Everydayness is the stratum where culture interacts directly
with human bio-social needs. Thus a world's everydayness signifies a mode of
Being of the human being, what Heidegger calls "Dasein," exactly then,
"when Dasein moves within a highly developed and differentiated culture,"
and conversely, even a so-called primitive Dasein would have both "its possi-
bilities of exceptional being [unalltäglichen Seins]" and "its own specific every-
dayness" (Heidegger 1984, 50–51). Habit is constitutive of everydayness and
shapes our perceptions and understanding of the world in its actuality. Habit
or ethos, a subject of philosophical inquiry since Aristotle's Nichomachean
Ethics, is recognized by modern literary writers not only as determining the
character of an individual, but as the rhythmic template underlying the style
of the world's appearance. "Habit," Samuel Beckett writes in an essay on
Proust first published in 1931, "is a compromise effected between the individ-
ual and his environment," and according to it, the "creation of the world . . .
takes place every day" (Beckett 1970, 7–8).

In Creative Evolution (L'Évolution créatrice), Henri Bergson systematically

examines the quality of habit, arguing that habitual action is not only unnoticed, but also something of which we are unconscious. The nature of this unconsciousness requires some explanation: it does not indicate absence of explicit consciousness, but its nullification. The unconscious state of habit is a nullity that is not originally nothingness, but rather expresses that we have two equal quantities of opposite signs which compensate and neutralize each other. Habitual action, in other words, involves an unconsciousness that is due to the total eclipse of reflection by action. For "the representation of the act is held in check by the performance of the act itself, which resembles the idea so perfectly, and fits so exactly, that consciousness is unable to find any room between them" (Bergson 1944, 158–59). When we go about our everyday business, and matters proceed much as we expect them to proceed, there is no need to develop self-reflective thoughts. Habitual action already conforms to our expectations and representations of what we are doing.

In its everydayness, habit has the effect of numbing human sensitivities, as Bergson, William James, and John Dewey have suggested. Victor Shklovsky argues unambiguously that habit "devours works, clothes, furniture, one's wife, and the fear of war" (Shklovsky 1965, 12). This view made the defamiliarizing effects of literature so appealing to the Russian Formalists. In light of this view even the absurd can be celebrated as a liberation. In quotidian life this creation by habit of the world goes without notice, and hence it is ostensibly opposed to the aesthetic or ecstatic experience which involves noticing intensely and, in particular, noticing in order to participate transformatively in the processes of world creation. This is the implication of Shklovsky's celebration of art as a form of rendering strange. In aesthetic-literary experience, attention is formalized toward or within the context of expression. In this context the world is perceived more intensely, and self-reflexively, than in the context of the habitual functioning of quotidian life. This intensification is the subject of Dewey's study of the relationship between art and everyday experience; yet it is, in Dewey's view, of one fabric with the experience of the quotidian. In contrast to Shklovsky, Dewey argues that we must understand art not as opposed to everydayness, but in continuity with the generally ordered relation a human organism has with its environment.

Dewey's analysis relies implicitly on the classical view, prominent since Aristotle's *Poetics,* that art is an expression of organic harmony, mimetic of life. For Dewey this involves the tensions of a living being, its striving, temporary satisfaction, and overcoming of obstacles within a surrounding environment. Such organic harmony is not static equilibrium, but the vital tension of balanced discord. In life "order is not imposed from without but is made out of the relations of harmonious interactions that energies bear to one another"

(Dewey 1958, 14). These interactions are subject to the interruption and desta-
bilization that characterize experience, and without which there could be no
vital harmony. In a perfect and finished world, experience in the fullest sense—
that is, experience as "heightened vitality"—would not arise (19). Art and liter-
ature expressively participate in this vitality; but such participation, Dewey
argues, "comes after a phase of disruption and conflict." By reestablishing
harmony of part to whole, life "bears within itself the germs of the aesthetic"
(15). Because equilibrium is continually threatened, it must be continually rees-
tablished with the "potency of new adjustments to be made through struggle"
(17). With these new adjustments we begin to reflect on the relations of har-
mony in the everyday for which we strive, and begin to invent new means of
achieving them, innovations which reach the apex of their creativity in art-
works. In Heidegger's philosophy, a recognition of the groundlessness of the
everyday world, exposed by the severe (definite but indeterminate) fact of Da-
sein's finitude, provokes a radically reflective alteration, and leads to the possi-
bility of an authentic self-understanding and understanding of Being. And in
Heidegger's reflections on the origin of the work of art, the strife between
revealing and concealment, or world and earth, provokes a similarly productive
tension. For both Dewey and Heidegger, then, reflection upon and innovation
within everyday life are induced by its underlying tensions.

While the aesthetic is engendered by everyday experience, there is also the
power of the everyday experience to inhibit this vitality, which is emphasized
in Shklovsky's claim about the devouring nature of habit. Dewey must explain
how and why "if artistic and aesthetic quality is implicit in every normal
experience . . . it so generally fails to become explicit" (13). While Heidegger
explains this by the notion that everyday life is subject to a kind of fallenness
(*Verfallen*), for Dewey the everyday is subject to entropy. Human experience
tends toward decreasing availability of energy for innovative reflection on
overcoming obstacles, an innovativeness—one could call it spontaneity—that
is necessary for a vital harmony and expression. Neither the practical necessi-
ties of everyday life, nor theoretical reflection, discourage this vitality. Rather
entropy is a feature of habit, in its slackening of purposive intention, in its
arbitrariness and rigidity. As Dewey writes: "The enemies of the aesthetic are
neither the practical nor the intellectual. They are the humdrum; slackness of
loose ends; submission to convention in practice and intellectual procedure.
Rigid abstinence, coerced submission, tightness on one side and dissipation,
incoherence, and aimless indulgence on the other, are deviations in opposite
directions from the unity of an experience." For Dewey something like Aris-
totle's mean is proper to both aesthetic and virtuous experience; but for the
aesthetic this belongs "to an experience that has a developing movement

toward its own consummation" (40–41), and this must overcome the entropy of habitual action. Thus quotidian life is not even in quality.

In Dewey's view, art represents a consummation of experience, experience in its purity and integrity. Yet the ecstatic nature of artistic experience must admit a sharper divergence from the ordinary than Dewey's thesis of consummation allows. Modern works of art and literature bring to reflection moments of consummatory vitality, which Dewey's theory admiringly describes. In writers such as Rilke and Proust, there is a savoring of a heightened moment of perception, wherein, as Jephcott argues in his study of their privileged moments, even "the existence of objects is seen no longer as a state, but as a process having the intensity of combustion; despite their stillness, they seem to exist actively, dynamically" (Jephcott 1970, 18). Here the immersion of the world into the existential context of literary reflection brings out the heightened harmony and perfection that are unattainable within the ordinary quotidian processes of life. Art can express the unity of form and content, perceiving and expressing, doing and undergoing; in a privileged literary moment, as Jephcott writes, "everyday functional relationships disappear, and are replaced by a far more complex and intense system of analogies not normally perceived. Now all parts of the field are seen to form a pattern" (19). The disappearance of ordinary functional relationships is, of course, a significant departure from everydayness, but not necessarily its rejection. The consummatory moment in art according to Dewey involves the maximum intensification of experience, when this unification is itself oriented toward communicability. This consummation or perfection and completion of experience can provoke a feeling of the ecstatic, such that the familiar world, as the basis of the literary or aesthetic expression, seems to be left behind.

Ecstasis occurs, furthermore, in more distressing provocations of discord represented in modern art that contain the possibility of alienation from everydayness. Modern writers and artists, from Baudelaire to the abstract expressionist painters, had to confront, and did so in a variety of ways, new forms of everyday life, new kinds of objects and habits, many of which were alienating due to a lack of individuality, of uniqueness, of what Benjamin called the "aura" of a sacred object or place. While Baudelaire could marvel at the spectacles of merchandise, of urban decay, and find in them subjects for ecstatic poetry, one possible response is uncanniness (*Unheimlichkeit*), a feeling of no longer being at home in the everyday. While Proust and Rilke, both of whom will be discussed in this and the next chapters, engender a reverence for the heightened, epiphanic moment of experience, transformation of quotidian life occurs also with a sense of uncanniness, breakdown, and/or absurdity.

This latter sort of transformation is found in exaggerated form in Kafka

and Sartre and in certain moments of Rilke's writings. Uncanniness is point-
edly exaggerated in Kafka's writings, as for instance in his most celebrated
story *Die Verwandlung* (Metamorphosis). Gregor Samsa, suffering from his
everyday responsibilities as a traveling salesman and supporter of his parents
and sister, wakes up to find himself transformed into an insect. What renders
the plot more wrenching than ridiculous is that it plays upon Samsa's attempts
to maintain his ordinary sense of being, his humanity, through maintaining
his everyday habits. Getting out of bed and dressed for work is a problem—he
panics about being late for the train—but so are his loss of appetite for ordi-
nary human food and his incoherent distress as the family removes the usual
furnishings from his room. In *Der Hungerkünstler* (The Hunger Artist) the
most basic everyday habit of biological existence—in particular, eating—is
mocked by the performance artist who submits to a spiritually exalted starva-
tion. He exhibits his triumph over ordinary physical need, and thus over
ordinary time, by means of a calendar and a clock kept in his cage which are
to record the length of his performance, but which are eventually neglected
by onlookers who find more thrilling and vital objects of amusement. The
hunger artist dies unnoticed in his cage without anyone having kept track of
his performance. In *Ein Landarzt*, the country doctor of the title is awakened
at night for a house call and endures fantastically illogical difficulties getting
to a sick patient in the neighboring town. On this seemingly ordinary house
call, the doctor finds himself in bed with the patient who is suffering from a
grotesque, inexplicable wound, and is subjected to the ritualistic-pagan spiri-
tuality of the local townspeople and the potential hostility of his spiritualized
horses. In Sartre's *La Nausée* (Nausea), objects break down in Roquentin's
world so as to present absurdity, not through the transformation of the pro-
tagonist's physical or spiritual state, but within the very substance of things.
For Roquentin absurdity is initiated through objects; it is situated not in the
mind but in the loss of familiarity with otherwise familiar things. And the
title character of Rilke's *Die Aufzeichnungen des Malte Laurids Brigge* (The
Notebooks of Malte Laurids Brigge) is subject to both frightening and mysti-
cal experiences as mundane surroundings of urban Paris and the familiarity of
his childhood home yield to nervous, then fantastic, destabilization.

The Void, or Nothingness, and Contingency in the Departure from Everydayness

The ecstatic quotidian—stepping outside an everyday familiarity—encom-
passes moments of negation, which existentialist philosophers associate with

the "void." Sartre, in particular, has examined the literary implications of what for phenomenology is a methodological detachment from the natural attitude. In the "epoché," the world as having objective existence is bracketed; this involves withdrawing from affirmation of ordinary belief in the world as objectively there. The *epoché* itself "achieves nothing positive" (Lauer 1965, 50). It is a negative act of consciousness inasmuch as it has no content, while withdrawing affirmation of that of which consciousness is habitually conscious—the world as immediately and objectively given, the world out there in its actual being. There is no experienced emptiness in that the world is retained as phenomenon.

Yet in literary descriptions, this moment of nonaffirmation is not merely a methodological technique, but rather an existential confrontation with the void. Insofar as recovery from this confrontation is possible, it promises access to a reality of greater intensity. The transition from the ordinary world to the world bracketed, commonplace enough for the phenomenologist, is parallel to a literary-aesthetic tear in the fabric of the presumed order of reality. This tear reveals the everyday look of the world as a veil that can be torn away, and exposes a kind of nothingness. Some literary writers have suggested that the purity of nothingness and the paradoxical result of its intuition can be achieved; "by abstracting everything which is outside the potential for consciousness, one seems to gain an interior ultimate" (Adams, 217). Although Bergson rejects the notion of the nothing or the void as an illusion (Bergson 1944, 308), he admits that it is compelling. In *Creative Evolution,* in a chapter devoted to the idea of nothingness, he writes: "I cannot get rid of the idea that the full is an embroidery on the canvas of the void, that being is superimposed on nothing, and that in the idea of 'nothing' there is less than that of 'something.' Hence all the mystery" (300).

The very obstinacy of this compelling mystery oppresses Sartre's Roquentin despite its evasion of any clear image or thought. This is expressed in the ambiguity of Roquentin's journal entry: "Tuesday. Nothing. Existed" [Mardi. Rien. Existé] (Sartre 1964, 140; 1938, 133). When objects have been vertiginously dislocated from their ordinary stations as meaningful things with stable qualities and values, Roquentin ponders the unthinkability of nothing: "You couldn't even wonder where all that sprang from, or how it was that a world came into existence, rather than nothingness. . . . It was unthinkable: to imagine nothingness you had to be there already, in the midst of the world" (Sartre 1964, 180–81).

And again, following Bergson's description of the effort of imagining nothingness as "swinging to and fro between the vision of an outer and that of an inner reality" (Bergson 1944, 304), Roquentin writes: "I told myself, as I fol-

lowed the swinging of the branches: movements never quite exist, they are passages, intermediaries between two existences, moments of weakness, I expected to see them come out of nothingness, progressively ripen, blossom" (Sartre 1964, 178). This nothingness itself cannot of course be perceived or imagined: "We have so much difficulty imagining nothingness. Now I knew: things are entirely what they appear to be—and behind them . . . there is nothing" (131). Here Sartre gets closest to describing a magnified interstice of the epoché: for the phenomenologist the bracketing of the world does not leave the thinker abandoned in the abeyance which is nothingness, for there is a retention of things as phenomena, as appearances; but for a mind habitually absorbed into the natural attitude, and subject to literary-aesthetic fascinations, this retention does not neutralize yet the distressing negation of the presumed actuality in itself once believed to reside within or 'behind' appearances. In this exposure consciousness tries to imagine the nothingness that haunts it, but fails to figure it; nothingness nonetheless lingers in an *irréel* abeyance between positive objects of thought. The image we have of nothing, in Bergson's analysis, is formed "in this coming and going of our mind between the without and the within," at a "point, at equal distance from both, in which it seems to us that we no longer perceive the one, and that we do not yet perceive the other: it is there that the image of "Nothing" is formed. In reality . . . the image of Nothing . . . is an image full of things" (Bergson 1944, 304). Sartre conceives of nothingness—which is nothing other than consciousness itself—as indirectly accessed by a kind of perception of temporality: it is in contemplating where the past goes and from whence the future comes that nothingness is felt in the folds between conscious events. As Bergson stated: "The representation of the void is always a representation which is full and which resolves itself on analysis into two positive elements: the idea, distinct or confused, of a substitution [of one actuality or event for another], and the feeling, experienced or imagined, of a desire or a regret [for the lost one]" (308). The conception of a void is possible as a longing for a lost familiar actuality, since consciousness, "lagging behind itself, remains attached to the recollection of an old state when another state is already present" (307). This illusion of the void, actually a longing felt by a lagging-behind consciousness for what has just passed, is diagnosed in Sartre's phenomenological novel as a facet of the nausea, Roquentin's illness.

Yet for all its evasion of positive thought, nothingness is an important concept in certain moments of the development of phenomenology, even if by denial. In the *Cartesian Meditations* Husserl presents the transcendental ego as a foundation that would succeed the annihilation of everything else, or at least its dissolution into chaos. Husserl refers to Descartes's discussion in

the second meditation of the primary knowledge of his own existence as a *res cogitans*, which Descartes in the fourth meditation defines ontologically as an intermediary between God's plentitude and nothingness. Nothingness is denied in this tradition by the irreducible presence of a transcendental ego, and then of the God of which it is capable of having a concept. In Bergson, nothingness is a mystery that can be cleared up only through an analysis of consciousness as "duration and free choice at the base of things" (300), a solution that is echoed in both Sartre and Heidegger. Bergson resolves the mystery of nothingness by referring to consciousness as duration and free choice. Sartre defines consciousness itself as "nothing," and insofar as it is a power of negation, the imagination can transform the given. According to Heidegger, while Dasein may indeed be a groundless ground, and thus intimate with the abyssal, Dasein's anticipatory resoluteness—its freedom to be its ecstatic self—overcomes anxiety that accompanies *das Nichts*.

Sartre's solution is worth discussing further, because it introduces the relation between contingency and the concept of nothingness in the context of specifically literary writing. *Nausea* illustrates the radical breakdown of the ordinary that interrupts the consummation, which Dewey defends, or the intensification and unification of experience, which Jephcott celebrates. The breakdown of ordinary quotidian reality is its exposure as contingent upon consciousness, itself revealed as a nothingness of radical freedom. But how does one fare in the wake of this revelation? Anny, Roquentin's love interest, ever attempts to make of the ordinary, aesthetically unsatisfying flux of everyday life *"an* experience" with its own positivity, purposivity, and meaning. Anny attempts in vain to render the world, and in particular a moment of the world, as ordered by necessary being. Her design and realization of "perfect moments" [moments parfaits] out of privileged situations—those which have all the right content and await the perfect form—would enact a moment of living as art, perfect like "a concerted silence, as when, at the Opera, the stage is empty for exactly seven measures of music" (Sartre 1964, 193). Anny's efforts toward the formalization and essentialization of everyday experience prove unsuccessful. Some contingency always seeps through the cracks of the world she has created, with its demand for perfection rather than merely a harmonious contribution of all the details of a given occasion. Roquentin's red hair, which inevitably clashes with the surrounding decor, symbolizes the unruly and arbitrary nature of quotidian life. Anny's staging of experience fails to justify her reality with perfection and exactitude, thwarted by the arbitrariness of experiential detail. Thus in her attempt to overpower everydayness, she remains within the snare of a superficially refined habit.

What is lacking in Dewey's notion of "aesthetic consummation" and in

the notion of a "privileged moment"—although they both include "the inten-
sification of sensation" and "the unification of awareness"—is an adequate
account of the possibilities of transformation in the face of contingency or
nothingness. This view of the purpose of art is reflected in Anny's attempts to
consummate moments of her existence, attempts which include acting in the
theater, where the quotidian is displaced by the constitution of a practiced
and staged mimesis of life and reality. But even here Anny fails to render even
those situations transformative, because she is aware that they are only mi-
metic and do not offer a real alternative vision that embraces existence as it
is. Thus Anny abandons her perfect moments without having developed an
affirmative vision of life in their stead.

Roquentin succumbs to the negating function of nausea and thus accepts
the contingency of the world and its events. This realization sparks his ecstatic
experiences and his eventual epiphany. These experiences—often distressingly
vertiginous, but occasionally exhilarating—expose him as much to the purity
of existence as to what he calls "the nothing" (*le néant*). Roquentin's experi-
ence oscillates between the heights of freedom—as the arbiter of things—and
the despair over the contingency of things. Everyday life becomes for Roquen-
tin a courting of nothingness, a distressing transformation for one who had
wanted to render his experiences necessary, fateful, and justified. Roquentin's
decision to write a novel is a decision to counter the contingency of quotidian
life. The necessity of art, rather than merely mimetic of life—as in the biogra-
phy he had attempted to write of the Marquis de Rollebon—invites, rather
than holds at bay, ecstasis, because art initiates a formal reality of its own
independent of that which it would represent. But art is uncertain, and the
novel ends without evidence of Roquentin's success or failure. The reader
does not know whether Roquentin's project will become an authentic project
in Sartre's terms, or remains just another manifestation of self-delusion. Art
as an authentic choice must not lead to the denial of reality or an escape from
it, but a transformation of its intrinsic possibilities, an expression of its ecstatic
latencies. Perhaps the most authentic novel Roquentin could have written is
the very one, *Nausea*, in which he is granted his literary existence.

These movements from perception of ordinary quotidian things, to reflec-
tion on them, to an exigent sense of the void, to potential recovery, are not
unique to existentialist narratives. Rather, this movement seems to be charac-
teristic of a wider strategy of modernist writers who consider the structure and
constitution of things that make up the ordinary world upon which their
characters or narrators reflect. Sartre's novel, while more phenomenologically
polished than those of his predecessors, seems to work out a concern that
emerged within literature some decades before, bearing similarity to moments

in Baudelaire, Rilke, Kafka, and Hugo von Hofmannsthal. Modern writers—
and one could also point to James Joyce, Virginia Woolf, and Stein—present
the world with a defamiliarized perceptual eye, and ponder the experiential
and ontological consequences of this estrangement.

This tendency is suggested by Hofmannsthal's work "Die Briefe des Zur-
ückgekehrten" (1907). The writer of the letters in question has returned to
Germany from far-off, exotic places. Rather than feeling at home, he feels
estranged and conveys his disturbing disorientation through the look and feel
of ordinary things, which seem to be divorced from their true essence. In the
mornings, he reports,

> in these German hotel rooms, the jug and the washbowl—or a corner
> of the room with the desk and the clothes stand—seem to me so
> unreal, despite their indescribable familiarity, so entirely nonactual,
> to a certain extent ghostly, and at the same time provisional, waiting,
> so to speak, anticipatorily taking the place of the actual jug, the actual
> wash-bowl filled with water.

> [in diesen deutschen Hotelzimmern, daß mir der Krug und das
> Waschbecken—oder eine Ecke des Zimmers mit dem Tisch und dem
> Kleiderständer so nicht-wirklich vorkamen, trotz ihrer unbeschreibli-
> chen Gewöhnlichkeit so ganz und gar nicht wirklich, gewissermaßen
> gespenstisch, und zugleich provisorisch, wartend, sozusagen vorläufig
> die Stelle des wirklichen Kruges, des wirklichen mit Wasser gefüllten
> Waschbeckens einnehmend] (166).

While a jug or a bucket filled with fresh water which he had encountered
during his travels, had something self-evident about it, something vital, here,
in modern Europe, it seems ghostly, *ein Gespenst*. The carriages seem not like
real carriages but like ghosts of them. Anticipating Sartre's motif, Hofmanns-
thal's narrator calls this effect of ghostliness a "quiet nausea" (leise Übelkeit),
and describes this nausea existentially: as if the narrator were swaying "over
an abyss, over an eternal emptiness" (über dem Bodenlosen, dem Ewig-
Leeren). Not only dilapidated houses, such as the Paris ruins that catch the
attention of Rilke's narrator in Paris, but the most trivial of presently inhab-
ited ones seem ghostly here. Even trees evoke an indescribable sense of the
"perpetual nothing," the "perpetual nowhere" [des ewigen Nichts, des ewigen
Nirgends] (562). This is a sense not of death, but of non-life, wherein every-
thing takes on the look of uncertainty and unreality.

The narrator's inner crisis is provoked by his perception of surrounding

objects within a modern European environment, after having achieved a significant defamiliarization through, and then acclimatization to nearly two decades of living abroad. Just as Roquentin's travels furnish him with memories of exotic places, significant experiences, and adventures, Hofmannsthal's letter writer has been awakened in his capacities for sensuous perception and adventure by his own journeys, and has been prevented from settling into a routine of everyday familiar life. This disorientation from the ordinary everyday occurs in a related case in Thomas Mann's *Der Zauberberg* (The Magic Mountain). Hans Castorp, who gradually adopts rituals of sanatorium life in the Swiss Alps, with their rigorous schedules of rest cures, walks, meals, temperature-taking, socializing, and physiological and psychoanalytic examinations, becomes gradually unfit for ordinary everyday life down in the now foreign "flatlands." For all of these protagonists the return to a formerly everyday setting is highly problematic, if not impossible from the standpoint of perceptual and attitudinal familiarity. But while Hans Castorp experiences a radical breakdown of sensibility and reason, in the context of his companions' nihilistic swirl of argumentation for his soul, and becomes addicted to disease and death, Hofmannsthal's letter writer experiences a disorientation that is really an achievement of critical distance from the atmosphere of modern life. Both cases suggest that it is impossible to regain the original sense of quotidian life once it has been exposed to a radical or illuminating defamiliarization; and what defamiliarization illuminates is the void. Yet, like Sartre's Roquentin, who decides to write a novel, and Rilke's Malte, who finds solace in art, journal writing, and poetry, Hofmannsthal's narrator reestablishes an inner equilibrium—a comfort with himself and the world—through aesthetic experience. Discovering van Gogh's paintings at a Dutch gallery, the narrator is astonished to find himself restored by the intensity of their color and the truth of their objects, which seem more real and alive there than in immediate perception. This sense of recovery of life occurs in conjunction with a sense of insight into the essence of things, thought to reborn out of the chaos of the void (565). Castorp, in contrast, emerges from his psychological haze to leave the magic mountain only by submitting to the fate of Europe at war.

World, Everydayness, and the Unobtrusiveness of Objects: Obtrusiveness and Ecstasis

An ontologically rich account of the lifeworld as the world of the everyday is part of the achievement of Heidegger's earlier philosophy. In highlighting the parallels between Heidegger's description of the obtrusiveness of objects when

disturbed from their everyday station and literary description of the same, the interconnections between these kinds of description can become apparent. In *Sein und Zeit* (*Being and Time*), Heidegger introduces the concepts of worldliness (*Weltlichkeit*) to describe the ontological structure of the world in which Dasein *is*, and average everydayness (*durchschnittliche Alltäglichkeit*) to describe the way in which the world is experienced or shows itself in its ordinary aspect. Worldliness "is an ontological concept and signifies the structure of a constitutive moment of being-in-the-world. [. . .] When we ask ontologically about the 'world,' then we in no way leave the thematic field of the analytic of Dasein" (Heidegger 1984, 64). The world is not an objective context pertaining to beings; the world is *there* by virtue of Dasein's involvements, habits, and concerns, the ways in which Dasein is and opens out the there of its being. Heidegger's discussion of world is useful in setting up an inquiry into everydayness and its relation to ecstasis.

One of the principal modes of Dasein's being there has to do with practically oriented employment of everyday objects. Heidegger writes: "This is the way in which everyday Dasein always *is:* when I open the door, for instance, I use the latch," and yet it is precisely those things that do not come to one's notice (Heidegger 1964, 96; 1984, 68). As for Bergson, involvement with things constitutes the meaningful space of human existence; but it is also the context in which everydayness is continually formed, for, as Heidegger put it, "to everydayness of being-in-the-world belong modes of concern" [Zur Alltäglichkeit des in-der-Welt-seins gehören Modi des Besorgens] (Heidegger 1984, 73). Familiarity of everydayness is also its temporal being. When the world is encountered as familiar, it is so by virtue of "initial and temporally particular givens which are closest to us and are there for a while in a certain 'whiling' or 'tarrying awhile' at home in them. . . . This tarrying awhile at home in . . . has its while, its character of a measured sojourn and holding out in the temporality of everydayness" (Heidegger 1999, 66).

Heidegger conceived of Dasein's concerned involvement with things as "equipmentality"—the being at hand (die Zuhandenheit) of the equipment (das Zeug), one principal mode in which things are present in worldliness, in their unobtrusive familiarity (unauffälligen Vertrautheit) (Heidegger 1984, 104). In an earlier work Heidegger used the example of a table in a familiar corner of the home; such a thing has practical significance, or meaning, by virtue of our involvement with it—the table is that "at which one sits *in order to* write, have a meal, sew, play" (Heidegger 1999, 69). Likewise, the hammer is there in respect to our need for it to work on this or that sort of project. Hardly noticed, the hammer belongs to a system of references by which it points to other things: the hammer, cut to fit the body of Dasein, indicates

the nail and points to the wood and the forest from where it came, the house that is to be built, the people who will live there, and so on. Because of this nexus, which in part makes up a world, this equipment encounters us as a totality; things belong to the world according to their arrangement alongside and significance for other things: "Inkpot, pen, ink, paper, blotting pad, table, lamp, furniture, windows, doors, room. . . . These 'Things' never show themselves proximally as they are for themselves . . . but as equipment for residing. Out of this the 'arrangement' [die Einrichtung] emerges" (Heidegger 1964, 98; 1984, 69). In Heidegger's terms, the hammer is ready-at-hand (zuhanden) as we are about to use it, pick it up, set it down; only when it breaks is it *vorhanden,* present-at-hand, encountering us, unusually announcing itself as a problem.

In such circumstances the object begins to look quite different from the way we habitually expect it to look, an appearing-otherwise Heidegger calls "obtrusiveness" [Auffälligkeit] (Heidegger 1984, 73). The ordinary becomes obtrusive when it is regarded in its very ordinariness; particularly when it is unusable, *un*ready-to-hand, the quotidian object becomes conspicuous, obstinate (Heidegger 1964, 104; 1984, 74; 1999, 77). Heidegger's aim is to show how the object, as it becomes explicit or is removed from its usual repose, illuminates and makes explicit the structure of human existence. . The naked presence of an object is disclosed, and so is the fact that it is our projects and concerns that are responsible for the way it formerly appeared (Heidegger 1964, 105; 1984, 75). *Die Zuhandenheit* is exposed as one unreflective manner of appearance of things in ordinary life when we are going about our labors; but its exposure is related to Dasein's own sense of uncanniness, to the ecstatic situation of stepping-outside the self, stepping out of the ordinary, though unnoticed, relation to Being.

Modern artistic and literary works, some of which have been introduced above, offer not merely illustrations, but imaginative provocations of this obtrusiveness of objects. This can certainly be related to reflection, prominent in the thought of Walter Benjamin and Rilke, about the nature of modern objects, the way mass-produced or commercialized objects differ from more natural, older, well-handled things. This difference is alternatively mourned, in nostalgia for a more authentic world of things past, and exploited, in many works of modern literature and art. To review only a sample: In *Nausea,* Roquentin's illness begins with the obtrusiveness of a stone, a newspaper, a beer glass, purple suspenders worn by a fellow café patron. In Hofmannsthal's *Briefe,* jugs and washbasins in the narrator's hotel room seem unreal, carriages and trees look ghostly. In Ravel's opera *L'Enfant,* the teacups and books the child has mishandled come to life and seek their revenge. In Tchaikovky's

ballet *The Nutcracker*, toys become animated in a dream to the point of caus-
ing fright. In Kafka's *Das Urteil* (The Judgment), objects in the domestic
space, for instance a newspaper and a pocket-watch, increase to a physical size
disproportionate to their owner, the aging father who will condemn his son
to death by drowning. At the outset of Proust's *A la recherche du temps perdu*,
the narrator feels the existence of familiar objects in his bedroom as a hostile
force. Eric Satie's furniture music seeks the status of surrounding domestic
objects. Rilke's Malte longs for a night without objects ("O Nacht ohne Geg-
enstände," he writes) when they become disturbingly present in his percep-
tion. In the essay "Puppen" (Dolls), to be discussed in the next chapter, Rilke
examines toys as the very anchor of orientation in childhood space. Surrealist
artists like Salvador Dalí have treated everyday objects of practical usage as
subject to grotesque or absurd transformation. In 1917 Marcel Duchamp made
the urinal as "Fountain" a spectacle of this transformation merely by display-
ing it as art. Wayne Thiebaud's intensely colored paintings of stubbornly pro-
saic things, such as displayed food—cakes, slices of pie, a club sandwich with
olives—and the frivolous bubble gum dispenser, a lit cigar, jars of cold cream,
lipstick render them aesthetically obtrusive. The cultural specificity and ordi-
nariness of Thiebaud's objects falls away when they take on iconographic
value, in abstract isolation from their everyday use. A similar dislocation of
things is illustrated in René Magritte's painting *Personal Values* (Les valeurs
personnelles). Ordinary objects from a bedroom toilette are faithfully, pain-
stakingly rendered as in a trompe l'œil still life, except for a significant distor-
tion of scale. In Magritte's painting the viewer faces a comb towering
disproportionately above a bed, an enormous shaving brush, a soap the size
of an ottoman. The viewer is wrested from—and yet also seduced into—the
everyday world these objects ironically announce. Cy Twombly's abstract
paintings of wobbly paint smudges and pencil lines both evoke and distort
the magical quality of the classroom chalkboard, which Fischer has called
"everyday life's most casual surface" (Fischer, 155). By means of such abstrac-
tions and distortions, literature and other artworks, rather than presenting the
practical world of objects with all its attendant human value, force the reader
or viewer to face this reality in isolation. Outside of habit, things protrude
as incomprehensible, absurd, meaningless, frivolous, uncanny, or strangely
beautiful. Whether this involves a repudiation of the quotidian or a revivifica-
tion of our attention to it is specific to each work.

 In Rilke's novel, completed in 1910, the narrator engages in prolonged
reflections on the relationship between the obtrusiveness of things and the
possibility of ecstasis. The young Danish nobleman, Malte Laurids Brigge,

finds himself, as did the author, alone in Paris at the turn of the century. He encounters the physical world, both present and remembered, in moments of heightened aesthetic clarity. There are moments, as in the moonlight, when "everything around one is bright, light, scarcely stated in the clear air and yet distinct" (Wo alles um einen licht ist, leicht, kaum angegeben in der hellen Luft und doch deutlich). Everything Malte notices is "simplified, brought into a few right, clear planes, like the face in a Manet portrait. And nothing is trivial and superfluous" (Alles ist vereinfacht, auf einige richtige, helle plans gebracht wie das Gesicht in einem Manetschen Bildnis). Of the objects that make up Malte's noticed and remembered world—books, walls, spools of lace, an organ handle, blanket threads, houses, toy masks, to begin with— Rilke writes: "Everything harmonizes, counts, takes part, creating a fullness in which nothing lacks" (bildet eine Vollzähligkeit, in der nichts fehlt). As if the world became a still life gazed upon by the painter who does not need to ask about its significance, but rather serves it, as Malte writes, in seeing it (Rilke 1958, 25; KA III 465). Rilke wrote the novel in the wake of his intense study of Cézanne's paintings; under the influence of such attention to vision, his Malte writes: "I am learning to see" [Ich lerne sehen] (14; 456).

Yet Malte is intermittently disturbed by the obtrusiveness of things, provoked by his discomfort in the sensuously intensified, chaotic atmosphere of urban Paris at the turn of the century. In part to steady his gaze, and also in expressing his loss of perceptual equilibrium, he devotes pages-long attention to "a round, tin object, let us assume the lid of a canister, when it slips from one's grasp" [den irgendein blechernes, rundes Ding, nehmen wir an, der Deckel einer Blechbüchse, verursacht, wenn er einem entglitten ist] (Rilke 1958, 153; KA III 578–79). This heightened perception expresses existential disorientation as it becomes the dominant quality of the experience of things. Malte attempts to comfort himself by insisting that this slippage is natural to objects, that things have been looking like this for centuries (153; 583). Yet in his journal he grants similar attention to some crumbling edifices he happens upon, to walls belonging to houses that had been torn down, and those of neighboring houses "in danger of falling down" [in Gefahr, umzufallen] (47; 485). The houses in ruins, naturally, have lost their equipmental signification; their existence, torn out of average everydayness, protrudes.

Malte prefaces the description by insisting that he is not misrepresenting (fälschen) these objects, rather "this time it is the truth, nothing omitted, and naturally nothing added" [Diesmal ist es Wahrheit, nichts weggelassen, natürlich auch nichts hinzugetan] (46; 485). The countermovement toward clarity is instigated when Malte resolves that he must be precise in describing these torn-down houses. He is especially concerned with the ruins, not the

intact houses, for there is something exposed in their dilapidation. He is interested in particular in their interior (Innenseite) suggesting an analogy between these exposed ruins and the inner feelings of the narrator himself. Malte notices the bare walls, exposed to the elements so that "one saw its inner side. . . . the walls of rooms to which the paper still clung, and here and there the joint of floor or ceiling . . . the stubborn life of these rooms had not let itself be stomped out" [Das zähe Leben dieser Zimmer hatte sich nicht zertreten lassen] (46–47; 485–86). What is important, he thinks, is the fact that he recognized them (43; 487).

Here Malte does not mourn the lost significance of the now-torn down houses, rather he is fascinated by the walls' present state of being, pockmarked by dilapidation, by the scars of their former quotidian functionality and their present disuse. They are a kind of objective correlative for the ambivalence of experiencing the world in its full obtrusiveness as its familiarity recedes. Of one wall he notes the "paint which, year by year, [time] had slowly altered," the "spots that had kept fresher" behind mirrors and pictures and wardrobes, the "damp blisters at the lower edges of the wallpapers." It is, he says, "of this wall I have been speaking all along," as if this wall served to illustrate, in full phenomenological clarity, the quotidian in general, and all of the other objects with which Malte (or Rilke) had been fascinated. Yet like Sartre's Roquentin, Malte is frightened by the protrusion of objects; he tells us he began to run as soon as he recognized the wall. It was the recognition itself that was so frightening. If we are comfortably absorbed in the trivialities of quotidian life, this comfort is lost as soon as the quotidian object, and here one in ruins, is recognized—as soon as its existence gains notice in its immense fragility. That Malte feels this as not only an implicit analogy but as an explicit self-reflection is suggested by his avowal that the ruined house is at home within himself—"Es ist zu Hause in mir" (KA III 487).

In *Grundprobleme der Phänomenologie* (Basic Problems of Phenomenology), Heidegger's enthusiasm for this passage in Rilke's novel is not aesthetic but ontological. The wall in its naked dilapidation is removed from everydayness; it is not ready at hand as an unthought functionality. Moreover, it is not merely imaginatively projected, but rather an actual truth of being itself. Heidegger writes: "What Rilke reads here in his sentences from the exposed wall is not fictionally imagined onto the wall, but, quite to the contrary, the description is possible only as an interpretation and elucidation of what is 'actually' [wirklich] in this wall, which leaps forth from it in our natural comportmental relationship to it" (Heidegger 1982, 173). Rilke, in Heidegger's view, describes the world as original, the primal element of things in their very presence, without theoretical domination. Rilke is thought to get "to the

very bottom of things. . . in the equivalent of the most radical phenomenolog-
ical vision" (Haar 1996, 104). Malte resolves "to always go at once straight to
the facts" [immer gleich auf die Tatsachen loszugehen] (Rilke 1958, 152; KA
III 578). He seems to illustrate Heidegger's view that "poetry, creative litera-
ture, is. . .the elementary emergence into words, the becoming uncovered, of
existence as being-in-the-world." In this way the world becomes first visible
(172). That is, literary language allows the phenomenon "world" to show
itself; the world becomes a world seen. Important for Heidegger is that in
Rilke's description Being "leaps toward us from the things" (173). In such
experience the human situation becomes ecstatic, if that means that it intrinsi-
cally affords a "stepping-outside-self" (267). Yet Malte's assertion that the
house is "in mir" suggests a lingering relation to the self of the ordinary
feeling from which he has broken out.

Everydayness and Fallenness

Aesthetic defamiliarization has the effect of "pricking the conscience" such
that the habitual look of things falls away (Shklovsky 1965, 13). But everyday-
ness can also cover over more reflective possibilities of being, so that familiar-
ity is unsettled only in crisis. Ordinarily the everyday world remains settled in
its everydayness. In Heidegger's account, the state of *Geworfenheit,* our being
thrown into the world, tends toward "fallenness," a state of inauthenticity
wherein one's practical engagement with things remains unreflective and Da-
sein's self-conception remains in the immediate presence attributed to beings.
Dasein regards itself as a being like other beings, or as one thing standing
against thing-objects in an objective spatio-temporal coordination, rather than
as uniquely involved in the constitution of the there or here in which things
are encountered. Since being with others involves a tendency—though by no
means an absolute one—to become absorbed in what Heidegger calls "idle
chatter, curiosity, and ambiguity," a major mode of everyday being is a state
of fallenness—"eine Grundart des Seins der Alltäglichkeit, die wir das Verfal-
len nennen." Fallenness (Verfallen; Verfallenheit) means that everyday exis-
tence has fallen "into the world" and away from itself as "being in the world"
(Heidegger 1984, 175, 176).

In his early writings, Heidegger employed the term "factical life" to refer
to this everydayness and the intrinsic tendencies and countertendencies of life
which determine it. One direction of factical life is a tendency toward "lost-
ness" in the world from which life must be turned around. This lostness arises
from life's inherent questionability, or Dasein's (definite) possibility of not-

Being, which life, or Dasein, instinctively avoids. As in *Being and Time,* he identifies care (Besorgnis) as life's (later Dasein's) relational sense, which manifests four categorical directions, discussed in *Phenomenological Interpretations of Aristotle.* These directions are: life's *inclination* or pull toward the world; the tendency to abolish *distance* between itself and the things before it; *sequestration,* wherein life avoid itself by looking away from itself (in fascination, for instance) seeking to evade worrying about itself; and *ease,* where life seeks to lose itself either in mundane difficulties or in a derivative mode of carefreeness. All of these directions of movement suggest that life's or Dasein's self-forgetfulness is due to an insatiable pull toward and absorption in the world which characterizes the quotidian. Since Heidegger understands these directions of life as primary, factical life and later Dasein are always immediately encountered in the inauthentic mode, already prestructured and reflected according to these basic tendencies.

In primordial fallenness, life loses itself in the world; and because its directions are relucent or reflexive, it tends to seek itself out in terms of worldly things. Life has a tendency to secure itself, according to what Heidegger calls in the *Phenomenology of Religious Life* "an objectively formed material complex" (Heidegger 2004, 6). This tendency to secure itself prevents a vital encounter of life or Dasein with its own insecurity—with the possibility of nothingness—necessary for existential authenticity. This leads to ossification or ruinance. For the purpose of this study this could be linked to a definitively prosaic conception of the world, a familiarity or quotidianness seemingly locked down.

Life's self-reflection is, however, also the source for a countermovement of clarification against ruinance. Life seeks to clarify itself in this countermovement, making phenomenology possible as an echoing reflection of it. In *Being and Time,* fallenness will have to be shattered against and so everydayness, which Heidegger characterizes as a constant evasion of death, will have to be broken through (Heidegger 1984, 254). Ecstasis here is initiated for Dasein by the "call of conscience." Haunted by the nothingness of finitude, Dasein experiences a feeling of uncanniness: "Das Gewissen ist der Ruf der Sorge aus der Unheimlichkeit des In-der-Welt-seins" (289). Only by a resoluteness in the face of finitude can an authentic (eigentliches) being-oneself and being-in-the-world be restored. This resoluteness comes with a recognition of Dasein as ek-stasis itself, as ecstatic temporality. To disclose Dasein's existence is to disclose both its temporality and its specificity in an ecstatic recognition, a resoluteness, or *Entschlossenheit,* against dissipation into everyday presence and anonymity. The result is a tightening or gathering of energies, one could say, wherein Dasein gathers itself not as positively present but as ecstatic time

understanding itself as opening up the "there'" of Being. Such a gathering, one that remains free for possibility, is echoed in the aesthetic experience, in the tightening of concentrations brought about by the formal rigor of aesthetic experience as Dewey has described it.

Indeed, in *Being and Time,* Heidegger calls for a "literary language" (dichtende Rede) that could amount to a "disclosing of existence" (Heidegger 1964, 205; 1984, 162). The necessity to "liberate language from logic" is already obvious to Heidegger in his aim to account for the worldliness of things experienced, of things which can be thematized phenomenologically (209; 166). After *Being and Time,* the emphasis on authentic recognition of death is displaced by poetic means that counter the fallen quality of everydayness. A poetic or painterly manifestation of the quotidian, as Heidegger finds in van Gogh's paintings of peasant shoes and the poetry of Rilke, among others, affords a countermovement against ruinance. Rilke, along with Hölderlin, becomes emblematic for a recovery from *Verfallenheit.*

Despite his description of the fallen tendency of everyday life, Heidegger shares Rilke's view, at least in his early writings, that ecstasis is latent within everyday experience. The possibility for heightened awareness about what ordinarily recedes from notice is already there within everyday life. In the *Ontology* lecture-course, he writes: "This possibility of the intensification of the character of the there of something which comes down on us like a storm or is already there as an inconvenience [its obtrusiveness] lies right within the *inexplicit* self-evidence of the familiarity of the there of the everyday world" (Heidegger 1999, 77). The possibility and motivational movement of ecstasis is latent within the quotidian itself. To Wittgenstein's view that familiarity is never noticed, only unfamiliarity is, Heidegger added this nuance: only because and insofar as something is familiar, can it become strange. Or, as Rosen put it: "The common thread to the multiple outbursts of extraordinary spiritual activity is ordinary existence" (296). Familiarity conditions strangeness; but in Heidegger's account, which emphasizes fallenness, strangeness, given the nature of factical life, inevitably arises, together with a reversal of expectations, an encounter with the unpredictable and the incalculable. "On account of this," Heidegger writes, "the possibility ever remains that distress will suddenly break forth in the world" (80). This seems to suggest an existential correlate to the seeming perception of the void expressed by modern writers when ordinary objects and surroundings become defamiliarized. While the void is evoked as lurking within even ordinary objects, until salvaged by a vital aesthetic seeing of their true essence, in Heidegger's account, death awaits Dasein and pursues life with the ever-latent possibility of confrontation. Heidegger's overemphasis of death, as Rosen saw it (124), was first charged by

Hannah Arendt in her retrieval of "natality." That there are experiences of ecstasis that maintain a more affirmative relation to the quotidian will be argued in the next chapter.

Ecstasis: Consciousness Outside Itself

Fallenness as denial of the fragility of everydayness finds its counterpart in Sartre's *Nausea*, where the breakdown of everydayness overwhelms Roquentin to the point of sickness. *Nausea*, like Rilke's *Notebooks*, is presented as the journal of a protagonist who has temporarily settled in an unfamiliar town. As in Hofmannsthal's "Briefe," the protagonist settles into what is to the European an ordinary place after extraordinary travels. It is here, not in exotic lands, but in the small-town European life, that Roquentin's crisis begins. Roquentin decides to keep a journal in order to detail "all these changes" [tous ces changements] which have happened both in "external things" [l'extérieur] and in consciousness, as he writes, "inside of me" [en moi]. At first it seems that "all these changes concern objects" [tous ces changements concernent les objets] (Sartre 1964, 8; 1938, 12). At issue is not only this or that particular object but, categorically, "any other object at all" [de n'importe quel autre objet] (7; 11). It becomes apparent that the breakdown of order in things affects that of consciousness, since consciousness *exists* only as consciousness *of*; it is "outside, in the world" (Sartre 1987, 31). Roquentin is gradually overtaken by a vertiginous illness punctuated by events through which the involvement, significance, and referentiality of everyday things are radically compromised.

The ordinary proximity and accessibility of things seems to be suspended for Roquentin—beginning with a stone he wants to toss into the sea, a scrap of paper he wants, but cannot bring himself, to pick up, the doorknob, a glass of beer. He finds temporary relief in the nonmaterial. A jazz song played in the café, a set of alexandrine lines he recites, the idea of a triangle, all exhibit a necessity that the quotidian is now seen to lack. The problem is that objects, though contingent, are inescapable; he writes: "Everywhere, now, there are objects like this glass of beer there on the table" [Maintenant, il y a partout des choses comme ce verre de bière, là, sur la table] (Sartre 1964, 16; 1938, 20). He wishes to avoid seeing them, that is, recognizing them, for besides its everyday features—its beveled edges, and so forth—there is "something else" to the glass of beer: its existence; and implied is Roquentin's own, the "raw material" [la matière brute] which he did not want to experience so directly, and which, moreover, resists not only natural attitude expectations but philosophical categories—substance and accidents, necessity and contingency—

with which he tries to *think* them. "L'essentiel c'est la contigence," writes Roquentin. The world had appeared to be self-justified and purposeful, and his life had been filled with content. Roquentin's existential crisis is preceded by the breakdown of the necessity of things, even of his own memories, when they are exposed as nothing.

Roquentin submits to a phenomenological lesson as objects begin to take on the lightness of consciousness, even the characteristics of subjectivity. They resist him; he cannot bring his will to exert itself even over a scrap of paper on the ground. His discombobulation is much more severe than that of Hofmannsthal's narrator. Ceasing to be useful, and no longer explainable by its use, the paper becomes obstinately present, even seeming to touch Roquentin deliberately. He writes in his journal: "Objects should not touch because they are not alive. You use them, put them back in place, you live among them: they are useful, nothing more. But they touch me, it is unbearable" [Les objects, cela ne devrait pas toucher, puisque cela ne vit pas. On s'en sert, on les remet en place, on vit au milieu d'eux: ils sont utiles, rien de plus. Et moi, ils me touchent, c'est insupportable]. Thus Roquentin recognizes the existence of objects just as he is aware of his own existence. His own freedom is compromised; he writes of objects: "I am afraid of being in contact with them as though they were living beasts" [J'ai peur d'entrer en contact avec eux tout comme s'ils étaient des bêtes vivants] (Sartre 1964, 19; 1938, 23). The nausea, Roquentin's ecstatic uncanniness, at first seems to come from the physical world. "It came from the stone, I am sure of it, it passed from the stone into my hand" [Et cela venait du galet, j'en suis sûr, cela passait du galet dans mes mains]—as if fear itself, a "sort of nausea in the hands" [une sorte de nausée dans les mains] came from the world (20; 23). This would seem a repudiation of the world. Yet he later realizes that it is the exposure of the contingency of being that makes things look as they do. Their presumed necessary order had in fact colored the quotidian with its prosaic aspect, which falls away when contingency is exposed. This contingency reigns not only over things but over ideas, memories, and language. When Roquentin is fascinated by the root of a tree, the relation between the thing and the word that names it becomes dislodged. Nausea is not only the "vivid pathological symbol of the utter externality between words and things" (Danto, 4), but also the recognition of the subject's externality to all things, by virtue of their coming to be seen as phenomena. When Roquentin reaches the end of his writing, this disunity has become liberating, since he has come to realize that the creation of art can render a purpose and even a substitute necessity that needs no external justification. Roquentin's realization is accompanied throughout the novel by

repulsion and fear, by what Roquentin calls "a horrible ecstasy" [une extase horrible], but also by moments of rapture (176; 166).

In literary description, the ecstasis can be unfolded gradually over the course of a narrative, and so the psychological processes which accompany this awakening, joyful or anxious, can be explored. In Rilke's novel, Malte is alternately exuberant in the face of the clarity of a world aesthetically seen, and highly disoriented and frightened. In recognizing ordinary things with a heightened clarity, he describes the listlessness and negligence of objects, like the tin lid of the canister or a thread from the blanket. Such objects have grown degenerate and frightening, "winking to one another" as they "begin their seduction" [Da fangen sie, einander zuwinkernd, die Verführung an] (Rilke 1958, 158; KA III 583). Proust's narrator is subject to the same distress in the face of things; describing his attempt to fall asleep, he relates: "I was convinced of the hostility of the violet curtains and of the insolent indifference of a clock that chattered on at the top of its voice as though I were not there" [J'avais . . . convaincu de l'hostilité des rideaux violets et de l'insolente indifférence de la pendule qui jacassait tout haut comme si je n'eusse pas été là] (Proust 1981, 8; 1954, 19).

Just as Roquentin is disgusted by existence, since it points to the very nothingness of his own existence, so does Malte cower from the sense of the horrible. Yet it is Malte's task to overcome this fear by accepting even the horrible. This is the meaning of Malte's affirmation of Baudelaire's poem "Une Charogne," dedicated to a corpse. Malte's enthusiasm has nothing to do with a nihilistic appropriation of death; he aims not to embrace the decay, but to accept all aspects of existence, even the repulsive ones, as valid, where there is no selection and rejection: "Auswahl und Ablehnung giebt es nicht" (KA III 505). Yet what is distressing for these narrators is that when quotidian things are exposed or torn away, the experiencing subject is compromised. "How serpentine is this feeling of existing" [Oh, le long serpentin, ce sentiment d'exister], Roquentin writes (Sartre 1964, 135; 1938, 129). In Malte's journal, ecstasis threatens to be irremediable, for "you stand almost outside yourself and cannot get back again" [du stehst schon fast außer dir und kannst nicht mehr zurück] (Rilke 1958, 69; KA III 506–7).

Admittedly, Sartre's Roquentin seems to remain a character of ideas. His existential breakdown leads logically from the exposure of contingency and arbitrariness to the discovery of purpose and necessity when, at the novel's end, he abandons his biography and aims instead to settle in Paris and write a novel. His affective range is narrower than that of Rilke's Malte and Proust's narrator, perhaps because Roquentin does not linger over richer experiences of the world, recalls no richness in a relation to things before the state of

alienation, despite the indication of the richness of sensuous observations of the world on his travels. He recalls no wonder felt in childhood perception, and his adventures in travel and love are never playful or spontaneous. Roquentin has little felt history, he begins his literary recordings as a complete Cartesian ego nearly absorbed in the present. Concordant with Sartre's view that consciousness is inherently free for and in the present, his delegation of the past and the self to constructs of memory which obscure this freedom, Roquentin never ponders his origins, his entrance into the world, the loss of a childhood home (as do Malte and Proust's and Hofmannsthal's narrators) even when he realizes that his residence in Bouville, like all of his travels, is without justification. In this respect Roquentin's crisis is inadequate to the history within quotidian experience: the fullness of everyday life and its slippages into fallenness, from which his crisis emerges.

But in all of the novels discussed in this chapter, a kind of turn against the fallenness of the everyday by a fascination with this reality is promised in the project of literary discourse. The narrators of the novels by Sartre, Rilke, and Proust all develop their difficult perceptiveness toward the project of literary writing. Literary language offers not a return to a pre-disclosed, naive state of being-in-the-world, but a recovery from crisis through creative transformation of everyday life. Their discovery of means to show how the everyday shows itself and situates expectations of the world is parallel to phenomenological insight, to phenomenology's dedication to the world as it emerges phenomenally. Heidegger's prescription for resoluteness, breaking out of the average everyday by seizing one's authentic specificity and finitude, is only one rather limited way of prescribing transformation; these efforts at poetical description, so receptive of the fluidity and flux of existence as experienced in its concrete specificity, are others, and this is why Heidegger too turned to literature after *Being and Time* as his primary subject of meditation. This does not necessarily suggest that concern for the everyday world is to be replaced by literature describing it. For all of these writers hope that literary description of the world brings reality nearer than before, that its truer relations are exposed. In the wake of his discovery in Rilke, Heidegger develops his philosophy by near-exclusive meditations on poetic language, though there is a tension there between attention to human dwelling and its subordination to a *Seinsgeschichte*, a history of Being, of which human life is thought as an essential manifestation (see Gosetti-Ferencei 2004). In Sartre, the literary or aesthetic project orders the vertiginously free existence of consciousness—burdened with nothingness—in a project by which the self can define itself.

If Proust's project of ecstatic remembrance is united with literary creation, Rilke's notebooks can be seen as one model of an attempt to steady the inner

life along with a renewed impression of the world. While Heidegger is increasingly concerned with the destiny of Being, Rilke stays closer to everyday life throughout its transformations: "Fate loves to invent patterns and designs. Its difficulty lies in complexity. But life itself is difficult because of its simplicity" [Das Schicksal liebt es, Muster und Figuren zu erfinden. Seine Schwierigkeit beruht im Komplizierten. Das Leben selbst aber ist schwer aus Einfachheit] (Rilke 1958, 176; KA III 599). Rilke seeks in one reality both the credible and the miraculous; this can be perceived only in such a steady gaze, "though one still," in Malte's words, "had to experience . . . how difficult this language was" [Noch stand ihm . . . bevor, wie schwer diese Sprache sei] (214; 633). Yet this difficult language does not seem to be reached in *Malte*. Rilke's later poetry achieves a rendering of the transformative constitution of reality, in particular the *Duineser Elegien* (Duino Elegies). His *Sonette an Orpheus* (Sonnets to Orpheus), too, renders the mysteriousness of the world by virtue of its constant possibility for transformation. And Rilke's understanding of the ecstasis in Cézanne's painting opens up an entryway into the visual aesthetic. These later works of Rilke will be discussed in chapters that follow.

As for Sartre's Roquentin, he too is, by the narrative's end, provoked to justify his existence in the writing of fiction, one "above existence," which would hint "behind the printed words, behind the pages, at something which would not exist, which would be beyond existence" [derrière les mots imprimés derrière les pages, quelque chose qui n'existerait pas, qui serait au-dessus de l'existence] (Sartre 1964, 237; 1938, 222)—that is, at the nothingness which, in Sartre's view, constitutes the freedom of consciousness learning to see anew. With this plan—in some sense a description of *La Nausée* itself—Roquentin hopes "that I might succeed . . . in accepting myself" [j'arriverais . . . à m'accepter] (238; 222)—and, perhaps also, the quotidian world in its ecstatic latency. Sartre's implicit prescription in this novel seems less a rich transformation of self than one might hope, particularly in that the reader does not experience what follows from Roquentin's decision. For an account of the possibility of the re-establishment and revivification of the quotidian in the wake of its breakdown, one must look beyond Sartre's novel, beyond the literature of alienation and subjective authenticity.

In this chapter the relationship between phenomenological and literary explorations of the quotidian, and its latent ecstasis, have been introduced. Habit structures the appearance of the everyday world; but in modern literature and art this mode of appearance is exposed as fragile, subject to dissolution in the process of defamiliarization, and further in confrontation with a sense of uncanniness and the void, or when ordinary objects stand out obtrusively. Not content to remain at the moment of recognition of the quotidian,

modern literary writers have investigated the nothingness or void which is evoked when everydayness is exposed as only one possible, though dominant, mode of the world's phenomenal manifestation. Uncanniness or alienation, as well as the often less-emphasized possibility of exhilaration, are possible effects of this exposure, provoking a sense of ecstasis, stepping outside the ordinary (sense of) self. If it is true that habitual everyday life tends toward fallenness, it harbors an opposing tension in estrangement from the familiar, when the familiar is made strange through artistic or literary expression, or through phenomenological study. What Dewey called the "consummation of everyday experience" in art is not opposed to ecstasis then, but seems to indicate a proto-ecstatic expression of our relation to the everyday that becomes thematic in phenomenology and modern literature.

Sources of Ecstasis in Childhood Experience

A proto-ecstatic latency underlying everyday experience is not merely the region of literary phenomena but also belongs to the structure of childhood experience. Maurice Merleau-Ponty declared that all his philosophical endeavors amounted to an attempt to recapture the experience of childhood. This declaration not only reflects a tone of wonder typical of Merleau-Ponty's thought, but also recalls the classical idea of phenomenology as a philosophy of beginnings. Phenomenology attempts to describe the world as we experience it in its native originality, the way it might be first encountered by an awakening consciousness, how it comes to be constituted in experience.

While Husserl maintained a scientific approach to lived experience, the technical determination of which may have put its real vitality out of reach, other phenomenologists have turned to art and literature to grasp the original quality of the world. Just as explicit reflection on the quotidian cannot but indicate the possibility of its breakdown, since its everyday quality is interrupted by reflection, so any substantial reflection on childhood as phenomenon does not occur until it has become, or in those moments at which it is, already inaccessible. When the child is most reflective about being a child, it is already on the cusp of transformation to the next stage of adolescence or adulthood, or is already anticipating childhood's inevitable passing. If we can presume that it is the nature of the child to experience the world in full saturation, child*hood* is reconstituted in hindsight, by some form of reflection or memorialization. This would seem to render the original modes of experience in childhood forever inaccessible to the adult. Yet this is not wholly confirmed by experience, for there are moments when adult life is revisited by

intimations of child experiences, when they "are met with again in adult life" (Merleau-Ponty 1964, 154).

Literary engagements with child consciousness can give the reader a feeling of returning to that state of being; visual art (for instance, in Twombly's paintings, to be discussed in a later chapter) can also give glimpses of the world's atmosphere before fixed concepts have taken hold. According to Gaston Bachelard, the luminosity of childhood cannot be captured by memory alone, but by the revivification of reverie through which the daydreamer, invited by poetic images, enters the freely moving vistas of imaginative life. This reliving of childhood, dependent on reverie and poetic images, attests to the persistence of former states of being within the human soul (Bachelard 1960, 89). To access this, according to Bachelard, requires some experience of the original solitude which is the child's, the imaginative space in which the child revels and dreams. Literary writers must develop innovative ways of drawing upon and expressing the imaginative life of child experience, perhaps through literary enactments of reverie, so that the remembrance of childhood, in spite of being memory and so inevitably mediated, emerges within the vastness, fluidity, and density of that original experience.

The originality or primitive nature of child experience, so idealized by the romantics, is cherished not necessarily for being original or more important than mature states of mind, but rather for revivifying a stage in which the world, being first constituted as world, is open to constant negotiation. While "initial or primordial feeling" need not be thought "intrinsically superior to or more illuminating than subsequent attunements," as Rosen argues in a critique of Heideggerian-Nietzschean celebration of mood and feeling, child experience is one neglected region of primordial feeling that deserves revaluation (Rosen 2002, 128). It seems undeniable that creative exercises of rational thought—whenever new theories are posited, innovations developed, and the status quo challenged by imaginative reinterpretations of old problems—are in some measure indebted to the resources of child experience which persist within the mature mind. But childhood is addressed in modern literature and art, as well as phenomenological study—such as in Bachelard's analysis and in Merleau-Ponty's study *Les relations avec autrui chez l'enfant* (The Child's Relations with Others)—because it is also recognized as valuable in itself, as a stratum of human existence and experience that, long neglected or merely idealized by philosophy and classical and romantic literature, demands to be addressed as it is or was lived.

The mediated immediacy of literary access to child-experience seems less stubbornly paradoxical when the nature of its reconstitution or revivification

in literature is examined further. While literary explorations of childhood reflect upon a largely extinguished state of being, they also access and revive a residual mode of childhood that persists in the adult consciousness. This persistence is defended in Bachelard's phenomenology of the soul and its reflection in poetic images, as in *La poétique de la rêverie* (The Poetics of Reverie); one could examine more specifically the undercurrents of language and its presymbolic aspects, sensuous perception, dream, and the complex textures of emotional life which are not extinguished, but perhaps only more rigidly codified, in the mature mind. Bachelard defends the idea that a nucleus of childhood remains permanent in us, inaccessible but in poetic "instants of illumination" (Bachelard 1960, 85). Stepping out of adult everydayness, explicit reflection upon or drawing from these childhood sources might be most possible for the literary or artistic consciousness, and in those modes of expression that rely most intensely on spontaneous creativity.

Seen from this perspective, childhood is never completely extinguished, though ordinarily it is inaccessible within adult modes of being—those of practical orientation in everyday life, social adaptation and discourse, rational or scientific thought. If it is assumed that childhood is a past stage of being that nevertheless remains within the human soul at some unexpressed level within adult experience, the access of literary writers to childlike awareness or perception, and the capacity of literature to invoke child experience in readers, is less perplexing. In this chapter the relation of childhood to the latent possibilities of ecstasis in everyday experience will be examined. To what extent and how philosophical reflection allows and profits from a revivification of this experience will be seen through a comparative study of treatments of childhood experience; these include theories of play and childhood perception and imagination by Freud, Benjamin, Bachelard, and Merleau-Ponty. Also examined will be why Heidegger's analysis of human existence necessarily leaves out an account of child-being. The evocations of Rilke, Proust, Robert Frost, and other writers will show to what extent literature can evoke this experience in a revivification of a lost state of being, and what value this might have for mature consciousness. It will be seen how modern literary writers and artists draw upon childhood and child-play for expressing both the nature of the beginnings of human consciousness as studied by phenomenology, and the radical fluidity of everyday expectations of the world which opens it up to reflective transformation. Not merely suggesting regression, accounts of child-experience reopen this fluidity which, when recaptured in literature, provides glimpses into the constitution of quotidian life as well as its potential reconfiguration.

Play, Fantasy, and the Literary Imagination

Through a theory of children's play, Freud establishes a relation between everyday adult consciousness and art. In "Der Dichter und das Phantasieren" (translated as "On the Relation of the Poet to Daydreaming"), Freud claims that artistic or poetic creativity, like daydreaming, continues in adulthood the drive toward play that is natural to child-consciousness, a notion originating in Schiller's theory of the *Spieltrieb* or play instinct. The German poet argues in the fifteenth letter of *Über die ästhetische Erziehung des Menschen in einer Reihe von Briefen* (Letters on the Aesthetic Education of Man) that the human drive toward play allows for the creation of beauty or living form (lebende Gestalt) by uniting capacities for engaging form and matter—*Formtrieb* and *Stofftrieb* (Schiller 1959, 324). Thus Schiller claims here: "Man plays only where he is human in the full sense of the word, and he is only human where he plays" [Der Mensch spielt nur, wo er in voller Bedeutung des Worts Mensch ist, und er ist nur da ganz Mensch, wo er spielt] (329). Similarly, in researching the conditions of literary imagination, Freud seeks the first traces of literary activity as early as in an activity germane to the child—"die ersten Spuren dichterischer Betätigung . . . schon beim Kinde" (Freud SA X, 171). Whereas Schiller's concept of play encompasses artistic creation of beauty, Freud's view centered specifically on early experience of play as a rich resource. Play, according to Freud, is a poetic activity in that the child creates for itself its own world. More precisely, this world created by the child is a transformation of the quotidian world. For the child takes the things of the familiar world and transposes them into a new and delightful arrangement.

According to Freud's theory, ordinary experience offers a related activity (verwandte Tätigkeit) to literary creation in everyday daydreaming or fantasizing. This relatedness is not merely similar but generative: fantasizing continues the play of childhood, and so childhood is the source for fantasizing in adulthood as its original form and experience, which does not cease, but is only modified by the processes of psychic maturation. The modifications are, of course, significant. Whereas children do not hide their play, and so render quasi observable their psychologically closed systems of assignments engineered for the purpose of play, adults hide their fantasies and find them shameful. The poet, by contrast, is comparable to a dreamer who makes his dreams visible, who communicates his fantasies. But this is nothing other than a presentation in the form appropriate to adult consciousness of the early experience of child's play. "Poetry [is], like the daydream, the continuation of and substitute for what was once child's play" [die Dichtung wie der Tag-

traum [ist] Fortsetzung und Ersatz des einstigen kindlichen Spielens] (Freud SA X, 178).

Through this connection, Freud establishes a psychological basis for the relationship between childlike consciousness and artistic creativity, a relationship that has been implicitly acknowledged since the Renaissance (particularly in the figure of Leonardo da Vinci, whose childhood fantasies Freud analyzed and Merleau-Ponty studied), celebrated in Romanticism (in idealizations from Friedrich Hölderlin to William Wordsworth and William Blake), and phenomenologically rendered by Bachelard and Merleau-Ponty. Importantly, Freud recognizes the seriousness of children's play. Play is not less serious than reality, it is only creative of an alternative to reality: "The opposite of play is not seriousness but rather—reality" [Der Gegensatz zu Spiel ist nicht Ernst, sondern—Wirklichkeit] (Freud SA X, 171). While the child does not confuse the imagined with the ordinarily real, it assigns imaginary objects and relationships to concrete and graspable things of the world. Play is distinct from fantasizing only in respect to this assignment to concrete experience. The literary writer—along with the reader of literature—engages the same capacities as the child at play, creating a fantasy world that is taken seriously and invested with emotion despite being distinguished from reality. The adult, in need of recapturing the pleasure and satisfaction of childhood play, reactivates the capacity to create a world that is distinct from reality, by means of fantasy, humor, and literary-aesthetic experience.

If Schiller's notion of play does not address the specificity of childhood, for play concerns the granting of necessity to what seems accidental, the rigor of form to the sensuous, and so forth, Freud's thesis is problematic in that it defines children's play predominantly in terms of imitation, and identifies the form of life that children imitate as identical with an imagined adulthood. In this view, the child's single wish, which directs its play, is to be grown up [groß und erwachsen zu sein] (Freud, SA X, 173). This wish, in whatever manifestation—to take on the role of mother or father, to work or act as adults do, to express the form of sexual possessiveness attributed to psychic development—he considered the driving force of children's play. Such wishes remain inevitably frustrated and so are repeated in later life through fantasy. In this way the template of play is rendered as proto-fantasizing, and adult fantasy does not significantly depart from this template. Empirical observation of children seems to confirm that Freud's description of play, if not of its purposes, is in part correct; children's play is often mimetic of adult activities and roles. But observations of children, memory, and literary reveries toward childhood experience indicate a far broader range of preoccupations and inventions that belong to play. Children do not only play at being grown-up,

they also regress, pretend to be babies, and delight in thinking themselves much smaller than they are, even radically miniaturized. They wish to be animals with their very primitive expressions of emotion and their (from the human point of view) underdeveloped hands. They even wish to be inanimate objects, stars and trees, or to be endowed with special nonhuman powers. Play also indulges the sensuousness of children's perception without necessarily imitating any persons or objects. Children enjoy repeating and modifying nonsensical sounds, pointing out and mixing colors without regarding them as attributes of things, delighting in the look of useless things, often remaining aloof to the intended purposes of objects, focusing solely on their sensuous forms, tangible qualities, colors. Children play not only by pretending but by cultivating sensuous experiences, repeating activities that allow them to experience a physical thrill in the speed of running, or in jumping, sliding, and climbing, laughing and singing, babbling or scribbling, throwing or being themselves tossed about; rearranging ordinary objects into new patterns, gathering and sorting objects, empathizing with animals and dolls. As Walter Benjamin points out in "A Child's View of Color," children's play also consists of intense observation: "Children like the way colors shimmer in subtle, shifting nuances (as in soap bubbles), or else make definite and explicit changes in intensity, as in oleographs, paintings, and the pictures produced by decals and magic lanterns" (Benjamin 1996, 50).

A defense of childhood observation is also found in one of Benjamin's major works, *Berliner Kindheit um Neunzehnhundert* (Berlin Childhood Around 1900). There, too, Benjamin treats the experience of color, the fascination with stained glass windows, soap bubbles, watercolors. What persists in these descriptions is the sense of the child being intimately bound up with the objects of (in this case) his observation:

> Something similar occurred with soap bubbles. I traveled in them throughout the room and mingled in the play of colors of the cupola, until it burst. While considering the sky, a piece of jewelry, or a book, I would lose myself in colors. Children are their prey at every turn.
>
> [Ähnliches begab sich mit Seifenblasen. Ich reiste in ihnen durch die Stube und mischte mich ins Farbenspiel der Kuppel bis sie zersprang. Am Himmel, mit einem Schmuckstück, in einem Buch verlor ich mich an Farben. Kinder sind ihre Beute auf allen Wegen]. (Benjamin 2002, 380/ IV/1, 263)

While the work is also a meditation on the metropolitan city at the beginning of the century, *Berliner Kindheit* is interwoven with reflections on the speci-

ficity of childhood. In a text that is both literary essay and autobiography, Benjamin's narrator comes to terms with the irretrievability of the past through description of just what is lost with the passing of childhood experiences of the details of everyday life. While he claims that the forgotten cannot be regained completely—"Nie wieder können wir Vergessenes ganz zurückgewinnen" (Benjamin IV/I, 267)—his descriptions of courtyards, balconies, and pantries of his childhood abodes, the sounds of the city railway and carpet beating and the goings-on in the street below, shopping in the market place, holiday destinations and the zoological gardens, particular streets and shops, are not only biographical testimonials to Berlin at a particular stage of modernity, but also serve to show how the child's perspective offers a singular insight into how these things are experienced, which usually recedes from the focal center of adult perception. Some of the reflections are devoted specifically to child perception and to experiences unique to the child phase of life: being late for school, reading boys' books, the hours of childhood illness, hiding in the house, having one's clothes mended by one's mother, searching for Easter eggs. Certain objects—the carousel, the sewing box, socks, a baked apple— bring a "fleeting message" [die flüchtige Kunde] when to the child's intense observation they seem to communicate from the depths of existence (Benjamin 2002, 357; IV/1, 248).

The most sensitive explorations of child experience describe an intimate bond between perceiver and world which is lost to the practical minded and more rational adult perception colored by what William James called the "attitude of rationality." Like the description of color above, three more passages—about butterfly collecting, watching a snowstorm, and hiding behind a door—serve to illustrate this intimacy. Chasing after butterflies is an enchanting experience of play, but also, as recalled by an adult narrator, it reminds the reader of a stage of more fragile subjectivity, more porous and negotiable distinctions between self and world:

> Then I wished to dissolve into light and air, just so I could approach my prey unnoticed and overwhelm it . . . the more I nestled, in all fibers of my being, against the animal, the more butterfly-like I became inside, the more this butterfly, in everything it did, took on the color of human resolve; and in the end, it was as if its capture was the price through which alone I could regain my human existence.

> [Dann hätte ich gewünscht, in Licht und Luft mich aufzulösen, nur um ungemerkt der Beute mich zu nähern und sie überwältigen zu können. . . . je mehr ich selbst in allen Fibern mich dem Tier an-

schmiegte, je falterhafter ich im Innern wurde, desto mehr nahm
dieser Schmetterling in Tun und Lassen die Farbe menschlicher Ent-
schließung an, und endlich war es, als ob sein Fang der Preis sei,
um den einzig ich meines Menschendaseins wieder habhaft werden
könne.] (Benjamin 2002, 351/ IV/1, 244)

The description of watching a snowstorm yields similar suggestions, and be-
comes a commentary as well on the child's experience of reading. The weather
outdoors and the contents of the stories are not held strictly apart. Rather, the
child seems to be enveloped by the storm outside just as it seems to enter the
experience of reading. Standing at the window or looking up from its reading,
the child gazes at the snowstorm, which gradually becomes intertwined with
the story it has been reading. The snowy weather dismantles the familiar
aspects of the world, it defamiliarizes the world and transforms the child's
attention:

> But sometimes in winter, when I was standing by the window in the
> warm little room, the snowstorm outside spoke to me just as mutely.
> Of what it spoke, I could never quite grasp however, for too dense
> and ceaselessly did the new intrude upon the well-known. Hardly
> had I allied myself more intimately to one band of snowflakes, when
> I realized that it had been obliged to yield me up to another, which
> had suddenly penetrated it. But now the moment had come to fol-
> low, in the flurry of letters, the stories that eluded me at the window.
> . . . These were filled with stormy exploits. To open one would have
> landed me in the lap, in which a brooding, changeable text was
> clouding over, which was pregnant with colors.

> [Manchmal jedoch, im Winter, wenn ich in der warmen Stube am
> Fenster stand, erzählte das Schneegestöber draußen mir so lautlos.
> Was es erzählte, hatte ich zwar nie genau erfassen können, denn zu
> dicht und unablässig hatte ich mich einer Flockenschar inniger ange-
> schlossen, erkannte ich, daß sie mich einer anderen hatte überlassen
> müssen, die plötzlich in sie eingedrungen war. Nun aber war der
> Augenblick gekommen, im Gestöber der Lettern den Geschichten
> nachzugehen. . . . In ihnen ging es gewittrig zu. Eins aufzuschlagen,
> hätte mich mitten in den Schoß geführt, in dem ein wechselnder und
> trüber Text sich wölkte, der an Farben schwanger war.] (Benjamin
> 2002, 356/ IV/1, 275)

In the third passage the shift to the third-person narration suggests the gener-
ality of the childhood experience as such. Beyond autobiography, the work is

a study of childhood experience. After describing in the first person his knowledge of all the hiding places in the house and of his experience of hiding ("I was enveloped in a world of matter"), the narrator shifts to the third-person, in a description which again suggests the inseparability of child and world in moments of intensity:

> The child who stands behind the doorway curtain himself becomes something white that flutters, a ghost. . . . And behind a door, he is himself door, is decked out in it like a weighty mask and, as sorcerer, will cast a spell on all who enter unawares.

> [Das Kind, das hinter der Portiere steht, wird selbst zu etwas Wehendem und Weißem, zum Gespenst. . . . Und hinter einer Türe ist er selber Tür, ist mit ihr angetan als schwerer Maske und wird als Zauberpriester alle behexen, die ahnungslos eintreten.] (Benjamin 2002, 375/ IV/1, 253)

Not merely the reference to fairy tales is childish here; what is most striking is the transferability of bodily feeling for the child to the objects he perceives, or better, the adoption of the world of matter as extension of his own material being. This experience will be described by Merleau-Ponty in a study of childhood social experience, to be discussed below.

In *Berliner Kindheit* and other essays, Benjamin studies the experience of play in terms that significantly depart from Freud's emphasis on imitation of adult life. He points out that children's games, drawings, and crafts, if properly attuned to child experience, are governed not only by imitation but by an intensified look of delight taken in color, shapes, and other material features. Play is here the means by which this delight is extended, deepened, furthered. With picture books children's attention is engaged not only through imagining adult forms of life in child-appropriable versions, but experiencing the rush of colors and forms, imagined in new movements and contexts. This pleasure does not seem altogether unlike what Kant meant by aesthetic reflection upon the beautiful: free play (freies Spiel) of the imagination without the legislation of the understanding, without subsuming images under concepts, in a reflective attitude that is indifferent to possession or ideas for which such phenomena would stand in. For the mature consciousness, there is a feeling of life provoked by aesthetic experience precisely when the understanding, which usually determines an image conceptually, is suspended and allows for free play. Such pleasure taken in freedom probably requires the maturity of a consciousness in a dominant mode from which the subject is

temporarily liberated. Yet the ease of such suspension for children, whose concepts of reality are not less functional, but more fluid and imaginatively negotiable, than those of adults, does not necessarily render their pleasure less intense.

This recalls Merleau-Ponty's attempt to explain why children seem to respond spontaneously to modern visual art. Because the child's sense of self is "in a way scattered through all the images his action gives rise to . . . he is apt to recognize himself in everything," a view substantiated by Benjamin's recollections cited above. That is, the child has an innate sympathy with manifestations of sensuous forms that need not be tethered to the identification of objects or legislated according to established perspectival expectations of objects. Rather, forms are posturally assumed into the child's general experience rooted in its own physical being. In his study of the child's relations with others, Merleau-Ponty writes:

> This explains the relative ease with which children understand the modern way of painting and drawing. It is altogether startling to see certain children much more apt to understand this drawing or that painting by Picasso than the adults around them. The adult hesitates before this kind of drawing because his cultural formation has trained him to take as canonical the perspective inherited from the Italian Renaissance, a perspective that words by projection of different external data on a single plane. To the extent that the child is a stranger to this cultural tradition and has not yet received the training that will integrate him within it, he recognizes with great freedom in a number of traits what the painter meant to show.

The child feels an unobstructed access to the vitality of the modern aesthetic image, without being bound to the conceptual recognition of objects and perspectives. Merleau-Ponty continues, in a passage that is best cited also in the original French:

> The child's thought processes are general from the start and at the same time are very individual. They are expressive thought processes that get to the essentials by means of a concrete corporeal recovery of objects and conducts as given.

> [La pensée de l'enfant est si l'on veut générale dès son début et en même temps très individuelle. C'est une pensée physionomique, qui

va à l'essentiel par le moyen d'une reprise corporelle des objets et conduites donnés.] (Merleau-Ponty 1964c, 150; 1960, 55)

This description of the child's experience of modern painting relies heavily on the assumption by the child of other experienced bodies as extensions of his own, the notion adopted by Merleau-Ponty of "postural impregnation." This might help to show that children's experiences in play are not governed simply by purposive imitations of adult bodies and actions. There is equal delight taken in assuming and expressing the given postures and activities of animals, which is part of "une pensée physionomique." There is a dispersal of self among a variety of experienced shapes, forms, movements, other people, and animals, the imitation of which Merleau-Ponty discusses earlier in his study (Merleau-Ponty 1964c, 145). Children's play can be linked to the notion of "free play" not by being arbitrary or chaotic but rather through its sympathetic, ateleological absorption of the world. In Kant's terms, if play is *zweck-mäßig* (purposive) in one sense, as adopting purposive movements or forms, it is also *ohne Zweck* (without purpose) in another sense, since such reanimation is detached from the original activity or purpose and is delighted in for its own sake. In support of just such a feeling in free play, Benjamin criticizes the typical interpretation and also modernization of children's books and toys: "The role of children's books is not to induct their readers directly into the world of objects, animals, and people—in other words, into so-called life. Very gradually their meaning is discovered in the outside world, but only in proportion as they are found to correspond to what children already possess within themselves." The immediate induction of children into adulthood through mimetic play, reflected in Freud's argument, is then not reflective of the richness of children's own experience. The view that childhood play and mimesis are governed by a teleological striving, which conforms to Freud's emphasis on child sexuality, overlooks such manifestations of the playful imagination, its "inward . . . way of seeing, where the dreamy life that objects lead in the minds of children are acted out" (Benjamin 1996, 410).

This idea that children's play enables a dreamy life of things in the imagination is compatible with Bachelard's view of childhood in his more poetic than scientific phenomenology of reverie. In reverie, memory and imagination come together in reliving childhood experience through poetic images. Unlike Freudian fantasizing, the satisfaction in reverie to which Bachelard attends comes not from the re-creation of the psycho-sexual situation and its powers, but from finding again a freedom in the newness, immensity, and beauty of the world through the child-imaginary. The world in childhood, at least insofar as, and when, the child is afforded the reprieve of daydreaming and free

play, is large and beautiful. This largeness, when revivified by the adult consciousness through poetic images and the reverie they induce, nurtures not simply a desire for escape, but a reverie of flight into a seemingly limitless world. This limitlessness is one form of freedom that the adult finds when turning to and dreaming toward childhood, evidenced particularly in images of childhood solitude, the subject not only of the French poetry Bachelard cites in his chapter on childhood, but also of works by Wordsworth, Blake, Rilke, and Frost. With childhood what is recovered is a feeling not of wished-for power to fulfill desires, but a freedom that comes from imagined limitless expanses, the "primitive immensities" of the imagination. In fantasy toward childhood, the world is a spectacle of dreamy geography. "A glimmer of eternity descends upon the beauty of the world" [Une lueur d'eternité descend sur la beauté du monde] (Bachelard 1960, 87; 1969, 102). When the adult's reverie is deepened, and memories are awakened, the nucleus of childhood in the human soul is vital enough to bear within it not merely the childhood actually lived, but its potentiality: "A potential childhood is within us. When we go looking for it in our reveries, we relive it even more in its possibilities than in its reality" [Une enfance potentielle est en nous. Quand nous allons la retrouver en nos rêveries, plus encore que dans sa réalité, nous la revivons en ses possibilités] (86; 101). Bachelard's account of childhood and reverie, however, depends on the primacy of images over experiences of action within the nucleus of child-memory that remains in the human soul. Bachelard is able to find these preserved, as it were, revivified, in the experience of poetical images, to which he attributes the same originality as the world as discovered by philosophers. When in dreaming of childhood "the world totters" (here Bachelard quotes from a poem by Paul Chaulot—". . . Le monde chancelle . . ."). This grants a discovery of the same opening on the world, the same "prestigious world of original contemplations," for which philosophers strive (103; 87–88).

Merleau-Ponty, Benjamin, Bachelard, and Freud hold strikingly different views of childhood, and a brief survey of some contrasting aspects of their views is useful in addressing the matter of recapturing childhood experience. Freud's view is problematic, since it relies principally on recovering the dramas of the unconscious as underlying fantasy and play; whereas Benjamin, in imaginative reflection upon childhood experience, and Bachelard, in a phenomenology of poetic images, and Merleau-Ponty, in addressing children's *pensée physionomique*, attempt to account for childhood on the level of perception, embodiment, and conscious imagination. While all of these accounts make important discoveries about child experience and art, Freud's thesis overlooks the breadth of potential contributions of child experience to artistic

activity, a breadth of which the other studies provide considerable confirmation. Considering the connection between literary activity and childhood, Freud does not linger over what is special to child consciousness that evades the adult *telos* and which is so difficult to recapture in adulthood; what it is about children's experiences that is lost to ordinary adult consciousness and so mourned by the adult consciousness when longing for childhood remains unilluminated in Freud's analysis.

Here Benjamin shows more insight. In one of Benjamin's many writings on childhood—in this case the essay "Old Forgotten Children's Books"—he suggests, similar to Freud, that in play children "produce their own small world of things within the greater one." But rather than predominantly imitating adult activities in such arrangement—for instance in manipulating the refuse from gardening, housework, tailoring, building, and other adult tasks—children make out of things "a new, intuitive relationship." Fairy tales often fascinate children not because of the story's moral about adult judgment, fate, or actions (nor necessarily the symbolic reflection of sexual fantasies as Freud's thesis suggests), but rather by such things as "the spectacle of animals that talk and act like people." Animals become just another material out of which "to build their own world out of motifs from the fairy tale, combining its elements" (Benjamin 1996, 408). But it is also possible that children enjoy personifying animals precisely because they do not need to be thought of in accord with the roles of adult persons which seem too limited. It is this freedom of creating and savoring of new worlds out of familiar ones that is precious to childhood experience and essential to the artist who, self-reflectively or not, recovers or maintains it. Even when children take on adult roles in play, wanting to be grown-up might be only a part of the attendant pleasure; another would be the thrill that simply attends the ability to pretend, to step outside their still emerging identities and take on ever different roles, and in so doing to transform the meaning of objects according to their imaginative designation. That children often take on roles of adults suggests not necessarily a drive toward adulthood and its powers and seeming liberties, but perhaps a pleasure taken in disrupting the forces that give quotidian life not merely its order and regularity but its fixity, its fallenness, the seeming finality of its arrangements.

Perhaps what is most savored in Romantic accounts of naive child-consciousness is the escape from fallen mature consciousness. But a more complex account is needed of the paradoxical ability of such consciousness to keep faith with both the order of things and their (perhaps only imagined) strangeness, the ability at once to believe in the world as it is and to delight in its constant transformation. While the child psychologically and physically

thrives in structured, predictable, and reliably nurturing relationships to life
and to those others on which it depends, the child imagination, nurtured by
this very reliability, remains faithful to a constant and from the mature point
of view radical openness. Thus the child consciousness, though it cannot be
immediately accessed, is one model for what has been called here the "ecstatic
quotidian." The order of everyday life, and its vulnerability to transformation,
are not opposed forces in the child experience. What the adult aims to recap-
ture in reveries of childhood is not merely the sense of having been protected,
a nurtured enclosure (images of which Bachelard studies in *La poétique de
l'espace* (The Poetics of Space), but also the sense of lost possibilities, the
child's sense of the open thread of adventure which, when re-engaged, goes
even farther than memories of our own childhood (Bachelard 1969, 106; 1960,
90).

In Freud's essay the study of the relation between child play and literary
imagination remains underdeveloped also because he deliberately chooses ex-
amples of less imaginative literature, popular works that illustrate wish-ful-
fillment fantasies. Elsewhere in his writings, he interprets rich literary works,
like E.T.A. Hoffmann's *Der Sandmann,* with the effect of tracking down the
apparent psychological mystery, the logic of associations, behind certain fears
or neuroses. In imaginative, artistic, and linguistically demanding literature,
childhood creativity is evoked through innovative language, narrative com-
plexity, surprising metaphorical leaps, rich and provocative imagery; and in
plastic arts it is evoked through the creation of intimate space, through reso-
nances of color, vitality of contour, virtual movement and malleable physical-
ity. Artistic creativity does not only replay psychic dramas but also recharges
the spontaneity and openness of childhood creativity, even if the simplicity it
aims to reach has to be accessed by difficult strategies. In this vein Thomas
Mann acknowledged child's play as the root of his art, play having been no
less seriously engaged. In his essay "Kinderspiele," Mann admits that there is
no strict division (keine scharfe Grenze) between them (Mann 1974, 66). The
very difficulty of retrieving the experience seems to be in part its simplicity,
and so much literary effort is expended on breaking through sediments of
expectation that obstruct access to it and with it the flow of adventure.

A look at the child's relation to everydayness will illuminate the latent
ecstatic possibilities that are evoked through artistic experience. As in Benja-
min's accounts or in modern literary works, such as those by Rilke, Proust,
and Frost, evocations of childhood manifest a maximal richness of certain
aspects of experience, particularly in contrast to the ordinary expectations of
the habitual (adult) world from which they seem to break away. In the context
of adult disenchantment with the technological, urban, or abstract experience

of modernity, so forcefully suggested by Hofmannsthal's *Briefe* and Rilke's *Malte* as well as Benjamin's ambivalent probes into technological reproduction of artworks and other aspects of modern life, childhood is called up as an alternative being-in-the-world. Thus childhood is not re-engaged because adult life is itself inherently any less beautiful or satisfying, necessarily fallen, but because modern life is seen to be particularly susceptible to the flattening out of reality, to the impoverishment of the potential richness of experience, to the alienation of nature. As Charles Taylor put it: "Modernist writers and artists [are] in protest against a world dominated by technology, standardization, the decay of community, mass society, and vulgarization" (Taylor 1989, 456). But childhood as a source of liberation from such domination is not restricted to romantic idealization, as in Wordsworth or Dickens, to whom Taylor refers (458). When nature no longer seems available as a source of inspiration and wholeness, childhood seems to be engaged as a natural state of being within, a primitive resource of resistance to the abstractions of modern life. As in Romanticism, childhood is associated with immediacy, wholeness, and enchantment, if not also a healing power. But not only did Freud's theses about children's sexuality render this idealization difficult to maintain; in modern accounts the turn to childhood is wedded to a greater interest in the real experience of children. The child's view of color is for Benjamin a spiritual experience but also a perceptual experience, just as for Bachelard the deepest reveries of the world's grandeur are enabled by childhood daydreams. Although not governed by the telos of expression, childhood experience in its most heightened forms has much in common with the consummatory or privileged moment sought in aesthetic experience, discussed by Dewey and Jephcott, as mentioned in the pervious chapter. The interest in childhood is perhaps a manifestation of the modern turn toward sources of interiority that, as Taylor argues, "couldn't be assimilated to the supposedly all-encompassing machine" (460).

Childhood, however, has its own exigency, for it is also through modernism that childhood is being recognized as a state of being with its own rights and demands. In a review Rilke praised Ellen Key's book (published in Sweden in 1900 and translated into German in 1902 as *Das Jahrhundert des Kindes*) on the status and education of children which defends the freedom of and rights of children. The idea is that even social reformers on behalf of children must begin with children themselves, rather than seeing them from the standpoint of the adult who knows so little of children (Rilke, KA III, 267). Benjamin has made the case for the need to recognize their specificity; and so children ought not be handled like miniature men and women, as he comments regarding children's dress, which only relatively recently had begun to

be differentiated in style from adult clothing. Rather, the unique existential status of children is to be recognized. Benjamin also notes, however, that the Rousseauian dream of the purity of children, which persists in poets like Wordsworth, is inadequate and inaccurate. Not only Freud's theses, but Klee's paintings, for instance, explore as well the "despotic and inhuman in children" [das Despotische und Entmenschte an Kindern] (Benjamin IV/1, 515), as does Ravel's *L'Enfant*. An aggressive and violent energy is evoked in the description of Marcello's childhood in Moravia's *Il Conformisto*. And Proust explores jealousy and social exclusion through the narrator's childhood love for Gilberte. Merleau-Ponty takes special note of these passages, given his interest in the social development of children (Merleau-Ponty 1960, 49–50). To whatever extent these descriptions are true to actual child experience, it is not their purity, but the spontaneity and world-transforming nature of their play, among other characteristics, that have made child experience a frequent motif in modern literature. According to most of the accounts examined here, when adults experience play, they are living out the persistent possibilities of childhood experience that are never completely extinguished from quotidian life, given its reliance on language, perception, and creativity that harbor vitalities of their original manifestations.

A remark should be made here about the relation of adult consciousness to retrieved child consciousness. Whereas contemporary humanity stands accused of self-infantilization and unworldliness, of a willingness to accept illusions (Marquaud 1991, 80–81), one might ask which aspects of childhood illusions, those emphasized by Freud or by Benjamin and Bachelard, are at work when this becomes reprehensible. According to Odo Marquaud's account of the "age of unworldliness," modern-day people, accepting of and clinging to illusions, "do not grow up anymore" and their loss and renunciation of experience and responsibility for truth is associated with becoming childlike. In the face of accelerated change, adults refuse to cope with reality, refuse to mature. Yet while Marquaud's assessment of adult irresponsibility is compelling, that of children is not when he states: "Children, for whom reality is overwhelmingly alien, need, to offset this, an iron ration of something familiar: their teddy bear, which they drag along with them everywhere for just this purpose. In just the same way, modern grown-ups—for whom the world again, tachogenically, becomes permanently alien—need the ideological immediate expectation of a whole, restored world" (81). But it seems rather that for children reality is not overwhelmingly alien, because they do not yet make absolute or rigid distinctions between what is their own and what is foreign. In early stages of childhood experience, as described by Merleau-Ponty and discussed below, child consciousness is rather the opposite, characterized by dispersal across all manner of external things. The *pensée physionom-*

ique of children, their reverie, their forms of play, are open to adapting to foreign aspects of the world. It is in tension with this openness that individuation and maturation occur. Children thrive in familiarity and regularity, and benefit from their assignment of personality to specific objects which help them to cope with change. Yet they are also apt, in other moods, to give them up easily, to reassign their meaning or value, just as they continually do for other things in their environment.

Despite their needs for emotional shelter, children are often remarkably open to new environments, other people, and new ideas, insofar as these are forces friendly to their well-being. Children, whose sense of reality is perhaps most vital and fluid, are perhaps least disposed, at least not for very long, to cherish any particular illusions as truth. While they might in some moods demand the affirmation or possession of whatever this or that assignment of meaning they deem important, these are passing demands or tantrums generally followed by surprising flexibility. What children precisely do not need, but childish adults do, is, as Marquaud puts it, "the ideological immediate expectation of a whole, restored world." The wholeness of life in the child experience is incomparable to a rigid ideology. When adults become childish in a reprehensible way, this childishness expresses only a very narrow aspect of child consciousness.

While Freud sees in adult fantasy a replaying of unconscious wishes, Benjamin acknowledges the liberating aspects of children's play, as Bachelard does of childhood reverie and Merleau-Ponty of children's reception of modern art. When adults observe children at play, accompany children caringly through the world, or engage the literary imagination of childhood, they experience at best not a regression into childishness (which can be reprehensible), but rather glimpses of an alternative to present reality, reminders of the capacity to form new ideas and be open to new ways of interpreting things. "Back out of all this now, too much for us," Frost's speaker prescribes in his poem "Directive," "back in a time made simple by the loss of detail." Frost's directive toward the past suggests the persistent though difficult source of an alternative experience of the world. In a review of an exhibition of old children's toys in a Berlin museum, Benjamin considers the image of an adult indulging in play: "One recognizes the image of the family gathered under the Christmas tree, the father sunken in play with a toy train which he had given the son, while the child stands there crying. If such a drive to play overwhelms the adult, this is not an unbroken regression into childishness. Admittedly play remains always a liberation" (Benjamin IV/1, 514).

Here the toy serves as a tool to gain access to child's play even for the adult who has long since left such objects behind, just as reverie, provoked by poetic

images, leads the adult dreamer back to the freedom of the childhood imagination. When the present becomes too much for us, the possibility of play beckons like a call to liberation, however fleeting and potentially absurd for the adult. Henri Lefebvre evokes this utopian notion of play in his promotion of new spaces of social experience, the "city as play" and the festival, which would contribute to a "revival of experience values" to oppose the values of consumption and exchange (Lefebvre 1984, 190–91). Yet this rather Dionysian model of play annihilates the quotidian, it unravels everydayness by juxtaposing it with the very non-everyday atmosphere of a festival. In contrast, childhood play takes place within the context of everyday life, and is endangered if everyday life becomes too unstable or unreliable. This does not make childhood any less an enclave for freedom. Bachelard attributes the liberation of reverie to the psychological freedom so prominent in childhood, asking, "What other psychological freedom do we have than the freedom to dream?" (Bachelard 1969, 101). While dwelling in reverie, becoming mere dreamers, is not particularly valuable for adult consciousness as Marquaud argues, the reminder of such psychological freedom is incompatible with the fixation of ideological illusions.

More empirical than Bachelard's account of images and daydreams, both Benjamin and Rilke see toys as repositories of the proto-ecstatic everydayness immanent to childhood experience. Both devote studied essays to the nature of toys and their relation to the transformation of the everyday world. Toys are objects of everyday child-being which seem to stand in for the constant possibility of a quasi-ecstasis, offering an example of the non-finality of illusion in child's play. For the child at play the toy can take on ever different roles and attitudes, and the surrounding space can be symbolically transformed, a transformation available in some slight measure even to the adult consciousness. Whereas the teddy bear is sometimes a stay against an alien environment, it is also subject to constant reconfiguration, taking on new qualities and roles, unlike the illusions to which the self-infantilized adult would cling.

In a narrative essay on dolls (*Puppen*) written in 1914, Rilke analyzes the means by which a doll provides for the child orientation in the spatial world, as well as a repository for the child's ideas and testing out of self-identity. The doll is a half-thing, helping the child to keep the overwhelming world at arm's length. The space of play is "neither inside nor outside," but constitutes what D. W. Winnicott in his analysis of play calls an "intermediate zone" or a "third area" between the inner life of the individual and the external objects of his attention (Winnicott 1971, 128, 141, 138). This space is the area of negotiation between subject and object. In childhood it is constituted and occupied

by play; according to Winnicott in adult life this space is taken over by art, religion, and other symbolic-creative experiences (18). Yet in child experience that space is constantly negotiated. The doll is not an armor against alien influences but the medium through which the child can participate in the creation of meaning.

The passivity of the doll is not that of an ordinary object which is opposed to a thinking, feeling, human subject. In order to personify the dolls Rilke's narrator in *Puppen* uses passive verbal constructions: dolls allow themselves to be dreamed at night ("sich träumen lassend") and to be lived ("gelebt zu sein") during the day; they cease to stand over against the child as an ordinary object. For this reason, the doll is not something that, in its full reality, is ordinarily present; it recedes into familiarity, into the unnoticed background, and is thus only half present: "Only you, puppet-soul [du, Puppenseele], of you one could never exactly say where you actually were. . . . When were you actually ever present? Perhaps on a birthday morning, as a new doll sat there and almost appropriated some bodily warmth from the warm cake next to it [neben ihr]?" (Rilke, KA IV 681). When familiarity sets in, its existential status becomes ambiguous for the child, what Rilke called "this being-less-than-a-thing" [dieses Weniger-sein-als-ein-Ding] (689). The narrator reenacts this ambiguity, not only by empathizing with the dolls' perspective but by shifting, as in the passage above, from the second person address (du, Puppenseele) to third person description (neben ihr). Even when the narrator addresses the doll directly, its real being seems to evade the gaze: the more physically present to an observer, the more it recedes ontologically. The doll lives in a constant mode of evasion, as if it were ever slipping out of a space of which it is paradoxically the center. This is because the real essence of the object lies elsewhere, in the spontaneous granting of existential relevance by the child's play.

Rilke's Malte and Proust's narrator are both drawn back into the fabric of childhood as it is recollected and re-engaged through vivid imagination. The ecstatic latency of quotidian reality is discovered in reliving the sensuous observation of the world's magical qualities in the experience of child imagination and play. Perhaps because the quotidian is under constant transformation in childhood and so not yet fixed, because it is still inchoate, not yet settled into the narrower purposefulness of adult practicality and habit, a recollection and revivification of its texture gives a vibrant sense of the encounter with what is taken to be original reality. Benjamin's essays, Bachelard's study of images, Rilke's writings, and Proust's major novel, all re-engage childhood as a state of freedom from fixed conceptuality and habit that characterizes adult consciousness, but also as a persistent source, when revivified in adulthood,

for the revitalization of quotidian life. The appreciation of child experience, of course, also helps one appreciate children themselves with a greater seriousness, and not merely in abstract idealization. They are not only valuable as future of humanity, for what they will be, but they are inherently precious for what they already are, as they inhabit the world in its most vital and living phases of constitution. Children are not merely the future but the vital past of much that is and remains human within us, and their present always could be the richest present. Appreciation of this would also affirm the complexity of the whole human soul. Not to escape our adult selves and responsibilities, not to replace everyday life, but to be reminded of its original constitutions, of its potential transformations, ought we turn to literary vivifications of child consciousness. As Bachelard writes, "Comme nous serions solides en nous-mêmes si nous pouvions vivre, revivre, sans nostalgie, en toute ardeur, dans notre monde primitif" [how solid we would be within ourselves if we could live, live again without nostalgia and in complete ardor, in our primitive world] (Bachelard 1960, 88; 1969, 103).

Child Being and Philosophical Accounts of Everydayness: Child Consciousness Between Heidegger and Rilke

While situated within the ordered world of habits and daily events, child being is ever destabilized by imaginative projections that continually challenge and break through the expectations and understandings that govern everyday worldliness. The world is constantly renegotiated through play and spontaneous designation: the chair on which the child reads is a ship surrounded by water, and then it is a house, and then a horse. The book is a pirate's map, then food for imagined animals brought along on the journey. This flexibility of meaning in childhood is considered in some of Wittgenstein's reflections on language (Wittgenstein 1965). While the theme of childhood appears in Romantic philosophy and in Nietzsche's writings, in Benjamin's critique of modern culture and implicitly in his "metaphysics of youth," and in Merleau-Ponty's studies, in the main, as a mode of human being, it has been almost completely ignored in philosophy. Childhood appears not at all in prominent accounts of everydayness, from Heidegger to the recent study of Stanley Rosen. In existentialist literature this absence is also conspicuous, since this literature directly concerns concrete ways of being in a world and the world's negotiability for a consciousness, the very negotiability of meaning to which the child consciousness is especially subject.

In philosophical accounts of everydayness, such as Heidegger's, the expec-

tations of adult being are presupposed, and their developmental generation unaccounted for. Heidegger's Dasein is decidedly adult, portrayed in practical tasks, adult distractions (such as idle chatter—*Gerede*), fascinations, and contemplations. If, as Rosen has pointed out, the principle of happiness is displaced by being-toward-death (Rosen 2002, 124), play also appears nowhere in *Being and Time*. Dasein's activities are described in largely practical terms, and even curiosity is demoted to a distracted, self-escaping gaze at the glittery and new, a demotion indebted both to Heidegger's adoption of Saint Augustine's critique of sensuous experience and to Kierkegaard's critique of the modern age, which had a great influence on Heidegger. (Both thinkers are discussed in the lecture-courses that make up *Phenomenology of Religious Life* several years before *Being and Time*.) The curiosity Heidegger discusses is not a childlike curiosity, but an inauthentic hunger for distraction from finitude and a fixation in static presence. When authentic, Dasein seizes itself and recovers a relation to its self within the context of time and historical being, in a decidedly nonchildlike struggle of resoluteness in the face of death. While Dasein's finitude is ontologically examined, its beginning, as Hannah Arendt has argued, is not. *Geworfenheit* or thrownness into existence, initiation into the world, is quickly stabilized into fallen everydayness. If Heidegger's account of everydayness is too narrow, this is due not only to the sources on which Heidegger draws (Aristotle and Christian theology along with phenomenology), as Rosen claims, but to the exclusion of whole regions of human experience in which determinations of existential authenticity and inauthenticity, resolute acceptance of finitude or fleeing from death, are not, or not yet, relevant. To redress what is missing in Heidegger's account of everydayness, Rosen points to happiness (Rosen 2002, 117). He and others, like Werner Marx and David Carr, for example, have pointed to ethics; but childhood and aesthetic experience are here too strikingly absent.

The problematic and conceptual structure of Heidegger's major work would, of course, not easily afford a recognition of childhood. A different mode of everydayness would have to be rendered to accommodate the activity of play and the imagination of child being. In *Being and Time*, everydayness is governed by practical labor, with its teleology opposed to childbeing. Moreover, temporality—and thus the essence of human Dasein—is brought to light by *Angst* and uncanniness (Unheimlichkeit) in Dasein's being pursued by the question of its own death. One condition of childhood seems to be its non- or not-yet recognition of such finitude. For the child, as for many so-called primitive cultures, death is not recognized as that which is opposed radically and with finality to one's very being.

The child's relation to death seems to be quite different than that of Hei-

degger's Dasein, a relation much contemplated in modern poetry, for instance in Rilke, Wordsworth, and Frost. Children, as Rilke writes, look "with the wide gaze of animals" [mit großem Tierblick] because they are free from fear of death [frei von Tod] (Rilke 2000, 46/47). In the eighth of the *Duino Elegies,* Rilke's speaker complains that the child is too soon inverted (by the adult "we") to look at the world through adult eyes. In Wordsworth the child refuses. In his poem "We Are Seven," a child, speaking to an interlocutor, insists that among her family are numbered the dead siblings around whose graves she plays. All attempts of the interlocutor to set her numbers right, to draw the proper boundary between the living and the dead, come to naught. The seed of adulthood, as recognition of death as life's opposite, is refused by the girl through her activity of play, which by nature includes imagined but empirically non-present beings. The girl knows that they are empirically non-present, that they will not return, but refuses the expulsion of their imagined being from the realm of real being and life. In Frost's poetry (for instance the poems "Directive" and "Birches" and "For Once Then Something") child-hood play—in an old playhouse, with toys, in the physical thrill of swinging on tree-trunks, or gazing into old wells and seeing cloud-pictures reflected there—is a resource for restoring adult consciousness which has fallen to a point of disastrous penury and confusion. This child consciousness is rich and resourceful in part by being empty of any concern for finitude. In Rilke the child's special power is its inclusion of death within its whole being, also emblematic of the Orpheus figure in his sonnet cycle. In part because of this non-anxiety in the face of death, in childhood any real ecstasis is not yet needed, since the child is not yet "fallen" (a notion discussed in the previous chapter) into a disenchanted everydayness. Rather, everydayness remains, with all its regularity and predictability, open to constant transformation by imagi-native play.

In *Being and Time,* another obstacle prevents Heidegger's recognition of Dasein's child being: according to his own admission, Heidegger had not yet sufficiently liberated language from logic. *Being and Time* is not yet a poetical enough thinking to resonate with the kinds of proto-ecstasis available to child consciousness as these poets attempt to access it through their writings. Hei-degger's thinking, for all its valuing of mood and attunement, is here not too poetic, as Rosen has argued (Rosen 2002, 127), but rather not poetic enough, insofar as authenticity is accounted for in the resoluteness of a narrow concern with Dasein's own finitude and singularity, rather than with the far broader and richer possibilities of authentic engagement with everyday life that are generated out of play and artistic activity, in addition to ethical civic engage-ment. After *Being and Time,* Heidegger approached, though indirectly, the

counter-stances against the tendencies of fallenness that are intrinsic to child-hood, but he does not take up the possibilities an engagement with child being might offer.

In Heidegger's later essay "Wozu Dichter?" (What Are Poets for?), the figure of the child does appear with the notion of play, and it is important to see how this figure is or is not taken up by Heidegger in his interpretation of Rilke. He interprets Rilke's *Sonnets to Orpheus*—addressed to, and memorial-izing, a girl dancer who died young—and the eighth of the *Duino Elegies*, with its discussion of the Open (das Offene), to which the animal and the child are said to belong unobstructedly. While the differing views of Freud, Benjamin, Merleau-Ponty, and Bachelard are helpful in showing what is at stake in interpreting child's play, some inquiry into the child-figure as it ap-pears in Rilke's poetry that Heidegger interprets will shed light on alternatives to the narrow possibilities of being-toward-death as key to an authentic rela-tion to life and being.

"Wozu Dichter?" seems at first far removed from the everydayness and worldliness of *Being and Time,* as well as from the scene of the breakdown of the quotidian described in *Basic Problems of Phenomenology.* Heidegger's essay begins with the title question taken from Hölderlin, whose reflections on the meaning of the poet's vocation are issued in a near-apocalyptic vision of modernity "determined by the 'default of God'" [durch den 'Fehl Gottes' bestimmt] (Heidegger 1971, 91; 1977, 269). Hölderlin presents a radically dis-enchanted vision of an age and world from which the gods have fled, while new gods have failed to arrive. As aforementioned, Hölderlin also uses the child-figure as an emblem of wholeness and healing, or a connection to the divine, in a fallen disenchanted age, for instance in his *Hyperion* and in the poem about an idealized- recollected boyhood, "Da ich ein Knabe war." But Rilke is the poet in this essay who provides life forms—through figures of angel, poet, animal, and child—that indicate a possibility of redemption in the radically penurious modern age.

By turning to Rilke's poetry, Heidegger confronts a "fallen" technological age, and considers more poetic, sometimes ecstatic, forms of engagement with the everyday world and with the natural world so endangered by modern ways of human life. For Rilke, our being at home in the world and, more widely, the cosmos, is concentrated in authentic (rather than mass-produced or sham) things. He praises the simple object that lives with us generation after genera-tion, lives with us until it "lives as our own" (als ein Unsriges lebt). In his elegies, among other writings (including the *Puppen* essay), this rich relation to things is associated with childhood, where an abundance of existence is experienced through things, just as for Hofmannsthal the narrator of the

Briefe experiences such fullness in primitive or non-European cultures as well as in remembering his childhood in Austria as he gazes at things brought to life in Dürer's woodcuts. This relation to being is possible, Rilke's speaker implies, only in the heart of one for whom neither future nor childhood has diminished. With reference to the child among other figures, the speaker evokes a relation to quotidian things and thus to the immanent world as alternative to human fallenness. For in the nonpoetic attitude that registers things only as empirical presence, intensely experienced things are falling away: "Mehr als je fallen die Dinge dahin" (Rilke KA II, 228).

This diagnosis is also offered in Rilke's early series of tales, *Geschichten vom lieben Gott* (1902/1904), in which a "Dämmerung mit Dingen," or a twilight in respect to things, is announced (KA III 494). This twilight of things is due to their fixity, their invulnerability to meaningful transformation. In a more enchanted age a thing can have several or changing designated meanings. In contrast to adult fallenness, the children in *Wie der Fingerhut dazu kam, der liebe Gott zu sein* (How the Thimble Came to Be God), assign the divine presence to an ordinary domestic object. By so doing they reinvest the everyday life with "God" whom adults had lost. Not incidentally, the entire collection of *Die Geschichten vom lieben Gott* is narrated for children; not told directly to them, it is supposed to be retold to them by the narrator's adult interlocutors. This narrative strategy suggests not only Rilke's complex views of the divine, but his understanding of childhood as evasive. The narrator attempts to reach childhood indirectly, to overcome its seeming inaccessibility, by creating through layers of narration and through various media of retelling a world in which the child's imagination and relation to things is relevant. In some of the stories this includes fantastic treatment of landscapes, people, objects, and places, such as when clouds over Europe talk with the narrator, or God is depicted in strife with his own hands, or when houses in a Venetian ghetto are built on top of one another up to the heavens.

Heidegger sees in Rilke's sonnets and elegies a poetic alternative to the fallenness and destitution of the modern age. While in the modern age, according to Heidegger, "even the trace of the holy has become unrecognizable," the poet's task is to open up our receptiveness to such traces (Heidegger 1971, 97; 1977, 275). This is accomplished in a meditation on Rilke's notion of "the open" (das Offene), the pure draft of being wherein all things are ventured and reverberate in a living, unobstructed relation to the whole. Stances toward and within this pure draft, the specificity of being ventured into it, are determined by the nature of consciousness and its language. Humans who have language, and thus also the possibility to represent the whole of beings to themselves, are said to have an obstructed relation to the open.

Instead of a pure relation, the individual stands before an already conceptualized world, demarcated by division and exclusion between visible and invisible, present and absent, living and dead, subjective feeling and objective thing. The poet, with a register of receptivity richer in nuance than representational thinking affords, can nonetheless understand this obstruction only in contrast to an image of unobstructed relation. While the poet is receptive to the mysteriousness and immediacy of beings, and has the capacity to transform them into an inner reality by naming them and designating them poetically, the animal and the child are models for an original pre-representational relation to the world.

It might be useful to contrast Rilke's conception of animal consciousness with that of the child, a coupling also found in Proust's description of childhood consciousness discussed later in this chapter. Animals according to Rilke have a pure relation to the open, and thus the elegy begins: "Mit allen Augen sieht die Kreatur das Offene" (KA II 224). As Rilke explains in a letter of 1926 (published in *Rilke in Frankreich,* ed. Maurice Betz, 288–91): "By the open, then, I do not mean sky, air, and space; they, too, are, for the one who observes and judges, 'object' and thus 'opaque' and closed. The animal, the flower, presumably is all that, without giving any account of it." [Mit dem "Offenen" ist also nicht Himmel, Luft, und Raum gemeint, auch die sind, für den Betrachter und Beurteiler, "Gegenstand" und somit "opaque" und zu. Das Tier, die Blume, vermutlich ist alles das, ohne sich Rechenschaft zu geben] (KA II, 673). In not accounting for it, it does not reduce the world to an object of its own representation—so that the animal experiences being more immediately, whereas we are turning against the open as an act of parting, or *Abschied,* and for Heidegger this is explicitly associated with "man's self-assertion" through technology, the capacity to objectify, to manipulate, indeed even to annihilate things (Heidegger 1971, 116). As subjects of representational consciousness we are always, Rilke's speaker says in the eighth elegy, "in the stance of someone just departing [welcher fortgeht]." In contrast to the animal, our eyes are "as if inverted [wie umgekehrt] and set all around it like traps at its portals to freedom." Therefore what is beyond our gaze we can know only through contrast: "We know only from the animal's countenance" [Wir wissens aus des Tiers Antlitz allein] (KA II 224).

In Rilke's poem the child figure, though unstudied by Heidegger, is also essential. It is because the child, like the animal, has an original relation with the open that human representation of beings can be turned around, transformed. Because we were once children, we harbor an originally unobstructed relation to the open which in adulthood can only be regained through poetic

or artistic manifestations. It belongs to human development and particularly to modernity that we lose this almost at once: even the young child is inverted:

> denn schon das frühe Kind
> wenden wir um und zwingens, daß es rückwärts
> Gestaltung sehe, nicht das Offne, das
> im Tiergesicht so tief ist . . .
>
> > (KA II, 224)

> . . . for from the first, we turn the child around
> and force it to see
> shapes and forms backwards, and take in the structure,
> not the Openness that lies so deep in the animal's face . . .

Perhaps one could say, following the terminology of *Being and Time,* that the child, thrown into the open, is subject to fallenness insofar as it grows into adult representations and interpretations of the world as governed by practical habits. In Rilke's poem the child is all-too quickly appropriated by a gaze fixed upon presence and for which the mysterious and nonconceptual—or the divine—will be excluded. This would be the Rilkean diagnosis of the age of the fled gods. Modernity is the world's age that reflects a state of consciousness alien to a child's perception of the world.

Though scarcely discussed in Heidegger's essay, the child appears both in Rilke's cited poems and in Heidegger's evocation of the notion of *Spiel,* where a cited passage from Heraclitus equates time with child's play. In the following meditation, Heidegger joins *das Spielen* (playing) and *das Wagen* (venturing or wagering) and, by reference to an untitled poem by Rilke, to the paradoxical coupling of *Schutz* (protection) and *Gefahr* (danger). In Heidegger's associative (rather than historically correct) etymological meditation, *Spiel* is associated with *Wagen,* for the play of time is of the kind that carries risk, where something is ventured. Human beings are ventured by nature and by time, as Heidegger gleans from Rilke's poem. Unlike animals, humans go with and farther than even nature's wager. They risk more than nature demands, for they surpass finitude by imagining and relating to the divine. This relation, however, is radically endangered in "destitute times" [dürftige Zeit] as Heidegger, through Hölderlin, diagnoses the modern age. Human beings are, according to Rilke's poem, protected in their being unprotected, protected by being risked through wager.

In Heidegger's essay the child is first mentioned in connection with Fragment 52 of Heraclitus. What Heidegger calls the "world's age" (die Weltzeit;

aion) is identified as "das Spiel des Kindes." Heidegger's translation from the Greek is: "Weltzeit, Kind ist sie spielendes das Brettspiel; eines kindlichen Spiels ist die Herrschaft" (Heidegger 1975, 280). The world's age, a child playing draughts; lordship is of child's play. In the Greek the child or childish is thrice emphasized: *pais / paizon / paidos.* It is necessarily reduced to *Kind* and *kindlich* in German (since *spielen* has no etymological relation to *Kind*), but the child figure and the childish are also not mentioned again directly in Heidegger's essay. Rather he examines the figures of animal and angel as alternative forms of consciousness. The connection between *Herrschaft* and the child is made again, however, in a poem from Rilke's *Das Stunden-Buch* (*The Book of Hours*), which Heidegger cites in full. In this early poem a lost inheritance (*Erbe*) is represented in an image of kings of the world grown old, whose sons have died as boys and whose daughters were given over to violence. Through death and violence both their childhood and their future as rulers are lost. What is lost in this rupture in the lineage? Not only will the world be without future kings; but also the children, their youth emphasized through contrast with the age of old kings, will not inherit the world. Discarded by fate, they will not influence or receive the future. Without children as inheritors, the world will be dominated by the concerns of adults, the rule of money, distorted by machines and factories. The children are lost not only as future, but as past, since childhood is characterized by a precommercial, pretechnological, pre-abstract consciousness, emblematic of a world before the domination of money, machines, and factories. A world without childhood is a world that has lost its future, with its potentially ever-renegotiated interpretations and receptions of the world, and its past, as a deep source for a pre-fallen mode of existence. Benjamin summarized this in an essay on Dostoevsky: "Because nature and childhood are absent, humanity can be arrived at only via a catastrophic process of self-destruction" (Benjamin 1996, 81). Dostoevsky's underground antihero is a man who suffers this modernity in his abstract city, who has lost his own sense of childhood and who, in relegating Liza's love to prostitution, repudiates the recovery of innocence.

Heidegger withholds affirmation of Rilke as a poet for an impoverished time, on grounds that Rilke's thought is still too metaphysical in the sense of fixing being within concepts of presence. Yet when the figure of the child is considered along with figures of angel and animal, this judgment seems in need of amendment. In Heidegger's account Rilke relies upon a still-metaphysical representation of nature as the wagering *Urgrund* or primal ground of beings. Nature as primordial ground is equivalent in the terms of modern metaphysics to the being of beings, conceptualized as presence. According to Heidegger, Rilke fails to think, where Hölderlin succeeds in thinking, the

radical *Abgrund* or abyss (literally groundlessness) of being, the withdrawal, and the danger of that withdrawal. It is the poet's task to reach deeper into the abyss and find, through the dangerous exposure of venturing into the unprotected, unknown, and non-predetermined, the salvation of another possible mode of thought and dwelling. But Rilke's child figure and the notion of child's play, overlooked by Heidegger in his immediate association of play with venturing and wagering, suggests a poetic figuration of just the groundlessness that Heidegger recommends. Just as Freud overlooks the range of possibilities in childhood play that remain unaccountable to adult telos, Heidegger straps play to the seriousness of wagering, overlooking its ungrounded spontaneity, its openness, and its world-savoring generosity. Transformation of child's play in Heidegger's adult determination would be the world-erecting business of political and technological intervention into nature. But because it is open to constant renegotiation of meaning, the child's relation to the world is groundless in the sense of unfixed within a metaphysical or representationally determined ordering of nature. Child consciousness, even while entering into forms of life and so into the context of already given rules for understanding the world, is not formally fixed so that one could speak of an implicit metaphysical basis on which the world is interpreted. The child figure in Rilke's writings, including in those poems cited by Heidegger, is incompatible with both metaphysics as Heidegger understands it and with a fallen everydayness, in its affirmation of only presence as the real and the real as determinable and measurable. But childhood play, if residual in the adult consciousness as argued in this chapter, also offers sources for imaginative transformation of adult modes of dwelling. Not only because of its cognitive immaturity can the child consciousness not conceive of nature as an *Urgrund* or a ground of beings to be metaphysically determined and scientifically conquered; for it is also due to the openness of meaning in the child's understanding of the world that nature could not be so objectified.

While Heidegger was accompanied in his meditations by two slim volumes of Rilke's late poetry (the sonnets and the elegies), both of which contain themes of childhood, there is another of Rilke's poems in which *Schutz* and *Gefahr* are thematized through the images of child and childhood. This is an unfinished poem meant for but not included in the *Duineser Elegien,* wherein childhood is characterized as "namenlose / Treue der Himmlischen" or a "nameless loyalty of the heavenly" (KA II, 186–87). In an earlier draft of this poem, Rilke's speaker calls the child's doll, taken into the absorbing hours of seemingly timeless play, a friend of death, because it is subject to imaginary transformation: "Freundin des Todes, denn in der leichten Verwandlung / wuchs sie ihn hundertmal durch" (579). In Rilke's terms the child is protected

by not being afraid of the exposure to the danger of nothingness, by not rejecting it as the other to protection. Thus in the unfinished elegy the child is described as "schutzlos," without protection, like animals in winter. Variations on *schutzlos* are repeated five times in the unfinished poem, and gradually joined with ambiguous images of protection and danger. The hands of protection endanger the one who is protecting; the mother is both protection and "pure endangerment of world" ("reine Gefährdung der Welt"), presumably by providing a retreat into the prefigurative mode of human consciousness where the world need not stand before one (186–87).

While Heidegger's own emphasis in "Wozu Dichter?" on *Schutz* and *Gefahr* is initially drawn from Hölderlin, Rilke's notion of childhood here as protective realm from danger and exposure is striking and innovative. It also differs from Hölderlin's model of the child in its wholeness and unity with nature. In *Hyperion*, Hölderin evokes the child as a figure of unity in not being subject to self-reflection and to a rationality grounded in the distinction between the "I" and "Not-I." The child, absorbed in life, is contrasted to a fallen race of modern humanity alienated from nature. The child maintains the possibility of goodness and affirmation of life's unity by existing unopposed to its wholeness. In Rilke this romantic image is made more difficult by the coupling of unprotectedness and endangerment, which includes acceptance of death. Whereas adults tend to fend off thoughts of death, by refusing to think through their finitude or positing an afterlife and so a future presence, the child is filled with a sense of finitude through its own constant change and becoming. In the fourth elegy, the figure of the child suggests not only a fresh and intense point of reception of the world, but a special relation to death by refusing to relegate it to life's absolute opposite: "To receive death even before the beginning of life so tenderly received and without anger, is indescribable" [Den ganzen Tod, noch vor dem Leben so / sanft erhalten und nicht bös zu sein, / ist unbeschreiblich] (KA II, 213).

This is what allowed Frost's child, the "swinger of birches," to lurch unafraid into the unprotected air: "He always kept his poise / To the top branches, climbing carefully / With the same pains you use to fill a cup / Up to the brim, and even above the brim. / Then he flung outward, feet first, with a swish, / Kicking his way down through the air to the ground. / So was I once myself a swinger of birches. / And so I dream of going back to be" (Frost 1979, 122). The fifty-nine lines of Frost's poem are unbroken by stanzas, reinforcing the adult narrator's identification with the boy who swings wildly out on the bent trunks of birches, lurches out into nothing unafraid of death and of heaven, and is set back down again softly on the earth. This fearless relationship with death also characterizes the girl playing in Wordsworth's

poem "We Are Seven," for she plays among the graves of her dead siblings without illusion that they will come back to life, but also without relegating them to a region absolutely beyond the world we know. In all of these poems the acceptance of death is a gentle acceptance to the openness of being not fixed as presence; in none of them does this acceptance of death require resoluteness, individualizing authenticity, or struggle.

The child figures in Rilke, Frost, and Wordsworth suggest that the child has no need for a Heideggerian resolute acceptance of finitude to escape the domination of a consciousness fixed on presence, to escape the penury of an abstracted modern world where, as Frost's speaker suggests, "life is too much like a pathless wood" (122). Even in the context of everydayness—and even in moments of boredom and repetition—the child's constituted world is constantly open to transformation and revision. This does not mean either that the child should be celebrated as a model for groundlessness or chaos, for the absolute irregularity of experience, for pure intensity or constant epiphany. The child is both best situated within the reliabilities of an orderly everyday life, and subject to constant change. This change has to do not only with the relative transformability of the world, but the child's own state of constant developing from one phase of being to another and in being always between any fixed points of development or maturity, unpredictably subject to regression, growth, or precociousness.

Childhood would remind us of an ontology of human becoming, for which the world is not a strictly measurable reality, everyday life is not fallen or "desiccated," and nature is not primal ground or *Urgrund* as the conceptual basis of the known world, but an ever-fluid state of becoming within a world the parameters of which nevertheless provide a stable ordering of things for human life. This becoming is rendered in modern poetry of childhood by metaphors of flight, lurching, falling, throwing, as in Frost's "Birches" and Rilke's poem "Der Ball" in *Neue Gedichte.* There is no lack of recognition of natural forces and physical realities (such as gravity). Yet these are themselves subjects for play. As Rilke writes in the *Duineser Elegien,* the child lives both in a stable mode of being and in an interstice between world and the toy—"im Zwischenraume zwischen Welt and Spielzeug"—the meaning of which is ever-negotiated. What has valid being for the child is not restricted to the visible at the expense of the invisible, nor to an invisible network of abstractions guarding the meaning of the world. The child is like the constellation, for which not only the identifiable points of light, but the measure of distance between the stars is necessary to the figural image rendered meaningful by the human imagination (KA II, 213).

Child consciousness is an essential motif in Rilke's *Duino Elegies,* a series

of poems, as affirmed in Heidegger's essay, that describe a time of need in the disenchanted modern age. The anguished speaker addresses those who are familiar with the world's more splendorous aspects (angels, heroes, animals, children). Animals are called upon for having noticed that humans are not really at home "in the interpreted world" (in der gedeuteten Welt), ordered by their representations. But it is those who have died young, whose graves Rilke had seen in Naples and Rome, who are still nearer to us, who call in "the voice of the wind / and the ceaseless message that forms itself out of silence" [in der Stimme des Windes / die ununterbrochene Nachricht, die aus Stille sich bildet] (Rilke 1984, 151; KA II, 202). Since Rilke saw death not as the opposite of life but its other side, the speaker imagines the dead youth returned to a region of being without the projections of representational consciousness. There it is "strange to see meanings that clung together once, floating away in every direction." This falling away of static meanings also occurs in Malte's childhood memories. The speaker, as it were, imagines the youths suspended in their youthful existence, experiencing beings no longer seen "in terms of a human future." In comparison living adults are exposed in their "error that they differentiate too strongly" between the visible and the invisible (155; 203).

What differentiates Rilke's poetry of childhood from that of Frost and from Proust's writings is his concern with not only living children but also with those who have died young. Rilke, like Wordsworth, poetizes their special experience of death—since they were never turned away from it—as well as the notion that in them childhood is suspended, denied its telos of adulthood and so, for the poetic understanding, set free. Rilke's memorialization of children or youths who died young does not have to be interpreted as a morbid acceptance of death or nihilistic joining of what should be opposed notions—youth or life and death. The intensity of Rilke's study of and affirmation of child experience, his praise of Ellen Key's book, which advocates recognition of childhood, and the persistence of this theme throughout his poetry from the *Stunden-Buch* to *Malte* to the *Puppen* essay, even to the late elegies, suggest otherwise. Rilke cherishes childhood as origin and telos of its own, not merely as a phase within the natural evolutionary progression to the adult consciousness. Perhaps the figure of a dead youth serves to highlight the urgency of Rilke's demand, indicating the need to overcome the subordination of child consciousness to the telos of adulthood. In any case Rilke's renderings of child consciousness might have pressed Heidegger to imagine other—and according to Bachelard "ageless"—forms of "poetic dwelling" that would not easily submit to the philosophy of the *Seinsgeschichte* to which

Hölderlin's poetry of the vanished gods is wedded in Heidegger's powerful interpretations.

A further instance of childhood cut short, and so non-idealized, is found in Rilke's seventh elegy, notable for its decidedly unromantic depiction. Here it is a rather sympathetic, though brutally frank, image of street girls "seemingly deprived, gone under" (scheinbar entbehrtet, versankt), like the king's daughters in the *Stunden-Buch* poem, given over to violence and so lost to the world. Here, in the filthiest corners of the city, the girls are robbed of their childhood, festering there "as someone open to the garbage" (dem Abfall Offene), like the young (but no longer child) prostitute almost saved by Dostoevsky's underground antihero. But even they, the speaker projects, must have known an hour of childhood bliss: "For each had an hour, perhaps not even an hour, a barely measurable time between two moments—when she had a real existence." [Denn eine Stunde war jeder, vielleicht nicht ganz eine Stunde, ein mit den Maßen der Zeit kaum Meßliches zwischen zwei Weilen—da sie ein Dasein hatte.] Such a moment, albeit painfully brief, was "everything—the veins brimming with existence" [Alles. Die Adern voll Dasein] (Rilke 1984, 189; KA II, 221). This fullness of existence in this elegy suggests both the resilience of childhood, which persists despite the corruption of innocence, and its fragility, since only this brief hour yields a sense of the fullness of becoming.

In the second elegy there is no mention of childhood proper, and yet a resonance between two images prepares the ground for the ecstatic child consciousness presented in the third elegy. The angels who are addressed in the elegies are blurred with the human, our essence a slight part of them, just as the infinite space we dissolve into must taste of us. This blurring is compared with a first image, the vague look on the faces of pregnant woman—an image that recurs in Rilke's poems and in *Malte*. His fascination with fruitfulness here resonates with an image of the "fruit-bearing soil" or "Fruchtland" longed for in the final stanza. The speaker longs for "a pure, contained, small human space, our own strip of fruit-bearing soil, between river and rock" [ein reines, verhaltenes, schmales / Menschliches, einen unsern Streifen Fruchtlands / zwischen Strom und Gestein] (Rilke 1984, 161; KA II, 207). This human space of fertile soil is discovered in the space of childhood imagination examined in the third elegy. There the lover is instructed to consider the hidden depths of the child and his mother in her beloved; not the child's adult lover but his mother has reached the ancient depths, the "inner wilderness" (seines Inneren Wildnis) of his origins and has brought calm there. This more human space in *Malte* is the space of the child's room at night, with its suspicious noises arousing fear; this space is made more human by the mother

who tames it. In this humanized space, childhood is suspended in repose, the darkness no longer trembling, as the restless future was for a while stayed, adapted to the folds of the curtain. The mother-figure here, like Maman in Proust, is not the endangering protector, but simply a guardian of the child space defending it against both the wild nothingness of its origins and its obliteration in the potential fallenness of adulthood. Not even fairy tales, Malte tells us, were needed when his mother came to read to the child sick in bed. "We had a different sense of the marvelous" [Wir hatten einen anderen Begriff vom Wunderbaren] (Rilke 1949, 88; KA III, 523). What Rilke imagines as child consciousness in the writings discussed here evades any metaphysical determination that is the subject of Heidegger's critique in "Wozu Dichter?" Just as Heidegger drew the poetic dwelling from Hölderlin, Rilke evoked the child's mode of being, despite its ambiguities, as the potentially revivifying and healing origin of adult consciousness. But unlike Hölderlin as voice of the destitute time, this child consciousness resides deep within the reserves of human possibility. It remains as an access to reverie and its flights, venturing experience, to the unblocked adventure, the conceptually ungraspable and the groundless, and the quiet, ateleological beauty of perceptual experience to which children's play and reverie are so amenable. The child's fearless lurching forth in Frost's poem "Birches" is not a heroic poetic resolute stance in face of death, a venturing into the abyss, but the risk and protection of trusting being despite its fragile manifestation as human existence.

Mediated Immediacy: The Child Consciousness in Proust as a Source of Ecstasis

Proust's novel *A la recherche du temps perdu* is phenomenological in part by virtue of its self-awareness: it is "a novel about the writing of a novel," just as it is a recollection about recollection and a memoir about being a self (Dufrenne 1973, 117). It is initiated by a recollection of childhood experience that renders thematic the relation between creative literature, or the narrator's potential writing of a novel of which the reader will soon learn, and the constitution of the world in child experience. Here childhood is defined by a differentiated enactment of the world's coming into being. This childhood perception is, by virtue of being recollected, saturated by explicit aesthetic awareness. While a lengthy study would be needed to point out the phenomenological nature of Proust's descriptions (and there is much in the scholarship on this point), the opening scenes of *Du côté de chez Swann* (Swann's Way)

alone can serve as a discrete literary field of the ecstatic quotidian, in particular as Proust here presents the initial recollections of child-consciousness.

In *What is Literature?* Sartre claims that in Proust we find real experience presented "in a thousand directions" (Sartre 1966, 118). In the overture to the first volume, in which the position from which the story will be narrated in recollection of childhood memories is set up, Proust's language effects a condensation that gives these directions a phenomenological orientation. One facet of this condensation is the play between aesthetic mediation of perception through literary description and the (paradoxically) recaptured immediacy through the lens of childhood memory. These two opposing ideas— mediation and immediacy—are held together in the tension of ecstatic experience which Bachelard might associate with flights of reverie. Proust gives us some clues how to understand this play of mediation and immediacy. His narrator self-reflexively describes how ideation takes place (how, for example, an aesthetically charged idea of a beloved can overtake direct perception—he remembers her with blue eyes though her eyes are dark) and how memory emerges with a feeling of (recaptured) immediacy. This is mediated through the sensuousness of childhood experience. It departs effortlessly and without significant discord from the everydayness of adult surroundings which serve its context. These processes belong to the emergence from a naive perception of the world, producing a heightened literary perception of the density of appearances. The child consciousness thematic in Rilke, Frost, and Hölderlin is joined to an explicit reflection on artistic creation, as it is in the studies of Freud, Benjamin, Bachelard, and Merleau-Ponty. This connection is not made, however, by showing the parallels between child consciousness and adult fantasy in the Freudian manner, but rather in evoking the physical, perceptual, and psychic density of the child's perception of the world, such as suggested by the other accounts.

The phenomenological resonances of the child's experience in the early part of Proust's novel will afford a return to the phenomenological suggestions about childhood by Merleau-Ponty. Proust's novel begins with the narrator describing his childhood habit of going to bed early. He describes his state of consciousness and the relation between the mode of his perceptions and the objects perceived. Consciousness seems to hover in a region between waking and sleeping, shifting between a perception of familiarity and that of unfamiliarity. He meticulously recounts the ambiguities of the mind drifting off to sleep and the provocations felt by the position of his drowsy yet still sentient body. The play between mediation and immediacy is already engaged when the narrator, falling asleep reading, becomes submerged in the reading consciousness and the feeling of the more immediate dream takes hold of him.

In his dream the narrator becomes the subject of his book. The feeling of being suspended between dream and reality subsides as the narrator gazes into the darkness. But it is the atmosphere of quotidian lived space remembered, rather than the fantastic dream of the rivalry between François I and Charles V, that nudges the narrator into an ecstatic reflection on childhood experience. In a flash of memory, he recalls rooms in which he has slept in childhood and his childish habit of nesting in bed. The recollection of bed-time nesting, however, betrays a magnification by the remembering consciousness, an imaginative entrance into the child space through what Bachelard called "rêverie," a term that also appears in Proust:

> Ces évocations tournoyantes et confuses ne duraient jamais que quelques secondes; souvent ma brève incertitude du lieu où je me trouvais ne distinguait pas mieux les unes des autres les diverses suppositions dont elle était faite, que nous n'isolons, en voyant un cheval courir, les positions successives que nous montre le kinétoscope. Mais j'avais revu tantôt l'une, tantôt l'autre des chambres que j'avais habitées dans ma vie, et je finissais par me les rappeler toutes dans les longues rêveries qui suivaient mon réveil: chambres d'hiver où quand on est couché, on se blottit la tête dans un nid qu'on se tresse avec les choses les plus disparates, un coin de l'oreiller, le haut des couvertures, un bout de châle, le bod du lit et un numéro des *Débats roses,* qu'on finit par cimenter ensemble selon la technique des oiseaux en s'y appuyant indéfiniment; où, par un temps glacial, le plaisir qu'on goûte est de se sentir séparé du dehors [. . .]. (Proust 1954, 18)

In the Moncrieff/Kilmartin translation:

> These confusing and shifting gusts of memory never lasted for more than a few seconds; it often happened that, in my brief spell of uncertainty as to where I was, I did not distinguish the various suppositions of which it was composed any more than, when we watch a horse running, we isolate the successive positions of its body as they appear upon a bioscope. But I had seen first one and then another of the rooms in which I had slept during my life, and in the end I would revisit them all in the long course of my waking dream: rooms in winter, where on going to bed I would at once bury my head in a nest, built up out of the most diverse materials, the corner of my pillow, the top of my blankets, a piece of a shawl, the edge of my bed, and a copy of an evening paper, all of which things I would

contrive, with the infinite patience of birds building their nests, to cement into one whole; rooms where, in a keen frost, I would feel the satisfaction of being shut in from the outer world. (Proust 1989, 6)

Not in the immediate memory, but in the reverie it elicits, is the narrator able to locate the depths of childhood memory called up by a sense of disorientation. The "brief spell of incertitude" as to where he is, a brief dislocation of self in the provocation of memory, opens up an anonymous childhood that subtends conscious experience as such. Thus the pillows' cheeks upon which his head rests are compared to the cheeks "de notre enfance" (Proust 1954, 14). The first person plural possessive *notre*, indicating our childhood, suggests that the narrator finds access to not only his own childhood but to a universal stratum of childhood that remains within human consciousness.

The narrator discusses the phenomenon of waking from sleep and losing his coordination in a familiar time and space (14). Our usual habits of bedtime and awakening in tact, one can, he claims, instinctively and instantly regain a sense of position within the ordered procession of hours and years; but this ordered procession will become confused if habits are broken, if one has fallen asleep in a different position after a sleepless night or in an armchair after dinner. A magical dislocation ensues, which affects his very sense of being-in-the-world: "I could not even be sure at first who I was." And in this slippage of self-certainty beneath the ordinary life, the narrator touches on what he regards as the animal origins of consciousness: "I had only the most rudimentary sense of existence, such as may lurk and flicker in the depths of an animal's consciousness" [j'avais seulement dans sa simplicité première le sentiment de l'existence comme il peut frémir au fond d'un animal] (Proust 1989, 5; 1954, 16).

The narrator would remain in this destitute state were it not for memory (here *le souvenir*)—and soon we will find that it is memories of rooms slept in during childhood, of awaiting his mother's goodnight kiss—that would "draw me up out of the abyss of nothingness [*du néant*], from which I could never have escaped myself: in a flash I would . . . gradually piece together the original components of my ego [*de mon moi*]." This memory is as yet a prelude to *mémoire involuntaire* prompted by such rarified sensations as that of the madeleine and the wobbly paving stones; it is not yet deliberate, since "it always happened that when I awoke like this, and my mind struggled in an unsuccessful attempt to discover where I was, everything revolved around me through the darkness [*dans l'obscurité*]: things, places, years." The body itself would recollect these rooms "even before my brain, lingering in cogitation

over when things had happened and what they had looked like, had reassembled the circumstances sufficiently to identify" them (Proust 1989, 6; 1954, 16). The real texture of childhood will be evoked by this bodily sensation, at first by the position of the body in bed (a passage that draws Merleau-Ponty's attention (Merleau-Ponty 1989, 181n), and more precisely by the sensation of some chance object in which the essence of a childhood reality must have been held captive. This experience is said to be accessed in a pre-intellective manner. In recapturing childhood "all the efforts of our intellect must prove futile" [tous les efforts de notre intelligence sont inutiles] since "the past is hidden somewhere outside this realm, beyond the reach of the intellect" (Proust 1989, 47–48; 1954, 65).

In the context of this childhood recollection, between the dim animal depths of original, pre-intellective consciousness and the self which identifies familiar things in their habitual station, we find in Proust the first evidence of something like a discovery of intentionality. Here first arises in the novel the insight that things are not as they seem to be in the so-called natural attitude, but are in fact correlate to the consciousness which perceives them. It might turn out that the naive attitude of childhood as reflected upon is more like phenomenological reflection than it resembles the natural attitude (cf. Levin 1991, 55). In the slippage between adult consciousness, with its fixed identification of things in time and space, and the more obscure reality of remembered childhood experience, the narrator supposes: "Perhaps the immobility of things that surround us is forced upon them by our conviction that they are themselves not anything else, by the immobility of our conception of them" [Peut-être l'immobilité des choses autour de nous leur est-elle imposée par notre certitude que ce sont elles et non pas d'autres, par l'immobilité de notre pensée en face d'elles] (Proust 1989, 6; 1954, 16). When this immobile conception gives way through the physiological confusions of sleep, awakening, and the play of imagination and memory, the narrator finds new access to the vital density of world as experienced in childhood. This reality is recaptured through condensation of disparate elements and images, like a nest of materials the child-narrator had, cozy in bed, contrived to cement together— "qu'on finit par cimenter ensemble selon la technique des oiseaux en s'y appuyant indéfiniment" (7; 18). It is reality vivified, rarified, crystallized through what the narrator admits is a recollecting and finding creation. Through literary realization, the narrator will grant it the reality that, he admits, cannot be logically proven, but the experiential evidence of which renders other experiences of consciousness pale and shaky in comparison.

In Proust, literary art is, among other endeavors, a paradoxical striving for the immediacy of childhood, paradoxical because it is achieved through

collaboration between memory and literary form, and therefore achieved through great effort. This effort, however, is a prolongation of reverie provoked by bodily memory, drawing up the residual child-consciousness that according to Bachelard remains within the human soul as a permanent source of reverie. For Bachelard, childhood is accessed in the unity of imagination and memory that is provoked in the reverie of poetic images. Proust's play with the recollection of images is instructive. Childhood recovery is said to be effected through a play between attention to the ever-changing surface of appearances, their centrifugal multiplicity—perhaps concretized best in the magic lantern, as it casts pictures of Golo on his horse transforming the objects in his room into material accomplices—and the centripetal reconstruction of a coherent self (see Macksey 1962, 109). The magic lantern passage illustrates these two directions of consciousness: in a literal dispersal of moving images from a mythical past, the lantern destroys the familiarity of the narrator's bedroom. These directions can be identified with the use of terms from Merleau-Ponty's review of studies of perceptual ambiguity, the acceptance of transition of images from one to another, and correlative emotional-psychic states (Merleau-Ponty 1964c, 105). The magic lantern, Proust's narrator recounts:

> . . . substituted for the opaqueness of my walls in impalpable iridescence, supernatural phenomena of many colours, in which legends were depicted as on a shifting and transitory window. . . . this mere change of lighting was enough to destroy the familiar impression I had of my room . . . now I no longer recognised it, and felt uneasy in it, as in a room . . . where I had just arrived . . . for the first time.

> [. . .] substituait à l'opacité des murs d'impalpables irisations, de surnaturelles apparitions multicolores, où des légends étaient dépeints comme dans un vitrail vacillant et momentané. [. . .] rien que le changement d'éclairage détruisant l'habitude que j'avais de ma chambre. [. . .] Maintenant je ne la reconnaissais plus et j'y étais inquiet, comme dans une chamber . . . où je fusse arrivé pour la première fois.] (Proust 1989, 9; 1954, 20–21)

While the bedroom at Combray is "le point fixe et douloureux de mes préoccupations," the fixed center of melancholic thoughts about having to go to bed far from the mother and grandmother whose company he craves, the magic lantern provides a distraction for the child's fixation. The lantern casts a strange light that multiplies and disperses images of gothic figures in a diver-

sity of colors, thus defamiliarizing the childhood space and altering the ordinary look of things. In light of this atmospheric transformation, the boy's senses are ripened for the recognition of figures as the moving images are cast onto previously familiar and ordinary objects which take on Golo's figuration, just as the child is fascinated with visual forms by means of what Merleau-Ponty called "pensée physionomique." But beyond the sheer forms presented is the extension of personality to Golo as the narrator watches the images while his aunt reads to him aloud. Her voice loses significance as the images of Golo are personified:

> Golo stopped for a moment and listened sadly to the accompanying patter read aloud by my great-aunt, which he seemed perfectly to understand, for he modified his attitude with a docility not devoid of a degree of majesty, so as to conform to the indications given in the text; then he rode away at the same jerky trot. And nothing could arrest his slow progress.

> [Golo s'arrêtait un instant pour écouter avec tristesse le boniment lu à haute voix par ma grand'tante, et qu'il avait l'air de comprendre parfaitement, conformant son attitude, avec une docilité qui n'excluait pas une certaine majesté, aux indications du texte; puis il s'élongait du même pas saccadé. Et rien ne pouvait arrêter sa lente chevauchée.] (10; 21)

The personality of Golo is the extension or dispersal of self in projection onto the image, which in turn transforms the material objects on which it is cast. This further decentralizes the narrator's focus:

> If the lantern were moved I could still distinguish Golo's horse advancing across the window-curtains, swelling out with their curves and diving into their folds. The body of Golo himself, being of the same supernatural substance as his steed's, overcame every material obstacle—everything that seemed to bar his way—but taking it as an ossature and embodying it in himself: even the doorhandle, for instance, over which, adapting himself at once, would float irresistibly his red cloak or his pale face, which never lost its nobility or its melancholy, never betrayed the least concern at this transvertebration.

> [Si on bougeait la lanterne, je distinguais le cheval de Golo qui continuait à s'avancer sur les rideaux de la fenêtre, se bombant de leurs

plis, descendant dans leurs fentes. Le corps de Golo lui-même, d'une
essence aussi surnaturelle que celui de sa monture, s'arrangeait de
tout obstacle matériel, de tout object gênant qu'il rencontrait en le
prenant comme ossature et en se le rendant intérieur, fût-ce le bouton
de la porte sur lequel s'adaptait aussitôt et surnageait invinciblement
sa robe rouge ou sa figure pâle toujours aussi noble et aussi mélancoli-
que, mais qui ne laissait paraître aucun trouble de cette transverté-
bration.] (10; 21–22)

Just as Golo appropriates a surrounding object—"en se le rendent intér-
ieur"—the narrator adapts to Golo's image in a kind of spiritual if not pos-
tural "impregnation." Not only Golo, but the narrator's sense of self, is
subject to a "transvertebration."

Two stages of early childhood experience, such as Merleau-Ponty has stud-
ied, resonate with the narrator's descriptions of Golo, insofar as his experience
suggests a regression to early forms of experience, a condensation within the
recollected childhood perception of several stages of its development in lived
childhood. The possibility of projection of his own feelings onto the moving
image traveling the room recalls the child's perception of *l'image spéculaire* as
well as the sympathy of *la sociabilité syncrétique* (Merleau-Ponty 1960, 32, 47).
Merleau-Ponty argues for a different sense of spatiality in child experience,
the possibility of ubiquity in the perception of his own image in the mirror,
namely the attribution of real being to both the physically located self and the
image. "There is a mode of spatiality," he argues, "in the specular image that
is altogether distinct from adult spatiality." This is like a space that seems to
adhere to the image in the mirror (comme un espace adhérent à l'image).
Gradually the child begins to treat the "quasi-locatedness" of the image as
mere image which "counts for nothing against the unique space of real
things" (Merleau-Ponty 1964c, 129–30). But while adult intelligence distrib-
utes spatial values, the very young child does not. The child neither denies
real existence to the mere image, nor regards the image as less ontologically
stable than his own bodily image. While the child's own bodily image has its
own complexities, one could also speculate about the attribution of real space
to other bodily images. For, as Merleau-Ponty explains: "The child in no way
distinguishes at first between what is furnished by introspection and what
comes from external perception. There is no distinction between the data of
what the learned adult calls introceptivity and the data of sight. . . . What is
true of his own body, for the child, is also true of the other's body" (134).
This is reflected in social syncretism, in which there is "the absence of a
distinction between the self and the other" (146). While the narrator is clearly

well beyond this stage of early childhood (he is able to feel quite unengaged by his great-aunt's reading aloud), he sympathizes with the image of Golo, while also projecting his own feelings onto that external, and transient, image.

While the child is charmed by these changing, ambiguous images, it disturbs the familiarity of his surroundings. This disturbance is an experience of uncanniness, a sense of no longer being at home in his room. The narrator feels discomfort (malaise) "at this intrusion of mystery and beauty into a room which I had succeeded in filling with my own personality until I thought no more of it than of myself" [cette intrusion du mystère et de la beauté dans une chambre que j'avais fini par remplir de mon moi au point de ne pas faire plus attention à elle qu'à lui-même] (Proust 1989, 10–11; 1954, 22). The extension of his sense of self to Golo's image as it appropriates things, as well as the play of color and light, leads to a compromise of his sense of orientation. The surrounding space, profoundly linked to the narrator's own self-familiarity by the notion that it was the fixed center of his thoughts, is no longer familiar. The destruction of habit, which is for the adult far more resilient, occurs rather easily for the child-narrator:

> The anaesthetic effect of habit being destroyed, I would begin to think—and feel—such melancholy things. The door-handle of my room, which was different to me from all the other door-handles in the world, insasmuch as it seemed to open of its own accord and without my having to turn it, so unconscious had its manipulation become—lo and behold, it was now an astral body for Golo.
>
> [L'influence anesthésiante de l'habitude ayant cessé, je me mettais à penser, à sentire, choses si tristes. Ce bouton de la porte de ma chambre, qui différait pour moi de tous les autres boutons de porte du monde en ceci qu'il semblait ouvrir tout seul, sans que j'eusse besoin de le tourner, tant le maniement m'en était devenu inconscient, le voilà qui servait maintenant de corps astral à Golo.] (11; 22)

These descriptions of change, and their attendant charms and discomforts, echo earlier stages of child consciousness where objects are not yet fixed in their substantive identities and time and space are not yet conceived as a continuity containing absolutely distinct perspectives. The narrator's experience is certainly vastly more refined in reflection than one would expect from a child—for he is not a child but the narrator as child—but the sensitivity to the disturbances of perception he is able to draw from memory suggests an aesthetic description indebted to early perceptual experiences, to the sensa-

tions of a first and perceptually primitive life. The dispersion of images in transvertebration will demand then recollection of the familiar atmosphere by the child-self.

Merleau-Ponty's account of drawings of young children explains a similar phenomenon. The child learns only gradually to depict things as seen from a single viewpoint—an acquisition that is dismissed as an obstacle to the rendering of vivid perception in modern painting from Cézanne to Cubism. As the child learns this, there is a play between "a duplication of the immediately given sensory spectacle in which the child was at first engulfed" and of a "subject who is henceforth capable of re-ordering and re-distributing his experience" (Merleau-Ponty 1964c, 152). In Proust's narrator's awakening from sleep, the lostness among displaced objects of the bedroom leads to a loss of certainty about the self, and soon to a description of its dispersal among objects and images. Yet psychological development demands that the flux of experience must be countered by a movement toward the self, as if grounding the flow in the constituting ego from which it will be recollected. Here memory is less an access than a reconstitution of child-experience. Macksey argues that "existence for Proust is thus defined in terms of an antinomy: a going out toward primitive experience, hopelessly fragmented into sensational instants, and a return toward the interior of oneself to relate these experiences, these instances, to the past: expansion and concentration" (Macksey 1962, 106–7). Both the expansion and the concentration, the dispersal and the regathering, characterize the tensions of child experience.

In Merleau-Ponty's account the syncretic stage is characterized by the absence of stable distinctions between self and world and its panoply of inchoate forms; the ego is gradually formed to center the child's experience at a point from which these forms appear ordered and stable. The narrator's missing of his mother and the familiarity of things regained by her presence re-enacts what is also for the child-narrator an earlier accomplishment of psychic development, the emergence from syncretism (Merleau-Ponty 1964c, 120). At the syncretic stage, "any form—for example, those we perceive in space in colored forms—is actually subject to a play of forces in different directions," and thus there is a "spatial syncretism" (149). The precariousness of this play of forces, their danger, is suggested in the ambiguous figure of the mother in Rilke's unfinished elegy; she is both a force of protection and of drawing the child back toward the preworldly, preinterpreted experience of the womb. In Proust, the child's experience with his mother brings about a recovery from sliding back into his own psychic past. It is in emerging from syncretism that self and other are reestablished as such in a social world.

It must not be assumed then that there is a single core of childhood experi-

ence which Proust's narrator is able to recover. The narrator enacts a revivifi-
cation of child-consciousness as interwoven with post-childhood capacities for
reflection, linguistic expression, and aesthetic form. But his memories are also
densely compacted retrievals of residual forms of experience, such as signifi-
cantly precede the stage of maturity of the child-as-remembered. This revivi-
fication engages a complexly layered and vital texture of child-experience, with
its interweaving stages of progression and regression. The reader does not
return with the narrator to a single static childhood state of being, but relives
the process of self-formation and dispersal, development and regression,
within a single recollected episode. This reanimation too might draw on ca-
pacities for organizing the world immanent to childhood play, as suggested in
Bachelard's discussion of reverie and Benjamin and Rilke's observations on
play.

That Proust can relive the immediacy of child experience, in particular the
constitution of the perceptual world in its vulnerability to dispersal through
literary writing is compatible with Bachelard's phenomenology of poetic im-
ages, even if the latter, so focused on the image itself, does not seem to be
able to account for the complexities of narration which make Proust's revisit
of child perception possible. What makes this mediated immediacy possible
is the jointure of memory and imagination, or the elaboration of memory
through reverie sustained in refined literary reflection. But it also brings up
questions about the indirectness of a phenomenology of child experience,
since its reflections cannot be performed by children themselves and the ob-
server, such as Merleau-Ponty, remains at an interpretive distance. But this
problem persists to some extent in the phenomenological interpretation of
painting and, to a lesser extent, literature itself. In each case the experience is
interpretable insofar as it expresses or draws upon some elements of experience
that are native to human consciousness as such.

The most ecstatic and best-known scenes of Proust's novel involve the
"involuntary memory" of childhood which were first provoked by the taste
of a madeleine dipped into a cup of tea. The recollection is in fact a magical
introduction to the whole world of Combray through a childhood memory,
a transport to that recollected and reimagined world. After having hardly
thought of Combray for many years, save for those bedtime dramas, the narra-
tor, coming in from the cold on a grey winter day, accepts a cup of tea and a
little madeleine cake, the familiar taste of which has an extraordinary effect,
bringing an exquisite pleasure and sense of release, as if "the vicissitudes of
life had become indifferent to me, its disasters innocuous, its brevity illusory"
[Il m'avait aussitôt rendu les vicissitudes de la vie indifférentes, ses désastres
inoffensifs, sa brièveté illusoire] (Proust 1989, 48; 1954, 66). The rapture of the

moment of memory is accompanied by a sense of liberation from fate and difficult consequences; it is followed by the description of the narrator's attempt to reexperience, and track down, the sense of being filled with a precious essence, and the difficulties of doing so.

The ecstatic nature of this experience, which soon yields the memories of a childhood in the provincial town of Combray and introduces the epic events of the novel, gives the narrator pause, for a moment distressing in transporting him from an ordinary sense of existence. "What an abyss of uncertainty whenever the mind feels that some part of it has strayed beyond its own borders, when it, the seeker, is at once the dark country through which it must go seeking" [Grave incertitude, toutes les fois que l'esprit se sent dépassé par lui-même; quand lui, le chercheur, est tout ensemble le pays obscur où il doit chercher] (49; 66). Such seeking, the narrator understands immediately, is at once a creation. If one regards this dark region as not only the past in general but, in the first instance, childhood, one can better sense the depths of the narrator's landscape metaphors, so prominent in Bachelard's study of childhood images, and the notion that the transport to this elsewhere buried in the soul requires overcoming resistance: "I can measure the resistance, I can hear the echo of great spaces traversed" [J'éprouve la résistance et j'entends la rumeur des distances traversées] (49; 67).

This creation, as a jointure of imagination and memory, calls upon childhood experience and its ecstatic latencies. In childhood recollected, the narrator will find the conditions of a world coming into being, a world that exists nowhere for Proust's narrator but in the dark region within. This world-in-formation becomes the model for the literary-recollective consciousness his epic novel constructs. It has been argued in this chapter that this dark region is also a source for the revitalization of quotidian life. Freud, Bachelard, Merleau-Ponty, and Benjamin, differences among them notwithstanding, attest to the persistence of childhood within the whole life of human consciousness; and Rilke, Frost, and Proust evoke or imaginatively recollect stages of child experience as a residual, perhaps buried but persistent source for the revivification of life. That a study of such can serve not only an ontological affirmation of childhood, as suggested in the discussion here of Heidegger's Rilke interpretation, but also a revitalization of everyday life, must be emphasized. For this revitalization explains the urgency with which certain modern literary writers, in an age they perceive as fallen into disenchantment, confusion, or spiritual penury, have illuminated this living undercurrent of the imagination.

The "reverie toward childhood" Bachelard prescribes is a source of ecstasis that need not indicate an escape from everydayness, a flight from our adult

selves. Rather, what is promoted in this literature are moments of remembrance of the world's vulnerability to transformation, and the freedom of transforming it, which often fails to be noticed in quotidian life when its habits have become rigid. To retrieve childhood as a source of ecstasis is not to reject the real quotidian life, with its order and predictability, in favor of fantasy and reverie, but to re-envision a state of being in which our belief in the world is first constituted. After a century's promotion by psychoanalysis of childhood as a psychic ruin, as a resource for the interpretation of its injured dramas, this chapter has addressed the exigence of its beauty, its freedom, its inner immensity. For it is within quotidian life, to quote Bachelard, that "our whole childhood remains to be reimagined" [tout notre enfance est à réimaginer] (Bachelard 1960, 85; 1969, 100).

Literary Phenomenology from the
Natural Attitude to Recognition

In the first volume of *Ideen zu einer reinen Phänomenologie und phänomenologischen Philosophie* (*Ideas Pertaining to a Pure Phenomenology and a Phenomenological Philosophy*), Husserl grants fiction—the fictional presentation of forms and their imaginative variation—a special relevance for the philosopher. Originary givenness is, while ordinarily primary for the phenomenologist, limited as a resource, in that the infinitely many eidetic phenomenological formations cannot be pursued alone through what is given in original intuition. Because of the need to reflect upon experience and to vary intuitions for the aim of discovering essences, the phenomenologist is required to operate in the realm of phantasy. Thus even in the phenomenology of perception "presentations, and, more precisely, *free phantasies* acquire *a position of primacy over perceptions*" [Vergegenwärtigung und, genauer gesprochen, *freie Phantasien* eine *Vorzugsstellung gegenüber den Wahrnehmungen* gewinnen]. It is, so Husserl claims, necessary "to exercise one's phantasy abundantly in the required activity of perfect clarification and in the free reshaping of phantasy-data" [die Phantasie reichlich zu üben in der hier erforderten vollkommenen Klärung, in der freien Umgestaltung der Phantasiegegebenheiten], and for this one's phantasy should be made more fertile by observations in originary intuition (Husserl III/1982, 130–32). Yet Husserl, in describing his method, argues that "*feigning*" or "*Fiktion*" is "*the vital element [das Lebenselement] of phenomenology as of every other eidetic science*," and that feigning is "the source from which the cognition of 'eternal truths' draws its sustenance" (132).

While Husserl gives clear and elaborate prescriptions for reigning in phantasy for it to serve scientific phenomenology, literary writers engage this free fantasy in their inventions of forms without such restriction. Even Husserl

looks to art and literature, especially the latter, as a model for *Neugestaltungen* or new formations, for literature manifests in new forms an abundance of features and a continuity of motivation. While this makes literature important for the phenomenologist, modern literature comes close to phenomenology in playing with similar strategies of description, in describing the world not as simply given but as phenomena. In modern literature—works of Rilke, Sartre, and Proust, discussed above, but also in such writers as Françis Ponge and Alain Robbe-Grillet, discussed in the present chapter—can be found serious poetic-literary examinations of the subject's relation to objects, of the structures of perception and thought, or of essences. All of these writers engage a kind of phenomenological reduction; there are hints or rejections of a transcendental basis of consciousness underlying experience; and there are questions of essence. Proust's claim to be getting to a precious essence within things, like similar pronouncements by Rilke and Hofmannsthal, suggests, if only in a very individualized, lyrical mode, a reduction analogous in some respects to phenomenology's eidetic reduction. In more general terms, Husserl's references to *Dichtung* and *Phantasieren* reveal that he is aware that the poetic-literary writer not only competes with but may exceed the phenomenologist in regard to facilities of description and imaginative variation, and so provides a resource for phenomenology. In a letter to Hofmannsthal Husserl acknowledged a special, explicitly phenomenological interest in the "inneren Zuständ lichkeiten" of the writer's art; the world, insofar as it is observed by the writer, becomes pure phenomenon, and so phenomenological and aesthetic seeing are intimately related. (Husserl 1994, 134–5) This makes it an appealing task to see how literature itself profits from procedures analogous to those of phenomenology.

In the present chapter phenomenological literature will be engaged with reference to two specific concerns about phenomenology itself: first, the problem of imagination and description in Husserlian phenomenology in light of poetic-literary description; and second, the relationship of poetic-literary description to the phenomenological, eidetic, and transcendental reductions. It will be argued that literature is useful for phenomenology 'proper' even in cases where the divergence from Husserl's procedures and aims is significant. The resonance between phenomenology and literature is strongest in what Rilke calls *das Erkennen*, the moment of "recognition."

There exists, of course, a historical context for the adoption of fictionalization by philosophical thought. It is worth remembering that imagination and literary description have played an important role even in rationalist philosophy, though an ambiguous one. In Descartes, whose philosophy is of foundational importance for Husserl, the imagination, insofar as it relies upon sense experience, did not yield clear and distinct ideas. While *Meditations* includes

highly imaginative exercises of sensuous description, they can be demarcated from fiction. As Gewirth puts it: "A distinction is possible between those ideas which are 'fictitious,' i.e., arbitrarily compounded by the mind itself, and those which the mind discovers without adding to their 'objective reality'" (Gewirth 1998, 91). The difficulty lies deeper as Descartes saw sense-experience itself as a source of uncertainty and ambiguity; and so imaginative projections can have the look or feel of perceptual reality. The factual and continuous existence of the world, the probability of which not yet established by cognitive reflection, seems to be supported by sense experience, as Husserl, considering the Cartesian "overthrow" of sense experience, remarks:

> The life of everyday action relates to the world. All the sciences relate to it. . . . More than anything else the being of the world is obvious. It is so very obvious that no one would think of asserting it expressly in a proposition. After all, we have our continuous experience in which this world incessantly stands before our eyes, as existing without question.

> [Auf die Welt bezieht sich das alltäglich handelnde Leben, auf sie auch beziehen sich alle Wissenschaften. . . . Allem voran ist das Sein der Welt selbstverständlich—so sehr, daß niemand daran denken wird, es ausdrücklich in einem Satz auszusprechen. Haben wir doch die kontinuierliche Erfahrung, in der uns diese Welt immerfort als fraglos seiende vor Augen steht.]

And yet Descartes established that this could prove to be an illusion:

> Not only can a particular experienced thing suffer devaluation as an illusion of the senses; the whole unitarily surveyable nexus, experienced throughout a period of time, can prove to be an illusion, a *coherent dream*.

> [Nicht nur daß Einzelerfahrenes die Entwertung als Sinnenschein erleiden kann, auch der jeweils ganze, einheitlich überschaubare Erfahrungszusammenhang kann sich als Schein erweisen unter dem Titel *zusammenhängender Traum*.] (Husserl 1993, 17; I, 57)

Thus sense experience is to be overthrown as a foundation for philosophical thought.

Yet from a literary point of view Descartes's treatment is remarkable, for it is through imaginative description of that possibility of illusion that he dis-

missed the senses epistemologically. Some of the most literary moments in Descartes's *Meditations* occur when he sets out to describe the experience of objects as known by sense-perception and imagination, a description issued long before similarly fantastical moments of unstable observation became a persistent theme in modern literature and the possibility of a coherent dream gave way to explicit literary reflection. Description of perceptions, usually objects, in free imaginative variation, is made much of by Rilke's *Malte*, with his constant references to visual perception. It is also essential to the events of Sartre's *Nausea*, to the whole substance of Alain Robbe-Grillet's hyper-observant obsession with the surfaces of things *(Dans le labyrinthe*, 1959; *La jalousie*, 1957); and it informs Françis Ponge's way, in the poems of *Le parti pris des choses*, of seductively caressing things with words until the writer can, as it were, imaginatively take up residence within them. Before Descartes made the reduction to the pure concepts of the intellect, he suspended his faith in appearances and allowed himself to imagine that perhaps he was *not* sitting by the fire in his winter cloak, but was wrapped in bed and only dreaming that he was so. Descartes was quick to associate such sensory illusions and dreaming with madness: in madness one could think that one's own head is made of pottery, or a pumpkin, or of glass. Only in poetic-literary language will the (much) more imaginative reverberations of such suggestion be freely explored.

Imaginative Language and Phenomenological Description in Husserl

While Husserl relies on the Cartesian overthrow, the relationship between philosophy and imaginative description shifts with phenomenology. In his essay "Metaphysics and the Novel," Merleau-Ponty, in the spirit of Husserl's concern for the lifeworld, notes that in philosophy "everything changes when a phenomenological . . . philosophy assigns itself the task, not of explaining the world or of uncovering its 'conditions of possibility', but rather of formulating an experience of the world, a contact with the world which precedes all thought about the world" (Merleau-Ponty 1964b, 27–28). Here philosophy and literature are not opposed but proceed side by side. Literature seems more adept than philosophy at formulating this experience, at presenting it directly (cf. Sini 2002, 23; Williams 2002, 43). It seems to be uncontested that Sartre was able to outline certain philosophical positions—about contingency and necessity, for instance—more poignantly in literary writing than in traditional forms of argumentation. Nevertheless, poetic-literary language resonates with phenomenology, too, as a problem, because Husserl thought the phenomeno-

logical philosopher must curtail imaginative language in the description of experience. The metaphors to which poetic language yield are "too imaginatively explosive, as it were, and therefore too difficult to put to controlled theoretical use" (Williams 2002, 43).

All the same, Husserl regarded the imagination itself as essential to the phenomenological discovery of essences. What profits can be yielded from phenomenologically sensitive literature, which indulges the phantasy in its productions and variations, will here be examined through works of modern literary writers, such as Rilke, Robbe-Grillet, Françis Ponge, and with some reference, again, to Sartre's novel. Whereas Sartre saw himself obligated, even in his literary works, to express some philosophically defensible ideas (such as the primacy of contingency over necessity in human existence, that for the human being existence precedes essence), other writers have been free to explore unbridled language in their descriptions of experience; they have also, in distinction from the phenomenologist, been free from a telos of univocity and absolute clarity as regards their discoveries and free to render in full delicacy what Dewey called the "recession into the implicit" germane to aesthetic-poetic experience (Dewey 1958, 194), without having to differentiate levels of clarity and the "gradual levels within the darkness" [graduelle Stufen innerhalb der Dunkelheit] (Rilke KA III, 128).

Literary language taken up in the context of Husserlian phenomenology becomes problematic when the two interrelated issues are considered in their role in the imagination and the procedures of phenomenological description. As suggested above, Husserl required imaginative activity of the phenomenologist. The phenomenologist's ability to divert the gaze from given facts in order to discover the structures inherent in their constitution is an essential imaginative facility, for it involves freely varying intended images as possible objects of intuition. While for Husserl perception itself is straightforward— "there is no fantasy to perception" as one scholar put it (Watson 1987, 50)— the imagination's activity is needed for describing the essences of things as phenomena, particularly for the eidetic reduction. In freely varying a given object of originary intuition, a general essence underlying all variations is to be found. For Husserl "things are apprehended in their essence (eidos) when they are grasped not only in their actuality but in their possibility"—grasped then, in terms of possible intuition (Kearney 1987, 19). There must be a free phantasy in the eidetic variation, for, starting with "the actual experience of a fact [we are to] project it into the impossible, in order to see which of its features withstand such a series of variations" (Ströker 1988, 252–53). To get to the essence of things, in other words, is not simply a matter of objective regard. With the eidetic reduction, the dual aim of subverting the dominion

of a naive acceptance of a world and of grasping the world in its essence will have been accomplished. The move from objective world to the essence of things takes a serpentine path through the possible toward the impossible. The phenomenologist's progress is thus a journey through heretofore unknown regions.

Husserl was aware that the projection in the eidetic variation is more akin to the literary imagination than to the scientific methods of philosophy; it remains problematic for the latter that the literary imagination can exert seemingly unbridled power. This chapter will present passages in which writers describe an object or objects from the point of view of phenomenological reduction, in a suspension of the natural attitude, and thus without presumptions about the ontological status of the object, of what the object, irrespective of changing appearances, might be in itself. There is a negation of prior acceptance of the world as having objective being; the literary space of difference between this negation and the affirmation of the world as phenomena provides occasion for literary flights of fancy, or for courting the void (as described in chapter 1). Descriptions of ordinary quotidian life give rise to a delicate fascination with the most ordinary of things. Rather than approaching the absolute, the sublime, the form of beauty, modern literature embraces the most available and least lofty objects as perceived and seeks through them the essences of things. In modern literary description, the world ceases to be regarded with any, usually implicit, attendant ontological theses and yields, as Husserl terms it in *Cartesian Meditations,* the world according to a "field of the present" (nach einem Gegenwartsfelde) treated as "mere phenomena" [bloße Phänomene] (Husserl 1993, 20, 19; I, 60, 59).

Robbe-Grillet, a writer, like Ponge, in whom Sartre found a valuable philosopher, acknowledges the world-turned-phenomena in what he calls the "new novel" (nouveau roman). In his manifesto for the new novel he defines its purpose: "Since it is chiefly in its presence that the world's reality resides . . . our task . . . is to create a literature which takes that presence into account" (Robbe-Grillet 1965, 23). Robbe-Grillet's aim in his obsessively descriptive novels is to empty phenomena of any natural-attitude prejudices (21). In literature this is accomplished by bracketing any supposition that the object has being independent of its phenomenal description, but that description could never be scientific as in phenomenology proper. There is in such literature imaginative variation analogous to that which initiates the eidetic variation—as if varying the intended objects of perception, measuring them up, examining them, conjuring them in various modes, freeing the potentially infinite associations with other contexts and things to which they might give rise. Any final formation that could be clearly described is resisted by the

seeming endlessness of the description, or by the pull of recession into the implicit that, for literary-poetical consciousness, surrounds a given phenomenon, by its sonorous tonal play beyond the identifiable, or by its vulnerability to the deviations and explosions of metaphor. In this vein Bachelard has argued that "poetic images are inherently *variational,* not as in the case of the concept, *constitutive*" (Bachelard 1994, xix). It has been suggested, for instance by Rilke, that the essences of things can be articulated poetically. For Rilke such acceptance of essences is not a denial of objective reality such as science would describe in favor of a merely personal epiphany, but an occasion for recognition of essences ungrapable in scientific modes through a poetical and indirect approach. Ponge described his attention to objects as a materialist-phenomenological rejection of univocal ideas that surpass and transcend the variability and texture of the material given. In the modern poetry of experience we find what Bachelard calls a "reality which will not necessarily reach its final constitution," but also a "field for countless experiments" potentially profitable for phenomenology if only in vitalizing the facility for variation and new formation (ibid.).

Several scholars have established connections between phenomenology and literature. Maurice Natanson associated phenomenology's "controlled but splendiferous seeing" with literary description. He found for instance "instructive illustration" in a story by Henry James of the nuances of the natural attitude (Natanson 1988, 184–94). And Käte Hamburger's study of the phenomenological structure of Rilke's poetry, to be discussed below, has argued for such terminology "not in the more or less, uncommitted sense, rather in that of precisely Husserlian phenomenology" (Hamburger 1971, 84). Her study of seeing or looking (*Schauen*) and of the structure of intentionality in Husserl and Rilke aligns them in parallel projects of getting "to the things themselves." Yet Husserl himself strictly demarcated the reign of that imaginative fictionalization he claimed was essential to phenomenology. In whatever imaginative variations the phenomenologist might engage, *descriptions* must be stylistically controlled—should not give way to what Iris Murdoch, herself a philosopher and novelist, nonetheless derisively called "fantasy" (Murdoch 1997, 11).

In this vein, Husserl posited several points regarding the phenomenologist's descriptive style. First, the phenomenologist must make a "clean separation" (reinliche Scheidung) between the act of intending and what is intended, a separation between noesis and noema, subject- and object- poles of an intention, which must be upheld at all times. In its analogy with literature this could be called a principle of anti-lyricism, since the lyrical in literary description relies upon the coagulation of 'sense' around the intentional-nar-

rative position (what for Hamburger is the 'statement-subject') rather than
around what is being described. Three points Husserl makes follow this prin-
ciple. Second, along with this, "self-control" (Selbstüberwindung) must be
maintained, especially when describing emotions. Third, phenomenological
description should be engaged in only in restricted spheres (nur in beschränk-
ten Sphären)—presumably those in respect to which the principle of anti-
lyricism can be upheld. Fourth, the phenomenologist must be "strictly con-
fined to this [proper] style," for "there is only *one* road prescribed by phenom-
enology's own essence" [Es gibt nur den einen [Weg], den ihr eigenes Wesen
vorzeichnet] (Husserl III/1982; 200, 201). This road abandons any paths that
might lead to lawless description, following imaginative variation—paths into
wildness, poetical fancy, and bewilderment. Thus the phenomenological ad-
venturer should not be wildly adventurous in order not to lose sight of the
scientific nature of the endeavor and the goal of the activity of phenomenolog-
ical philosophy.

Before turning to the phenomenological literature, it must be noted how
language, as the medium of description, represents a further consideration for
Husserl. On the one hand, sedimented language, with its lack of fresh contact
with phenomena, might prejudice the phenomenologist's genuine apprehen-
sions and descriptions; on the other hand, the free-play of association to which
literary language might give rise presents a danger to science as Husserl con-
ceived it (Husserl 1970, 362). Such science requires that being is, as he writes,
"definitively decidable" [entgültig entscheidend] (Husserl 1993, 19/ I, 59). De-
spite Husserl's appreciation of the imagination, as a scientist, he had to insist
on faithful description of appearances: what appears as revealed imaginatively
(or as a possible adumbration of something given to consciousness) should
not be confused with the originarily seen. Thus Husserl's writings reveal an
ambivalence about the imagination, at least in relation to phenomenological
description. Consider the following passage from the first book of *Ideas*, where
Husserl discusses the descriptive task of phenomenology. Here the imagina-
tion as a "habit of inner freedom" [Habitus innerer Freiheit] (Husserl III, 201)
is necessary for the exploratory nature of phenomenology and its discoveries of
the structures of experience, structures unknown to the natural attitude and
to all previous philosophies carried out in the natural attitude. Yet such explo-
ration must be curtailed by faithfulness when it comes to expressing to what
is experienced:

> But one thing we may and must strive for: that at each step we faith-
> fully describe what we see, from our point of view and after the

most serious study, actually see. Our procedure is that of an explorer journeying though an unknown part of the world and carefully describing what is presented along his unbeaten paths, which will not be the shortest. He can rightfully be filled with the sure confidence that he gives utterance to what, at the time and under the circumstances, *must* be said—something which, because it is the faithful expression of something seen, will always retain its value—even though new explorations will require new descriptions with manifold improvements. With a like conviction . . . we propose to be faithful describers of phenomenological structures and, moreover, to preserve the habit of inner freedom with respect to our descriptions.

[Aber eins dürfen und müssen wir anstreben, daß wir in jedem Schritte getreu beschreiben, was wir won unserem Augenpunkte aus und nach ernstestem Studium wirklich sehen. Unser Verfahren ist das eines Forschungsreisenden in einem unbekannten Weltteile, der sorgsam beschreibt, was sich ihm auf seinen ungebahnten Wegen, die nicht immer die kürzesten sein werden, darbietet. Ihn darf das sichere Bewußtsein erfüllen, zur Ausage zu bringen, was nach Zeit und Umständen ausgesagt werden *mußte* und was, weil es treuer Ausdruck von Gesehenem ist, immerfort seinen Wert behählt—wenn auch neue Forschungen neue Beschreibungen mit vielfachen Besserungen erfordern werden. In gleicher Gesinnung wollen wir . . . getreue Darsteller der phänomenologischen Gestaltungen sein und uns im übrigen den Habitus innerer Freiheit auch gegen unsere eigenen Beschreibungen wahren.] (Husserl III/1982, 201)

Husserl's ambivalence about the imaginative facility so necessary to the phenomenologist stems from his scientific and ethical conviction that freedom of discovery must be kept in check by "faithfulness." All the same, he recognized the importance of literary fiction—in the positive sense of feigning—as a rich resource. What profits are drawn from it, and what is to prevent the philosopher from slipping into literary description? For Husserl, what ultimately guarantees phenomenology's scientific telos is that the results of imaginative variation must yield to "univocal language" in which the essence that phenomenology discovers will be fixed. Thus phenomenology maintains its status as first philosophy by restricting its *medium* of description to univocal language, even if its *method* allows for the initial free exploration of potential ambiguities in what is actually seen.

The Inexhaustible Reality of the World in Literary Description

Several other literary descriptions of objects intended by sense perception and regarded as phenomena can now be considered. Sartre, Rilke, Ponge, and Robbe-Grillet have endowed the things they encountered in everyday life with a richness and fantasticism analogous to the phenomenological reduction. These perceptions are broken out of their quotidian look; their qualities are no longer fixed within a complex of everyday identification—in practical life, an object identified according to its use, for example—a hammer on the shelf arranged among nails, wood, and so on; in scientific modes, as a measurable or otherwise calculable substance—but begin to be regarded in their status as appearances. As if suspending any scientific study of their objective structures, imaginative play is indulged in literary description of their features. One perception is freely provocative of poetic-aesthetic, rather than habitual-quotidian, association with another.

This is exemplified in an early passage from Sartre's novel *Nausea*. Here we find Roquentin's description of perceptual experience in the wake of the phenomenological reduction. After such a "change has taken place" [il s'est produit un changement] in Roquentin's consciousness—"une véritable révolution," he calls it—fantastic images are presented in order to grasp the appearances once the natural attitude has been suspended (Sartre 1964, 12; 1938, 16). Metaphor here contributes to the loosening up of the presumption of these objects' self-subsisting being. Metaphor allows a transfer of identification between one thing or idea and something else which it is not. The greater the leap from one image to another, the more powerful a connection is made between them. Since the difference is not obliterated, but rather takes on a new function, this can serve phenomenological-literary description: by presenting an object as something vastly different from itself, attention is given to the immediate appearance of both things—for instance, in the passage below, a newspaper and a bird, the white and throbbing appearance as one flutters in the wind as if to take off in flight—and, at the same time, to the implied consciousness that produces the analogy between them in recognizing similarities. By transferring inanimate objectivity to animate beings, the what of the phenomena—what they are as appearances, their fluid and living nature respective to a living consciousness—can be illuminated. Thus in the journal-entries that make up *Nausea*, Roquentin describes newspapers he finds in the park:

> In summer or the beginning of autumn, you can find remnants of sun-baked newspapers in gardens, dry and fragile as dead leaves. . . .

In winter, some pages are pounded to pulp; crushed, stained, they return to earth. Others quite new when covered with ice, all white, all throbbing, are like swans about to fly, but the earth has already caught them from below. They twist and tear themselves from the mud, only to be finally flattened out a little farther on.

[En été ou au début de l'automne, on trouve dans les jardins des bouts de journaux que le soleil a cuits, secs et cassants comme des feuilles mortes. . . . D'autres fuillets, l'hiver, sont pilonnés, broyés, maculés, ils retournent à la terre. D'autres tout neufs et même glacés, tout blancs, tout palpitants, sont posés comme des cygnes, mais déjà la terre les englue par en dessous. Ils se tordent, ils s'arrachent à la boue, mais c'est pour aller s'apaltir un peu plus loin, définitivement.] (Sartre 1964, 19; 1938, 22)

That the papers, now swans, are said to twist and pull away from the mud attributes to the objects seen the living quality of the gaze which sees or perceives them. This is then a special anthropomorphization by metaphor, which achieves in the transfer an explicit affirmation of the vital quality of being visible and perceptible. Transfer from consciousness to objects indicates a correlation between things, as seeable, perceivable, and a living, embodied, moving, consciousness that perceives them.

Roquentin soon describes how another piece of paper, stepped over by the riding boots of a cavalry officer, had been degraded by rain, and thus "was covered with blisters and swellings like a burned hand" [était couverte de cloques et de boursouflures, comme une main brûlée] (Sartre 1964, 19; 1938, 23). Again there is the metaphoric projection of animate and now anthropomorphic quality upon an inanimate object. Such passages occur in Roquentin's reportage of how objects have suddenly been wrested from their ordinary look, as discussed in chapter 1; but the phenomenological reflection is not yet complete, for although by means of metaphorical transfer there is already, layered within the description itself, a subtle illumination of consciousness, Roquentin is not yet ready to acknowledge this. The initial movement toward a recognition of consciousness as the region in which the revolution has occurred is only hinted at by the treatment of an inanimate object as an animate bodily thing; again the animation of the inanimate prepares for the recognition of the participation in living consciousness in the structure of appearances. But for the time being Roquentin dismisses any reflection into the inner life (la vie intérieure): "There is nothing much to say: I could not pick up the paper, that's all" [Il n'y a pas grand'chose à dire: je n'ai pas pu ramasser

le papier, c'est tout] (18; 22). This dismissal soon gives way to ecstatic self-reflection when he must consider his own regard as correlating to these appearances, indeed contributing to, then constituting, their structure. Roquentin experiences the thrill of feeling himself to be the arbiter of things, as well as the uncertainty of being subject to their radical contingency, of the lack of the world's stable objective essence.

In Rilke's *Malte,* objects—books, threads, faces, canisters, spools of lace, for example—are intensely observed by the narrator who finds himself learning to see as if for the first time. A reduction prefiguring that of Sartre's narrator has been effected in Rilke's study of looking. But here the metaphorical transfer is applied not only to the object of perception, but describes the gaze itself. In the following passage the narrator recalls sitting with his mother at an old desk and unraveling spools of old lace. What is remarkable about the description is that the lace becomes metaphorically identified with imagined places—gardens, cloisters, prisons, hot-houses, a graveyard. This occurs as the description follows the gaze through imaginative variation upon the object. Quickly the gaze itself is identified with the same places with which the lace is metaphorically identified.

> First came bands of Italian work, tough pieces with drawn threads, in which everything was repeated over and over, as distinctly as in a cottage garden. Then all at once a whole succession of our glances would be barred with Venetian needle-point, as though we had been cloisters or prisons. But the view was freed again, and one saw deep into gardens, more and more artful, until everything was dense and warm against the eyes as in a hot-house: gorgeous plants we did not know opened gigantic leaves, tendrils groped for one another as though they were dizzy. . . . Suddenly, all weary and confused, one stepped out into the long track of the Valenciennes, and it was winter and early morning, with hoar frost . . . the branches hung so strangely downward, there might have been a grave beneath them. (Rilke 1958, 121–22)

> [Da kamen erst Kanten italienischer Arbeit, zähe Stücke mit ausgezogenen Fäden, in denen sich alles immerzu wiederholte, deutlich wie in einem Bauerngarten. Dann war auf einmal eine ganze Reihe unserer Blicke vergittert mit venezianischer Nadelspitze, als ob wir Klöster wären oder Gefängnisse. Aber es wurde wieder frei, und man sah weit in Gärten hinein, die immer künstlicher wurden, bis es dicht und lau an den Augen war wie in einem Treibhaus: prunkvolle Planzen, die

wir nicht kannten, schlugen riesige Blätter auf, Ranken griffen nach-
einander, als ob ihnen schwindelte. . . . Plötzlich, ganz müde und
wirr, trat man hinaus in die lange Bahn der Valenciennes, und es war
Winter und früh am Tag und Reif. . . . Die Zweige hingen so merk-
würdig abwärts, es konnte wohl ein Grab darunter sein.] (KA III,
550–51)

Here the objects seen and the seeing itself are intertwined through the meta-
phors of place. The correlation between the appearance and the gaze that
receives it is made not only intimate by metaphor, but rather they are col-
lapsed into a single identification "as if we were cloisters or prisons." Malte's
association of the lace with other object-places—metaphorical gardens, clois-
ters or prisons, riverbank and, ultimately, a grave-site—extends the gaze from
the associations of one object toward other possible imagined objects of inten-
tion, without resistance from the actual content of the perception which pre-
delineated them. For the literary imagination, there is the further path of
metaphorical association extending from each discrete appearance; here the
gaze itself is the conduit for extension to and creative production of surround-
ing images. But their identification suggests the phenomenal correlation be-
tween poetically regarded images of things and the interiority of
consciousness, a notion which Rilke some years later captured in the term
"the world's inner space" or *Weltinnenraum.*

 Weltinnenraum (the term is presented in a poem of 1914, "Es winkt zu
Fühlung fast aus allen Dingen") is the space of worldly things as intimately
known to the interior consciousness. This transforms worldly things without
their losing objectivity, for to know them, consciousness must project itself
around things; if things must become intimate, consciousness must be exter-
nalized to make this possible. Thus traditional oppositions of subject and
object are annulled as each is poetically rendered as crossing over into the
realm from which the naturalism of ordinary perception would exclude it.
This mutual crossing in the space of world constitutes world as intimate space,
as the intimacy of subject and object. In the 1913 essay "Erlebnis," this is
suggested by the crossing of a tree's vibrations as it shakes in the wind into
the interior of the protagonist's feeling, such that borders between self and
tree are broken. Yet even before he discovered *Weltinnenraum,* and still in the
time of his studies of Cézanne's paintings and his empathetic study of objects
in *Neue Gedichte,* Rilke intimated that the gaze toward objects can also be
unsettling when it becomes self-aware, as in the following moment from
Malte, recording an experience not unlike Descartes's description of madness.

This passage evokes the uncanniness of ecstasis discussed in chapter 1. Alone in bed, Malte remembers childhood fears and records:

> The fear that a small, woollen thread that sticks out of the hem of my blanket may be hard, hard and sharp like a needle; the fear that this little button on my night-shirt may be bigger than my head, big and heavy; the fear that this crumb of bread now falling from my bed may arrive glassy and shattered on the floor . . . and the fear that I may not be able to say anything, because everything is beyond utterance. (Rilke 1958, 61)

> [Die Angst, daß ein kleiner Wollfaden, der aus dem Saum der Decke heraussteht, hart sei, hart und scharf wie eine stählerne Nadel; die Angst, daß dieser kleine Knopf meines Nachthemdes größer sei als mein Kopf, groß und schwer; die Angst, daß dieses Krümchen Brot, das jetzt von meinem Bett fällt, gläsern und zerschlagen unten ankommen würde . . . und die Angst, daß ich nichts sagen könnte, weil alles unsagbar ist.] (KA III, 498–99)

Malte's fear intensifies as his imagination leads his thoughts uncontrollably from one perception to its fantastic variations. This deep existential probing of imaginative variation stands in stark contrast to other writers who similarly build up works of fiction out of imaginative descriptions of perception. Rilke's rendering of the imaginative description of objects is far more existential than, for instance, the same in Robbe-Grillet. Whereas Malte's perception of things continually evokes metaphoric transfers or even identifications with the interior life, Robbe-Grillet's characters and narrators seem to be characterized by a lack of any interiority. Consciousness is exhausted in its outward intention of perceptual things that yield no space of resonance for the affective relation to it.

Although Robbe-Grillet rejects the lyrical aspect of the gaze toward things suggested in some of Rilke's poetry, he describes the appearance of objects as primary in a similar way. In his writings all natural-habitual presumptions are suspended as to any hidden depth behind appearances. Things are regarded in the manner in which they appear as things. The object in Robbe-Grillet's writing "has no being beyond phenomena" (Robbe-Grillet 1965b, 13). It is a play of surfaces. Unlike the other authors considered here, Robbe-Grillet dismisses the psychological implications of the vertiginous reality he describes. In his novel *In the Labyrinth*, the description of a soldier's ordinary room takes up some eight pages of painstaking detail. The first-person narrative

voice comes from a localized consciousness rather than an omniscient narrator, but the individual expression is soon submerged by the details, and after the first pages the "I" (je) disappears. Instead of interior reflection, there is a description of the streets of the city the soldier walks trying to deliver a package and fulfill the last request of a dying comrade. The apparent erasure of any speaking or reporting subject, yet intensely observant description, so faithful to the stream of perceptual consciousness, dissolves any possible reflection on an empirical ego. As a result, the reader slips easily into the "transcendental" position of the narrator. Insofar as the narrator's surroundings, constituted by his perceptions of objects, are painstakingly mapped out and the reader's view is unobstructed by personality, the consciousness-stream becomes the reader's own. Here is an opening description of the room in *In the Labyrinth:*

> A fly is moving slowly and steadily around the upper rim of the shade. It casts a distorted shadow on the ceiling in which no element of the original insect can be recognized: neither wings nor body nor feet; the creature has been transformed into a simple threadlike outline, not closed, a broken regular line resembling a hexagon with one side missing; the image of the incandescent filament of the electric bulb. This tiny open polygon lies tangent at one of its corners to the inner rim of the great circle of light cast by the lamp. It changes position slowly but steadily along the circumference. When it reaches the vertical wall it disappears into the folds of the heavy red curtain. (Robbe-Grillet 1965b, 144)

Page after page of description of this room eventually dissolves the reader's expectation to find within the narration any the empirical center of experience: a self with a history. Only very gradually, over the course of the novel, a thin empirical character is built up on the basis of the transcendental-universal structure of the description. With this attention to detail Robbe-Grillet embarks on a project of building up a narrative solely from the record, not of the world as actual, but rather of "the acquisition of a new region of being" (Husserl 1982, 63) of observed world as phenomena.

This observation borders on the fantastical in Françis Ponge's collection of object-poems, *Le parti pris des choses* (Siding with Things). Ponge constructs an elemental mythology from descriptions of the most ordinary things—a cigarette, a pebble, a mollusk, an orange, a sponge, the rain, and so on—with a peculiar, adoring attention to detail. Unlike Robbe-Grillet's writing, the prose-poems of Ponge expressly present the ego of the speaking subject, and yet any personality is likewise merged with the described object. In some

prose-poems, such as "Les plaisirs de la porte," the ego is generalized to a third-person subject and the pleasure of seizing a porcelain doorknob, of stepping into the space to which the opening door grants access. In "Pluie," the speaker describes the rain:

> The rain I watch fall in the courtyard comes down at quite varying tempos. In the center it's a fine discontinuous curtain (or net), an implacable but relatively slow downfall of fairly light drops, a lethargic, everlasting precipitation, a concentrated fragment of atmosphere. Near the right and left walls, heavier, individual drops fall more noisily. Here they seem the size of a grain of wheat, there of a pea, elsewhere almost of a marble. The rain runs horizontally . . . while on their undersides it hangs in convex lozenges, like hard candy. . . . Each of these forms has a specific tempo; each a specific resonance. The ensemble has the intensity of a complex mechanism, as precise and unpredictable as a clock activated by the weight of a given mass of condensing vapor. . . . The ring of the vertical cords on the ground, the gurgling gutters, the tinkling gongs, multiply and reverberate together in a concert that is never monotonous, never lacking in delicacy.

> [La pluie, dans la cour où je la regard tomber, descend à des allures très diverses. Au centre c'est un fin rideau (ou réseau) discontinu, une chute implacable mais relativement lente de gouttes probablement assez légères, une précipitation sempiternelle sans vigueur, une fraction intense du météore pur. A peu de distances des murs de droite et de gauche tombent avec plus de bruit des gouttes plus lourdes, individuées. Ici elles semblent de la grosseur d'un grain de blé, là d'un pois, ailleurs presque d'une bille. . . . la pluie court horizontalement tandis que sur la face inférieure des mêmes obstacles elle se suspend en berlingots convexes. . . . Chacune de ses formes a une allure particulière; il y répond un bruit particulier. Le tout vit avec intensité comme un mécanisme compliqué, aussi précis que hazardeux, comme une horlogerie dont le ressort est la pesanteur d'une masse donnée de vapeur en précipitation. . . . La sonnerie au sol des filets verticaux, le glou-glou des gouttières, les minuscules coups de gong se multiplient et résonnent à la fois en un concert sans monotonie, non sans délicatesse.] (Ponge 1994, 7/6)

The presence of the "je" does not affirm the lyrical poetic function, the coagulation of meaning around a statement-subject, as the description progresses to

present the object from various points of view without lingering affect. Yet it is also not objective, as suggested by the evocation of seeming (elles semblent) and atmosphere or resonance (allure, résonnent) and indefinite or noncommittal adjectives (relativement lente; probablement assez légères). Both the lethargy and the vitality of the speaker's progressive description are projected onto and paint the movement of the rain (sans vigueur, vit avec intensité) as it makes audible and visual formations on various surrounding surfaces. In the prose-poem "La cigarette," atmosphere, since created by the object itself, is explicitly primary: "Rendons d'abord l'atmosphère à la fois brumeuse et sèche, échevelée, où la cigarette est toujours posée de travers depuis que continûment elle la crée" (Ponge 1994, 20).

As in these examples, the mobility in Ponge's style is one of exteriorization, consciousness stepping outside itself and settling in among things, rather than transcending them toward a higher conceptual idea. This is achieved by a thickening of self-reflective language rather than by rendering a transparent medium for the illumination of phenomena. In the prose-poem "Le cageot" (The Crate), consideration of the object is introduced by the speaker's pondering its name, halfway between two related words and objects: *cage* and *cachot,* or cage and prison cell. In "Les mûres" (Blackberries), the object named is presented not as a natural object but one found among things and the mind, in the "typographical thickets" (aux buissons typographiques) that constitute the poem (15/14). In contrast to Robbe-Grillet's, Ponge's language seems to intertwine with the materiality of the world. Again, taking the side of an orange, Ponge compares it to the sponge (l'éponge) which suggests, in French, also the writer's name. This is played upon in the description of its expression, linking the thing as housing consciousness to language that is thought to reside in consciousness, and which is yet, like fluid from a sponge, expressed. Whereas Rilke elaborated the possibility of the reciprocal and non-oppositional intimacy of *Weltinnenraum,* Ponge's s description remains dialectical, challenging the division of inside/outside through a double helix of what one scholar calls "symmetrical opposition" (Meadows 1997, 18–19). Thus in "L'orange" he opposes two quotidian objects, the sponge and the orange, an opposition justified only by the sonorous similarity of the two words "éponge" and "orange."

> Like the sponge, the orange, after undergoing the ordeal of expression, longs to recover its composure. The sponge always succeeds, though the orange, never: for its cells have burst, its tissues are torn apart. Only the peel, thanks to its elasticity, to some extent regains its shape. Meanwhile an amber liquid has been spilled, which, re-

freshing and fragrant as it may be, often bears the bitter consciousness of a premature explosion of seeds.

Must sides be taken, preferring one of these modes of resisting oppression to the other?

[Comme dans l'éponge il y a dans l'orange une aspiration à reprendre contenance après avoir subi l'épreuve de l'expression. Mais où l'éponge réussit toujours, l'orange jamais: car ses cellules ont éclaté, ses tissus se sont déchirés. Tandis que l'écorce seule se rétablit mollement dans sa forme grâce à son élasticité, un liquide d'ambre s'est répandu, accompagné de rafraîchissement, de parfum suaves, certes,—mais souvent aussi de la conscience amère d'une expulsion prématurée de pépins.

Faut il prendre parti entre ces deux manières de mal supporter l'oppression?] (Ponge 1994, 23/22)

This dialectic of subject-object is here complicated by the comparison of two objects: orange and sponge. The reader is invited to take up the position of the speaker-seer-fantasizer by the slippage in the sounds of words form one thing to another (sponge-orange) and their comparison. But the emotive significance is projected immediately upon the orange, in which, it is said, lies an aspiration to regain its *contenance*. Although the refreshing and fragrant juice that has been spilled implies the position of the speaker enjoying the fruit's sensuous aspects, consciousness is again immediately returned to the personified orange itself, embittered at having lost its contents. The speaker's position is both reestablished and again put in doubt by the opening of the next paragraph, which questions the necessity and possibly justice of comparing the two objects and their experience of oppression. Like the comparison of *l'éponge* and *l'orange*, this characterization of their experience is likewise justified only by its similarity in sound to *l'expression*, playfully describing both the physical reaction to the objects being squeezed and the process by which they are described, that is, linguistic expression. In this play between language, object, and expressive position of the speaking subject, Ponge at once refuses lyricism and commits its indiscretions from the point of view of objective description. Thus he thwarts the antilyrical principle, suggesting that what Husserl demanded of phenomenological description, a "clean separation" of subject from object, of intentional act from object of intention, is impossible due to the slippages of language.

All of these writers discussed, except Robbe-Grillet, tend to anthropomorphizes the objects they describe. Elements of consciousness, mood, feeling, thought, and so on, are projected onto the object through imaginative descrip-

tion recalling Gertrude Stein's references to the "sad size" of a plate, the "hurt color" of glass. Stein likens a chair to a "widow"—and these evocations have the effect of bringing into consideration the role of perception itself in the look of objects perceived. Sartre has argued that the anthropomorphic language in his own writings and in Ponge aims, paradoxically, at exposing things as seen by the human being and as other than the human. The visibility and perceptibility of things would, therefore, be highlighted in these works through anthropomorphization. Ponge adopted the 'perspective' of things in a kind of "active contemplation," or imposition of consciousness onto things; this is meant, as he writes in another poem, to galvanize the reader. In reality it leaves the reader unsettled, incapable of adopting the position of either subject or object. This unsettlement is meant to liberate the reader through a reminder that, one scholar has argued, "our relation to things is dynamic and dialectical and requires our active participation" (Lancaster 1997, 58), as suggested by both senses of expressing the orange and sponge. Sartre's formulation is however much more severe: the nothingness of the imagination is the power of negating the given, so that the transformation of the world is possible through literary description, a reigning theme in *What is Literature?*—"the creative act aims at a total renewal of the world," he writes (Sartre 1966, 36).

Inherent in some of these descriptions is also a tendency toward playing at scientific scrutiny, which can take the form of collection of evidence. As Husserl has argued, intuition of an object can be adequate or inadequate, complete or intrinsically incompleteable; and it is the inadequacy of empirical intuitions that seems to be exploited to ironic effect in Robbe-Grillet. For the reality Robbe-Grillet presents will not hold still. It reverberates seemingly without end beyond the fixed structures by which it can be made sense of objectively. Instead of fixed structures and their indications of system, there is an accumulation and layering of perceptual details seen too closely—yet without clarification of their relation to the position of the seer—to confirm any feeling of familiarity. One does not find a leitmotif or a sense that the details add up to a whole picture which is unequivocally more meaningful than its constituent parts. Reading Robbe-Grillet's novels is a vertiginous experience, as if looking at a pointillist painting close up, with little possibility to step back except in a retrospective review of the reading experience. Describing his procedure, Robbe-Grillet writes in *For a New Novel*: "We keep going back to . . . the exact position of a piece of furniture, the shape and frequency of a fingerprint, the word scribbled in a message." There is an intrinsic skepticism to this observation that denies system. The overwhelming quantity of evidence in any given perceptual field, he states, give us the mounting sense that nothing is true. "Though they may conceal a mystery, or betray it, these elements

which make a mockery of systems have only one serious, obvious quality, which is to be there. . . . The same is true of the world around us" (Robbe-Grillet 1965a, 23).

In sharp contrast, Husserlian phenomenology seeks to get to the things themselves in their originary givenness, and for certain moments, to get to the essence of things in eidetic intuition. It is the true nature of reality that the phenomenologist is after. Robbe-Grillet's fascination with the infinite multiplicity of perceptions in the visual field resonates nonetheless with a passage in Husserl's *Ideas I* that treats of the seeing of essences, or eidetic seeing (Wesenserschauung) and the intuition of something individual (individuelle Anschauung). For Husserl the essence of something means "what is to be found in the very own being of an individuum as the What of an individuum"—a content that can, however, be put into an idea [das zunächst bezeichnete Wesen das im selbsteigenen Sein eines Individuum als sein Was Vorfindliche. Jedes solches Was kann aber in Idee gesetzt werden] (Husserl 1982/III, 10). Experiencing individual objects of consciousness can, in the eidetic reduction, be transformed into an intuition of essences, or eidetic seeing. In the case of physical things, the subject-matter of Robbe-Grillet's intense descriptions, it is most obvious, following Husserl's argument, that even as an object of eidetic seeing, they can be given only in one-sided, inadequate empirical intuitions. Eidetic seeing is like empirical intuition in that it is "consciousness of an individual object" that is given originarily in its personal selfhood [originär, in seiner leibhaftigen Selbstheit zu erfassen] (Husserl 1982/I, 11). But an eidetic intuition can be objectivated as well in other acts. It can be the subject of vague or distinct thoughts, subject to true or false predications. The pure possibility of that What is sought. Robbe-Grillet's obsessive descriptions of material detail in what is for the narrator-center an empirical intuition, seem to illustrate precisely, but also playfully, the inexhaustibility of actual natural perception constituting the character's point of view, as well as the inexhaustibility of description by the writer whose language seeks to capture the essence of this infinitely vital complex of sensations in a structured-transcendental imaginative variation. Pure possibility is never seized upon; the description spins endlessly around an empty center.

While for Husserl fiction is "nothing other than a certain type of consciousness at play with possibilities," its employment in imaginative variation leads in phenomenology to the discovery of eidetic necessity, which is identical with this pure possibility. This points to what Kearney calls, in his study of the phenomenological imagination, a "paradox of freedom and necessity." In Husserl, he finds that free variation leads to necessary invariation of the discovered essence. Husserlians must steer clear of the wildness of imagina-

tion, thereby of the risks of relativism, and yet must avoid determinism (Kearney 1987, 24, 29). Thus there is a resistance to the scientific conceptual organization of the essence of such phenomena—the invalidation of what Husserl has called the "infinite regulative idea" of the "system of all objects of possible consciousness" and then of the essences of such, freed to their pure possibility, their "essential necessity" (Husserl 1993, 54–55; 70–71). Creative resistance to this formulation is found in Robbe-Grillet, whose novels nonetheless provide vibrant illustration of Husserl's precept of the potential interminability of eidetic seeing in an "incessant uncovering [beständige Enthüllung] of horizons" (Husserl 1993, 54/ I, 91).

Robbe-Grillet's seemingly endless descriptions of objects recalls a notion to which Husserl gives some attention in *Ideas I:*

> It is essentially impossible for even the spatial shape of the physical thing to be given otherwise than in mere one-sided adumbrations [in bloßen einseitigen Abschattung zu geben ist] and that—regardless of this inadequateness which remains continually, despite all gain, throughout any course of continued intuitions—each physical property draws us into infinities of experience [uns in Unendlichkeiten der Erfahrung hineinzieht]: that every experiential multiplicity, no matter how extensive, still leaves open more precise and novel determinations of the physical thing; and it does so *ad infinitum.* (Husserl 1982/III, 10)

This infinity of the experiential multiplicity is affirmed by Robbe-Grillet's descriptions, which gradually suggest the writer's antitranscendental refusal to centralize his narrator's perspective in an ego for whom the world is stable, and marks his phenomenological skepticism in favor of the proliferation of perspectives on phenomena. Although their logos cannot be negated, it is denied any transcendental grounding.

The only clarity that seems to be won from Robbe-Grillet's descriptions is that adequation of description to reality is impossible. While Proust, as discussed in the previous chapter, affords his narrator the play of centrifugal dispersion of sensual perceptions (through images) with the centripetal movement toward a provisional emotional-imaginative center from which they are perceived—a recovery of his narrator's self as threatened, for example, by the overwhelming unfamiliarity of his room when it is transformed by the magic lantern—in Robbe-Grillet no such centripetal recovery is even provisionally given. It is as if Proust gave us a pause, a location for consciousness on the map of imaginable spatio-temporal perspective, a reprieve from the dislocalizing uncertainty of an unstable reality. But with Robbe-Grillet such a pause is

refused, and will not hold, not even for an illusory moment of orientation. Both writers disallow the grounding of such localization in transcendental subjectivity, but in Robbe-Grillet the refusal belongs to the task of the new novel, liberated from traditional structures of narrative focalization, characters, plot development, and so on.

Robbe-Grillet's descriptions likewise challenge the interiority of a narrating consciousness, and thus also of any potential ethical position on the part of the narrative self. His work *La jalousie* is constructed entirely of a measuring, optical description of objects surrounding the speaker. These descriptions are precise and thorough to the point of threatening insanity, which reveals the narrator's own blind spot, the self he, and the reader, cannot see as he looks through the blinds to spy on his wife, whom he suspects of having an affair with the neighbor. In the following obsessively objective description there is no indication of a conscious interiority. The narrator describes the banana plantation without any resonance of subjective feeling:

> The line of separation between the uncultivated zone and the banana plantation is not entirely straight. It is a zig-zag line, with alternately protruding and receding angles, each belonging to a different patch of different age, but of a generally identical orientation.
>
> Just opposite the house, a clump of trees marks the highest point the cultivation reaches in this sector. The patch that ends here is a rectangle.
>
> [Le trait de separation entre la zone inculte et la bananeraie n'est past tout à fait droit. C'est un ligne brisée, à angles alternativement reentrants et saillants, dont chaque sommet appartient à une parcelle differérente, d'âge different, mais d'orientation le plus souvent identique.
>
> Juste en face de la maison, un bouquet d'arbres marque le point le plus élevé attaint par la culture dans ce secteur.La pièce qui se termine làest un rectangle. (Robbe-Grillet 1969, 13)

The geometrical terminology—*le trait, la zone, une ligne brisée, angles, le point le plus élevé, ce secteur, un rectangle*—suggests a view from no localized subjective position, which serves in the narrative as an unsettling contrast to the intensely interested nature of the jealousy which motivates description.

Robbe-Grillet's narrator nearly dissolves in the empirical details, but the reader, while perhaps disconnected by the narrator's uncanny absence, is to embrace the freedom that issues from the narrator's insistent gaze at the stub-

born presence of things—in other words, from the rejection of a secret thing in itself, as it were, behind and obscured by phenomena, and from the whole conception of the world that might attend any such metaphysics, from which it would be naive to deduce a secret depth behind or beneath things (cf. Morissette, 8). Robbe-Grillet effects this liberation by going over the object repetitively, incessantly, cinematographically, or scientifically describing it from every conceivable angle, with the geometrical assignment of measurement, angles, lines, and surfaces. He effects a Nietzschean festival of surfaces, but unlike Nietzsche, whose philosophy celebrates the painful bliss of Dionysian dismemberment of the sensuous in order to fuse with life, suffering, the abyss, and earthly nature, Robbe-Grillet aims at this same fusion by virtue of liberation from interiority and the depths presumed by metaphysics or even by Nietzsche's antimetaphysics. From this perspective, Nietzsche's thought seems resiliently vertical, even while inverting, as he claimed, Platonic thought by inverting the order of Being and its attendant values. Robbe-Grillet's universe, in contrast, is given horizontal orientation. This refusal not only of ethics but of a revaluation of any values is more radically disruptive than Nietzsche's sublime suffering and praise of sensuality. Sartre considered this a promising aspect in Robbe-Grillet's writings, since he too sought an ethics that would be one of invention, deposed of the interior self which we can, inauthentically, objectify (and also refuse) as a responsible party. Robbe-Grillet's efforts are thus antiphenomenological insofar as he strives for exterior description, all in negating any noetic reference. He not only refuses the depths of thinking and subjective perception as infected by psychological and instinctual forces, as found in Nietzsche, but he effects a "total rejection of introspection . . . or descriptions of states of mind" or even of acts of perception (Morissette 1965, 7). For Sartre such states of mind as Robbe-Grillet expels from his narrations are always already a construct of reflection (see Sartre 1960, 61–68).

Despite their differences, all of these writings respond to what Sartre has called the "something overflowing about the world of 'things.'" The indirectness of literary description affords illustration of the notion that "there is always, at each moment, infinitely *more* than we can see" (Sartre 1948, 9–13, 26–27), a notion made popular in modernism through echoes of Nietzsche's perspectivism. In Robbe-Grillet this "infinitely more" is indicated by the inexhaustibility of appearances, all the more so to a literarily charged and poetically vitalized experience that lends force to varieties of elusiveness. In Ponge this "infinitely more" is brought to the fore in a cosmology of the material world as intertwined with that of language, whereas in Sartre, as seen previously, it leads to an existential treatment of contingency. But it is in Rilke

that the description of this inexhaustible nature of phenomena is pierced
through with a desire for clarity, for recognition of an essential and inalienable
truth that resides within this vivid and vital density.

Poetic Recognition and the Seeing of Essences

The poetic relation between this inexhaustibility and the essences of things is
to some extent analogous to that between the infinite variability of phenom-
ena and the eidetic reduction. A literary-poetic striving for clarification of this
relationship is most explicit in Rilke's writing. Rilke invokes the notion of
clarity in his novel, some passages of which he copied from letters he wrote
about his experiences in Paris in the autumn of 1907, when he was engaged
in describing Cézanne's paintings after a visit to a memorial exhibition of the
painter's works (see chapter 5). In both his letters and in *Malte,* Rilke writes
of an apprenticeship in seeing, as if the veil of ordinary seeing had been gradu-
ally worn away by the exquisite precision of a new way of looking. Hamburger
has pointed out that the verbs seeing and looking (sehen, schauen) in the
sense Rilke sometimes used them, must be understood in a pregnant sense. In
describing Cézanne's paintings and Rodin's sculpture, he conveys a sense that
will "intensify when it comes in expressive relation to the creation of the
plastic artist" (Hamburger 1971, 85).

Seeing here is not merely a matter of physical perception, but one of intu-
ition of the essence of things. Indeed, in the context of a discussion of eidetic
seeing, Husserl writes of "seeing in the pregnant sense" ("Erschauung im
prägnanten Sinn") as seeing and not in a "mere and perhaps vague making
present" but as an "originarily presentive intuition, seizing upon the essence
in its elemental uniquess [leibhaften Selbstheit]" (Husserl 1982/I, 11). The
difference between eidetic and individual intuition is determined by their
relation to matters of fact, of which the eidetic intuition claims none. With
this separation, the notions of essence and eidos are differentiated, according
to Husserl, from any "semi-mystical thoughts" that might cling to them (12).

In Rilke there is something paradoxical in the way he strives for precision,
learned in part from Cézanne's method of displacing singular outline in favor
of color volume. The objects portrayed thus appear to be in a state of moving
reverberation as if freshly appearing to the vital seeing consciousness. In de-
scribing his experiences in Paris, in letters and through Malte's journal, Rilke
attempts the difficult task of getting very close to the facts. These facts are,
properly recognized, of the essence. As discussed in chapter 1, Malte's fantasti-
cal description of objects perceived in fear, as well as his sober and stunned

amazement at the bare presence of the dilapidated walls of a half-torn-down house, evidence a reclamation of seeing and, at the same time, elicit the expression for which Rilke had been striving. But this also suggests the radical instability of ecstasis which, in admitting the objectivity of variation itself, approaches the boundless. To stabilize this approach, to stay this approach so near the ever-threatening oblivion, requires a recognition of things, of specifically perceived experiences.

Intuition of essences, as the task of the Husserlian phenomenologist, is accomplished in the intuition of objects correlate to different and imaginatively varied acts of consciousness, for instance, those of direct perception and memory. But relevant to the literary descriptions presented here is Husserl's claim, mentioned at the outset of this chapter, that essences can be brought to intuition from out of "data of mere fantasy" [in bloßen Phantasiegegebenheiten] (Husserl 1982/III, 12). Given his descriptive strategies in *Malte*—drawn from streams of aesthetic perception, from memory, and from fictional productions of the imagination—Rilke does not, as the scientific phenomenologist would, neatly distinguish these modes from one another. Rather in his writing the imagination, the efforts of writing (self-reflexively represented and at once enacted by Malte's journal writing) and remembered and present perception collaborate in a manner which, however, always approaches the ecstasis with which quotidian reality is felt to be charged. All of these modes of intuition, nonetheless, are admitted into the capture of essences similar to that which Husserl prescribes for the eidetic moment of phenomenological thinking. Most important here is the intuition of the productive imagination or fantasy. Husserl writes: "To seize upon an essence itself, and to seize upon it originally, we can start from corresponding experiencing intuitions, but equally well from intuitions which are non-experiencing, which do not seize upon factual existence but which are instead 'merely imaginative'['bloß einbildenden' Anschauungen]" (ibid.). Rilke engages a literary insight analogous to this capture of essences through imaginative free-flowing fantasy. For Husserl the essence is equally original regardless of its origin in actual existence; this too can be said of the facts seized upon by Rilke, in that they are represented specifically as objects of perception, of imagination, and of childhood memory. Rilke's writings approach the longed-for essences of things and give recognition to them. For Malte a phenomenon borne of perception or one borne of mental presentation (Vergegenwärtigung) would be equally original; the essence of things is grasped in recognition no matter where it originates, whether in perceived beings or in imaginings or memories.

Variations of the term "recognition" (das Erkennen) appears in a special way repeatedly in Rilke's novel, as it does in his "thing-poems" or *Din-*

ggedichte. Käte Hamburger has shown in her heretofore unsurpassed study of the phenomenological aspect of Rilke's work that it represents an epistemology (Erkenntnistheorie) in lyrical form (Hamburger 1971, 84). Although her oft-cited study is exceptionally cogent in drawing out the relationship between phenomenology and Rilke's poetry, her underlying theory stands in need of critical revision. It is precisely the attribution of epistemological status to Rilke's poetry wherein more differentiation is needed. This differentiation is not intended as a dismissal of the epistemological relevance of poetry; but it needs to be explained that what the poet sought to encapsulate in poetic language goes beyond the specific constraints put on the phenomenologist, who must, in deference to the logos of phenomena, identify general structures.

Hamburger links the Husserlian notion of the seeing of essences with Rilke's "representation of intuitive-immediate grasp of the 'essence of things'" (87). In a reading of the poem "Blaue Hortensie" (Blue Hydrangea), she shows that the Rilkean treatment of the essence of the phenomenon "blue" parallels Husserl's treatment of the essence as the specific "what content" of the given phenomenon. In Husserl's treatment of the example of the red of the blotting paper, the phenomenologist is able to abstract from the red of this or that individual thing and achieve an intuition of that red as such. One intuits not the essence of red as opposed to other colors in abstraction from the individual thing, but rather that specific red of that thing, the essence of that species of red as what Husserl calls an "identical generality" (identische Allgemeine). Yet it is possible that the poet has greater facility to express the essence of specificity, the specificity of essence, which is wound up with the relationship between a color and that of which it is a color. While the phenomenologist identifies identical generality—the specific red of that thing—what Rilke's speaker seems to grasp is the specific color as the essence of that thing. In the poem about the blue hydrangea, it is by moving away from the direct subject of the poem—the flower of the color blue—to other blue things—sky, letter paper, faded apron—that the poet grasps blue as hydrangea and hydrangea as its own blue. It is the essence of this specific thing as this specific blue that cannot be grasped directly, but is grasped through metaphoric variation. The blue is identical to itself, and therefore graspable, only by also being not absolutely distinct from other colors named in the poem (green, yellow, violet, gray) and by being not absolutely distinct from other blue things (sky, apron, paper).

Given this metaphoric indirectness, it appears that Hamburger's theory, while valuable, is misleading. Epistemology is an account of knowledge, of

the conditions of cognition, *Erkenntnis.* But what Rilke's poetry achieves is a noncognitive grasp that works the registers of intuition and feeling so that the specificity of that which speaks to the poetic gaze can be preserved there. Rilke's grasp at essences occurs only through the performances of language, which for Husserl would have to be restricted to a function of expressing the phenomenologist's findings. Rilke's poem does not represent, it enacts the capacities of poetic recognition. This becomes obvious if we try to determine just how poetry might be able to preserve the specificity of a quality as part and parcel of the essence of a thing. While the phenomenologist will struggle with the tendency of concepts to negate specificity—in fact the specific actuality must be suspended—the poet has at his disposal the transfers and transformations of metaphor which, while less precise, preserve specificity in the very interstices of conjured images: it is, to use Natanson's phrase, an art of "indirection" (Natanson 1978, 35). The grasping of essences thus is indirect; it occurs through metaphor and its attendant and always manifold imagery. The transfer of metaphor between two nonidentical things affords the means of preserving as well as accessing specificity. Specificity, while always slipping through the identifications of language, is at the same time magnified or rendered intuitable between images; the nonidentity inherent in the metaphoric transfer allows a nonobliteration of the specific essence by the two images with which it is associated and which cross over one another, as in an eclipse, without extinguishing each other. This works in Rilke's poem through repeated interimplicating crossings. While the blue hydrangea is blue like old letter paper and aprons no longer worn, it is capable of indicating both life's brevity—"wie fühlt man eines kleinen Lebens Kürze"—and regeneration— "doch plötzlich scheint das Blau sich zu verneuen." The blue of the flower is that of the unused letter paper, dead to meaning, cut off from communication; but it is also indicated in the life granted by the paper when letters (for instance of the poem) are inscribed upon it, and in the final stanza when the plant shows signs of life with green, before which the blue is said to become joyful (sich freuen). Important is that the green of new life echoes the yellow of the old letter paper (since with blue it makes green), so that a relationship between two disparate things touched with green, old paper and living leaves (which can be both designated by the same word *das Blatt* in German, more common than the English "leaf" of paper), yields the essence of this specific blue. That the blue is also "verweint" (tear faded) suggests the color's melancholy associations which are intertwined with its lyrical essence, contrasting with the speaker's attribution of joy to blue as it approaches or involves a green hue. Here is the poem:

Blaue Hortensie

So wie das letzte Grün in Farbentiegeln
sind diese Blätter, trocken, stumpf, und rauh,
hinter den Blütendolden, die ein Blau
nicht auf sich tragen, nur von ferne spiegeln.

Sie spiegeln es verweint und ungenau,
als wollten sie es wiederum verlieren,
und wie in alten blauen Briefpapieren
ist Gelb in ihnen, Violett und Grau;

Verwaschnes wie an einer Kinderschürze,
Nichtmehrgetragnes, dem nichts mehr geschieht:
wie fühlt man eines kleinen Lebens Kürze.

Doch plötzlich scheint das Blau sich zu verneuen
in einer von den Dolden, und man sieht
ein rührend Blaues sich vor Grünem freuen.

And the author's translation:

Blue Hydrangeas

As the last green in the palette of color
are these leaves, lusterless, rough, and dry
behind the bunch of blossoms, which the sky
mirrors blue from far despite their being duller.

They mirror it, all cried out and vague
as if they wanted once again to lose it
and like the blue old letter papers fade
there is yellow in them, grey and violet.

Like a child's apron washed to pale,
no more worn, to which nothing happens anymore:
how one feels the little life is frail.

Yet suddenly one cluster's blue will seem
to revive itself and one sees how
a touching blue enjoys before a green.

Other metaphorical transfers in this poem are important. The blue, having
faded behind the green of the dull and dried leaves, is given vibrancy in the

first stanza of the poem by its reflection of the sky; and so its native quality, its specific blue, is granted from an other source. This other source is not only the named sky but the poetic metaphor that brings together earthly plant and heavenly element. Metaphor here functions as what Jephcott called a "verbal mirror" against which the object is projected in order that its truth or essence can be grasped (Jephcott 1972, 123). This is not a representation of the grasping of essence—an epistemology—but rather its performance and linguistic achievement. What the phenomenologist accomplishes in reflective study of the structure of phenomena, the poet accomplishes only through an indirect approach. We may speak of the common aim of grasping essences, but this means something different to the Husserlian phenomenologist than it does to the speaker of Rilke's poem.

The essence which Rilke's poem seeks to grasp is not found in the phenomena themselves ready to be grasped in intuition, as present to consciousness in itself. Rather poetical intuition extracts the essence that is ungraspable as presence to consciousness. This essence exists only between the positively intuitable images between which metaphor transports the process of intuition. The transfers of metaphor effect movements parallel to the movement from natural to phenomenological seeing; but the achievement is indirect in the poetic approach, for the precise reason that a certain specificity the phenomenologist tends to abandon might be salvaged and savored. The philosopher reflects on natural experience in order to clarify it, but not to supercede it. But it seems that Rilke's aim was to grasp something not available to natural experience, something available only to poetic experience, something interphenomenal.

This essence, this blue of this hydrangea, is graspable for the phenomenologist as an identical generality; the poet's blue, with all its complexity and inner tension with other colors, as the essence of this hydrangea, with all its lyrical tension with other things and its both melancholic and joyful associations, is not. But a grasp of its essence is achievable through poetical language. In addition to metaphor, other features of the poem make possible this achievement. Just a selection of such features would include: (1) the relations made by the end-rhyme, not preservable in the translation, for instance between *Kürze* and *Kinderschürze* (brevity and the child's apron); between *rauh, blau, ungenau,* and *grau* (raw, blue, inexact, and gray); between *Briefpapieren* and *verlieren* (the old letter papers and losing); (2) the repeated use of the indefinite pronoun in *man sieht* (one sees) and *wie fühlt man* (how one feels), which renders a position that accommodates both speaker and reader, both external to and participating in the sighted flower and its metaphorically related images; (3) the adoption of the sonnet form, with its historical sense of the

preservation of fleeting, but beloved, things of beauty, as well as its rhythmic shape and length so appropriate to the interior voice and to memory.

While this flowerly blue is a "cried out" blue (verweintes), like the apron no longer worn, no longer vital, the poem gives recognition to this blue, unlike the childhood item left behind, something does happen (geschieht) to it. For by the final stanza the blue is enlivened again—not from external reflection but from out of itself and its inherent life—one cluster seems to enjoy itself, to be happy—which is made visible in contrast to the green, possibly still lusterless leaves. This inherent life is uncertain, seems to revive itself (es scheint sich zu verneuen). This seeming is inseparable from the green identified in the last line, which no longer suggests the last bit of drying paint on a palette. Both blue and green in the last line are referred to as nouns, but together. The hydrangea-blue is transformed from an object that only reflects the blue of another opposed element (the sky) to an object that has been left aside and is unused (like the apron-blue) and is only regarded externally, to a thing with its own uncertain but immanent and vital tension. Here the reflexive German verb for "to be happy" or "to enjoy oneself" (sich freuen) assists in this attainment of poetic vitality, rhyming with the coming back to life again of *verneuen*.

What Hamburger finds in this poem is essentially a form of recognition. The poem achieves recognition of the essence of the blue hydrangea; but by less direct means than intuitive abstraction. She acknowledges the indirect nature of this recognition, but attributes the particularity of the poem to a form of cognitive abstraction, the act of isolating of blue from the hydrangea. Here "indirectly, an experience of phenomenological reduction asserts itself, that isolates the perceived [erschaute] blue, extracts it from the flower. . . . 'Extracting moments,' as Husserl says, which are inessential for this blue. The blue-phenomenon . . . will be isolated from these—and the particularity of the poem is thereby constituted." (Hamburger 1971, 99). This reduction is however not a performance of a cognizing mind but rather of a complex of metaphoric transfers and other features of the poem described here, for which no moment or association is inessential. Contrary to Hamburger's cognitive approach, it is clear from the interaction of these features that the blue is not extracted and seized upon in itself as an identical generality, shedding any less essential associations. The essence of this blue of this thing is inseparable from the totality of its manifestations, from the thing of which it is blue; recognition of the blue itself occurs only in varying its associations, not in isolating it from any associations.

These other associations are not inessential. They do not serve merely to liberate the blue from the hydrangea and from any other associative objects

with which it might be related; rather each of these associations carries with it a resonance of this blue's emotional essence. The blue is blue-as-this-hydrangea, and what the poem achieves, through the blue-as-hydrangea-via-sky or blue-as-paper or blue-as-apron, is that this is also reversed, so that by the end, the reader grasps this-hydrangea-as-this-blue. The achievement of recognizing blue as substantive, as not an adjective modifying the flower or associated objects but capable itself of enjoying, is situated in a line where it is related to another noun, the green. This green, since it has not undergone the process of reduction which would disperse it toward other metaphorical identifications, can only be thought of as the living leaves of the hydrangea plant to which the old writing paper (with its own hint of green pigment) had provided an intimate contrast. The green at the poem's beginning was only an abstract, dried-up, isolated green, the pigment on a palette; by the last line the green's association with the blue, which has undergone the process of poetic transformation and revitalization, is by association also revitalized. Insofar as the blue comes into its own as grasped essence, this is possible through its moving association with other images, its intimacy and distance from them. It is the hydrangea's blue, which is only a reflected sky's blue; then it is the letter paper's blue; then it is the apron-blue. By returning to its source of vitality, in its relation to green as the green not of painter's dried palette but living plant, the blue is grasped in its essence and so presented on its own, as a noun. The phenomenological reduction then is a particularly poetic variant here; the specificity of the blue hydrangea is achieved and preserved through the movements of metaphoric identification and its necessary internal distances.

The notion of phenomenological recognition in Rilke's work can be however retained as the attainment of poetic seeing and expression. The reflections on phenomenological literature in this chapter suggest further that a grasp of essences will not be admissible to univocal description, nor to "unmixed thinking about them" which, as Husserl prescribed for phenomenology, must not confuse essence with existence or, as he put it, "not connect matters of fact and essences" (Husserl 1982/III, 13). Whereas Husserl aimed for recognition of essences that are "analogous to experience, to seizing upon a factual existence," Rilke sought to grasp the factical existence as part and parcel of the poetical essence of things. This requires an extension toward their intimacy or *Innigkeit* which, as shown in the discussion above, cannot be unequivocally isolated.

Hamburger, who addresses Rilke not in general phenomenological terms but in specifically Husserlian ones, does not take full account of how much this departs from what was called earlier in this chapter Husserl's "antilyrical

principle," the dictate that the phenomenologist must maintain a strict sepa-
ration between subject and object. In reflecting on Cézanne's painting and
the essences it seems to him to have achieved, Rilke writes: "The further one
goes, the more private, the more personal, the more singular an experience
becomes, and the thing one is making is, finally, the necessary, irrepressible,
and, as nearly as possible, definitive utterance of this singularity" [Je weiter
man geht, desto eigener, desto persönlicher, desto einziger wird ja ein Erlebnis
und das Kunstding endlich ist die notwendige, ununterdrückbare, möglichst
endgültige Aussprache dieser Einzigkeit] (Rilke 1985, 4; KA IV, 594). For Rilke
this singularity does not eschew all objectivity, but it is an objectivity that is
inaccessible to the scientific gaze because it has to be achieved through artistic
means and experienced only as the achievement of the most individual poetic
seeing. It is an objectivity the scientist is perhaps unable to express, given the
dependence of scientific language upon identified and isolated essences as a
legitimating foundation. It seems that when these identifications themselves
are incompatible, scientists reach a boundary that must be overcome by in-
venting new approaches to what they seek to explain. What Rilke sought was
not an objectivity of essences abstracted from the manifold variations, but
recognition of a "limitless objectivity that refuses any kind of meddling in an
alien entity" [unbegrenzte, alle Einmischung in eine fremde Einheit ableh-
nende Sachlichkeit] (65; 623). This remains faithful to the particular, ragged
experience of specificity. That this is inconsistent with the most ambitious
idea of Husserl's phenomenological vision, the infinite regulative idea of a
complete system, is obvious. What Rilke aimed at was rather to appropriate
for poetic experiences those essences that are unavailable to any other kind of
experience, and also not subject to usual forms of validation.

Forms of Recognition in Literary Phenomenology

Forms of recognition, though varying, can be said to be achieved in the liter-
ary works here discussed, insofar as imaginative expression of phenomenal
experience enables a grasp of essences or of a phenomenality that in some way
suspends the quotidian look of the world in favor of a truer apprehension of
it. In Rilke, recognition is of singular facticity, of the essence, in Husserl's
terms, of "what is sighted" yet without being able to guarantee that it has not
been, as in perceptual intuition, "seized upon as factually existent" [nicht als
daseiend erfaßt] (Husserl 1982/III, 14). In Robbe-Grillet, this seizing upon the
originality of phenomena is thought as liberation from any metaphysics that
posits a deeper or more original, stable, identifiable reality behind the shifting

appearances. Sartre, too, thought of the seizing of reality as correlate to consciousness as a liberation, a revelation that consciousness is not trapped within the essential structure of things nor is in any way like the character of what is given, what is merely *en soi*. Ponge constructed a fantastical dialectic of consciousness with the material world through the density and slippage of language, yet one which refuses the alienation of either. In the works of all of these writers insight occurs in some form of phenomenological suspension of the natural attitude, when the quotidian is a scene for reflection, and then, if not for clarification, for ecstatic fascination.

Yet even the divergences of these literary phenomenologies from phenomenology proper show that literature's use for the phenomenologist is more than merely illustrative; literature does more for phenomenology than inspire "free transformation of data." It not only illustrates experiences of rich phenomenological import, but initiates discoveries that parallel and instantiate moments of phenomenological understanding, thereby vivifying the necessary capacities by breaking open the quotidian expectations, the habitual regard, which would hinder phenomenological seeing. Husserl appreciated the literary imagination for its contrariness to sedimented expectations about the given world, and these writers break with this sedimentation radically. This writing breaks through to original sources—to objects as objects, world as world, phenomena as phenomena. Poetic-literary language opens the reflective consciousness to the reverberating horizons that attend the actual but which are, in ordinary cognition, predelineated and contained by it. If natural reality is subjected to the phenomenological reduction as enacted by poetic literature, its break from the natural attitude suspends any ontological prejudices about the world, the natural attitude presumptions about objective being, at once effecting the phenomenological reduction, and initiating the activities of free intentionality of the imagination. But any univocal expression of the discovered essences of things is precluded, and in diverging from scientific phenomenology, literary phenomenology reveals its own limits and those of scientific philosophy.

Rilke came close to a poeticization of phenomenology in its classical form, though with important qualifications. Recognition, a poetic alternative to the eidetic reduction, yields not the reduction of a given particular and its variations to a universal essence, but the particular grasped, momentarily, as if absolute, in the limitless objectivity of the specific. This kind of absoluteness of the phenomena characterizes poetic-literary phenomenology, inasmuch as it recognizes the facticity of the intentional relationship between meaning and meant. The insistent presence of the factical particular in Rilke—a retention of actuality, which ought to be left out of eidetic seeing, without a reduction

to actuality—would challenge the phenomenologist's attempt to seize upon a univocally expressible essential core of phenomena as its pure possibility. This does not yet bring out the added problem of the centrality of a transcendental ego, and the means by which Rilke, through poetic ecstasis and the notion of *Weltinnenraum,* seemed to annul the distinction between subject and object. Their interpenetration is at least hinted at, though not yet explicit, in *Neue Gedichte,* where the metaphoric identifications and other poetic operations allow the essence of something to be drawn out. In "Blaue Hortensie," the speaker offers a participatory position for the reader who co-performs these identifications, and so suggests the structure of poetic constitution.

This interweaving is explicitly and narratively exhibited in Rilke's ground-breaking essay "Erlebnis" about a spiritual experience that challenges the structure of ordinary perception. An unnamed protagonist leans against a tree in a castle garden and feels vibrations from the tree inwardly; he feels at one with a bird in flight, unimpeded by his bodily and therefore ordinary percep-tual position. He feels that he has reached the essence of things, a feeling celebrated in the notion of *Weltinnenraum* which, though appearing only once in Rilke's poetry, has become emblematic of Rilke's poetic-phenomenological seeing. This can be thought of not only as a description of the world seen poetically, but as a transformation of consciousness, though one incompatible with the notion of transcendentality, since it is not a return to an a priori state of affairs but rather an achievement and overcoming through poetic or artistic expression. Malte, though not yet able to fully develop his capacities of recognition, experiences the growth of his consciousness not only in seeing outward but in experiencing *ein Inneres* of which he had theretofore been unaware. This inwardness is not a reliable core of autonomous selfhood but rather a means by which the self is opened up toward the intimate depths of world. Malte's struggles to articulate his recognition of things do not yield the assured reciprocity expressed in the notion of *Weltinnenraum,* but they trace its origins as Malte learns to see.

From the poetic point of view, it appears that Husserl, as one scholar put it, "can account through transcendental subjectivity for the appearance of objects and the world *in general,* but not for the fact of this object and world" (Busch 1980, 22). And whereas Husserl sought to exclude any mystical associa-tions with a theory of essences, Rilke's poetic intuitions indulge the perception of their mystery and of some mystical resonance, albeit in a persistent devo-tion to sensuous realty. Poetic descriptions, that is, those relying upon images which, by means of metaphor, do not settle within a single image, seem to offer a field of articulation for seizing a specific reality indirectly. In phenome-nological literature, description is never fixed with any philosophical finality.

This is not to say that poetic-literary descriptions are untrue for being unfixed or equivocal, or for being, in one sense, inconsequential. Rather, poetic-literary descriptions are functional for poetic as well as aesthetic insights that remain open-ended. If they are not useful for the project of knowledge in its traditional sense, for the epistemology with which Hamburger identified Rilke's project, their achievements must be thought of differently, in terms of a kind of knowledge that remains tacit. This would be a kind of poetic knowledge, with its recession into the implicit, as harbored, for instance, in the folds of metaphor. Poetic-literary descriptions can evoke latent possibilities that underlie our ordinary experience of the objective world. However, this kind of poetic literature does not represent cognition of objects. Only with an epistemological bias, as well as an ill-placed realism, do we demand from a poem that it tell us something true about something, even about cognition of something; rather poetic language aims to constitute an encounter, and only in so constituting, grasp a specific reality in its essence, a recognition.

The relationship between phenomenology and literature is a vital and complex one, and while literature assists in the imaginative variations of the phenomenologist, phenomenology often helps to explain the particular operations of modern literature as it transforms everyday perceptions into what writers hope to be truer, more intense forms of recognition. Even Robbe-Grillet's work, which rejects any essence behind phenomena, seems to perform a kind of constitution. The "function of language," Roland Barthes writes of Robbe-Grillet, "is not a raid on the absolute, but a progression of names over a surface, a patient unfolding that will gradually 'paint' the object, caress it, and along its whole extent deposit a patina of tentative identifications, no single term of which could stand by itself for the presented object" (Barthes 1965, 12). In Rilke, metaphoric transfer among other poetic devices allows for a closer inspection and more intimate expression of reality than the everyday attitude affords. In Ponge, the fantastical attention to quotidian objects discharges their subordination to the non-material, the intellectual, the Platonic idea. The freedom Husserl argued was required for phenomenological thinking is of course significantly affirmed by the literary work of imagination in that, transcending one static version of 'facts,' the phenomenologist can "envision alternative modes of experience transcending our present state of affairs" (Kearney 1998, 23). Phenomenological recognition indicates a contact with things that is reached only in breaking down our usually unreflective relationships to them or our operating philosophical prejudices. Beyond Husserlian phenomenology, literary-phenomenological recognition nurtures ecstasis when the world as lived is approached in its inexhaustibility and innate mysteriousness.

The Mysterious and Poetry of the World's Inner Horizons

While the world is not inherently mysterious for one who adheres to the strict scientific description of its essential structures, modern poetry seems in part devoted to defending the margins of unknowability that surround the horizons of the known. The mysterious suggests what is beyond the reach of everydayness, beyond the quotidian realm. It is opposed to the familiarity of the everyday in being other, unknown, incalculable. Everyday life seems to be altered when mystery is sensed, whether it emerges as a quality of atmosphere, of a perceived object, or as a presence of the unknown that cannot be explained by a determinate impression. Yet modern poetry tends to suggest that the mysterious does not leave the everyday behind for some transcendent realm, but can seem to surround it as its halo, emerge as its usually unthought depths, as its ungraspable and hidden inner workings. This emergence of mystery within the mundane is the occasion of much of the poetry of Robert Frost and of Rilke, whose poetry serves in this chapter to represent a defense of the unknowable both at the edge of world as an experienced spatio-temporal totality and within the world's inner horizons, as describable in phenomenological terms. Despite Husserl's conviction that the world is in principle describable, his phenomenology offers much assistance in articulating how the inner boundaries of the unknown might be approached. While phenomenology is helpful in describing the structure of everydayness which may be attended by a sense of mystery, in poetry the potentiality attending the given phenomena will be explored more freely since poets make connections between images that diverge from the ordinary logic of appearances. The evocation of the mysterious, often in direct contrast to dominant views about the world, is part of the initiation of the ecstatic in these poets, and it can be seen

to what extent the poetical imagination profits from and strains the phenomenological approach.

Beyond the Quotidian: The Mysterious and Horizonality

The structure of the sense of mystery might be described by contrasting it with the sense that one lives in a familiar world. Husserl's notion of horizonality in his description of the synthetic constitution of a world can be useful in describing the sense of mystery as found in literature. A phenomenologically perceived world is a regulative ideal of a totality of actualities and potentialities, conscious acts and objects of consciousness, enacted and seen, yet-to-be-enacted and yet-to-be-seen. For every object of a conscious intention, whether a sensuous perception or an idea, a temporally governed halo of potentiality appears as its horizon. The world according to Husserl is never completely given in actuality; it is not a totality of actual phenomena but of actualities that predelineate potentially limitless modifications and augmentations of actuality. What one would see if the cup is turned over, or if one walked around to view its other side, how one idea appears to connect with an endless nexus of other ideas, all this attends simultaneously the actual phenomena. This not only enriches one's perception of things as things, but makes it possible in the first place and allows an understanding of the everyday world. If for Husserl the things themselves should be knowable within a determinate system of essences, even potentiality would be phenomenally prefigured. At the same time, the experience of what is present in actuality requires the horizon of the merely potential, for that which does not directly appear is needed for the identification, context, and meaning of what does. What is given is given as something of which other non-given aspects might be actualized.

Phenomenology, according to Husserl, describes the performance (Leistung) of consciousness, a synthetic performance, as responsible for the connectedness of the tissue of the world, for its quotidian worldhood. There is nothing necessarily mysterious about the relationship between actuality and potentiality that fills the complex of world. It either remains unnoticed in the natural attitude, or it is described by the phenomenologist according to a determinate system of intentions and objects of intention, and according to the qualifications of meaning and the horizonally co-meant, the intended and the co-intended, the perceived and the apperceived. While Husserl referred to the phenomenological enterprise as a venture into the unknown, his theory of constitution nonetheless demands fixed and univocal terms, as discussed in

the previous chapter. World is the infinite regulative ideal of a "system of possible objects of possible consciousness" in an "incessant uncovering of horizons," all its extensive complexity, interconnections, and depth (Husserl 1993, 54–55). Some poets, particularly those invested in the conditions of appearances, attempt to bring to the fore the relationship between the actual and the potential-horizonal. In presenting a view of world as mysteriousness, they evoke a transcendent or interphenomenal beyond in excess of what can be expected on the basis of appearances; this need not suggest a world that transcends this world altogether, but rather one that transcends the structure of our ordinary phenomenal grasp of it. An acceptance of the mysterious as the implicit or receding part of experienced reality, as its marginal conditions, seems to augment a sense for life, which may be reflected and renewed in poetic language.

If, from the perspective of this poetry, the world is mysterious, this mysteriousness does not evade any form of description; rather it can be described according to the bonds between the seen and the almost seen, between what appears and the invisible, as the peripheral, marginal, or horizonal. The quotidian in modern literature is often depicted at the cusp of transformation by virtue of this attendant marginality; this transformation is provoked, as discussed in previous chapters, by intense attention to the ordinary perceptual world. The mysterious involves a kind of reversal which Husserl has attributed to the work of imagination: the imaginative fantasy in phenomenological explication tarries with potentiality such as to "make the invisible visible" (48). The world can seem mysterious when the tacit, the recessive, the marginal become indicated or apparent—through some kind of "tacit knowing" or sense—in surprising and incalculable ways. Mysteriousness evokes what evades any ordinary manifestation, or what cannot be experienced within the parameters of ordinary expectations of the world; but it need not—and does not in Frost and Rilke—affirm a transcendent realm more significant than or wholly beyond the world. In Rilke's *Sonette an Orpheus (Sonnets to Orpheus),* for instance, a figure of poetical synthesis joins in harmony the realm of the visible and invisible, life and death, present and absent. Orpheus's song keeps open what Rilke calls a "dual realm" (Doppelbereich) between the actual and the potential or that which lies beyond it, invigorating a sense of world that is irreducible to the actual, present, or given.

Since in the previous chapter some ways have been discussed in which Rilke's poetry is analogous to the phenomenological project, there is no need here for an account of the phenomenological approach to interpreting his poetic-literary works. It should become clear in the present chapter's study of the *Sonnets to Orpheus* that the unified texture or tissue of world—its world-

hood—can be regarded as the work of poetic synthesis, analogous in some respects to the syntheses performed by consciousness as Husserl describes it. The poet-figure to whom Rilke's sonnets are addressed is the mythological Orpheus who, according to legend, sang so divinely that all of nature hearkened to his call. Orpheus was thus able to charm the god of the underworld and bring back his dead wife, Eurydice, until, forgetting his promise, he glanced back to see her and lost her forever. Although Rilke's sonnets are only loosely based on this legend, the Orpheus figure serves a hermeneutic role. The moment before his ultimate loss, Orpheus seems emblematic for holding open what Rilke calls "the pure relation" (den reinen Bezug) (Rilke, KA III, 263) between life or nature and what is called in the essay "Erlebnis" "the other side of nature" [die andere Seite der Natur] (KA IV, 667). In light of the Orphic theme, the precariousness of this relation to the mysterious emerges as one of the reigning concerns of the sonnets.

Aspects of the Mysterious in *Sonnets to Orpheus*

Rilke considered the sonnets the most mysterious of his poems for the way they emerged in a sudden overflow of inspiration in February 1922. Their apparent inspiration was twofold. First, it is indebted to the Orpheus legend, an illustration of which hung in the Château de Muzot, where Rilke was staying at the time he wrote the poem cycle in an intensely contracted period of inspired writing during which he also finished the elegies. The second source was apparently a friend's daughter, the dancer Vera Ouckama Koop, who had died young and to whom he dedicated the cycle. In some sense Rilke seems to have taken the task upon himself, as Orpheus did for Eurydice, to hold open the relation to the realm of the other side, which the dead girl symbolizes for him. In a letter to his translator Witold von Hulewicz (November 13, 1925), Rilke writes that the *Sonnets* (in M. D. Herter Norton's translation, with partial necessary reference to Rilke's German) are "placed under the name and protection of the dead girl whose incompletion and innocence holds open the door of the grave, so that she, gone from us, belongs to those powers who keep the half of life fresh and open toward the other wound-open half" [zu jenen Mächten gehört, die Hälfte des Lebens frisch erhalten und offen nach der anderen wundoffenen Hälfte zu] (Rilke 1942, 136; KA III, 711). This holding open the door receives a concrete poetic possibility in the invocation of Orpheus, in whose song all beings were drawn together in unity; the sonnets evoke the invisible potential horizon of things that the song to which Rilke refers praises and brings into poetic intimacy. The dedication to

the girl, who as the dancer figure in the second part of the sonnets, becomes a symbol of the incompleteness of living things, of their becoming and so relation to both being and death, and thus to that horizon. This recalls the importance for Rilke of the child-figure, in the elegies and other works discussed in chapter 2. In the sonnets, Orpheus becomes a figure symbolic of unification of the incomplete realms of life and death.

Rilke's sonnets are divided into two sequences of twenty-six and twenty-nine poems each. Their subject matter is diverse, which in part makes approaching the poems difficult. The connections between the individual sonnets are not always obvious. Also adding to their difficulty, as Rilke admits, are their "condensation and abbreviation (in the way they often state lyric totals instead of lining up the stages necessary to the result) that they seem intended to be generally grasped rather through inspiration in those similarly directed than with what is called 'understanding'" (Rilke 1942, 130). This abbreviation makes any phenomenological reconstruction of their generation highly speculative. Their concern is with perception of objects, both human-made (jugs, rings) and natural (trees, flowers, and fruit); time and space; death and the wholeness of being; the acceleration of the machine age which negates or neglects this wholeness. In a letter of 1923, Rilke described the sonnets as framed by the intertwining themes of death and love, their intertwining belonging to the mystery of life; the poems are about what he calls "the determination constantly maturing in me to keep life open toward death, and, on the other hand, the intellectual necessity of instating the transformations of love differently in this wider whole than was possible in the narrower orbit of life (which simply excluded death as the Other). It is here that one should, so to say, seek the 'plot' of these poems" (ibid.). The following sonnet (I, 14) concerns the relationship of living, transient things—the fruits of nature—to the dead, those who sleep with the roots and invigorate the earth:

> Wir gehen um mit Blume, Weinblatt, Frucht.
> Sie sprechen nicht die Sprache nur des Jahres.
> Aus Dunkel steigt ein buntes Offenbares
> und hat vielleicht den Glanz der Eifersucht
>
> der Toten an sich, die die Erde stärken.
> Was wissen wir von ihrem Teil an dem?
> Es ist seit lange ihre Art, den Lehm
> mit ihrem freien Marke zu durchmärken,
>
> Nun fragt sich nur: tun sie es gern?
> Drängt diese Frucht, ein Werk von schweren Sklaven,
> geballt zu uns empor, zu ihren Herrn?

Sind *sie* die Herrn, die bei den Wurzel schlafen,
und gönnen uns aus ihren Überflüssen
dies Zwischending aus stummer Kraft und Küssen?

And M. D. Herter Norton's translation, slightly altered:

We have to do with flower, vine-leaf, and fruit.
They speak not only the language of the year.
Out of darkness rises a motley manifest
having perhaps the gleam of the jealousy

of the dead about it, who invigorate the earth.
What do we know of their share in this?
It has been their way to marrow the loam
through and through with their free marrow.

The only question: do they do it gladly?
Does this fruit, work of heavy slaves,
push up, clenched, to us, their masters?

Are *they* the masters, who sleep with the roots,
and grant us out of their overflow
this hybrid thing made of dumb strength and kisses?

(Rilke 1942, 43; KA III, 247)

As in earlier sonnets, the fruit is symbolic of the duality of life and death, and
thus it is a *Zwischending* or between- (hybrid-) thing. The fruit we enjoy and
love is, he writes in sonnet I, 13, "ambiguous" (doppeldeutig) in its dual
expression of the tree's life, surrounding its seed, and in its fall and decay, so
as to nurture regeneration. Human enjoyment of the fruit is to allow a savor-
ing of this ambiguity, emblematic of our human finitude. Even our earthiest,
most sensual pleasures involve a nameless occurrence of the unity of love and
death. The previous sonnet joins this in the vision of a child tasting fruit:
"Full round apple, pear and banana, / gooseberry . . . All this speaks / death
and life into the mouth . . . I sense . . . / Read it from the . . . face of a child/
tasting them" [Voller Apfel, Birne und Banane, / Stachelbeere . . . Alles dieses
spricht / Tod und Leben in den Mund . . . Ich ahne . . . / Lest es einem Kind
vom Angesicht] (40; 247). At this sonnet's end, experience, feeling, joy—
Erfahrung, Fühlung, Freude—are brought into relation with death, which
Rilke regards as essential. In an earlier sonnet his speaker declares: "Only who
with the dead has eaten / of the poppy that is theirs, / will never again lose /

the most delicate tone. / . . . Only in the dual realm / do voices become / eternal and mild" [Nur wer mit Toten vom Mohn / aß, von dem ihren, / wird nicht den leisesten Ton / wieder verlieren /. . . Erst in dem Doppelbereich / werden die Stimmen / ewig und mild] (33; 245). Of course the dead, as Rilke conceives of them, have returned from life to the more primal earthly roots. This metaphor suggests that while they no longer belong to life, the dead remain of its very source: "Death is the side of life that is turned away from us: we must try to achieve the fullest consciousness of our existence, which is at home in the two unseparate realms, inexhaustibly nourished by both. . . . The true figure of life extends through both domains, the blood of the mightiest circulation drives through both." For the poet who achieves understanding of the mystery, "there is neither a here nor a beyond, but the great unity" of both (Rilke 1942, 132).

Death and love, then, are equally important themes, joined in Rilke's rendering; for the most embracing kind of love also includes, in its reach and protection, the other side of things, their horizonal beyond which in part constitutes them. For the life of poetic consciousness, death's semi-transcendence holds and protects for Rilke the mystery of presence and invests the quotidian with a mysterious depth, glimpsed in natural phenomena. Finitude is the horizon which gives shape and possibility to all things, he writes in the letter to von Hulewicz, "for the very falling away of time conditions their existing." For Rilke, "transience everywhere plunges into deep being" (Rilke 1942, 133). His interest in openness toward death is an attempt to keep the quotidian open toward the unknown consequences of finitude, rather than shut off in false comforts of present distractions. The task of the poet is to unify this wider whole by taking it into the inward relation of poetic images, thus taking, as it were, the receding background of potentiality as explicitly informing and illuminating the figures of the apparently real. The sonnets present, in condensed and abbreviated form, a lyrical totality without addressing directly the play of association according to which they are generated, without translating that totality into logical or even associative statements. When the activities and things of everyday life are evoked in the poems, they are often transformed through unusual constructions, such as: "Dances the orange" [Tanzt die Orange] and "She slept the world" [Sie schlief die Welt] (KA III, 248, 241). Rilke creates images of unity between the rhythms of life—dancing, sleeping, and in the poems cited above, tasting and eating—and the life-infused things of the world, indeed the world itself.

The Orpheus myth concerns the relation between this known side of life and the mysterious beyond which is made accessible through poetic song. Orpheus, as the one who "has lifted the lyre among shades too" (die Leier

schon hob / auch unter Schatten), who has entered the underworld, is al-
lowed the "infinite praise" (das unendliche Lob) of poeticizing (KA II, 245).
It is because the figure of Orpheus, like the dead girl's, is characterized by this
transcendence, that he serves Rilke well in his desire to address the mysterious.
From the first sonnet of the series, Orpheus and his song are associated with
"pure transcendency" [reine Übersteigung] (241). Orpheus transcends the or-
dinary relation (prosaic) language and ordinary habitual attitudes of life have
to things, a relation which Rilke conceives as relying upon polarized opposites,
for instance the cleavage (Zwiespalt) between being and nonbeing. Rilke's
references to Orpheus are marked by a repetition of German verbs that indi-
cate a crossing of such boundaries: *übertreffen, überschreiten, übersteigen.* "In
that his word transcends the being-here/ he is already there, where you cannot
follow" [Indem sein Wort das Hiersein übertrifft / ist er schon dort, wohin
ihrs nicht begleitet] (243/25). In the last line of this sonnet, Orpheus oversteps
(überschreitet) boundaries even as he obeys them; and so Orpheus enters into
relation with the mystery of things and their transience. Not only natural
things, but even ordinary things of human making—"finger-ring, clasp, and
jug"—are recognized as mysterious, for they, too, belong to the dual realm of
the here and the beyond. Their transience creates intimacy with our own; and
so we must, according to Rilke, resist the will to "run down and degrade
everything earthly, just because of its temporariness, which it shares with us"
(Rilke 1942, 133). Everything poetry renders draws it into the metamorphosis
of Orpheus, his transcendence from the here to the beyond and back; this is
the movement between life and death, which together constitute the dual
realm or both realms to which Rilke's sonnet series repeatedly refers (*Sonnets*
I, 9 and I, 6). In sonnet I, 6, the speaker asks: Is Orpheus of this realm?

> Ist er ein Hiersiger? Nein, aus beiden
> Reichen erwuchs seine weite Natur.
>
> (KA II, 243)

But he does not belong to this side of the world: rather his wide nature grew
from both realms. Memorialization of Orpheus and his sublime gifts happens
in the carrying on of poetry, such as in these sonnets; for it is poetry that
keeps alive his song. This is why the speaker enjoins us not to set up a stone
to his memory, but rather to see in the blooming of the rose a dedication to
Orpheus. The flower comes into being and passes away, and in this, as in the
death of the young girl, Rilke finds the mysteriousness of the wider circuit to
which things belong.

Seen in this light, natural things are both alive and dying, stable and tran-

sient. All things are like the wine from the vineyard, the substance savored by Orpheus and those who hear his praise and lament. Wine is particularly symbolic here, for it is the decay of living grapes that brings forth succulence and celebration. Wine is thus emblematic of the *Zwischending*. Here again, Rilke resists any final distinction between here and beyond, reality and appearance, life and death, poetry and silence. Orpheus is held to be "one of the remaining messengers, / who still holds far into the doors of the dead/ bowls with praising fruits" (244). Through Orphic poetry all things are gathered into a whole.

Poetic Synthesis and Phenomenological Constitution

The praise of Orphic song might be approached with the notion of synthesis. Poetic synthesis is central to both the form and the content of Rilke's sonnet cycle. The poet's task is to draw together the prosaically opposed realms of life and death, the visible and the invisible, the known and the unknown. In respect to the perceived object, synthesis brings together the presence of the thing with its "withdrawn" (Entzogenes) element, the "unheard-of center" (die unerhörte Mitte) the "specter of transience"[das Gespenst des Vergänglichen] (KA II, 269, 272, 271). In describing Orpheus's poetic endeavor, Rilke employs the terms "song" (singen, Gesang), "praising" (Rühmung), "longing" (Sehnsucht), as well as "hearkening" (das Hören) with which beings respond to the poetic call. These terms suggest the draw toward synthesis as both the theme of the sonnets and their own formal accomplishment. Rilke's poeticizing of things in song involves his praise of Orpheus and of the pure relation, a longing for a world in which the dead girl's loss would not be absolute but recognized as life's other side. In the second part of the sonnets this is joined to a lament over the modern technological age, its destructive rejection of the transient and ignorance of the part of the world that lies beyond the useful and visible, the incapacity to recognize and harbor the mystery of things.

Poetic synthesis is opposed to what Rilke seems to consider the modern form of technological subjectivity, which reduces the world to the data of the statically given, the unmysterious, the "dull quotidian" (den stumpfen Alltag) (Rilke KA II, 268). As Rilke's speaker claims in an early sonnet about Orpheus's poeticizing, poetical synthesis draws things together without imposition of the poet: "Song, as you teach it, is not desire, / not suing for something yet in the end attained; / song is existence" [Gesang, wie du ihn lehrst, ist nicht Begehr, / nicht Werbung um ein endlich noch Erreichtes; / Gesang ist Dasein] (Rilke 1942, 21; KA II, 242). Neither subject nor object is primary but

rather the relation to things which is created in the song of praise to Orpheus. In this way Rilke evokes a mysterious quality of the world poetically rendered, its inexhaustibleness and strangeness, of which we ought to be made aware through poetry. This involves the constant reference to mundane things, regarded not with a disdainful eye but with recognition of their world space. But consciousness too must be awakened from its tendency toward a prosaic grasp and reception of the world, its tendency to dominate or objectify things. Poetry is then distinguished from ordinary representational language, with which, Rilke's speaker claims, "*We*, with words and finger-pointing, / gradually make the world our own, / perhaps its weakest, most precarious part" [*Wir* machen mit Worten und Fingerzeigen / uns allmählich die Welt zu eigen, / vielleicht ihren schwächsten, gefährlichsten Teil] (47; 248). Poetry does not externalize a meaning held by consciousness but goes out to the concealed source of things. And this, too, is in opposition to the practical life of the technological subject, which according to Rilke, "wallows and wreaks revenge,/ distorts and weakens us" [wälzt und rächt / und uns entstellt und schwächt] (51; 249). The concern for the destructiveness of modernity is found again and again in lines of the second half of the first series (sonnets 18, 22, 23, 24), the final poem of which (sonnet 26) renders an account of the dismemberment of Orpheus by the Maenads. The reductive nature of modernity is also the theme in many of the sonnets of the second part. While, from the speaker's point of view, the machine age is destructive, Orpheus's poetic synthesis taught all beings to hearken to nature's wholeness, with immeasurable horizons surrounding what is given in actual presence.

While the mysterious in Rilke's poetry can be approached through the notions of actuality and potentiality in the synthesis of world-constitution, the analogy is limited. A critique of the epistemological affiliation between Rilke's poetry and phenomenology, maintained by Käte Hamburger, was presented in the previous chapter (cf. Hamburger 1971). With respect to the problem of synthesis and constitution, the divergences between poetic and phenomenological renderings are threefold. The first concerns the describability of the world. Rilke's poetic investment in finitude and limitation, in the radical transience of what is perceived and known, informs his notion of the other side of phenomena or of nature. The transient is taken into the world's inner space by poetic consciousness, but must remain and be affirmed, at least for human consciousness, as inherently beyond description, life's other side, evocable only through the indirect means of poetic song. Although we can think of the Husserlian world as attended by the horizon of potentiality surrounding all given phenomena, the world for Husserl is in principle describable, though in practice it is beyond the grasp of any reflecting consciousness,

since its potential variations are infinite. Second, for Rilke the horizonal potentiality is not restricted to potential actuality, as it is in Husserl. What extends beyond the phenomena of the actual, as things recede into nonbeing and absorb a poetic margin of this finitude, includes those realms that are inherently interphenomenal and cannot become manifest. While the phenomenologist would have to be content to describe what appears and co-appears in their potential variations, arriving with the eidetic variation and reduction at essences, poetry must venture to evoke what otherwise never could appear except indirectly, as suggested through images or evoked in the interstices of metaphor, discussed in the previous chapter. The constitution of a world in Husserl's terms is describable within the phenomenological method, because the horizon of potentiality is predelineated and structured by actuality. Rilke strays far from the phenomenological project in that for poetic synthesis, it is the absent, the horizonal, that is to give meaning and fullness to actuality. The horizonal remains to be uttered in the resonant, residual song of Orpheus, who stands for the "magic power at your senses' crossroad / . . . and the meaning of their strange encounter [Zauberkraft am Kreuzweg deiner Sinne, / ihrer seltsamen Begegnung Sinn] (Rilke 1942, 272; KA II, 127).

The Mysterious in the Poetic Image

The poetic image offers a unique focal point for phenomenological investigation, because it claims a special status in what Husserl called "intuitive presentation" (anschauliche Vergegenwärtigung). The poetic image is neither an object of direct perception, nor a cognitive idea, but is constituted in a passive and spontaneous synthesis as provoked by language. The poetic image is temporal, in its individual flicker as well as in its successive and modifying relationship to other images. It is also spatial, not only in its textual space, but in its capacity to evoke an intuition of lived spatiality, such as in Bachelard's analysis of poetic images of insides and outsides, of houses and rooms, where he observes a "topography of our intimate being" (Bachelard 1994, 36). The poetic image both presents the world and strays from direct reference. For the poetic image is not reducible to the function of representing for mental vision, as poetic images can both picture elements of the visual world and present the un-picturable through linguistically immanent evocations. In *Creative Evolution*, Bergson associates poetic images with a generative idea:

> The generative idea of a poem is developed in thousands of imaginations which are materialized in phrases that spread themselves out in

words. And the more we descend from the motionless idea, wound
on itself, to the words that unwind it, the more room is left for
contingency and choice. Other metaphors, expressed by other words,
might have arisen; an image is called up by an image. . . . All these
words run now one after another, seeking in vain . . . to give back
the simplicity of the generative idea. . . . But our mind, by successive
bounds, leaps from the words to the images, from the images to the
original idea, and so gets back, from the perception of words—
accidents called up by accidents—to the conception of the Idea that
posits its own being. So the philosopher proceeds, confronted with
the universe. (Bergson 1944, 348)

But what generates a poem is not a motionless idea which words strive in vain
to represent; poetic images do not try to catch up to a primordial idea the
way a philosopher tries to account for reality. They admit a spontaneity of
their own. While the poem can be prompted by an initial image, a string of
words, a vague notion, the poet often *discovers* the subject-matter in and
through the language in which the poem finds its being, a discovery to which
Bergson attributes the accidental. Modern poems are often as much about the
poetic striving toward signification as they are about their explicit subject
matter or idea. Spontaneity suggests the unforeseeable nature of poetic images
which are inexplicable according to a logical or associative motivational cau-
sality; and so images might harbor the inexplicable mystery rendered at the
margins of life. One of Rilke's Orpheus sonnets (I, 9), cited in part above,
reflects on the image as joining life and death. The poem concerns the poet's
singing to the dead in the underworld, yet through a perplexing symbolism
brings them to life by virtue of memorialization in a perpetual voice. The
oblivion of forgetting is paradoxically countered by their eating poppies with
the poet, a flower associated, in Greek mythology and pharmacology, with
oblivion, sleep, and death.

> Nur wer die Leier schon hob
> auch unter Schatten
> darf das unendliche Lob
> ahnend erstatten.
>
> Nur wer mit Toten von Mohn
> aß, von dem ihren,
> wird nicht den leisesten Ton
> wieder verlieren.

Mag auch die Spiegelung im Teich
oft uns verschwimmen:
Wisse das Bild.

Erst in dem Doppelbereich
werden die Stimmen
ewig und mild.

[Only one who played
the lyre among the shadows
may intimating repay
the infinite praise.

Only one who has eaten
poppies with the dead
will never lose again
the softest tone.

Though reflections in the pond
may also often confuse us:
Know the image.

Only in the dual realm
do the voices become
perpetual and mild.]

(Rilke 1942, 32/33)

The reader of poetry who is to learn from Orphic poetics must know the image. Images are not empty shadows, but living reflections, just as the shades in the underworld who eat poppies and are sung to are emblematic for the horizon of the poet's world. The third stanza marks a leap from the description of Orpheus eating poppies with the shades to an imperative "wisse das Bild" or "know the image." The image is linked by the adverb *erst* in the final stanza to the voices becoming perpetual, overcoming the confusion of transience through poetic acceptance. The leap from the image of shades eating poppies to the wavering image in the pond is made by the voices becoming infinite and mild of in the final line, with a curious necessity. In Frost's poem "For Once, Then, Something," this excess of signification is indicated by a question about the flickering white that interrupted the speaker's ordinary perception, his customary looking into the well. He asks is it "Truth? A pebble of quartz?" The answer is only the "for once," affirming the appearance of the indeterminate, mysterious, but real: "something."

Bachelard's phenomenology of the poetic image helps to explain the role of images in 'rendering' the mysterious. The mysterious finds expression in the poetic image in that "the reader of poems is asked to consider an image not as an object and even less as the substitute for an object, but to seize its specific reality" (Bachelard 1994, xix). The creativity of poetical images must then involve a kind of fulfillment of creative intention, not merely reproducing but generating a level of 'reality' in expressing what cannot be conceptualized. This intention is both passive, through association and synthesis, and a striving, a progression forward toward fulfillment. How does the poetic image contribute to this generation? In poetical images and their "reverberation" (le retentissiment), as Bachelard calls it, borrowing from Minkowski, there is a condensation of experiential temporality—what in phenomenology is regarded as retention, attention, and protention—and in their unfolding, an interior spatiality (Bachelard 1957, 2). Poetic images and their collaboration in a poem capture a condensed and thus intensified experience of the inter-involvement of space and time in productive generation. The reverberation of poetic images attests to both their temporality and their virtual spatiality; and this togetherness is linked in notion of life. Bachelard writes:

> If, having fixed the original form in our mind's eye, we ask ourselves how that form comes alive and fills with life, we discover a new dynamic and vital category, a new property of the universe: reverberation (*retentir*). It is as though a wellspring existed in a sealed vase and its waves, repeatedly echoing against the sides . . . filled it with their sonority. Or again, it is as though the sound of a hunting horn, reverberating everywhere through its echo, made the tiniest leaf, the tiniest wisp of moss shudder in common movement and transformed the whole forest, filling it to its limits, into a vibrating, sonorous world. (Bachelard 1994, xvi)

This new property of the universe need not and probably cannot be fully conceptualized. It indicates a poetic horizon of things that admits a recessive incalculability.

Like echoes, which bring to our awareness time through space and space through time, poetic images form a microcosm of life through spatio-temporal fulfillment. One of Rilke's poems about roses, "Das Rosen-innere," attests to the dispersal and overflowing of this kind of fulfillment. The poem gives off successive waves of images of summer's fulfillment and finitude. As in T. S. Eliot's "Burnt Norton," where a rose garden is the scene of "our first world," each image reverberates with the next, generating a poetic spatiality that be-

comes explicitly thematic here when summer is identified as "a room in a dream." Rilke's poems of roses—not unlike William Carlos Williams', for whom the "fragility of the flower/unbruised/penetrates space" (Williams 1949, 27) annul the ordinary distinction between inwardness and outwardness.

Das Rosen-innere

Wo ist zu diesem Innen
ein Außen? Auf welches Weh
legt man solches Linnen?
Welche Himmel spiegeln sich drinnen
in dem Binnensee
dieser offenen Rosen,
dieser sorglosen, sieh:
wie sie lose im Losen
liegen, als könnte nie
eine zitternde Hande sie verschütten.
Sie können sich selber kaum
halten; viele ließen
sich überfüllen und fließen
über von Innenraum
in die Tage, die immer
voller und voller sich schließen,
bis der ganze Sommer ein Zimmer
wird, ein Zimmer in einem Traum.

[The Rose's Innerness

Where is to this innerness
an outwardness? Upon what ache
could one lay such linen?
What heavens find their reflections
in the interstitial lake
of these wide open roses,
these carefree floating blossoms, see:
how loosely they lie in their looseness,
as if a trembling hand
could never spill them.
They barely manage to hold themselves;
many of them let themselves

> be filled to overflowing
> and now flow over with inner space
> into the days that ever more fully
> encircle them, until the whole summer
> becomes one room,
> a room in a dream.]
>
> (Rilke 1986, 224; KA I, 569)

The delicate images in this poem serve to extend a mysterious inwardness, ordinarily felt only in consciousness, to the physical world. The entire rose becomes intimate in the speaker's regard, exposing an inside that admits no outside, and where any boundaries will be restored only in a dream that encompasses time, all of summer. The poem opens with a question that is only resolved by the poetic transformation of the whole scene in the final lines, and resolved only by being taken up or harbored in a dream image. Of the opened rose, the speaker then asks, what heaven could be reflected in the metaphorical sea of its openness? The speaker seeks in vain an outward side to this innerness of the rose, with its petals, usually cradled together intimately like an interstitial lake (Binnensee). The rose exposes its inner space as endless and immeasurable, such that the speaker acknowledges no external heaven will be reflected there, questioning rhetorically whether any could be so reflected. The rose is open but paradoxically sheltered in being open, so that the inside cannot be made exterior despite the ripeness of the summer season in which it opens. This innerness is paradoxical: made by the enfolding self-protective petals of the rose, it is also carelessly manifest by the rose; the petals can hardly hold themselves together but remain undisturbed. It seems that a trembling hand could never spill them, could never make them fall into that outwardness of being un-centered. The rose image, open and precarious, becomes the center for the perpetually unfolding days of summer, so that its own careless self-containment takes on an elemental function of anchoring time in timelessness. As the days gather around the rose, summer itself becomes a shelter like a room in a dream. The dream suggests the protection of what would be summer, its life and ripeness, as well as the mysterious inner space of the rose which manifests that summer life, within a pretheoretical, prerational realm of consciousness, never given in immediate perception. Though out of reach of everyday experience—according to which the rose would have been assigned boundaries, in which its innerness would become unrecognizable—the dream is of the margins of the world, an image of which then displaces the dominant manifestation of ordinary reality, along with any other-worldly heaven that would represent a truer reality.

Everydayness and the Mysterious in Robert Frost

Frost's poetry continually turns to the dark earthly sources of mystery that subtend everyday experience. An analogous return from the possible contemplation of an otherworldly source (a heaven) for the mysterious halo of worldly phenomenal reality occurs in Frost's poems "For Once, Then, Something" and "A Boundless Moment," both from 1923. While Rilke's poem cited above begins in a mood of heightened and ecstatic poetic perception, where a transfer from ordinary seeing has already taken place, Frost's poems present the rather more modest but equally provocative moments where such transformation is initiated for the speaker. In the first of these poems, the speaker looks into a well at an image on the surface of the water, and glimpses something white behind the image, beneath the familiar ripples, emerging from its fluid ground. Here, as in "A Boundless Moment," Frost engages the shift in perception as something unexpected is perceived in the background of or gaps between familiar things. In considering the phenomenology of vision, Merleau-Ponty provides a helpful description of attention to the ordinary world which can easily be transformed through this kind of perceptual shift; a person "contemplating the wallpaper in his room suddenly sees it transformed if the pattern and figure become the ground while what is usually seen becomes the figure. The idea we have of the world would be overturned if we could succeed in seeing the intervals between things (for example, the space between the trees on the boulevard) as objects and, inversely, if we saw the things themselves—the trees—as the ground" (Merleau-Ponty 1964b, 48–49). While Merleau-Ponty does not go on to say what this overturned world would look like, this inversion of the everyday relation between background and foreground introduces a standpoint from which things might begin to appear informed by another level of reality, an ordinarily unavailable source which is never wholly present, but for privileged moments, recedes. This occurs in Rilke's rose poem when the *Binnensee* of the rose's openness, rather than the dispersed petals, becomes the focus of the speaker's attention. In Frost's "A Boundless Moment" the speaker's companion stops during a seemingly ordinary March walk to contemplate a mysterious pale vision in the distance among the maples. Like Rilke's rose poem, Frost's poem begins with a question:

A Boundless Moment

He halted in the wind, and—what was that
Far in the maples, pale, but not a ghost?

He stood there bringing March against this thought,
And yet too ready to believe the most.

"Oh, that's the Paradise-in-Bloom," I said;
And truly it was fair enough for flowers
Had we but in us to assume in March
Such white luxuriance of May for ours.

We stood a moment so, in a strange world,
Myself as one his own pretense deceives;
And then I said the truth (and we moved on).
A young beech clinging to its last year's leaves.

 (233–34)

The opening words and punctuation—"He halted in the wind, and"—effect
an interruption that is revealed to be caused by a sudden vision of something
surprising, ghostly, and unexplained. There is a "what" but not yet a judg-
ment as to what that might be; there is recognition of the object only as a
pale undetermined something.

 While the companion halts to consider the vision, the wind blows, so that
the human pause stands out against the inarticulate and continuing presence
of a natural force which becomes an indeterminate and borderless background
for his thought. The three stanzas present three possible attitudes about the
vision: in the first the companion asks if it might be a ghost, and yet struggles
with the sense of season, reminding himself of March and implicitly of what
white flora might appear. In the second the speaker determines the vision
with assuredness despite its unlikelihood, looking to a natural explanation:
the pale appearance is the flower "Paradise-in-Bloom," a May flower the early
appearance of which would be also mysterious, though the flower's existence
in itself is not. While Rilke's speaker savors and leaves unanswered his largely
rhetorical question, since it addresses an enveloping intimacy of something
beautiful rather than a ghostly uncertainty, the indicative mood of Frost's
speaker suggests a desire to close down the mystery and identify the unknown
phenomenon. The third stanza concludes with the "truth" about the mystery:
it was "a young beech clinging to its last year's leaves," an image sharply
contrasted to the forward-looking anticipation of a blossoming white flower
of paradise. Rather than forward looking toward paradise (and thus to some-
thing in another future world) the phenomenon is identified with death and
a merely material clinging to the bare physical past. The seeming finality of
the answer precludes any speculation about the inexplicable presence of white
in the snowless landscape. But the way the image is contextualized, as well as

the image itself, suggests a lingering mystery. The copse of maples surprisingly contains a single tree of a very different appearance. The verb "clinging" suggests that the tree, unlike the surrounding maples, thwarts the ordinary progression of the seasons, and that there is in this personified activity both anxiety and childishness. The image of a young beech with dead leaves itself evokes an unsettling contrast, since the new foliage should push out the old leaves and the tree's youth should erase this evidence of aborted regeneration. The clinging to the leaves suggests both futile (childish) self-protection and immanent death. The mystery is maintained despite being identified by the ambiguous phrase "its last year's leaves," for it is unclear whether this means only the leaves of the previous year or also the leaves of the tree's own final year of life. But it is in the third stanza's first line where the mysteriousness of the vision has blossomed into an inextinguishable sense of transformation: "We stood a moment so, in a strange world" (233). This spatial description of the experience indicates that the whole sense of place has become defamiliarized.

In addition this defamiliarization is radicalized by the poem's title. The moment wherein the ordinary March landscape is turned into a "strange world" by a brief perception of an unidentified ghostly something "far in the maples" is, the title indicates, a "boundless moment." This boundlessness suggests both the infinity of space (of the strange world, no longer determined by familiar parameters) and of time, since what turns out to be the tree clinging to dead leaves has unsettled the ordinary processes of seasonal change and produces a sense of boundlessness linked to the end and endlessness of death. Though on a significantly darker tonal register, this poem resonates in some ways with Rilke's rose poem: both engage the relation of a single visual phenomenon of nature for contemplation and seeming infinitization of the season (Rilke's summer, though bounded in a room, is liberated from its impending end by its status as dream; Frost's tree through its refusal to yield to seasonal change); both indicate the precariousness of the phenomenon (Rilke's blossoms barely manage to stay afloat while Frost's young birch clings to dead leaves); both provoke transformation of the speaker's world by metaphoric spatial expansion (the sea of the roses, the boundlessness of contemplating the unidentified whiteness). In both poems, though to differing degrees and in quite different emotional suggestions—the life-affirming evocation of perpetual summer or the darker evocation of a final winter in springtime—the mysterious is evoked through the fragility of a briefly contemplated vision that deepens perception of the world beyond its usual inner horizons.

In "For Once, Then, Something," another level of reality is felt in a myste-

rious encounter as an ordinary scene is briefly penetrated by something un-
known. As in Hofmannsthal's "Weltgeheimnis," a child peers into a well:

> For Once, Then, Something
>
> Others taunt me with having knelt at well-curbs
> Always wrong to the light, so never seeing
> Deeper down in the well than where the water
> Gives me back in a shining surface picture
> Me myself in the summer heaven, godlike,
> Looking out of a wreath of fern and cloud puffs.
> *Once,* when trying with chin against a well-curb
> I discerned, as I thought, beyond the picture,
> Through the picture, a something white, uncertain,
> Something more of a depths—and then I lost it.
> Water came to rebuke the too-clear water.
> One drop fell from a fern, and lo, a ripple
> Shook whatever it was lay there at bottom,
> Blurred it, blotted it out. What was the whiteness?
> Truth? A pebble of quartz? For once, then, something.
>
> (225)

This poem suggests a mysterious primal depth that seeps into quotidian expe-
rience and yields a questioning of ordinary reality. The speaker experiences
the beckoning of elemental life—a something—that evades identification. He
begins by setting himself apart from others, and apart from ordinary ways of
seeing, and so he is already situated for exposure to mystery. He kneels at the
curb "always wrong to the light" so that he is unable to see the depth of the
water. His gaze is stopped at the water's surface, which becomes a mirror for
the image it throws back. The image is of the speaker himself, elevated to a
god-like perspective as it seems he is peering down from the sky. The *"Once"*
breaks through this illusion, which seems to have been, however, the necessary
condition of what follows. He begins to see deeper, through the picture,
something white and uncertain, "more of a depths." The "something," which
disturbs the expected vision, arouses a feeling of wonder and ultimately re-
gret—"and then I lost it." When a drop of water falls from a fern into the
well, the perception is lost, a loss registered by three transitive verbs: shook,
blurred, blotted. But this thrice-registered loss is followed by three questions,
suggesting the persistence of the mystery even as the speaker returns to ordi-
nary seeing. "What was the whiteness? / Truth? A pebble of quartz?" The
answer is much more evasive than in "A Boundless Moment." It affirms nei-

ther of the two named possibilities: "For once, then, something." The construction of the phrase, slowed by two commas and the word "then," suggests a disruption of the speaker's ordinary expectations, a conviction that something extraordinary had finally been perceived.

The disruption of the quotidian by the mysterious appearance is prefigured by several tensions in the poem. As in Merleau-Ponty's description of seeing the interstices of the pattern rather than the positive structure, the speaker experiences a shift in visual perception. There is a tension between looking (at what one intends to see) and seeing (what appears unexpectedly). Beyond mimesis, the reflection in the water presents a tension between surface and depth. This is equivalent to the tension between the visible and the invisible, the apparent and the unknown, the conscious and the darkness that subtends thought, often evoked by Frost in connection with natural physical phenomena (for instance in "Leaves Compared with Flowers" of 1936). The speaker discerns not only "beyond the picture" but also "through the picture," suggesting that the picture, the illusion of the speaker as god in the clouds, is a necessary illusion that must be displaced in order for something truer—perhaps truer than the face of any anthropomorphized and heavenly god—to be perceived. The occasion, introduced by "once," breaks the ordinary temporal flow of habitual experience. This is given spatial extension in the speaker's looking "beyond" and "through." The poem then builds up a momentary space, in which the under-determined "something" will appear within the recognizable world.

The poem begins with a playful description of self-certainty, how the speaker has always looked into a well always "wrong" to the light so that not the bottom but the surface reflection—including the light itself—is returned in an image. He would deliberately look into the well at an angle that made ordinary seeing impossible. This habit allowed the speaker to look at himself in a heaven of cloud-puffs, as if he were a god, and the ordinary purpose of looking, seeing all the way to the bottom of the well (to the thing-in-itself?) would be disrupted by self-perception. Here is Frost's implicit critique of human subjectivity: we see ourselves first, and perhaps narcissistically, within a world governed by our own expectations; we project our own image onto the clouds. That which "came from the depths" disturbs this self-projection. It appears just for a brief moment not from the godly heaven, associated with illusion, but from out of the elemental water. As in Nietzsche's celebration of the earthly world, the mysterious comes not from the intervention of the divine, but from the elemental source of material existence which, however, is irreducible to what can be fully known. There is a similar suggestion of mystery in one of Frost's later poems, "Directive," to be discussed shortly,

where the reader is referred to the "waters" and the "watering place," sugges-
tive both of the elemental physical world and the fluidity of imagination. To
these as primordial sources we must return—and here Frost is less Dionysian
than Nietzsche—in order to achieve a clarity "beyond confusion."

In "For Once, Then, Something," this something "white" and "uncertain"
evokes the possibility of a truth not available to everyday perception, but
remaining at its margins. Ecstasis is here only hinted at. Water, the worldly
element that projected the image, came to "rebuke" its own generosity, and a
drop from the fern falls to blur and blot out the luminous appearance. This
fleeting, uncertain perception of something that might be truth, which throws
the speaker into a moment of self-doubt, provokes a potential ecstasis, as it
breaks through ordinary representations of world so that something deeper
and ordinarily elusive might appear, just as in "A Boundless Moment" the
ordinary March landscape became for a moment "a strange world." The mys-
terious in its near-appearance is not necessarily contrary to knowledge, but it
does not yield to final knowledge. In "A Boundless Moment" there is no
explanation of why or how the beech tree clings to its dead leaves, only the
sense that its ghostly paleness disturbs the ordinary world, such that it was
tempting to hold on momentarily to the "pretense" that these persistent dead
leaves could be flowers ahead of their season, and perhaps the pretense that
the paradise of the future can blur a vision of the pastness of death. In "For
Once, Then, Something," knowledge is not itself repudiated but opened to a
realm beyond the certain or verifiable, while the pretense of clarity is likewise
rebuked.

"Directive" announces a more radical break with ordinary perception, for
the disruption of quotidian experience evoked in the poems discussed above
opens up a more complex and unsettling journey into the realms of memory
and imagination. The poem was published in the wake of the Second World
War. Frost's speaker emerges from a crisis, juxtaposed with memories of the
past, a childhood that is remembered, perhaps by virtue of naïveté, to have
been characterized by a moral, spiritual, or quasi intellectual clarity. The
speaker's mind returns to a childhood place, a small-town rural landscape,
which no longer exists, and describes the return to this now-inner place as a
journey through all of the decay, injury, and erasure to which that reality has
been subjected. The journey is not a certain one, for the guide to which the
speaker refers—is it memory? or consciousness? or the imagination itself?—
"only has at heart your getting lost." The speaker seeks to arrive at a restora-
tion of self, to regain a wholeness the present is painfully lacking (377–79). In
several ways the poem affirms an acceptance of the mysteriousness of life and
its resistance to the absolute clarity demanded by the understanding:

Directive

Back out of all this now too much for us,
Back in a time made simple by the loss
Of detail, burned, dissolved, and broken off
Like graveyard marble sculpture in the weather,
There is a house that is no more a house
Upon a farm that is no more a farm
And in a town that is no more a town.
The road there, if you'll let a guide direct you
Who only has at heart your getting lost,
May seem as if it should have been a quarry—
Great monolithic knees the former town
Long since gave up pretense of keeping covered.
And there's a story in a book about it:
Besides the wear of iron wagon wheels
The ledges show lines ruled southeast-northwest,
The chisel work of an enormous Glacier
That braced his feet against the Arctic Pole.
You must not mind a certain coolness from him
Still said to haunt this side of Panther Mountain.
Nor need you mind the serial ordeal
Of being watched from forty cellar holes
As if by eye pairs out of forty firkins.
As for the woods' excitement over you
That sends light rustle rushes to their leaves,
Charge that to upstart inexperience.
Where were they all not twenty years ago?
They think too much of having shaded out
A few old pecker-fretted apple trees.
Make yourself up a cheering song of how
Someone's road home from work this once was,
Who may be just ahead of you on foot
Or creaking with a buggy load of grain.
The height of adventure is the height
Of country where two village cultures faded
Into each other. Both of them are lost.
And if you're lost enough to find yourself
By now, pull in your ladder road behind you
And put a sign up CLOSED to all but me.

Then make yourself at home. The only field
Now left's no bigger than a harness gall.
First there's the children's house of make-believe,
Some shattered dishes underneath a pine,
The playthings in the playhouse of children.
Weep for what little things could make them glad.
Then for the house that is no more a house,
But only a belilaced cellar hole,
Now slowly closing like a dent in dough.
This was no playhouse but a house in earnest.
Your destination and your destiny's
A brook that was the water of the house,
Cold as a spring as yet so near its source,
Too lofty and original to rage.
(We know the valley streams that when aroused
Will leave their tatters hung on barb and thorn.)
I have kept hidden in the instep arch
Of an old cedar at the waterside
A broken drinking goblet like the Grail
Under a spell so the wrong ones can't find it,
So can't get saved, as Saint Mark says they musn't.
(I stole the goblet from the children's playhouse.)
Here are your waters and your watering place.
Drink and be whole again beyond confusion.

Like the other Frost poems discussed in this chapter, this poem too begins with a disruption. However, the temporal transport is more complex. There is, first, a temporal ecstasis effected by the poetic voice. "Back out of all this now too much for us" is how the poem begins; the speaker explicitly steps outside the present moment which has become unbearably confounding. The confusion is highlighted by the use of "all this" rather than a description of any acute crisis, suggesting the failure of ordinary existence to offer the simplicity as it should, and to quiet the chronic confusion that has perhaps cumulatively led to a moment of crisis. The suspension of crisis is made possible by implicit projection of another, poetic level of reality against which that present might be measured and perhaps restored. By the second line of the poem transport to that elsewhere has already been effected, as Frost uses the preposition "in" rather than "to" to describe a transformation: "Back in a time made simple by the loss / Of detail." The first present has been replaced by a poetic duration. The loss of detail that pertains to this duration is not due to abstract

representation, but is the effect of the injuries of time, inflicted perhaps by what have become habitual, adult perceptions of reality: the details are "burned, dissolved, and broken off / Like graveyard marble sculpture in the weather." The metaphor asserted here is that of art, like time, injured by the repetitious nature of the mundane which, seemingly innocuous, ultimately destroys specificity—for what detail is erased on graveyard marble more injuriously than the name of the dead?—and ends only in death. This mundaneness is that of adulthood, in contrast to a childhood wherein transformation of the world is ever possible, as discussed in the second chapter of this book. Yet undoubtedly that burning and breaking off has a second, historical resonance: the destructions wrought by the recent war have made the past less accessible and the transport to a more innocent time inevitably painful. Frost's poem, the poetic duration in contrast to that loss, fosters "directive" to the imagination to regain a sense of self and of a meaningful life in a time of crisis.

Half-way through the poem, having described the meanderings of an imagined return to a place that no longer exists, the speaker again uses the imperative voice, introducing it with an explicit marking of poetic temporality: "By now, pull in your ladder road behind you / And put a sign up CLOSED to all but me." The journey that had been drawn imaginatively through reference both to real geography and imagined landscape turns out to be a mere "ladder road"—an induction to a mysterious, inner poetic place, truer than any ordinary human voice—where the details and their loss no longer hold sway over the understanding. Here the imagination is no longer reproductive, retracing or rearranging the contents of memory, but spontaneously productive of a new level of reality (a poetic time-space) in contrast to both the present which has been left behind and the past which could not be recaptured. In a gradually unfolding moment of ecstasis, the speaker discovers this third possibility of understanding, symbolized by the goblet—productively found by the imagination—out of which the speaker can "drink and be whole again beyond confusion."

Some prosodic aspects of Frost's poem are relevant to its capacity to evoke the marginal implicit knowledge of mysterious sources of renewal. Meter and metric variation are important: the meter is blank verse, unrhymed iambic pentameter, the variations of which are productive of supra-metrical significance that enriches the poem's meaning. The classical meter, by virtue of its traditional nature, itself effects a passage to the past that cannot be directly accessed (does not exist) but must be poetically projected. However, Frost's rhythms are both controlled and surprising. The regularity of the iambic rhythm, and its natural affinity to the English language in which Frost writes,

performs well in this poem, providing at one stroke both a stepping-outside-of ordinary speech, which is not metered, and a reiteration of the regularities of ordinary talking, ordinary doing, ordinary habit through the rhythms of which the details of the simple poetic time have been erased. The metric variations are important. The first line already departs from the iambic pentameter, with a trochee followed by four iambs. The trochee sets the poem off immediately from ordinary descriptive speech, and breaking in after the (only implied) verb leaves it undecidable whether an imperative or indicative mood, whether passive or active (transitive or intransitive) voice, and which tense is suggested. This undecidability is compatible with the development of the poem's themes of breaking out of the ordinary experience and its confusions and reverting to a simpler but as much spontaneously generated as remembered time. The second and third of the iambs exhibit weak and strong stresses—"this now too much"—almost undifferentiated enough to be spondaic, a staccato which forces a dramatic slowing down of the line in which confusion and clarity compete. The second line is also initiated by a trochee, reinforcing the ecstasis demanded by the transport back "out of all this"—this being perhaps the postwar adulthood of humanity—and "in[to] a time made simple"; whereas lines 3 and 4 are highly regular, as if enacting the workings of weather, such as rain, which gradually dissolves the details of the past. The sixty-two lines of the poem weave in and out of rhythmic regularity and irregularity, issuing particularly trochaic and spondaic variations which gradually suggest a demand for completion of meaning—to fill the gaps that have been left by the irretrievability of the past and the incomprehensibility of the present. The penultimate and ultimate lines reproduce the trochaic initiation of the first two lines of the poem, now no longer, however, suggesting undecidability in a yet-to-be-determined space of ecstatic awakening, but in an interior poetic space, free from mere reproduction of the past that is after all irretrievable. "Here are your waters and your watering place. / Drink and be whole again beyond confusion."

The directives (imperatives: drink and be whole) here do not, as at the poem's beginning, suggest uncertainty; the verbs are clearly indicative and imperative; the person is second (you—both the speaker to himself and the reader) and the tense is present. But this present is different from the present at the poem's outset, with its confusions. This poetic present is a production from the elements of the speaker's imagination and from the mysterious nowhere suggested in the symbolic waters from which one is to drink. If the dissolution of the past is troublesome, the future "beyond confusion" provides a liberation both from the burdened initial present and the elusiveness of childhood. This liberation is made possible by the poem's ecstasis, the striving

of the speaker's imagination to transform the given look of the present world in deference to an earlier, original, unknowable source.

Metaphoric language enables a rendering of the mysterious. Almost exactly half-way through this poem, Frost employs one of his most intriguing and complex metaphors: "The height of adventure is the height / Of country where two village cultures faded / Into each other. Both of them are lost." Adventure, suggesting freedom of the spirit and the childhood of memory, is a seeking out of the unknown. The abstract noun is identified with a perhaps both physical and spiritual "height of country" recalling Shakespeare's identification of death as an "undiscovered country." Bringing it closer to Shakespeare, Frost's metaphor is further modified by dissolution and loss. For like childhood and adventure, as well as the religion the speaker adopts later in an echo of childhood morality, the country and its village cultures have faded, are no longer reflective of the current state of the world and its crises. Related to metaphor are other moments in transferal phrasing on which the poem turns. In Line 49 destination is carried over into "destiny." The latter is identified with a "brook that was the water of the house" which the speaker tries to find in recollection. This identification becomes a metaphor by extension when the brook, by the poem's end, will become the source for a cure for the confusion with which the poem begins. Like the present crisis at the poem's outset, the source of the brook is not directly named. That it cannot be resolved by the Christian symbolism of baptism and communion is suggested by the speaker's insistence that the water is (unlike Saint Mark) "too lofty and original to rage."

The modernism of Frost and Rilke emerges with their refusal to subordinate this world to a transcendent beyond. Just as Nietzsche's Zarathustra urges faithfulness to the earth, Frost's poetry reserves the mysterious for the inner horizons of the world, rather than for a wholly transcendent beyond. The poem "For Once, Then, Something" displaces the illusory heavens with a mystery of the depths and "A Boundless Moment" displaces the potential infinity of paradisal bloom with the boundlessness of the lived present confronted with death. And Rilke's speaker denies the heavens any greater sublimity than the sea of the rose's own intimacy. Similarly, in "Directive" religious symbolism is implicitly criticized by Frost's speaker who looks to more "original" waters of an unknown, mysterious, but not otherworldly source. The transfer from the drinking goblet the speaker variously refers to as hidden, (implicitly) found, and also stolen from the children's playhouse, is metaphorically identified with the Holy Grail, with its various mythical and mystical significance. The Grail symbolizes the relic from the Last Supper, the lost object per se. The lost object presents a mystery, for the seeking (and

therefore absence) of it is required by a particular mythology of civilization. This absence is mirrored in the metaphor itself, since the gap in identity is required: the cup is not the Grail, and because it is not that object, it can be a symbol for the lost thing. The waters and the watering place, through which the speaker is to regain his clarity, do not spring from the cup itself, which is broken, but in those more original natural sources where, though through a painful journey of the imagination, the original mysterious source might be preserved.

The evocation of the mysterious in the poetry of Rilke and Frost—through the Orphic song and the depicting of natural elements and things as sources of transformation of ordinary seeing—suggests a depth within the world's inner horizons, a reality that recedes in everydayness but is available in poetically accessible manifestations. Both poets reject the exclusion of the sources of mystery from the lived world; they show the mysterious as immanent within the physical world but irreducible to explicable materiality. Both Rilke and Frost suggest that the modern age might be one of fallenness, one that relies upon illusory representations of the world which negate mysteriousness altogether or relegate its mysterious sources to a transcendent beyond. In their poetry they explore privileged moments of consciousness which might strain the restriction of possible meaning to the correlative of what can be potentially actualized, and so to what in principle can be prosaically manifest, directly experienced, or definitively explained. Situated among ordinary things, and in the context of lived experience, their evocations of the mysterious do not serve as a dismissal, but rather as a potential enrichment, of quotidian life.

The Painterly and the Poetic Image
Between Rilke and Cézanne

There is an implicit phenomenology in Rilke's fascination with visual works of art, particularly paintings by Cézanne. Rilke found in Cézanne's paintings an ecstatic transport from everyday perception, as they render strange, original, startlingly fresh perception of the familiar world and seem to break through to the essence of things. For a poet who is concerned with sheltering from transience things poetically recognized, through the transformation of things by a perception of the world's inner space or *Weltinnenraum*, Cézanne provoked nothing less than a revolution in seeing, as his paintings captured the permanence of things along with their inextinguishable transience, the stable objectivity of the world through the tissues of its perception. In 1907 Rilke wrote extensively about Cézanne in a series of letters from Paris to Clara Rilke, letters he hoped would lead to a book about Cézanne. That was the year of a memorial exhibition of Cézanne's paintings which Rilke visited over and over, sometimes spending hours in front of a single painting. During this time he also continued work on *Die Aufzeichnungen des Malte Laurids Brigge*, discussed in previous chapters, a novel intensely devoted to the seen world and influenced by the poet's viewing of the paintings. Phenomenological questions about images, verbal and visual, arise from Rilke's encounter with Cézanne. These questions will be formulated in this chapter in the context of Rilke's fascination, expressed through analogies he draws between poetry and painting. These initiate, from a phenomenological standpoint, a reconsideration of the oppositions between painterly and poetic images supported by traditional aesthetics.

Rilke was more fascinated with visual images than almost any other modern poet. Long before the Cézanne exhibit, he had been enthralled with the

plastic arts through his associations with artists, most prominently Rodin, but also the Worpsrede artists, the painters Clara (Westhoff) Rilke and Paula Modersohn Becker. He had long been preparing a book about Rodin, for whom he had worked, and had spent the summer perusing a portfolio of prints of van Gogh paintings which moved him profoundly. Yet during his repeated visits to the Cézanne exhibition, and in the midst of his attempts to write about the effect on him, Rilke was nothing less than astonished. In coming to understand Cézanne, one is transformed, he claims: "Suddenly one has the right eyes" [plötzlich hat man die richtigen Augen] (Rilke 1985, 43; KA IV, 612). Viewing the Cézanne paintings amounted to a virtual visual ecstasis, an experience that transformed Rilke's writing and had a profound impact on his literary work. Through Cézanne he learned that a certain kind of abstraction gets closer to the real, an approach that requires breaking away from a practically oriented or abstract relationship to objects and discovering how they are constituted in perception. Rilke recognized that Cézanne's departure from the ordinary and received ways of conceiving spatial relationships might lead the poet, too, to other kinds of verbal images, to "unusual word formations which leave behind the rules of speech sanctioned by everyday use" such that Rilke could "venture into utterly new territory" (Petzet 1985, xviii). But what this particular form of abstraction will lead to in Rilke's writing is not a simple matter, since it not only celebrates a liberation from artificially realistic depiction, but also the achievement of a new objectivity. The following passage from one of his accounts of a visit to the Cézanne exhibition illustrates the transformation or ecstasis that occurred in his aesthetic perceptions of the most quotidian things; here an apple:

> Today I went to see his pictures again; it's remarkable what an environment they create. Without looking at a particular one . . . one feels their presence drawing together into a colossal reality. As if these colors could heal one of indecision once and for all. . . . Their simple truthfulness, it educates you. . . . He knew how to swallow his love for every apple and put it to rest in the painted apple forever. Can you imagine what that is like, and what it's like to experience this through him? (Rilke 1985, 50–51)

> [Ich war heute wieder bei seinen Bildern; es ist merkwürdig, was für eine Umgebung sie bilden. Ohne ein einzelnes zu betrachten . . . fühlt man ihre Gegenwart sich zusammentun zu einer kolassalen Wirklichkeit. Als ob diese Farben einem die Unentschlossenheit abnähmen ein für allemal. . . . Ihre einfache Wahrhaftigkeit erzieht

einen. . . . Er wußte seine Liebe zu jedem Apfel zu verbeißen und in
dem gemalten Apfel unterzubringen für immer. Kannst Du Dir den-
ken, was das ist und wie man es an him erlebt?] (Rilke KA IV,
616–17)

What Rilke learned for his own poetry was Cézanne's aim, as he surmised it,
to achieve "the convincing aspect, the reification, the reality intensified and
potentiated to the point of indestructibility through his personal experience
of the object" [Das Überzeugende, die Dingwerdung, die durch sein eigenes
Erlebnis an dem Gegenstand bis ins Unzerstörbare hinein gesteigerte Wir-
klichkeit] (Rilke 1985, 34; KA IV, 608). That a true grasp of reality is not
given immediately to everyday perception, which is made up of "confused
sensations," is suggested in Cézanne's conviction that aesthetic concentration
and research are needed for the artist to get closer to nature (Cézanne 1941,
17). Rilke found a grasp of the real in common with Cézanne's work and his
own poetry—"instinctive beginnings toward a similar objectivity" [instinktive
Ansätze zu ähnlicher Sachlichkeit] (Rilke 1985, 51; KA IV, 617). For both
images become "thinglike and real . . . simply indestructible in their stubborn
presence [so sehr dinghaft wirklich werden sie, so einfach unvertilgbar in ihrer
eigensinnigen Vorhandenheit]. For Rilke, Cézanne's perception, made visible
through painting, introduced a more genuinely seen nature. "Here all of real-
ity is on his side" [Da ist alle Wirklichkeit auf seiner Seite] (29, 33; 608, 606).

Rilke's Fascination in the Context of Cézanne Interpretation

As a poet practiced in transforming the ordinary significance of the contours,
surfaces, and inner depths of things, Rilke is particularly gifted at describing
the quality of Cézanne's visual achievements. His celebration of Cézanne
stands in contrast to reviews by other contemporaries (some of whom Rilke
met at the 1907 exhibition), and remains unique among a century of critical
approaches. To understand the novelty of the way of seeing presented by
Cézanne's labors of perception and expression, it is helpful to consider in
what ways Cézanne's work, now so familiar to viewers, was initially received.
Cézanne was alternately misunderstood and wildly admired. Yet even among
artists who understood Cézanne's genius, there were those who tended to view
Cézanne's greatness ever tarrying on the edge of failure. This was the sense of
Zola's figuration of Cézanne in the novel L'Œuvre. Émile Bernard was one of
the few painters who were close to Cézanne in his later years, and one whose
critical appreciation of Cézanne's work was widely influential. But even Ber-

nard is said to have been ill prepared to fully grasp many of the ideas Cézanne broached with him in the course of their discussions. Bernard worried that Cézanne was unable to express the ideas that his friend was developing. Yet conventional ideas about reality had to be revised in order to understand Cézanne's advances. Bernard, it has been claimed, remained too conservative to appreciate the bold modernism of Cézanne's notion of *réalisation,* an adequate insight into which would be necessary to unfold, as one scholar put it, "the opposition between the real and the ideal, between observation and imagination, which all too easily extrapolates to that between content and form" (Rishel 1996, 47). Established ideas about painting had to be dismissed in order to account for what Cézanne had accomplished.

Cézanne's notion of *réalisation* seeks to make visible the visibility of nature—how it constitutes itself as visual appearance, gathered by the painter into his intensely intuited motif. This intuition is not immediate but is achieved in the course of repeated observation, a method employed, for instance, in his paintings of the Provençal landscape and in particular in those of the Mont St. Victoire he painted scores of times. *Réalisation* becomes a visual consummation of the ordinarily unseen structure underlying nature's appearance, in concordance with the artist's intentionality and aim to get to nature's substrate. *Réalisation* is not equivalent to perfecting the work, nor is it identical with its execution. *Réalisation* is first of all an intuitive study of nature. As Kurt Badt put it: "It is not through the artist's execution that realization is achieved but through his intuitive appreciation of what is universally beautiful . . . and by his grasp of the eternal laws of his art, that is to say by the metaphysical conditions which make his artistic existence possible" (Badt 1965, 200). Although *Réalisation* is inexplicable without an account of the painter's intention, Cézanne "expressly drew attention also to the role of nature in the process of 'realization.' The fundamental prerequisite was 'intelligent observation,' 'comprehension' of nature through a personal temperament, which entailed discovering her character, her state of 'being,' and her riches. . . . Cézanne possessed this capacity in an extraordinarily high degree and was moreover well aware of this" (213). Nature is the subject, but also the means for realization, providing color, structural solidity, and harmonized movement. *Réalisation* achieves unity of nature and self, object and perceiver, in expressing the structure of the appearance of things. Cézanne's paintings do not merely express subjective interpretation of their subject-matter, but a fusion of his own looking with the structure of the object. In Cézanne, according to Schapiro, "a way of seeing has become property of the objects he looks at" (Schapiro 1952, 17). But this is not mere projection:

the painter is "poised between sensing and knowing . . . mastering its inner world by mastering something beyond itself" (9–10).

Rilke's poetic intuition of the depths of phenomena is analogous in some respects to this process. For Rilke, the divine is not transcendent to realized nature; imagination is essential to observation; artistic form is intertwined with content, with the being of what appears. Rilke found immanent and intimate structures in things which, as in Cézanne's works, provoke revaluations of the relations among perception, intention, imagination, and expression. Both Rilke and Cézanne sought to bring out the relationship between object and perceiver; yet neither's work can be understood according to the traditional notion of inspiration as taking rule from nature. Both involve a transformation of consciousness in the act of perceiving—which requires taking part in—the world's intimate space. Equally inadequate would be a theory of artistic creation which opposes discovery and invention, or spontaneity and deliberate techniques of craft. One critic once asked: "Was Cézanne's art essentially a matter of spontaneous finding or of controlled making?" (Shiff 1984, 132). Joseph Rishel cites this question in his review of the last century of Cézanne criticism as summing up a whole century of difficulty in understanding Cézanne (see Rishel 1996, 47), for it suggests the opposition of discovery and invention. But it also applies to Rilke insofar as his perceptions of the inner space of things aimed at a deeper perception of their objectivity which is available only through the accomplishment of a reality immanent in the poetry, implying a transformation of consciousness.

Maurice Denis, writing in the same year Rilke wrote his letters, presented Cézanne's way of painting as an oppositional struggle—between reason/sensation and between technique/perception. Denis described the synthesis of these factors through the notions of oscillation and variation. The painting, he wrote, "oscillates perpetually between invention and imitation: sometimes it copies and sometimes it imagines" (Denis 1910, 214; cited in Rishel 1996, 48). But the inadequacy of this view suggests a need to press beyond received aesthetic principles. Denis fell back upon the principle of mimesis (which he thought of as copying), which Cézanne's art makes problematic, and presupposed an essentially representational model of consciousness: imitation, based on a given perception, re-presents that perception, whereas imagination departs from it, perhaps by variation and distortion. To his credit, Denis recognized the inadequacy of his own terms, through which Cézanne's painting "seems impossible" and is "so refractory to criticism" (Denis 1910, 214). According to Merleau-Ponty, Cézanne's originality lies not in mimesis but in his rendering of original structures of perception, for which the spontaneity of invention and expression is inseparable from original seeing. All the freshness

and spontaneity of an original apprehension is enabled and sustained by a procedure of evoking the fluidity and tension of perception itself, such as Cézanne developed through use of color and its subjugation of the line. In his rendering of a mountain, Merleau-Ponty writes, Cézanne was able "to unveil the means, visible and not otherwise, by which it makes itself mountain before our eyes." Cézanne achieves this not by copying or recording visible features of the object, since light, shadows, reflections, and color as he evokes them "exist only at the threshold of profane vision; they are not ordinarily seen. [Ils ne sont même que sur le seuil de la vìsiòn profane, ils ne sont communément pos vus]. The painter's gaze asks them what they do to suddenly cause something to be and to be this thing, what they do to compose this talisman of the world, to make us see the visible" (Merleau-Ponty 1993, 128; 1964, 29).

Merleau-Ponty's phenomenology of painting has contributed considerably to the philosophical interpretation of Cézanne, and resonates with some of Rilke's most striking poetic discoveries. Focusing on the relation of the body to vision and expression, presented in his essay "Eye and Mind" (L'œil et l'esprit) as well as in "Cézanne's Doubt" (Le Doute de Cézanne), Merleau-Ponty attempts to explain Cézanne's fusion of nature and self in an analysis of painting as expressive and embodied seeing, since the body, like things, is "caught in the fabric of the world" (125; 19). The act of painting is not primarily cognitive but rather embodied. To paint is to engage hand, body, and brush, with its movements and suspensions, in active vision. To paint is, moreover, to express an inner reception of the physicality of nature's extension, thereby making visual the way in which things take up space, inhabit, obscure, illuminate, resonate, and all of the other verbal qualities attributed to Cézanne's images, and for all of which there are resonances in the lived body. Painting makes visible the *extraordinaire empiétement* of the mobility of vision and the visible world (Merleau-Ponty 1964, 17), and more deeply than intertwining, "a secret and feverish genesis of things within our body" [cette genèse secrète et fiévreuse des choses dans notre corps] (30). Like Merleau-Ponty, Schapiro also refers to the presence of both mind and hand of the painter—and indeed the whole network of bodily perception—to be located within the tangible quality of the apple in Cézanne's still life, which "looks . . . as it would feel to a blind man" (Schapiro 1952, 9–10).

This correspondence between and overlapping of the outside and the inside—between seeing and being, perceiving and expressing—is highly resonant of Rilke's notion of *Weltinnenraum*. Overcoming the natural attitude assumptions about the external objective existence of the world—its simple givenness—the poet achieves an expression of the intimacy of things (such as in the poem "Das Rosen-innere," discussed in the previous chapter) which is

not merely represented inside a seeing consciousness; rather innerness is both discovered in and granted to things through recognition of their analogous intimacy with poetic consciousness. Just as things are taken into consciousness through perception, consciousness goes out among them, a projection described in Rilke's essay "Erlebnis." The annulment of opposition between spirit or thought and embodied experience, which is Merleau-Ponty's focus in "Eye and Mind," is expressed in Rilke's essay, which also initiates the notion of *Weltinnenraum* as it appears in the 1914 poem "Es winkt zu Fühlung fast aus allen Dingen." The speaker feels the vibrations of a tree, and then the flight of a bird, as if it were interior to his consciousness, while at the same time his consciousness wanders out among things toward a truer and undivided perception of them; a description that provides perhaps a preliminary model for the angel-consciousness in the *Duino Elegies*. But while Rilke's protagonist in this narrative has the feeling of having left his body behind, in the collapse of distinction between the spiritual and the material self, Merleau-Ponty shows how this intimacy expresses the deep original unity within the body of perception, expression, and world.

For Rilke, as for Cézanne, aesthetic seeing seems to draw out the "inner" life of things, rendering an experience of the everyday ecstatic. Another interpreter of poetic disposition, D. H. Lawrence, also insists on the living quality of Cézanne's objects, personifying them in his descriptions: "Cézanne's apple hurts" (Lawrence 1929, 19–20). Joachim Gasquet, who attempted a presentation of Cézanne's personal understanding of his art through a remembered poetic dialogue, writes of the "soul" of the quotidian objects in Cézanne's paintings: "People think a sugar-bowl doesn't have a physiognomy, a soul. But that changes every day, too. . . . Objects interpenetrate one another. . . . They never stop living" (Gasquet 1921, 121–22). This attribution of not only life but of subjectivity to objects seems an inversion of Cartesian metaphysics, which is also suggested in Paul Klee's descriptions of painting, of being seen by the forest rather than being its neutral observer. In Schapiro's later criticism, Cézanne's objects are depicted as dominant in the fusion with the self: the mind is informed by the quality of things. Thus he suggests: "Is not the style of 'knowing,' however personal, shaped in part by the character of the objects of attention, their meaning and interest for the responding mind?" (Schapiro 1968, 56).

Certainly it is so for Rilke. The experience of Cézanne's paintings is echoed in Rilke's poetic rendering of what he calls the *Gefühls-Raum* of things, their space of feeling. For the poet aims to reach the inner reality of things through an empathetic-spatial communion, where things are granted an immanent spatiality. Rilke aims to present, as he writes in notes for a reading tour in

Switzerland: "Das Tier, die Pflanze, jeden Vorgang;—*ein Ding* in seinem eigentümlichen Gefühls-Raum" (KA IV, 708). This project of grasping the space of feeling of living animals and plants as well as things is exemplified in the *Neue Gedichte* contemporaneous with Rilke's studies of Cézanne, to which Rilke referred as his "Ding-Gedichte" or thing-poems. In the celebrated poem "Der Panther" (The Panther), the description of the panther as motion around a paralyzed center is situated between two stanzas describing the animal in lived perceptual terms. The first stanza describes "Sein Blick," its gaze and how the world must look from the panther's point of view; it is annihilated by the cage: "To him it is as if there were a thousand bars / And behind the thousand bars no world" [Ihm ist, als ob es tausend Stäbe gäbe / Und hinter tausend Stäben keine Welt]. This empathetic transfer to the panther's point of view is modified in the third stanza. There the speaker shifts to his own perspective of observation. But the panther's power and paralysis, described as paralyzed motion in the second stanza, are evoked again as the observer sees his own image enter the panther's pupils, an image which is finally extinguished at the poem's end, thus fusing the self and the life of the thing seen. The presentation of motion in the poem, contrary to Jayne's account, does not reduce the panther to abstract symbolic space (cf. Jayne 1972, 66–69), but rather contributes to an empathetic evocation of the inner life of the panther, and then a radicalization of this empathy such that the observer is swallowed up by, no longer distinguishable from, what is seen. The subject-speaker is no longer distinguishable from object described—departing from analogy with phenomenological description proper with its demand for the clean separation of observing and what is observed (see Gosetti-Ferencei, 2007).

With this reversal and even fusion of subject and object, the question arises as to what kind of objectivity is to be achieved. The question of faithfulness to objective reality is relevant in both Rilke's and Cézanne's presentation of aesthetic perspective, and of their relations to modernism and abstraction. The relationship of both Rilke and Cézanne to modernism and its forms of abstraction is not a simple one, and in the case of Cézanne has long been debated among critics. Bernard and Denis associate Cézanne with the classical past, whereas for Rilke Cézanne is reduced to the utmost primitive element in his perception of things (KA IV, 632). Cézanne is also viewed as the initiator of modern movements, in particular Cubism, a view advanced by Clive Bell, for instance, who attributes this progeny to Cézanne's willingness toward and capacity for distortion (Bell 1922, 14). Yet this distortion is effected by a departure from ordinary seeing that is not merely deconstructive; it brings to light the tissues of perceptual structure, rather than presenting the world in

its assumed natural realism. If distortion occurs in Cézanne's painting, it must be understood as a rejection of optical perspective (and the techniques of dimensional representation since the Renaissance) and a rejection of artificial verisimilitude. Instead Cézanne renders "a moving harmony of colored touches representing nothing" (Shapiro 1952, 9–10). Cézanne's abstraction can be understood as an elemental intensification. This brings to mind Fritz Novotny's term "reduction." If abstraction has subjectivist or negating overtones of distortion, reduction indicates rather a distillation of the essential or the elemental (Novotny 1937, 7). Such distillation is also characteristic of Rilke's approach to the specificity of things, as shown in the discussion in the previous chapter of his poem "Blaue Hortensie," where the specific blue of this hydrangea is captured through the indirect plays of metaphorical identification. Abstraction, in its Latin origin, *abstrahere,* has the sense of to "draw away" and thus remove, whereas *reducere* means to "bring or lead back." Thus "to reduce" also takes on the meaning of restoration, for example a dislocated part of the body, to its proper place. What is rendered in Cézanne, and perhaps also in Rilke's poetry, is not the abstraction but the restoration of essence to perception, leading back to a more primal apprehension of this essence as it breaks through the abstractions that are actually predelineated by ordinary habitual perception.

Whether Cézanne's distortions are seen as abstractions or reductions informs the critical ambivalence with which Cézanne's relation to Cubism is treated, also a complicated relationship. Lionello Venturi, for one, would protest against Cézanne's association with Cubism (Venturi 1936, 45) as a serious misunderstanding of the nature of Cézanne's intuition of nature, only to admit later that Cubism "descends from Paul Cézanne" (Venturi 1956, 61). Prefacing an exhibition at the Guggenheim Museum in New York in 1963 on "Cézanne and Structure in Modern Painting," Daniel Robbins recorded this ambiguity, both with respect to the Cubists and to other formal movements like abstract expressionism. While Cézanne knew himself to be entering an unknown realm, he most likely would not have embraced Cubism, in Robbins's view. If Cézanne had known that "the promised end was cubism, which so logically developed out of the painting and compositional techniques of Cézanne . . . the old master would not have wished to enter it." The problem is only compounded by the fact that the Cubists "saw between themselves and Cézanne 'only a difference of intensity'" (Robbins 1963, n.p.). It is not surprising that Rilke, while celebrating Cézanne's innovations, should have rejected many forms of abstraction in modernist painting. The return to primal seeing might be thrilling in painters like Cézanne or Paul Klee, but from the point of view of a poet attempting to project the *Gefühls-Raum* of things,

this enthusiasm would not be extended to Cubism or early forms of abstract expressionism.

Whether abstracting or reducing, the transformations of the visual in Cézanne's paintings involve a breaking away from or breaking down the everyday look of the physical world—of the quotidian habits of seeing—by studying how it comes to appear in vision. For the "magic that pertains to this way of looking at things is that even the most ordinary scene acquires a strange and original freshness" (Sedlmayr 1957, 132). The variations in critical reception suggest that Cézanne's struggle to articulate nature was both a matter of appropriating techniques of classical painting, which he studied with intensity and intention, and inventing the necessary formal innovations, particularly in perspective and color, in order to move beyond it. These innovations would be appropriated by subsequent artists for purposes Cézanne could not have foreseen. His innovations were devoted to capturing not the ephemeral changes of the Impressionists, but permanence. Cézanne was not, as were the Impressionists, fascinated by the transience of nature, nor by the intensity of inner emotion that it might provoke, as in Expressionism, but wanted rather to capture its solidity—a more stable reality behind apparent change, along with the apparent change by which the world becomes known to us and is seen. But capturing this required a startling break from ordinary ways of seeing.

Rilke's Fascination and the Ekphrastic Principle

In his letters Rilke compares the Cézanne paintings to his own just-finished poem "Die Gazelle" (The Gazelle). In this poem and in Cézanne's paintings, Rilke recognizes the same objectivity, the same "turning point" [die Wendung] toward the essence of things (Rilke 1985, 63; KA IV, 622). The attempts in Rilke's poetry to trace the same path of *Sachlichkeit* are thematically reflected in the homage this poem pays to the image. Here is the poem:

> Die Gazelle
> *Gazella Dorcas*
>
>
> Verzauberte: wie kann der Einklang zweier
> erwählter Worte je den Reim erreichen,
> der in dir kommt und geht, wie auf ein Zeichen.
> Aus deiner Stirne steigen Laub und Leier,

und alles Deine geht schon im Vergleich
durch Liebeslieder, deren Worte, weich
wie Rosenblätter, dem, der nicht mehr liest,
sich auf die Augen legen, die er schließt:

um dich zu sehen: hingetragen, als
wäre mit Sprüngen jeder Lauf geladen
und schösse nur nicht ab, solang der Hals

das Haupt ins Horchen hält: wie wenn beim Baden
im Wald die Badende sich unterbricht:
den Waldsee im gewendeten Gesicht.

<div align="right">(KA I, 469–70)</div>

Here is the author's translation, indebted to Stephen Mitchell's:

The Gazelle
Gazella Dorcas

Enchanted one: how can two chosen words
ever reach the harmony of rhyme
that comes and goes in you, as by a sign.
From your forehead branch and lyre climb

and all that's yours passes similarly for
lovesongs, whose words, as soft as petals of roses
are lain upon his eyes by one who closes
them, shutting his book, reads no more:

in order to see you: tensed, as if each tread
were loaded with leaps that remain unfired while
your neck holds still your listening head:

as when a girl swimming in the forest pool
interrupts her bathing, stops and sees
in her face a pool among the trees.

In this poem Rilke explicitly considers the traditional view of language, which regards the word as an external sign for the identification of an object. The naming capacity of words is subordinated to a more primary envisioned image. The speaker considers the taxonomical name for the animal, *gazella dorcas:* "how can the two chosen words / ever reach the harmony of rhyme /

that comes and goes in you as by a sign." Contrary to everyday uses of language, it is not the naming (conceptual) capacity of words but their capacity to evoke images that is the key to their power. Rilke then refers to an envisioned image: in the speaker's imagining, the gazelle's coming and going is read as movement as if by a sign, but this too is abandoned in favor of shutting one's eyes to see the image: one no longer reads (*liest*) the gazelle's movements, but closes the eyes "in order to see you" [um dich zu sehen].

The power of the image of the gazelle in the speaker's mind's eye is affirmed by the leap at the poem's end to the image of the interrupted bather. The gazelle's movement withholds its leaping, the continuation of which the poem itself seems to trace by the metaphorical leap between the animal and the bather. The suspended movement of imagining is affirmed through this metaphorical movement, as the image of the gazelle becomes the (also imagined) bather who sees the *Waldsee* in her turned face. The image is here a complex of surfaces, since the bather sees the forest lake reflected in her face, in the image of her face the lake reflects. The lake is the mirror in which she sees herself; and in the image of herself, presumably in her eyes, is reflected again the lake. Jephcott's notion of metaphor as a verbal mirror is drawn explicitly from this poem (Jephcott 1972, 123). But the bathing girl is also a mirror for the gazelle, itself imagined explicitly by the speaker, in that her image makes possible the paradoxical continuation and grasp of suspended movement. And suspended movement is also what the poem itself is: the speaker within the movement of describing closes his eyes in order to see the image, that for which ordinary vision (with eyes open) and ordinary language (as primarily identifying rather than image evoking) does not allow. At the level of images this poem, which will be discussed again later in the chapter, the speaker is able to bring about an encounter between imagining and imagined, seer and seen, visible and invisible, reflecting and reflected.

Cézanne's attempt to get to the structure of and permanence behind appearances brings about, through painterly means, an analogous intimacy of these elements. But Rilke's poem also introduces the element of language. If the poet is fascinated by visual images, in their bringing forth the usually invisible structures of seeing and imagining, discovering and inventing, what is the relationship between words and images they can provoke? This question becomes pressing when poetic language is inspired by painterly images, and aims to capture them, as in the ekphrastic tradition.

The difficulty arises with Rilke's study of Cézanne, for he interprets Cézanne in terms that are wound up with his own poetic strivings. Rilke not only appropriates Cézanne's innovations for his poetry, he also describes Cézanne's

paintings with terms usually reserved for the musical or audible quality of poems. He writes in his lemons and apples: "He knows how to contain their loudness within the picture: cast into a listening blue [ein horchendes Blau], as if into an ear, it receives a silent response from within" (Rilke 1985, 87; KA IV, 634). And Rilke is thrilled to find, despite Cézanne's own inarticulateness, the latter's love of poetry. Rilke feels a kind of artistic and metaphysical collaboration with Cézanne, but also between the visual-aesthetic image and the visually imagined images generated by poetic language. Rilke is not, in the Kantian sense, a disinterested observer of paintings, as might be said of the art critics and contemporaneous painters who strove to understand Cézanne's originality. The poet's fascination is clearly not aesthetic in the classical sense, but decidedly poetic and appropriative. Although in the letters he repeatedly expresses a hesitation about putting Cézanne's paintings into words—a hesitation shared by contemporary critics like Maurice Denis—he nonetheless gleans from the paintings what he himself seeks to accomplish in his own writing, in his own poetic-literary medium. What he says he learned from Cézanne is nothing less than genuine objectivity.

How Rilke was able to achieve the same objectivity through the resonant precision of poetic images, and how this can be inspired by visual, painterly images, remains perplexing within the framework of traditional aesthetics, especially since aesthetic theory had long relied on the rarely challenged, strictly asserted difference between the visually presented and the verbally imagined. If classical aesthetic theory regarded painting as an imitation of reality, the word was thought to be still further removed from the visual world it aims to capture. Verbal signs are generally arbitrary, but the word is able to evoke an image of its referent. In contrast, the painterly image, it seems, exists in the real world as an actual object of perception; whereas the poetic image is only intelligible, a potential object, or a series of such, only for the intellectual sense, for the mind's eye. The distinctions go further: the visual image is spatial and static, the poetic is nonspatial, temporally unfolding, and immaterial. While painting can capture space, poetry can capture movement. These differences seem to be irreducible, and they fuel what Murray Krieger has called "the ekphrastic tradition in literature," wherein writers of poetic images attempt to capture the visual—and even compete with it—by writing about works of visual art.

Rilke's investment in Cézanne raises phenomenological questions that are relevant for the ekphrastic tradition, in which a poet tries to put into words, to capture in description, a visual work of art. Some poems have become standard examples of ekphrasis: Keats's "Ode on a Grecian Urn"; Wordsworth's "Elegiac Stanzas" written on Sir George Beaumont's painting of Peele

Castle; William Carlos Williams's and W. H. Auden's treatments of Brueghel's *Landscape with the Fall of Icarus,* not to mention other works from Rilke's *Neue Gedichte,* including descriptions of a fragmentary statue of Apollo and the stained-glass rose window of a cathedral. By virtue of his intense association with painters and sculptors, the poetic letters on Cézanne, his poems modeled on visual media— *Das Buch der Bilder* (*The Book of Images*) presented like a gallery of paintings and the sculptural presentation of things in *Neue Gedichte*—Rilke can be called an "ekphrastic poet" in a broader sense. Ekphrasis brings up questions about the relative capacities of medium in aesthetic works, whether the poet can collaborate with the painter, for example, in capturing the deeper sources of objectivity than are apparent through ordinary perception, and through what means of abstraction or reduction this is possible. At issue then is a possibly intimate correlation between what Lessing considered "natural" (visual) signs and "arbitrary" (verbal) signs; between the spatiality of the plastic arts and the nonspatial temporality of the verbal; between sensibility—real seeing—and merely intellectual sensibility. Yet, as shall be shown in this chapter, the relation of Rilke to Cézanne transcends the ekphrastic problem; not ekphrasis, but analogously ecstatic vision links their works.

Ekphrastic writing demands an account of what Murray Krieger, in his lengthy study, calls the "ekphrastic principle," extending beyond the question of capacity of poetic language itself to represent or even become the picture, into the aesthetic and literary theories we have employed in order to make sense of both kinds of works (Krieger 1992, 9). It must be noted that until the rise of eighteenth-century aesthetics, the visual image had been privileged over the verbal image by an epistemological affirmation of representational consciousness within which a visual image can be adequately intuited. This privilege is contested in Kant's dictum that poetic language is the highest artistic medium because it can represent ideas; in the Romantic demand that philosophy become poetry; and then again in Nietzsche's celebration of the Dionysian in the principles of music. But for the most part this privilege has been maintained not only for those images on canvas, but in the mind.

Pictures trump the kind of vague images that might be evoked by poetic language. For the pictured image in consciousness, such as that of a triangle, could still be compatible with clarity and distinctness, though not so clear and distinct as the idea of a triangle, a distinction Descartes draws, in the *Meditations,* by contrast to the unpicturable chiliagon. Poetic images are still less distinct than ideas of picturable sensual objects represented in the mind (acquired ideas), and those are themselves far less reliable than ideas of pure cognition, only those being tethered to an essential aspect of the knowing self.

But by virtue of Descartes's reduction of things to ideas about things, it is the mind's eye picture, not the unstable sensuous thing, which is the object of knowledge or doubt; the epistemologist abstracts from the faulty and some-times misleading bodily faculty of vision and sublimates it to the level of mental representation, a kind of mental vision. Descartes reasoned that, while one might be mistaken about things in the world, one cannot be mistaken about ideas of such things, at least when they are perceived clearly and dis-tinctly. And if a divine benevolence guarantees my-not-being deceived about these, one can accept the perceived world with probability, whereas products of the imagination are still derivative of that probable but uncertain source.

Traditional aesthetics, too, much criticized by phenomenologists like Merleau-Ponty, might conceive of a painting as a representation or projection of a mental image, which is itself only the mind's eye representation of or elaboration upon the real. This view maintains its hold in early criticism on Cézanne. Where Rilke understood at once an objective original perception, Maurice Denis perceived an alteration of copying and innovating—which in Denis's account must imply more than devising by variation and recombina-tion, but the formulation remains caught within the mimetic model. In mod-ern art, this aesthetics is challenged by the playful "combine" paintings of Robert Rauschenberg, for whom the two-dimensionality of the painting could be extended into three dimensions by virtue of the painting's continuation into a chair, for example, or an unmade bed, an obvious reference to the example discussed by Socrates in the discussion of painting in Plato's *Republic.* Within this context the ekphrastic poem does not fare well: the poem which tries to capture the uniquely visual, remains but a representation of a represen-tation of a representation, and without the weight of a painting's formed matter which, at least, shares ontological (and in Rauschenberg material) status with the physical world. Merleau-Ponty's critique of traditional ac-counts of painting make clear that the notion of the image has to be recon-ceived. Just as painterly vision articulates the overlapping of seeing and seen through embodied experience, the image is not merely a copy or rendering but a correspondence between things and the gaze in its recess toward the seer. "Quality, light, color, depth . . . are there only because they awaken an echo in our bodies." The image is a thing's " internal equivalent" (équivalent interne) in the seer, "cette formule charnelle de leur présence que les choses suscitent en moi" (Merleau-Ponty 1993, 125–26; 1964, 22). Images, then, are not tracings or copyings of the world; they are the overlapping of the seeing and the seen, the "inside of the outside and the outside of the inside" [ils sont le dedans du dehors et le dehors du dedans] (126; 23).

While Merleau-Ponty's aesthetics proposes a revaluation of the visual

image, its privilege over verbal signs has been contested by treatments in post-structuralism and deconstruction; and of modern and contemporary poetry (and literature in general), the thingliness of words, their capacity to create a kind of spatiality on the page, their materiality and material origins, have been (re-)celebrated in so-called language poetry. Moreover, the seemingly natural character of the visual sign has been under deconstruction in much the same tenor as the arbitrariness of the verbal sign has been celebrated. The greater epistemological stability of the visual has been put into question by modern art. At least since Andy Warhol, the visual sign is now considered in art the proliferation of what Baudrillard has called "simulacra," an issue reinvigorated by Gerhard Richter's hauntingly classical paintings of photographs. Circulating are questions about authenticity, the work of art's reproducibility, as first made problematic by Benjamin, as well as the ideology of social and cultural forces according to which visual images are written, and according to which they can be read (cf. Krieger 1992, 28).

Thus the traditional division between the visual sign and the verbal sign is under reconsideration. But the theoretical debate that has emerged between Krieger's ekphrastic principle and the criticisms of Paul de Man is still under way in the scholarship, a debate that boils down to the effort of marrying visual and verbal images, on the one hand, and sparing the temporal, inner, verbal image from the impositions of spatiality, on the other. For de Man, as one scholar sums up his debate with Krieger, "the crucial relation in . . . poetry is not between the mind and the natural world but between the mind and time" (Donoghue 2000, 104). Keeping with Lessing's assignment of poetry to time rather than space, de Man favors, in reading Keats's "Ode to a Nightingale," for example, the decidedly "nonaesthetic character of poetic language" (de Man 1993, 186). This debate, however, might be resolved by investigating the spatio-temporality of the image with a greater phenomenological sensitivity. It is necessary to analyze aesthetic and poetic images at the level of consciousness, and to ask: what happens when we *experience* verbally inspired and visual images? What is their status vis-à-vis the acts of consciousness? How can one account for the poetic image's seemingly magical relationship to vision? Is there here, between poetry and painting, some element of intermediality, not only in the conceptual fusion between poem and painting (as one might see, for example, in optical or calligraphic poetry, in the epigraph or the emblem), but as an experiential or procedural—in short, phenomenological—intimacy? This intimacy may well be located in the common form of ecstatic seeing as Rilke saw it in his own poetry and in the paintings of Cézanne.

Phenomenology of the Visual Image and the Poetic Image

Since Lessing, the eighteenth-century German poet and art critic, aesthetic theory has still more sharply divided visual and verbal imagery than the Platonic tradition had prescribed. While Lessing still regarded mimesis as the major principle of both media, he conceived of their capacities as distinct and even incompatible. In the sixteenth chapter of *Laocoön* (1766), he writes: "If it true that its imitations painting uses completely different means or signs than does poetry, namely figures and colors in space rather than articulated sounds in time, and if these signs must indisputably bear a suitable relation to the thing signified, then signs existing in space can express only object whose wholes or parts coexist, while signs that follow one another can express only objects whose wholes or parts are consecutive" [Wenn es wahr ist, daß die Malerei zu ihren Nachahmungen ganz andere Mittel, oder Zeichen gebrauchet, als die Poesie, jene nämlich Figuren und Farben in dem Raume, diese aber artikulierte Töne in der Zeit; wenn unstreitig die Zeichen ein bequemes Verhältnis zu dem Bezeichneten haben müssen: so können nebeneinander geordnete Zeichen auch nur Gegenstände, die nebeneinander, oder deren Teile nebeneinander existieren, aufeinanderfolgende Zeichen aber auch nur Gegenstände ausdrücken, die aufeinander, oder deren Teile aufeinander folgen] (Lessing 1962, 78; 1965, 157).

Coexistence and consecutive existence—or immediacy and process—are taken to be mutually exclusive. Moreover, following Lessing, artists themselves have expressed their conviction about the absolute singularity of their media, particularly when it comes to the visual medium of painting. The painter Hans Hofmann claimed that "a plastic idea must be expressed with plastic means just as a musical idea is expressed with musical means, or a literary idea, with verbal means. Neither music nor literature are wholly translatable into other art forms. . . . The artist who attempts to do so . . . subjects himself to a mechanistic kind of thinking which disintegrates into fragments" (Hofmann 1994, 40). The singularity and specificity of a medium is indeed essential to the self-understanding of modernism. For many painters, the painterly search for the real must be executed in strict fidelity to the visual image, a fidelity the reflections of which might be said to develop from Malevich to the Color Field paintings of Morris Louis, Mark Rothko, and Barnett Newman, where all lyrical reference is abolished in favor of the lyricism of an absolute surface, celebrated as what Herbert Read once called a "sublime directness" (Read 1974, 290). In these paintings the pictorial image has become detached from any determinate object of representation, and so provokes an ecstatic experience of exposed vision. However, the ubiquity of the

insistence of separation of media in aesthetic theories since Lessing, though perhaps justified from the point of view of maximizing the possibilities of a given medium, is what makes any attempt to understand Rilke's unique apprenticeship to Cézanne difficult. It prevents a more intimate understanding of aesthetic (visual) and poetic (verbal) images as they are experienced in some way collaboratively. Departing from the traditional approach to the artwork as a objective synthesis of matter and form, medium and content, one can proceed to inquire whether phenomenology provides some methodological resources for this discussion.

A reading of Husserl yields some useful points for considering the status of the visual images of painting, and perhaps for getting closer to those of poetic language. Husserl's distinctions among what he has called the "physical image," the "image-object," and the "image-subject" [das physische Bild, das Bildobjekt, das Bildsujet / das Bildsubjekt] (Husserl vxxiii, 18–19), helps to loosen the hold of the idea that painting, in addressing the visual sense directly, belongs with ontological finality in empirical-spatial actuality, whereas poetry, in only evoking an image, is removed from the real and thereby manifests a sharp ontological contrast to paintings. Rather, one begins with the intentionality of consciousness for which such images appear, and with the notion of a kind of "intuitive presentation" (anschauliche Vergegenwärtigung), by which Husserl meant, as Brough formulates it, a "genus of conscious acts that do not posit their objects as present and actual, as perceptions do, but rather set them before us in some other intuitive way, as do memory and fantasy and image-consciousness" (Brough 1992, 241). At first this sounds like a description of poetic images, since poetic images are correlates of acts that "do not posit their objects as present and actual," whereas a painting has been understood as the object of present and actual perception. However, intuitive presentation here refers to depictive images, such as Gericault's painting of a horse or a Cézanne portrait of Madame Cézanne. This is due to the fact that the physical image—which poetry does not share with painting—can be differentiated from what Husserl called the "image object," the image that occurs as a correlate of aesthetic seeing (Husserl vxxiii, 36–38) and in which we see the image-subject (33).

This distinction suggests that perceptual experience of a work of art is not structurally identical to that of ordinary objects. Whereas the physical image of a painting is constituted by the canvas, the lines of paint, and so forth, the "image object" is what, beyond the paint, is seen in it: the mountains in Provençe surrounded by vibrant, lush green foliage. The image-subject is *La Montagne Ste. Victoire,* which Cézanne visited for years and painted scores of times, and with which we need not be familiar in order to appreciate the

painting. To make the distinction still clearer: even though there may be only one image-subject—the same mountain was visited over and over again—there are scores of physical images, that is, the paintings themselves once they have become correlates of perception, and the same quantity of image-objects—the image constituted on the basis of the physical image, but not reducible to it (since the physical image has determinate size, for instance, whereas the image-object, the evoked mountain in its landscape, does not)—given that we have an opportunity to view them all and can see each one with fresh eyes.

In accord with Husserl's terms, the image-object a painting presents is not ontologically identical to the physical image, but is only subtended and prefigured by it. The image of Cézanne's apples and lemons inhabits a different level of ontological-virtual reality than the colors and lines of which they are composed; these inhabit a stratum for which Sartre, in his study of the imagination, reserved the term *irréel,* and which has the characteristic of a relation to *l'absence* (Sartre 1936, 45). This aspect of aesthetic images is perhaps best highlighted by a juxtaposition of antidepictive developments in art since Malevich's *White on White,* and abstract paintings that do away with depiction altogether. In such cases aesthetic comprehension requires the recognition that the image-object and physical image are collapsed into one, a collapse playfully reflected in Malevich's title. Recognition of collapse still renders the elements analytically distinguishable. Of course such paintings have no image subject, save whiteness, or fields of color, as in later related examples, for instance the lyrical calm or spiritual sensation such as Mark Rothko sought to effect. In depictive painting, the image-object is constituted by the viewer through a special intuitive synthesis, correlate in some respects to, and reenacting, the painter's own acts of composition, though temporally condensed. This brings the visual image somewhat closer in metaphysical status to the images of poetic language, which likewise exist, as Husserl would say, for consciousness and its syntheses, on a plane of a specially constituted reality.

The visual image, then, must be granted a similar ontological status as that of the poetic. As Iser notes in *The Act of Reading,* literary images "are neither manifested in the printed text, nor produced solely by the reader's imagination" (Iser 1978, 135). Rather, the literary image exists, to employ a similar formulation by Dufrenne, as a "middle term between the brute presence where the object is experienced and the thought where it becomes idea, allows the object to appear, to be present as represented" (Dufrenne 1973, 345). But if Husserl is right about aesthetic images, this middle term, this third level of objectivity dependent upon the constitutive (and "phantasizing") imagina-

tion, applies as well to experiencing the painting; for the image-object likewise exceeds any empirical object of perception, including the physical image that subtends it, and cannot be constituted on the basis of direct perception alone, without aid of imaginative syntheses. The image, while *irréel*, claims its own ontological status, albeit a precarious one. Attempting to grasp this ontological status in Cézanne, Julius Meier-Graefe, whom Rilke met at the exhibition in October 1907 (Rilke 1985, 28), writes of the "ideated space" of Cézanne's images as bearing an "extraordinarily probable existence" (Meier-Graefe 1927, 28). Both the visual image and the poetic image are "middle terms" or "third levels" between objects of perception and conscious ideas thereof, and constitute or bring forth new levels of being.

The question might be asked whether Husserl's distinctions, though made more recognizable by the juxtaposition of non-depictive art, are at all useful in the context of the latter. One would have to examine other paintings which collapse the image-object and the image subject: the image-object is, in modern painting—as in Morris Louis or Jackson Pollock discussed in the next chapter—subtended by the physical stains or drips of paint on the canvas, and what is seen in them, the image-object, is also the image-subject. Especially among the Color Field painters like Louis, some of whose paintings are entitled by a single letter (rather than a reference to an imaginable object of experience), or Pollock's "concrete pictoral sensations" (Read 1974, 262), this collapse aims to be absolute, and that is painting's manner of transcendence. The absolute surface, the immediacy of the concrete, arises in isolation from depiction, from references or narratives; the paintings serve as a spiritual refuge of departure from traditional aesthetic strategies. The absolute immediacy desired is in a sense achieved by mediation, an implicit recognition of such departure from depiction, by the ecstasis of isolation as such. Their representation as works of art makes this departure recognizable. In such paintings, what is presented is immanent to the presentation. The relation of Cézanne to these paintings is defended in particular by formalist critics like Clement Greenberg, to be taken up in greater detail in the next chapter.

In any case, these phenomenological categories are adequate for at least approaching the problem of Rilke and Cézanne, since both were invested in the relationship between artistic practice and a transformed, but truer perception of the recognized world—even if the ultimate conclusion must be to override, in both cases, Husserl's terminology concerning depiction. Rather than depiction, Cézanne's *réalisation* of a given, perceptually gathered motif can be brought to bear on Rilke's poetic method. This notion caught Rilke's attention, for it reflects the task he set himself as a poet: to bring the essence of things, not their ordinary aspect, to the reader's (intuitive) perception, an

intuition that requires active engagement with the real within a departure from prosaic seeing.

Rilke and Cézanne both conceived of their work metaphysically, as a penetrating access to the ground or genesis of reality. But their methods followed an aesthetic ecstasis provoked by determined modes of dutiful seeing. It is as if both Rilke and Cézanne arrived at the real by way of breaking through the presumptions about visuality, or by breaking through ordinary uses of language as identification in favor of language in its dominant image-evoking function. While Husserl posited the "things themselves" in the final reduction of the phenomenological method—the eidetic reduction, wherein an *eidos* common to all possible variations on an object is posited—Rilke and Cézanne discovered an essence of things as the consummation of poetic or painterly seeing, a seeing which, as both made evident, involves labor and innovation and a constant re-awakening of the senses.

Temporality of the Painterly Image

With these phenomenological clues, one can approach, albeit with caution, the experiential intimacy between verbal and visual images, for one is no longer caught at the impasse of the physical reality of the image in painting and the irreality of the poetic image (the signified) words evoke in the mind. The difference does not lie in their physical status or ontological status, but rather in what way the synthesis of consciousness, in part responsible for the experienced image, is predelineated, provoked, and limited by the visual or written correlate. The comparison does not deny the specificity of both paintings and poetic images; it provides a proper ground for contrast when both are understood phenomenologically.

Despite the physical status of a painting and its more determinate relation to the image-object, both painterly and poetic images are constituted not in direct acts of perception. For example, we would not constitute the mountain or Madame Cézanne on the basis of an in person, perceptual contact, but rather intuitively. In what way, then, do the painterly and the poetic image claim a certain adherence to perception, as Iser claimed poetic images do, and in what ways do they differ in this regard? (Iser 1979, 137). It is possible to say that because of its optical penury, the poetic image is largely produced by the reader in the temporally unfolding process of reading, and thus that its constitution in the mind of the reader requires a more complex phenomenological account. Yet to claim, in contrast, that a painterly image involves no temporal synthesis on the part of a viewer, is phenomenologically naïve, as if

the painting were itself a finished representation in the mind, first of the artist, then of the viewer, without the synthesis required for perception even of an ordinary object, and the special sort of synthesis Husserl outlined as regards intuitive presentation. While the experience of every phenomenon has its temporality, intuitive presentation involves acts of synthesis that are not necessary for ordinary perception.

The interior temporality of any experience is outlined in Husserl's phenomenology of internal time-consciousness. The temporal aspect of these acts of synthesis, in particular those involved in intuitive presentation, would have to be outlined according to the nature of the image involved. This is related to the difference asserted between aesthetic and poetic images, which also has to do with the relation between their elements. Lessing assumed that this relation is perceived with immediacy in the aesthetic image (all aspects of a painting being perceived at once) but in a poem it unfurls gradually. This view has been inherited as an unresolved problem by the de Man-Krieger debate about the ekphrastic reading of poetry. Yet the exclusive assignment of temporality to poetry would obscure the problem of the relation between elements in both paintings—the perception of which is not only spatial but also virtually temporal—and poetic images, which are not only temporally accessed but also virtually spatial. In both cases the significance of the work as experienced cannot be located in an individual element, but in the relation to one another of several or many, and this relationality is temporal in nature. This is, as Hofmann described it, "a third fact of a higher order," created from the relation of two facts, even from just two lines drawn on a page (Hofmann 1994, 41), and this can be considered both spatially and temporally. Even in Barnett Newman's nearly monochromatic paintings, the color field is often outlined with marginal bands, or "zipped" by an intervening line of color.

On the level of aesthetic perception, the painting is taken in consecutive moments of realization of the whole, or more precisely, movements between whole and part, prominence and recession, in albeit densely contracted alterations. Peter de Bolla has examined the scale of Newman's (very large) paintings in relationship to this perception and very aptly writes of "the time of looking occasioned by color, the time of color" (de Bolla 2001, 43). This intervention is a stand-in for movement, what has been called "the side of space turned toward time" (Dufrenne 1973, 277). Newman's "paintings are concerned neither with the manipulation of space nor with the image, but with the sensation of time" (de Bolla 2001, 43). Time also concerns a sensitive interpretation of Monet's paintings *The Red Kerchief* and *Wheatstacks* given by John Sallis in *Shades—Painting at the Limit*. In these paintings, Sallis is

able to demonstrate "a matter of time that belongs always to the shining of the sensible," even if, as he argues in the case of these paintings, this time is a "matter of instantaneity" afforded in a temporal gathering unique to Monet's intense intuition of shadings and light. Monet accomplished this gathering by "painting the envelope of light at different hours of the day, of painting the different envelopes of light that spread over things at different times" (Sallis 1998, 51). Thus is achieved the depiction of an "elemental time," a time that is "inseparable from space." The intertwining of time and space is emblematized in the spatiality of the stacks of wheat "around which the temporal shining comes to be gathered" (55).

In Cézanne, color and line surrender to an intense constitutive collaboration, and so build up a spatial world, it seems, from within. In his letters on Cézanne, Rilke comments that "the color dissolves completely in its realization; no residue remains" [Die Farbe geht völlig auf in dessen Verwirklichung; es bleibt kein Rest] (Rilke 1985, 47; KA IV 614). "It is as if every place were aware of all the other places . . . that much adjustment and rejection is happening in it; that is how each daub plays its part in maintaining equilibrium and in producing it: just as the whole picture finally keeps reality in equilibrium [die Wirklichkeit im Gleichgewicht hält]" (80; 630). This equilibrium is perceived as and within an achievement of an aesthetic temporal duration. For any "pictorial space becomes temporalized when it is given to us as a structured and oriented space in which certain privileged lines constitute trajectories that, instead of appearing to us as the residue of some movement, appear as filled with a movement realized in immobility" (Dufrenne 1973, 278). Likewise, in a poem image is given texture and meaning in part through the "compilation" of several images, and "each facet is subject to modification by others. Our image is therefore constantly shifting, and every image we have is duly restructured by each of its successors" (Iser 1978, 138). In a poem, not only the flicker of an individual image, but the way in which one is, from line to line, mediated by the next in consciousness, creates this third level of reality out of their relation, be it harmonious or oppositional.

Admittedly, this level of being, this middle term of the image-object of a painting, is bound up in a tight condensation of time, similar to the contraction to which Sartre ascribes the *irréel* object, such as imagining a centaur, which is "a sort of contracted or compressed duration" [une sorte de durée contractée, comprimée](Sartre 1936, 249). The correlate level of significance in a poem, alternatively, is built up more gradually. This is the origin of the traditional relegation of a painting to space, simultaneity, and a poem to time, or succession, as discussed above. Yet the experience of painting, even in its apparent simultaneity, involves succession by virtue of moments of realization

in consciousness. This seems to be made thematic in Cézanne's and other paintings that impart both stability and movement, duration and permanence. This seems also to be thematic in Rilke's "Die Gazelle" as the suspended movement of the gazelle; in "Der Panther," this is conveyed in the centering of the animal's pacing of both paralyzation and movement. Lessing's distinction refers to imagining consciousness, since in a poem, just as in a painting, all elements coexist physically (on the page), but cannot be perceived as meaningful language (as poetic language) without the temporal unfolding of reading (or hearing). As Mikel Dufrenne writes on the subject of movement in painting: "The work . . . cannot manifest this movement which is imprisoned in the immobile unless there is a consciousness which is capable of deciphering the work and thus of breaking the spell which holds movement captive." Perception of a painting involves a unique and in-itself-differentiated temporal duration which "can be perceived only if it is integrated in our own duration." The painting blossoms into a temporal mediation of simultaneity by succession, where "the look wanders over the object and never comes to a complete stop," for it is held "through the allure of contrasts and transitions" (Dufrenne 1973, 278).

These contrasts and transitions are striking in Cézanne such that modulations of color appear to be "trembling, but very precisely," as de Kooning put it (de Kooning 1988, 11), and a single immobile outline is often refused in favor of several incomplete but together collaborative circlings around the object. For consciousness the stillness of a painting is much like suspended movement, the lingering movement Rilke compared to the rests and pauses in music and dance (for instance in his poem "Spanische Tänzerin" in *Neue Gedichte*). This movement is what fascinated another interpreter of Cézanne, again D. H. Lawrence. Lawrence saw mobility of Cézanne's human figures as mobility "come to rest," while he rejected the immobility of stationary objects in their ordinary regard, since in living perception nothing is stationary. Thus Cézanne "set the unmoving material world into motion. Walls twitch and slide, chairs bend or rear up a little, cloths curl like burning paper. Cézanne did this partly to satisfy his intuitive feeling that nothing is really *statically* at rest." And in respect to landscape: "We are fascinated by the mysterious shiftiness of the scene under our eyes; it shifts about as we watch it. And we realize, with a sort of transport, how intuitively true this is of landscape. It is not still. It has its own weird animal, and to our wide-eyed perception it changes like a living animal under our gaze" (Lawrence 1929, 29–30). Although Rilke was likewise fascinated by the "oscillating transitions" which usurp contours in Cézanne's work, he deemed Émile Zola's judgment of this discovery to be overwhelming for the painter and as evidence of the novelist's misunderstand-

ing of Cézanne (cf. Badt, 211). To Rilke's mind, the movement within the painting, particularly in still lifes, can be described musically. The immobility, indeed the permanence of things in Cézanne's paintings is, according to Dufrenne, "the end of [one] movement [but] retains a certain vibrancy" (Dufrenne 1973, 282, 278, 280). This vibrancy is analogous to the spatial reverberation of the poetic image.

In narrative painting, the temporal differentiation within aesthetic perception has to do with recognizing different aspects of the painting in their narrative sequence. This can be suggested by way of example, for instance, Brueghel's painting of the fall of Icarus, the subject of several ekphrastic poems, in which Icarus's tiny figure is half-submerged in water in a vast coastal landscape. The viewer's eye moves through consecutive moments of wandering, juxtaposition, and realization and only gradually becomes conscious of the event that is depicted and is occurring in the present image. The temporality of before and after, of cause and effect, requires some knowledge on the part of the viewer of the myth of Icarus and his fall, which is called up not only by the title but by identifying the tiny figure in the water, after which the landscape surrounding him is interpreted otherwise.

By the same token, the demand for absolute immediacy on the part of non-narrative and non-depictive painters is often relative to a perception of virtual movement, which provides the musicality of Morris Louis and Jackson Pollock, of de Kooning, and certainly of Paul Klee, who thematized music by way of the most abstract images of squares of color and light in their primal interaction. Examined phenomenologically, aesthetic seeing involves special variations of retention, attention, and protention—the components of internal time-consciousness in any experience—even if their interplay is not as gradual and complex in seeing a painting as it is in reading a poem, wherein one image-object is replaced and altered by another. The temporally condensed nature of the experience of painting, then, does not justify its relegation to stasis or simultaneity.

The most significant difference between the painterly and the poetic image remains the manner and quality of the intuition. Whereas the painterly image-object is determinate in the viewer's consciousness, and almost exclusively determined by the physical image, in literary images, particularly poetic ones, the "imagination remains unfettered" (Iser 1978, 138). Poetic images, in particular, allow for a greater degree of indeterminacy, and so perhaps the most significant difference between the kinds of images we have been discussing remains their completeness, or the differing level of closure of exchange between the physical object and the image-object. The painting can achieve significance beyond a determinate meaning of what might be represented. We

feel such resonance in Anselm Kiefer's ominous paintings of postwar fields, charred and conspicuously devoid of human elements; but the painting's image-object is nonetheless completed in acts of synthesis through intuitive presentation. In a painting, the image-object can resonate or reverberate in significance beyond the picturable, but it cannot present the unpicturable even if, as Newman sees it, the content of his paintings exceeds the image. This excess is accomplished by some kind of resonance between the viewer's acts of perception and the curiously temporal presence of the painting. To point to other examples, paintings of surrealist sensibility, from Hieronymous Bosch to René Magritte, or the drawings of M. C. Escher, which involve perceptual illogic, are nonetheless bound by laws of what can be perceptually presented, resonances beyond the picturable to be referred to emotional or psychological, at best quasi-cognitive, reverberations.

The poetic image, on the other hand, can succeed its incompleteness, presenting only partially picturable images which are outweighed by the resonance of the unpicturable meaning they subtend or offer. Here the Holocaust poetry of Paul Celan and that of the Hungarian-Jewish poet Miklós Radnóti come to mind. In these works, the poetic image is more radically negotiated or modified by what follows or precedes it—by another image, by a silence, indicating an absolute nothing—or by a startlingly dissonant combination of images (Celan's *Brandwolken Atem,* or "blaze-clouds of breath"; in a translation from Radnóti's Hungarian: "Sometimes a year looks back and howls / then drops to its knees." (Celan 1995a, 184/185; Radnóti 1971, 16). For here we have pictorally incompatible images—incompatible either by their illogical jointure or the concrete sensuality of one and the ideal quality of the other— joined together in a tightly antagonistic semantic collaboration, wherein all of the images so touched become oversaturated with post-iconographic reference. The incapacity to capture this saturated reference within the bounds of a complete and univocal mental image stimulates an undercurrent of unease or anxiety, a very specific helplessness, which nurtures an intimacy with the poem's subject-matter. In poetry, as Bachelard has argued, the real and the unreal are made to cooperate as "actual conditions are no longer determinant. With poetry the imagination takes place in the margin [dans la marge] or precisely where the function of the unreal [de l'irréel] comes to seduce or disturb" the ordinary (Bachelard 1994, xxxv; 1957, 17; translation altered).

While poetry can more readily conjure a sense or feeling corresponding to the unpicturable, the art of painting is far more successful in collapsing the image-object and the image-subject to make out of the absolutely concrete something significant or even peculiarly spiritual. Paintings that are effaced of all but the concrete (for example, Newman, Rothko, Pollock, Louis) are more

successful than so-called language poetry is when it presents to its utmost the material presence of the word in such ways as to, as far as possible, disarm semantic meaning. The effect of usually linguistic elements arranged as aesthetic-visual signs—from the Baroque tradition of figured poetry to Christian Morgenstern's "Fisches Nachtgesang" and John Frederick Nims's "Six-Cornered Snowflake" (Morgenstern 1992, 35; Nims 1983, 1–12)—is, apart from its novelty, a momentary and superficial one both cognitively and affectively, unless some external referent of, usually, menacing or religious significance is indicated, in which case it is no longer purely language poetry in the narrow sense of the now-technical use of the phrase. One such definition is provided in Käte Hamburger's study of the lyric, who calls it an "overemphasis—on the fact that poems are made out of words" (or in the case of Morgenstern, with punctuation marks). Here "words are not pretexts for objects, but rather objects pretexts for words" (Hamburger 1993, 256).

There is, no doubt, much more to say about the unpicturable, and it would involve a discussion of the phenomenological relationship between meaning and significance, or between a completed representation and an aesthetic intuition that remains unsettled. The vortex of that discussion could be located within the problem of resonance. But returning to the original problem of ekphrasis, which supposes the spatiality of visual images and the nonspatiality of temporal images, it has been argued, so far, that visual images involve a virtual temporality. Aesthetic images clearly should not be excluded from an account of temporality, but it is also necessary to point out the virtually spatial character of poetic ones. As before, rather than reifying it, a phenomenological approach here too renders this difference less absolute and assists in uncovering the logic of Rilke's ecstatic response to Cézanne.

Spatiality of the Poetic Image

Poetic images provide a kind of experiential space. This space is the subject of Bachelard's *The Poetics of Space,* which he calls a "phenomenological determination of images," the major concern of which is to create a topology of such images and "of the soul" (de l'âme) in which they reverberate (Bachelard 1994, xviii, xxi; 1957, 2, 5). This topology leads to a very different understanding of poetry than is found in Lessing's view of the genre, which restricts verbal signs to temporality and excludes the spatiality reserved for the visual. In attending to spatiality, Bachelard does not seek a materialist reduction of language to its own physical structure or textual space, nor is he concerned with how the words of a poem itself unfolds on the page, their relationship to the margin,

the bodily act of reading, and so on; rather his focus is on the virtual spatiality evoked by certain poetic images. This has to be understood as space constituted by the poetic image, which in Bachelard's view, appears either in a flicker of a single image or in a burst of images, though his emphasis is on the former. His analysis is not restricted to a phenomenology of reading, but of intuitive presentation as such, of what can be contained within that verbal medium that seems so capable of spatial reverberation.

Bachelard's term is *retentissement* (Bachelard 1957, 2, 6). The reverberation of a poetic image indicates the way in which the image communicates by means of resonances, the newness of which he associates with ecstasy (1). The ecstatic nature of the experience of the poetic image has to do with the fact that its resonances reach "different planes of our life in the world" and grant "a greater depth to our own existence" (Bachelard 1994, xxii; 1957, 6). Like Rilke's notion of *Weltinnenraum*, and Merleau-Ponty's account of the painterly image, both of which involve exchange between inside and outside, this reverberation collapses the ordinary understanding of space as external. Although Eliot argues that words "will not stay still," both painterly and poetic images open up "the still point of the turning world" that is captured in the image of a Chinese jar in his *Four Quartets*. Lawrence referred to the "mysterious shiftiness of the scene under our eyes" in a Cézanne painting; and Bachelard repeatedly draws analogies to painterly images (xx–xxi, xxviii; 5, 11). The poetic image in Bachelard, though not a rational concept, can communicate between subjects (reader and writer) on a deeper level because it echoes the "play between the exterior and intimacy" (le jeu de l'extérieur et de l'intimité) that belongs to the experience of being-in-the-world. While this experience is sometimes protective and, as suggested in literary presentations, sometimes hostile, evasive, or confounding (as space is presented in Rilke's *Malte*, Kafka's *Das Schloß* for example), Bachelard restricts his analysis to images *de l'espace heureux*. For the spaces of quotidian life—Bachelard examines the space of houses, of their garrets and cellars, closets and drawers, of corners, of vastness such as when looking at the sea—is space that has not only been practically experienced, but imaginatively lived through. The everyday space that has been lived through imaginatively lives within us and is thus open to resonance with the "wealth of imagined being" of the poetical image (xxxvi; 17).

While Bachelard differentiates imaginative-poetic space from that read according to the "reflections of geometry" and its measurements, Bergson draws an analogy between reading a poem and the constitution of "extension in space" by geometry (Bergson 1944, 230–31). But Bergson clearly refers to geometrical space solely as cognized by the mind. In both such geometrical space and that of poetic images, a virtual spatiality opens out within consciousness,

or rather between consciousness and the ideas of geometrical or poetical significance. In contrast to geometry's grasp of formal space of the mind, poetic topology suggests the lived space of the mind, the atmosphere of remembered and present perception, as well as of expectation, suggesting a spatial element of the image. Bachelard's study involves poetic images of interior and exterior space—the aforementioned seashells, drawers, cabinets, cellars, and so on—which are also, in his view, emblematic of poetic language itself. If Cézanne taught Rilke how to see things and their relationship to space—not merely occupying but generating space—poetry too is able to generate the sense of lived spatiality by means of merely verbal images. Jephcott's otherwise brilliant study of Rilke fails to bring out the real implications of Rilke's own realization when he confirms the traditional restriction of poetry to time (Jephcott 1972, 116). Because it is not primarily temporal but a play between temporality and virtual spatiality, poetry can aid us in the act of visual looking. Thus in reference to Rilke, Bachelard writes: "Poets will help us to discover within ourselves such joy in looking that sometimes, in the presence of a perfectly familiar object, we experience an extension of our intimate space" (Bachelard 1994, 199; 1957, 181). And this is, of course, the connection between Heidegger's earlier understanding of a phenomenological looking and his later rediscovery of Rilke. This extension or expansion of intimate space in the presence of the familiar culminates in an experience of ecstasis or ecstasy, which is what Rilke, Lawrence, and other critics found in Cézanne's paintings.

In many of his poems, Rilke explicitly takes up the notion of space, as discussed in the previous chapter in terms of the "inner space" of the rose and the discovery of *Weltinnenraum*. The notion of intimate or inner space with its inner horizons is compatible with a certain kind of ecstatic looking. In an untitled late poem Rilke writes:

> Raum greift aus uns und übersetzt die Dinge:
> daß dir das Dasein eines Baums gelinge,
> wirf Innenraum um ihn, aus jenen Raum,
> der in dir west. Umgieb ihn mit Verhaltung.
> Er grenzt sich nicht. Erst in der Eingestaltung
> in dein Verzichten wird er wirklich Baum.
> (KA II, 363)

> Space reaches from us and construes things:
> if you want to achieve the existence of a tree,
> throw inner space around it, from this space

that has being in you. Surround it with restraint.
It has no bounds. And really only becomes
a tree, is formed so, in your renouncing.

 (Rilke 1982, 263)

The poem suggests a directive for looking that at least to some extent Rilke
seems to have learned from the painterly images of Cézanne, for it suggests
the projection of internal space toward things. This can be understood best
not as a poeticization of a priori categories—as in Käte Hamburger's associa-
tion of *Weltinnenraum* with Kantian categories (cf. Hamburger 1988), but as
the aesthetic-poetic accomplishment of spatio-temporal constitution, through
which the way things become visible is rendered. Rilke's notion of an inner
space (Innenraum) of things—a space that is constituted by seeing intimately
what is in ordinary life (as well as the natural attitude) regarded as external
reality radically different from the interiority of consciousness—affords a
common register for the effects of visual and poetic images. Both poetic and
painterly images render the double life of visibility and invisibility in the play
between the intimacies of perception and the objectivity of things. This play
is described in Merleau-Ponty's reading of Cézanne discussed above, wherein
the painterly gaze is described not as taking-in of things by perception, but
vision's moving-out toward things. The image is the inside of the outside and
the outside of the inside, as Merleau-Ponty writes of Cézanne, a description
that could also help to explain Rilke's difficult notion of *Weltinnenraum*.
Throwing one's own space around the tree, as in Rilke's poem here, is analo-
gous to the painter's capacity to render of an object what it means—even what
it feels like—to take up space. With this extension of intimacy, consciousness
experiences the object with a special and complete proximity; in the poem
"Es winkt zur Fühlung fast aus allen Dingen," the speaker declares, "in mir
wächst der Baum."

Cézanne, Rilke, and the Phenomenology of Seeing

The circuit of this exchange between inner and outer space is the poetic image
in Rilke's poetry; but the infusion of external things with inner space Rilke
also found in Cézanne's aesthetic or painterly image. It can now be seen why
Cézanne's paintings, in particular, were provocative of ecstasis for Rilke as
well as for painters who followed him, though similar astonishment is ex-
pressed of van Gogh's modernism in Hofmannsthal's *Briefe,* mentioned in
previous chapters. It was in his break from Impressionism that Cézanne ac-

complished a unique discovery regarding painterly constitution. Originally he had much in common with the Impressionists, especially their turning away from what they considered the artificiality of nineteenth-century French academic painting. The Impressionists aimed to show the quotidian world as it was naturally seen, *en plein air,* in the splendor of the transitory moment of sensation, the fluid and changing nature of perception. Theirs was a decidedly anti-Platonic endeavor. It was not essences but the object as occasion that interested them, an occasion, for instance, of light which granted the viewer and artist a particular albeit ephemeral sensation. In comparison, traditional academic landscapes, still lifes, and portraiture looked artificial even if they succeeded in mimetic mastery. But Cézanne aimed to bring to visual consummation the durability of natural things underlying their ordinary appearances, to bring to visibility at once their phenomenal unfolding, solidity and cohesion. Durability, solidity, and cohesion are, given the fluid nature of perception, not given in ordinary perception, according to Cézanne; rather they must be restored to perception, in an intensification and reduction that gets closer to the structure of reality. As reflected in the critical reception, in Cézanne's painting a classical, and even quasi-Platonic aim, was married—to get to the even geometrical essence of things subtending their fleeting and fragmented appearances—to the illumination of the vibrancy of color and light. According to Merleau-Ponty, Cézanne accomplished this by seeing through visibility, by looking at looking. He went further in discerning not just how we see, but the way in which the thing itself turns visible before our eyes (Merleau-Ponty 1993, 128). Luminosity is subordinated to the trembling vitality that emerges from solid and, in quotidian perception, static nature.

Like the impressionists, Cézanne broke with post-Renaissance academic painting by "breaking the conventions of scientific perspective" (Novotny 1938, vii). Key in his case is not the illusion of depth, but the way depth generates visibility. Not a substitute objectivity, but the objectivity of the thing itself and its command of the visibility is what he aimed to realize. In pursuit of this depth, as is well-known, Cézanne spoke of the geometrical solids (cubes, spheres, cones), favoring contours of shading and color over the outline of the thing's surface, which he regarded as "secondary and derived . . . not that which causes a thing to take form" (Merleau-Ponty 1993, 140). His geometrical tendencies, it has been argued, remained largely theoretical (Rewald 1941, 31–32). He achieved depth not through an implicit geometricality alone (and in fact geometrical figures are rarely directly seen), but through modulations of color that generate spatiality or place. With this Cézanne "invented a new kind of painting." His "systematic breakdown of the distinction between color and drawing, between hue and outline (and the double role of

outline as form), introduced an entirely new kind of aerial perspective" (Rishel 1996, 60). Spatio-temporal movement, which interested Merleau-Ponty for its relation to embodied life, is generated by the vibration or radiation of his colors . Thus Cézanne made visible the role of constitution in the act of painting. There is "no longer any composition in the ordinary sense of the word," writes Novotny; but in respect to the ordinary object or the familiar landscape we find a new form of "monumentality" (Novotny 1937, 13–14).

What Rilke seems to have learned from Cézanne is how to render exterior space through an intimate space generated by a similar reduction, a constitutive realization in the image. In the above untitled poem, the approach to actuality—to real seeing—occurs through the image and the metaphorical mirroring image. Both Rilke and Cézanne revolutionized ordinary perception through a kind of proto-phenomenological registration of the nature of constitution of phenomena. If Cézanne, as Merleau-Ponty has argued, renders visible the act of painterly seeing, Rilke was able to evoke in his poetry the manner in which language effects a constitutive realization of the inner space of things. The poet, as Merleau-Ponty says of the painter, "lives in fascination" and in "the feeling of strangeness" that belongs to seeing (Merleau-Ponty 1993, 129, 68).

6

The Silent Ecstasis of Vision

In the wake of Cézanne an exclusive emphasis on vision seems to have become characteristic of much of modern painting. Some early critics of Cézanne argued that the isolation of vision in the experience of his paintings alienates art from real worldly experience. What his form of modernism introduces, it has been charged, is not only a break from the ordinary experience of seeing, but is contrary to it. With Cézanne's painting, it has been claimed, the "total absorption in the visual demands a mode of behavior which in life can only occur under certain very exceptional conditions" (Rishel 1996, 62). Sedlmayr referred to the "empty place in the midst of the world" opened up by modern art in Cézanne's wake, leaving "in the lost centre the empty throne" that awaits the perfect seer (Sedlmayr 1957, 255–56). Whether Cézanne's rendering of vision is viewed as alienating or liberating, it caused a departure from the habits of ordinary seeing.

While there are phenomenological intimacies between poetic and visual images, modern painting also offers singular departures from ordinary seeing by maximizing the visual. One way in which this occurs is through isolating the visual from its usually full experiential context, suspending the coordinated expectations of ordinary sensory experience with its several senses, and withdrawing from the potential activities of habitual action and expression, as well as from representative figuration. While poetic and painterly images share some phenomenologically describable qualities, as discussed in the previous chapter, the unique experience of visuality in painting that has been one of the preoccupations of some modern artists remains to be addressed. This is highlighted in paintings that eschew nearly all, if not all, traces of narrative or other linguistic expression, provoking a supremely visual encounter. Such

paintings confront the viewer with the maximum significance of their medium, and so the question of meaning arises from within a silent ecstasis of vision. In this chapter a few modern paintings representative of this silent ecstasis will be examined to determine the extent to which the prevailing phenomenologies of painting are able to address modern art.

The nature of this ecstasis in some ways resists definition within the dominant phenomenologies of painting, as much as those have been instructive in drawing out the ecstatic possibilities of modern art in general and its relation to ordinary perception. Phenomenological philosophers most invested in art have addressed modern painting in terms that are intertwined with a phenomenology or ontology of language. Heidegger's interpretations of van Gogh and Merleau-Ponty's of Cézanne have both defended the significance of painting through ontological and phenomenological theories which rely, respectively, upon a poetic or expressive-gestural understanding of art. Despite the differences in their views, both of their accounts present visual art in accord with a linguistic model that issues from a radical critique of traditional theories of linguistic expression. In approaching the silent ecstasis of vision in modern painting, the possibilities and limits of treating the art of painting as a language, even in a radically renewed and ontologically broadened sense, need to be considered. This can be accomplished by extending the range of potential application for these theories, by considering some paintings that seem to resist the poetic or the expressive-gestural model.

The idea that painting is rooted in bodily expressive gesture is part of Merleau-Ponty's approach. Yet some modern paintings (and here the qualification as "modern" is less chronological than stylistic, considering both intra- and postwar works) seem to admit both quasi-linguistic expression (through writing and gesture) and a form of muteness, represented here by works of Cy Twombly and Egon Schiele. Heidegger's theory involves the idea that painting, like poetic language, can be understood as a gathering of unconcealment on the basis of an ever-withdrawing source of concealment. In considering the breakthroughs of Color Field painters—here a few works by Morris Louis and Barnett Newman—it can be shown that the maximization of visuality in modern painting strains this model. Some modern works resist the notion of painterly language, whether this means expressive gesture made visible or the image as the gathering unconcealment and so saying manifestation of Being. Merleau-Ponty's theory is strained by the painterly refusal of gesture or writing, or their ironic initiation and abandonment, in paintings that tend toward visual muteness. Heidegger's linguistic-ontological understanding, while extraordinarily appreciative of art, is strained by paintings that do not seem to harbor the tension of unconcealment which would render them as a

kind of language in Heidegger's poetic sense. One must move beyond these phenomenologies of painting in order to register the silent ecstasis of vision in some modern works. The intensity of the visual experience projected by these works—whether effacing writing and gesture or resonating fields of luminous color—heightens a sense of vision's solitude and opens ways of seeing that transcend everyday seeing. Ecstasis occurs through the viewer's intense responsive perception as well as a meditative silence between viewer and work. While this may be alien to everyday seeing in its practical habitude, as critics of Cézanne have claimed of his work, such experience affords renewal of the visual texture of quotidian life.

The Poetic-Linguistic Model: Heidegger's Theory of Art and the Status of the Visual Image

The phenomenological account of art is indebted to a revaluation of language, thought in Heidegger in ontological terms, as the language of Being. In the essay "The Origin of the Work of Art" (Der Ursprung des Kunstwerkes), Heidegger rejects traditional aesthetics and the accounts of the artwork as imitation of reality, as the vessel of aesthetic feeling, or as the self-expression of an artistic genius. Art, more essentially, has a deeper origin, which Heidegger, in his later phenomenological ontology, relates to Being's self-concealing disclosure, to the relation and tension between world and earth as opening out and setting forth truth. In departing from the aesthetic tradition, Heidegger grants primary philosophical status to the work of art, overcoming the Platonic mistrust of art and superceding the Kantian relegation of art to a supplemental-tertiary (although also unifying) role in the life of a free and knowing human subject. More than mimesis, more than an occasion for reflective judgment or the symbol of the good, art is the manifestation of truth itself. By the third section of the essay, in which he discusses in depth van Gogh's painting of peasant shoes, Heidegger concludes: (1) truth is Being's self-disclosure in tension with its concealment, and (2) art is the happening of such truth. At this point, he is ready to make a third claim, which will be more closely considered here: *"All art,* as the letting happen of the advent of truth of what is, is as such *essentially poetry"* [*Alle Kunst* ist als Geschehenlassen der Ankunft der Wahrheit des Seienden als eines solchen *im Wesen Dichtung*] (Heidegger 1971, 72; 1960, 73–74). Although this is meant in a qualified sense—since poetry means something quite different from merely poetic expression—"Nevertheless the linguistic work, the poem in the narrower sense, has a privileged position in the domain of the arts" [Gleichwohl hat das Sp-

rachwerk, die Dichtung im engeren Sinne, eine ausgezeichnete Stellung im Ganzen der Künste] (73; 75).

For Heidegger poetry is a "projective saying" (das entwerfende Sagen). By naming beings, language makes them manifest as something; it draws them out, projects them as what they are, in their Being. Thus poetry is a form of unconcealment, bringing things out of a former state of obscurity, or non-manifestness, which for Heidegger is equivalent to their concealment. But since poetic language does not present the thing as definitively and finally manifested in its naming, a certain tension with concealment remains. Poetic language is special in manifesting this very tension as inherent to the beings it names, and therefore manifests the relation of these beings to Being and to language as the manifesting relation. For Heidegger truth is not the adequate correlation between a thought or idea and external facts; rather it is a form of uncovering or unconcealment. What becomes known in poetic language, though indirectly, is the relation between presence and absence that each being or entity has in its Being, the tension of its manifestation through naming as this thing rather than as something else. That poetry opens up a realm of such ontological unconcealment for the beings it poeticizes—rivers, fields, mountains, jugs, bread and wine, walls, flowers, fruit, and the like—manifests their essential relation to Being and, at the same time, reveals language or *poiesis* as the way in which their Being comes to happen as an event of truth.

According to Heidegger this structure is the basis for all forms of manifestation in art. Thus other forms of art, when considered in their ontological significance, are poetic, that is, they are forms of poetry; considered as poetry, paintings, and other artworks can be understood as art, as the founding of truth (Heidegger 1960, 77). In light of the intimacies between the arts discussed in the previous chapter, occasioned by the debt Rilke's poetry owes to Cézanne's discoveries in seeing, this privilege may seem problematic. Yet for Heidegger, painting and poetry are not essentially different; poetic and painterly arts are almost one and the same ontologically, once the origin of art is discerned. They are both forms of language as the manifesting relation to Being. Again, what Heidegger calls *Dichtung* is not ordinary language, but a movement of unconcealment which, unlike other modes of unconcealing, does not present itself completely but always retains an element of hiddenness, elusiveness, concealment (Verborgenheit). Heidegger's claim that the advent of truth is poetry, and that painting (along with other art forms) is essentially poetry, is nevertheless a difficult assertion. Although poetry is meant in a very broad sense, it is "at the same time . . . intimately thought in an essential unity with language and the word" [zugleich in . . . inniger Wesenseinheit mit der Sprache und dem Wort gedacht] (76). Access to the ontological significance of art is given through a poetic-linguistic model.

This intimacy of poetry with language and words is necessitated by the relation of unconcealment, or making manifest, with naming and meaning. According to Heidegger's "The Origin of the Work of Art," poetry is a manner of Being becoming apparent; but this projection of truth is the saying of world and earth in the play-space of their struggle (Streit). Truth as unconcealment occurs in the tense relation between the concealing nature of earth, or the materiality of the work, and the manifesting nature of world, or the opening up of meaning within the human realm. This involves the antagonistic tension created by the resistance of things (or earth) to the manifestation of meaning in their (worldly) opening. Poetry is the projection of this tension as meaning. In this sense both linguistic arts and visual arts are forms of ontological manifestation that can be described as *Dichtung* in the broader sense. Heidegger's play on the German verb for poetizing, *dichten* (which denotes literary language in general), and the adjective for thick or dense, *dicht,* is also important. The poetic work brings together, gathers in its vital density of relations, the event of revealing of truth.

In light of this it hardly need be reviewed that language for Heidegger is not principally the expression of a subject's internal thoughts, but rather Being's own coming-to-utterance. Heidegger thought of language as the language of Being, and poetry as language in its most essential form. The poet is not expressing personal thoughts or feelings, but rather the movements of Being's own self-withdrawing manifestation. While Heidegger treated painting as a form of language, it should be clear that he did not treat painting as a visual form of the subject's speaking, or as a sign-system, but rather as the complex revealing-concealing structure of the manifestation of meaning. Even speaking can be considered a saying, a showing, a bringing-forth into appearance, rather than an externalization of a thought in words. Thus Heidegger elsewhere attended to the materiality of the word in the context of which meaning emerges.

That painting should occasion such issuance of the Being or essence of things is not only suggested by Heidegger, but by the responses of others to modern painting as well. In the previous chapter Rilke's response to Cézanne showed a similar ontological intensity: the manifestation of things in Cézanne's paintings seemed to reveal their very essence, their deepest vitality. Hugo von Hofmannsthal too was struck with admiration by the presentation of things in modern painting. In *Die Briefe des Zurückgekehrten,* aforementioned, an exhibition of van Gogh's paintings elicited this response. In the fourth letter, after deploring his state of alienation from much of modern European culture (also characteristic of the relationships of both Heidegger and Rilke to the abstractions of modern life), the letter writer describes his overwhelming encounter with the artist's painterly rendering of things. That

it was not the artistic genius itself, but the essence or soul of the things presented, their ontological significance, that the narrator savors, is suggested by the fact that van Gogh's name is mentioned only in the postscript. First reflecting on the use of color, the narrator contemplates the essences made manifest in the things portrayed:

> But what are colors, if the innermost life of things does not burst forth in them! And this innermost life was here, tree and stone and wall and narrow pass gave off their innermost self, hurling it at me so to speak [. . .]

> [Aber was sind Farben, wofern nicht das innerste Leben der Gegenstände in ihnen hervorbricht! Und dieses innerste Leben war da, Baum und Stein und Mauer und Hohlweg gaben ihr Innerstes von sich, gleichsam entgegen warfen sie es mir . . .] (Hofmannsthal 1982, 169)

In contrast to the magical atmosphere of old pictures, such as the woodcuts of Albrecht Dürer he described in earlier letters (an artist also mentioned in Heidegger's essay), van Gogh's paintings stun the narrator with the sheer force of the things' existence—"die Wucht ihres Daseins, das wütende, von Unglaublichkeit umstarrte Wunder ihres Daseins" (169). The narrator finds himself confronted with the essence of things and the shocking wonder of their very existence, their manifest presence. Prefiguring Heidegger's sense of poetic manifestation from out of concealedness, the narrator perceives the essence of each thing in its salvation from nothingness. Each thing, once manifest in its essence, silences the nothing and obscurity of the inessential, such that:

> here each being—a being of each tree, each strip of yellow or greenish field, each fence, each footpath cut into a stony hill, the entity that is the tin jug, the earthen bowl, the table, the crude chair—emerges as if born anew out of the terrible chaos of nonexistence, out of the abyss of nonbeing, so that I felt, I knew, how each of these things, these creatures, was born up out of a terrible doubt about the world, and now covers forever by its very existence a gruesome cleft, a yawning nothingness!

> [hier jedes Wesen—ein Wesen jeder Baum, jeder Streif gelben oder grünlichen Feldes, jeder Zaun, jeder in den Steinhügel gerissene

Hohlweg, ein Wesen der zinnerne Krug, die irdende Schüssel, der
Tisch, der plumpe Sessel—sich mir wie neugeboren aus dem furcht-
baren Chaos des Nichtlebens, aus dem Abgrund der Wesenlosigkeit
entgegenhob, daß ich fühlte, daß ich wußte, wie jedes dieser Dinge,
dieser Geschöpfe aus einem fürchterlichen Zweifel an der Welt her-
ausgeboren war und nun mit seinem Dasein einen gräßlichen
Schlund, gähnendes Nichts, für immer verdeckte!] (169–70)

For Heidegger it is primarily language that draws things out of nonbeing, out
of concealedness, into their manifest Being. Just as Hofmannsthal's descrip-
tion identifies the tension in van Gogh's paintings of things between their
manifest being and the obscuring inessentiality of merely material being, Hei-
degger's purpose is to show that van Gogh's painting is not simply a depiction
of a particular subject matter, but a manifestation of the true Being of what
is being seen. The painting Heidegger considers shows the ontological ten-
sions that are essential to beings, in this case the equipment of shoes. The
ordinariness of peasant life, its everyday world and concerns, are brought forth
in the painting through a worn-out pair of shoes. The painting exposes a
deeper original bond with the earth as well as the difficulties of material life
whereby it represents a visual manifestation of a relation to the tensions of
Being. Visual art here accomplishes what Heidegger in his early writings had
attempted with the phenomenological strategy of the formal indication; even
this, fascinatingly, he described as "a way of looking." But now he also refers
more robustly to the setting-into-work of truth, the bringing-into-unconceal-
ment, effected by the painting, where the quotidian life of the peasant, indi-
cated by the shoes, is balanced within the earth-world tension Heidegger
describes. Not merely a theoretical description, the painting brings about a
manifestation of that tension: "The Being of the being comes into the steadi-
ness of its shining" (Heidegger 1971, 36).

According to both Hofmannsthal and Heidegger, what we find in van
Gogh's painting is not a sensuous mimesis, but a manifestation of the essence
of things. The experience does not remain primarily sensual, but is a happen-
ing of truth, an experience of what Heidegger himself refers to in the essay as
"the things themselves" (26). Things themselves are things manifested in the
light of unconcealment, with its lingering tension. Not merely mimesis, but
manifestation of beings in their Being or essence, occurs in van Gogh's paint-
ing. For both Heidegger and Hofmannsthal, van Gogh's painting brings
about an event of truth.

Yet while Hofmannsthal's letter writer contemplates in detail the visual
aspect of van Gogh's painting, in particular his very modern use of color,

Heidegger, for all the ontological depth of his account, tends to neglect the image. He does not give any significant description of the painting's visual surface and overlooks the historical context of its visual presentation. His argument for the ontological relevance of the work, despite references to shining and to the manifestation of appearance, tends to downplay the specificity of the visual means by which van Gogh was able to portray things in their essence. Since he rejects the notion of the artist as the primary origin of a work, Heidegger does not (and does not need to) refer to the thick brush strokes, the rough outlines of the shapes, or other elements of van Gogh's technique. Nor does he ponder the darker tones of the colors in the paintings of shoes, or the spatial arrangement of the shoes on the flat plane of the floor, their isolation from other objects. Heidegger makes no mention of van Gogh's contribution to the evolution of modern art, whereas Hofmannsthal expressly contrasts these paintings with the harmony of old pictures and sees van Gogh's work as a manifestation of modernism, and an alternative to the abstractions and superficiality of modern European life. Heidegger does not link van Gogh's painting of the peasant shoes to other modern paintings of peasant life in the wake of Courbet's depictions of humble quotidian, peasant objects, or to the influence of Chardin's intense renderings of everyday things. These omissions are, of course, to be expected given Heidegger's wish not to give an art-historical account. He likewise expresses no appreciation of the uniqueness of van Gogh's work when contrasted with traditional still-life paintings, their decorative functions, political, religious, or symbolic associations, nor even of the differences between van Gogh and Dürer, who as in Hofmannsthal's *Briefe*, is mentioned later in Heidegger's essay. Heidegger not only leaves aside any art-historical perspective that would focus on the historical genesis of the painting—a move that has significant phenomenological advantages—but also the treatment of painterly technique as well as a reception within the work's visual history. And having rejected the aesthetic focus on the viewer's subjective perception of the work, Heidegger does not linger over the reception of the work, its effect on the viewer. That the artwork will "let us know what shoes are in truth" does not specifically require visuality. Heidegger looks through the picture to the inner depths of Being it evokes, a strategy legitimated by his model of painting as a form of poetry, and poetry as the gathering event of Being.

For Heidegger what remains visible in the painting of the shoes is only their "blank usefulness"—their relation to world and earth and the tension that ever reigns in the region of manifestation. Unlike the fascination with beings expressed in Rilke's reception of Cézanne and in Hofmannsthal's de-

scription of van Gogh, Heidegger aimed to get at the "deeper origin" and more "distant source" of the shoes' equipmental Being. Not only is mimesis discredited, but the beings which would be imitated or represented are secondary, except insofar as they represent the peasant world and its relation to earth. In Heidegger's account, then, *Befangenheit im Seienden* or being caught up in existing beings is opposed to the openness of Being which is initiated by manifestation (Heidegger 1960, 68). This distant source, the possibility that Being can be projected in the event of truth, is initiated by language in the broader sense. In the context of Heidegger's essay, the painting not only brings out the equipmental reality of shoes to its "shining" appearance, but also issues a kind of utterance, all qualifications of Heidegger's understanding of language as *poesis* kept in mind. For him "this painting spoke" (Heidegger 1971, 35).

In short texts written throughout his career, Heidegger did comment on other visual artwork or artists, for instance a work by Raphael, which had also been discussed by Husserl, and briefly on Cézanne and Georges Braque. In these commentaries the status of the visual is remarkably complicated due to Heidegger's preference for the linguistic model as described above. He was highly appreciative of visual art, and of what the thinker might surmise from its disclosures, but in these writings he does not ponder the sensuous surface of the painting and the beings manifest there. Given his rejection of mimetic theory and traditional aesthetics of beauty, Heidegger expresses ambivalence with regard to the *Bild* itself because it is concretized in an entity or a presentation of entities (beings) rather than in the self-concealing "presencing" of Being. The *Bild* threatens to remain too metaphysical. Even in Heidegger's readings of poetry, the relevance of the poetic image is underemphasized, because he takes great pains to avoid treating such images as symbols for ideas, as occurs in some of the *Literaturwissenschaft* he attempts to overcome, or as depictions or representations of feelings harbored within the poet's soul and taken up in the poet's lyrical expressions. More importantly, perhaps, Heidegger's view of language as the language of Being rather than of speaking subjects needed to eschew all traces of Cartesian subjectivism with which an image was associated. Thus the imagination itself was suspect unless it was divorced from the notions of representation and fantasizing and also given a radically productive role, as Heidegger grants in his interpretation of Kant. In the commentary, he then attempts a linguistic model of the *Bild*, which could be thought of according to the ontological model of revealing or unconcealing of Being, as a kind of gathering for the event of Being. The shining of the painting is like the illumination brought about by worldly unconcealment of

beings. Thus the picture can refer us to the deeper origin beyond the visual presentation of beings. Above all Heidegger hesitates to reduce such an ontological event to a perceptual event, just as he aims to undermine any understanding of Being that relegates Being to an image-concept presentable to the mind and expressible by a subject.

In considering the status of the visual it is also important to note that Heidegger had attempted a kind of writing that would do away even with the pictoral image of language. In 1941, in a text he called "Winke"—hints or gestures—Heidegger aims for a "saying of thinking [that] is, in contrast to the poem, pictureless [bildlos]." This was a moment of Heidegger's impossible attempt to rid his own thinking of images. Perhaps evidence of what he hoped, ultimately, for the achievements of *Denken* and *Dichten,* he writes: "And [here] where a picture seems to be, it is neither the poeticized of a poem nor what sense intuits, but rather only the last recourse [Notanker] of a daring, unsuccessful picturelessness" (Heidegger 1983, 33). This picturelessness is desirable for overcoming what Heidegger thinks has plagued modern philosophy: the visual metaphor of representational consciousness, and a tendency to think of Being in terms of beings, which are, unlike Being, visualizable. At least poetry, if it involves images, can be gathered by the thinker into a dialogue about Being and its deeper nonvisible, and even unimaginable, origin. It is an origin to which we must rather listen, as to an original language; and in the shining of the visible we must be gathered to an origin to which we must hearken as we do to the poet's essential saying. Thus the poet, in particular the Hölderlinian figure, is a figure of the between-time—between the fled gods and those to come; between a lost age and a new kind of dwelling—who extends his listening into the abyss to hear both the last echoes of a past age and the anticipatory tremblings of a time to come; this listening is done by means of the poet's speaking of the abyss, a receptive speaking, a speaking that is a gathering listening. In overcoming the view that the word is a stand-in or tag for a thing, and thus itself a kind of present thing, Heidegger addresses the evocative relation of language to beings, irreducible to any present image in an ontologically sensitive hermeneutic of manifestation and absence. As this evocative relation to beings, manifesting from out of concealment, other forms of art such as painting must be thought.

In "On Time and Being," Heidegger's invocation—albeit without explication—of the problems of contemporary physics (specifically Heisenberg's uncertainty principle) suggests that he seeks confirmation for his displacement of a visualizable reality in the non-picturability of post-Newtonian relations between time and space. There he searches for a model of physical reality, perhaps afforded by the new science, that would be immune to localizable

and imaginable presence, thus implicitly exploring the "uncertainty" with respect to position or momentum which could be evoked by Heisenberg's formula. The configuration of reality suggested by quantum mechanics has the advantage of a challenge to the imaginable. The later Heidegger contemplates time and space not in any visualizable coordination but as "locale" and "whiling," both resonant of Hölderlin's river poetry. Space, which in aesthetics is considered the perceptual region of the plastic arts and of painting, is rendered in this reading as a kind of time. Space is not locality (as given in measurable coordinates) but locale (as in dwelling, which means lingering originally in a region) where thought lingeringly gathers as in language. Space is then a form of temporality that likewise evades positive configuration.

Given this temporalizing of space (a project that recalls Bergson's attempt to counter the dominant spatializing tendencies of the practical intellect), the visual-spatial element in painting need not be explored on its own surfaces. It is noteworthy then that Heidegger's comments on paintings by Braque and Cézanne are offered only indirectly, through remarks on a poet's remembrance of Braque (by René Char) and, in the case of Cézanne, through nonvisual thought: in a text he names *Gedachtes* (that which is thought) and dedicates to the same poet. Heidegger is interested in unity: of manifestation and what is manifested (Cézanne); of the one within the manifold of manifestations (Braque). In both commentaries, how the paintings look, their visual aspect, their startling alternatives to ordinary seeing, is scarcely mentioned or not mentioned at all. Whereas Merleau-Ponty will see Cézanne's paintings as evidencing the very birth of perception, Heidegger steers clear of theorizing perception. His question to that painter is peculiarly linguistic: "Does a path show itself here which leads into the togetherness of poetizing and thinking?" (Heidegger 1983, 223). The visual-perceptual sensuality of the painting, and its relation to perception, are not taken up. As in *Der Ursprung des Kunstwerkes* and its treatment of van Gogh, there is in Heidegger's commentary on visual art little discussion of the experience of seeing, for the language of Being's manifestation in its tension with concealment is the origin of the work of art. This emphasis on language as manifestation with lingering tension is also what sets up the conditions for Heidegger's view that the painting "speaks," a view that, as we shall see, is echoed by Merleau-Ponty, albeit with significant differences.

In his concern to avoid the image as the residue, if not emblem, of modern representational consciousness, Heidegger negotiates visuality by reference to "gathering" (Versammlung) which he attributes throughout his later writings to the word of the poet. The poet gathers the arrival of Being in its historical self-manifestation. The place opened out by sculpture, according to Heideg-

ger, is also such a "gathering" (207–8). He engages this notion again in the
essay on a Raphael painting of the Madonna, around which "gather" all of
the still unresolved questions about art and the artwork. Even if he was inter-
ested in the visible appearance of the painting, his thinking turns away from
the visual and to other, ontological tensions. If this is a "window painting,"
Heidegger defines the window as a frame (Rahmen) that limits the open of
the shining-through in order to "gather it in a release (Freigabe) of appear-
ance" (20). The countenance (Anlitz) of the painting is considered, but is
described not in its specifically visual aspect but as a *temporal* structure—as
return and arrival, to the gathering of Being as he elsewhere describes the
poem. Heidegger is not concerned with the specific visuality and spatial being
of the work itself, but the way in which it brings to manifestation echoes of a
deeper poetic origin. Heidegger is concerned about the capacity of works of
art to found or gather their proper place or locale—*den Ort zu stiften, an den
sie gehören*—in a world reconceived as dwelling, for which lingering and whil-
ing, and the temporal unfolding of language in unconcealment, are the origi-
nal structures. Because of the prominence of temporality in Heidegger's
commentary, painting can be seen as a form of language, bringing into utter-
ance from out of a between-time, the same manifestation that belongs to
essential poetic language. In light of the concerns of the previous chapter, it
is remarkable that the specific visuality of the painting is relegated to a tempo-
ral rather than a uniquely plastic-extensive phenomenon. This is compatible
with the view that painting is a kind of language, a gathering manifestation
that retains the tension of concealment. To what extent this view of art can
accommodate the silent ecstasis of vision in modern paintings will be ad-
dressed later in the chapter. First it is necessary to outline a second phenome-
nologically sensitive theory of art which, like Heidegger's, relies on a linguistic
model.

The Gestural-Linguistic Model: Merleau-Ponty on Painterly Constitution and Expression

In contrast to Heidegger's privileging of poetic language, Merleau-Ponty de-
fends painting as the form of art most relevant to phenomenology and phe-
nomenological ontology. Since Merleau-Ponty's phenomenology in its larger
concerns is devoted to the centrality of embodiment in perception, thought,
and language, Merleau-Ponty's theory of visual art more readily addresses the
spatial aspects of visual art. In his several essays on painting, Merleau-Ponty
investigates the phenomenal incarnation of things in perception as involving

density, a diversity of profiles never fully realizable in a single glimpse, in a single manifestation, and he argues that painting can uniquely express this density of being. In "Eye and Mind," Merleau-Ponty juxtaposes a scientific or prosaic looking at things with that of the modern painter, who understands that the object is not exhausted by a single viewpoint. Like the seer, things we perceive are never wholly given, but include a whole complex of recessive aspects that remain implicit in only apperceivable margins. In perception, the thing's unity is a given style of being caught within a set of paradoxical operations. The thing is recognized as an entity, and yet cannot be fully accounted for in terms of its measurable presence, for its full being is indebted to the whole complex to which it belongs, including other things within their common phenomenal field and the built up expectational horizons that fill in for perception its unencountered, unactual, still potential aspects. The painter respects this opacity. The visible world, when looked at through the painter's eye, is recognized as secretive and withholding. This view recalls Rilke's recognition of the mysterious horizon of the quotidian as well as Heidegger's arguments for the concealment that remains within any manifestation of beings.

In Merleau-Ponty's view, modern painting, which abandons classical perspective, gets closer to a pre-reflective awareness of this inexhaustible density. Painting is not the projection of a preconceived image in the mind, but an expression of what Merleau-Ponty calls "indigenous perception," involving a certain style as being manifest in a painting. In painting we encounter the inexhaustible, yet "prototypical," ciphers of being's perceptual manifestations (Merleau-Ponty 1993, 93). Merleau-Ponty's analysis locates in painting the origin, the nascency, the birth of meaning itself. This is the source of the linguistic analogy in Merleau-Ponty's understanding of art: painting is the speaking through gesture of the lived-bodily subject. The equation of painting and language, while appropriate for Heidegger's theory of the origin of the work of art as Being's original saying, is here ostensibly at odds with Merleau-Ponty's valorization of lived spatiality and sensuous experience. But when it is seen that expression in painting is gestural expression of lived bodily perception, the common logos underlying both perceptual life and painting is discovered, and this admits a linguistic structure.

Cézanne is the artist in whom Merleau-Ponty finds the expression of indigenous perception in painting. For Cézanne had overcome not only Renaissance science of perspective, but also what he considered the more recent reduction of nature to its subjective fleeting appearances. Merleau-Ponty finds in Cézanne's achievement the same approach to the things themselves that concerned Rilke and which concerned Heidegger in "The Origin of the Work of Art" and Hofmannsthal in descriptions of things in paintings by van Gogh.

Cézanne's work contains both the objectivity, or essence of things, and the individual perception by which they are manifest. It seems then that his contribution to initiating modernism in painting has to do with his rendering not only the world but the vitality of visual perception of it. While this becomes explicit in modern painting, it is the nature of painting as such in Merleau-Ponty's view. Here the function of painting is "to grasp the nature of what appears to us in a confused way and to place it before us in a recognizable object" (Merleau-Ponty 1993, 68). In this, Merleau-Ponty asserts, "the writer's act of expression is not very different from the painter's," for the literary writer does not merely represent a world but creates it—an accomplishment which is at the same time a discovery of how a world comes to be (Merleau-Ponty 1993, 82).

For Merleau-Ponty painting is a kind of language of our perceptual encounter with things in the world. Even abstract painting does not express the "translation" of a preconceived, clearly defined thought, but takes root in the painting's "execution," which expresses that there was *something* rather than *nothing* to be said" (Merleau-Ponty 1993, 69). This leads to the question: "How would the painter or poet express anything other than his encounter with the world?" (Merleau-Ponty 1993, 93). Again, to express an encounter with the world as encounter is to step outside of ordinary seeing: this expression becomes an ecstatic provocation. Abstract art is not locked up in the subjectivity of the painter, but speaks of the painter's relationship to the world, even if, in some way, repudiating it. Merleau-Ponty refused to make a distinction between representational art and subjective or nonfigurative art. His aim was to describe the process of expression that underlies both. Whereas for Heidegger artistic manifestation admits the deeper origin of Being's self-withdrawing unconcealment, for Merleau-Ponty artistic manifestation admits the deeper origin of expression that is an extension of perception itself, and so this origin is the common visuality that joins seer and world.

Merleau-Ponty's project involves painting as a privileged model for perception and for the space of encounter between self and world. He, like Heidegger, thus sought to overturn the Cartesian model of representational consciousness and corresponding interpretations of reality, particularly that of physical space and the structure of objects, and the view of painting as mimesis. Cézanne's rejection—much criticized even by his close associates—of Renaissance techniques of linear perspective, that is, of a scientific model of spatial representation, thus, in Merleau-Ponty's interpretation, allowed for the development and expression of a different kind of seeing. Rather than representing the real perspectivally, or presenting a highly subjective total impression, as did his Impressionist predecessors, Cézanne sought to participate

in nature and grasp its mode of objective reality. He aimed, as he said, to become nature's consciousness by eliciting the depth, solidity, form, and interdependence of objects through the realization of a general motif. This realization was highly reliant on "gathered seeing," a notion not unlike Heidegger's *Versammlung,* which happens in the work of art. According to Merleau-Ponty, Cézanne's paintings render visible the move toward phenomenological seeing, a suspension of the natural attitude, which in vision takes on our scientifically and practically biased presumptions about the objective spatial being of the world, in order to express the way this is constituted in our vision. Suggesting the thesis that art breaks through our practical orientation toward objects, Merleau-Ponty writes: "We live in the midst of manmade objects, among tools, in houses, streets, cities, and most of the time we see them only through the human actions which put them to use. We become used to thinking that all of this exists necessarily and unshakably. Cézanne's painting suspends these habits of thought and reveals the base of inhuman nature upon which man has installed himself" (Merleau-Ponty 1993, 66).

To reveal the base of inhuman nature is not to access the ground of Being before perception and sensibility, but rather to turn away from, or suspend, the already (scientifically and practically) constituted meanings of things in order to reach the origins of meaning. Wherever in the natural attitude we see those things that "viscous, equivocal appearances" present rather than the appearances themselves, the painter returns to those appearances, and in so doing, captures "the cradle of things" (68). Cézanne sought to render the strangeness of appearances before they are recognized as specific objects in space. The labor of seeing was to involve entry into that "cradle of things," and the task of the painter, recognizing the general motif of a particular moment of the world, was to realize that motif through vibrating line and modulating color and, in his middle period, by reliance on the solidity of geometrical shapes. Merleau-Ponty's interpretations of Cézanne trace thematically the order the emergence of things, the realm of the pretheoretical, an account of what he calls the "source of silent and solitary experience" that occurs preceding cognition, a source or primary logos that prefigures the world of culture but is lost in it. The artist who realizes, or makes apparent, the self-organizing tendencies of appearances to be seen in this or that way is able to make visible the emergence of these appearances. Realization is a form of constitution that is not so much the accomplishment of consciousness as a breakthrough vision and expression of visibility itself, a way of showing "how things become things, how the world becomes world" (141).

Merleau-Ponty's theory of painterly vision is grounded in a principle of embodied constitution of the visible. However, this constitution is not cen-

tered within the Husserlian transcendental ego in its indubitable presence, but rather within the reversibility of subject and object given in the aesthetic or painterly encounter. What happens in a painting is neither an imitation of external objects nor projective imitation of an image from the subject's consciousness. According to Merleau-Ponty "art is not imitation . . . but a process of expression" (67–68). Insofar as he defends a linguistic model, pains are taken, as in the case of Heidegger, to differentiate this model from a traditional account of speaking which would suggest the externalization of the subject's ideas. Merleau-Ponty rejects the view of speeches as expression, just as he rejects the view that the artist externalizes an inner image. The painterly image is not, he argues, "a simulacrum that I carry away inside myself, and through which I can grasp the object of my perception a second time" (Merleau-Ponty 1992, 113). He repudiates the prevailing, though often implicit, notion that painting relies on translation of an image from the mind which in turn represents a piece of the world. In order to defeat the mimetic principle without abandoning perception, Merleau-Ponty must account for the relationship between visually expressed images and the world that the painter sees without reference to the intermediation of representational consciousness. Sartre, for instance, likewise reputed the image as a reborn sensation by arguing for its "nothingness," that "the image is but a name for a certain way consciousness has of intending its object" (ibid.). The image is then not an object but an activity on the part of consciousness, an intentionality that addresses its object in the mode: *as imagined* and therefore as absent (Sartre 1986, 45). Rather than nothingness, for Merleau-Ponty the painterly image is a concentration of visual density. This recalls Heidegger's notion of *Versammlung,* in the release of appearances; but for Merleau-Ponty the ontological import of this remains at the level of the painterly image, rather than pointing the way toward the unity of *Dichten und Denken.*

In order to show that a still life is a concentration of the visible rather than its imitation in the traditional sense, Merleau-Ponty suggests several theses in "Cézanne's Doubt" and "Eye and Mind." First, the metaphysics of space as represented by scientific and prosaic vision must be overturned in favor of lived space. The notion of a cognitively discernable, itself not situated order of homogenous, depthless space must be replaced by a gradual unfolding of lived depth as seen in modern painting. Second, modern painting is important in having overturned principles of perspective as the ground of pictural composition and in having rendered instead the processes of lived perception. Third, the essentially Cartesian model of the imagination as intervening between consciousness and the world of things will have to be broken through. This third argument has two facets. It involves: (1) revising the concept of the

imagination as the storage and rearrangement of physically-induced copies of things they resemble, in favor of a more dynamic model of immanent visibility where the image is the outside of the inside and the inside of the outside; (2) such a model would be based on Merleau-Ponty's thesis of reversible subjectivity, indicated in "Eye and Mind" and more thoroughly worked out in *The Visible and the Invisible,* where the subject is so thoroughly situated as to be "reversible" with a likewise situated material object. The painter sees only because he himself is seen, and sees not from nowhere, as it were, but as someone who is also enfolded within the texture of the visible. The reversibility thesis replaces the notion of immanent mimesis by shifting the focus from a representing consciousness to the artist's existence among visible things with which he is himself analogous.

This sets up an equivalence that eliminates the distance of representation in favor of being "enfolded," to use language from *The Visible and the Invisible,* within the flesh (la chair) of being. Merleau-Ponty writes: "This extraordinary overlapping, which we never give enough thought to, forbids us to conceive of vision as an operation of thought that would set up before the mind a picture or representation of the world, a world of immanence and ideality. Immersed in the visible by his body, itself visible, the see-er does not appropriate what he sees; he merely approaches it by looking, he opens onto the world" (Merleau-Ponty 1993, 124). Things are no longer reduced to reflections of the mind but reflect the other side of the power of looking. This is related to Sartre's notion that the imagination is not a deceptive quasi-perception, but is precisely characterized according to its presentation of the object as non-present, as a kind of nothingness (Sartre 1986, 30–35). The reversibility thesis permits thinking of the means by which—in Cézanne's experience of painting and in its reconstitution in the viewer's vision—things "arouse in me . . . a carnal formula of their presence" (Merleau-Ponty 1993, 126). This carnal formula is not a simulacrum because it does not affirm an object perceptually available for the subject. The correspondences felt in Cézanne's realization of a motif, in his "becoming nature's consciousness," are made visible in his painting. Merleau-Ponty asks: "Why shouldn't these correspondences in turn give rise to some tracing rendered visible again, in which the eyes of others could find an underlying motif to sustain their inspection of the world?" This visible to the second power is not a faint replica; it is what allows seeing according to these correspondences between seer and seen that are felt by the painter (ibid.).

In the context of this notion of reversibility, which is now related to the induction of a way of seeing in the viewer by the painter, Merleau-Ponty attempts to reformulate the notion of the image that is at the core of the

aesthetics of imagination or *Einbildungskraft*. The displacement of immanent
mimesis has done away with the idea that the mind formulates a phenomenal
replica of what stimulates sensation, which belongs to the painter's "private
bric-a-brac" and is then reissued by the hand, on canvas, for the viewer. The
painting is not a private image that intervenes between consciousness and
sensation, blocking what is really there, is thus in contest with the real. In a
1936 review of Sartre's work on the imagination, Merleau-Ponty praised Sar-
tre's assignment of nothingness to the imagination, which supported his own
emphasis on the primacy of perception over the imagination. In his essay
"Indirect Language and the Voices of Silence" of 1952, to be discussed shortly,
the imagination remains a kind of perception which registers the invisible
within the visible. But Merleau-Ponty did not accept the Sartrean assignment
of the imagination to the pure nothingness of spontaneity, which would then
oppose perception of a being to the imagination's nothingness. Rather, the
image, neither being nor nothingness, might be considered the space of inter-
nal reverberation of the sensuous when it presents itself and is intended as
imagined. The image cannot be captured entirely in a positive picture, for it
too is informed, as is the visible, by its own margins of invisibility, its own
temporality and resonance. Any image, like any direct perception, is informed
by what is not picturable, full of traces and of only partially fulfilled sugges-
tions. In Merleau-Ponty the existence of this ontological stratum between
being and nothingness is suggested with the concepts of reversibility and flesh.
Like both seer and seen, the imagination is enfolded within the flesh of being,
and so "offers to vision its inward tapestries" [la tapisse intérieurement]. He
also insists that the image must be understood as the "pulp and carnal ob-
verse" of the actual, not its copy. The imaginary "does not offer the mind an
occasion to rethink the constitutive relations of things, but rather it offers the
gaze traces of vision, from the inside" [mais au regard pour qu'il les épouse,
les traces de la vision du dedans] (Merleau-Ponty 1993, 126; 1964, 24). This
tracing, as we shall see, is a kind of language, a kind of visual speech.

Painting, in Merleau-Ponty's words, "celebrates no other enigma but that
of visibility" (Merleau-Ponty 1993, 127). This celebration of the enigma of
visibility becomes a mode of expressing—speaking—the experience of percep-
tion. There is already an ecstasis effected here, in that the painter's task is to
overcome profane vision, to investigate light shadow, color, reflections—all
those aspects of the visible that "exist only at the threshold of profane vision"
and to "ask them what they do to suddenly cause something to be and to be
this thing, what they do to compose this talisman of world, to make us see
the visible" (128). Cézanne makes us see what is always happening in vision
but which, since it is dilated beyond the everyday foci of the natural attitude,
we fail to notice. Painting, one could say, is the gestural expression of vision.

Whereas for Heidegger the language "spoken" by van Gogh's painting is the language of Being, an event of truth, for Merleau-Ponty the language of Cézanne is the language of constitution and perception, closely related to the origins of expression in gesture. Critics have argued that this makes Merleau-Ponty's theory difficult to apply to abstract painting (Foti 2000, 137–38). If the language of painting is regarded as an expression of the way things become visible for seeing, how could one account for painting that aims not to present any discrete entities at all? Such painting could not be said to be expressing the emergence of appearances at the point of their constitution or realization as objects perceived. While Merleau-Ponty attended with great care to the structure of visuality, he did not address the recession or what Sallis, in reference to Paladino, calls the "withdrawing of language" (Sallis 1998, 127). Merleau-Ponty's view of abstract painting is telling; it must be understood as borrowing from the structure of the emergence of a thing into being, and so is a derivative form of celebrating the enigma of vision. This enigma is a gesture toward and expression of perception, a gesturing from out of perception that is the visual realization of speaking.

Merleau-Ponty's vision is not a simply active constitution, but rather a reversible one in which the visible—as in Husserl's model of passive synthesis, with which Dufrenne associated Merleau-Ponty's view—is received as an "event in the visual field" (Dufrenne 2000, 258). This event receives expression in the language of vision that is painting. Two problems arise in considering Merleau-Ponty's view within the context of modern art apart from Cézanne. First, the conception of painting, with its gestural basis, as a silent expression of embodied perception, while quite useful in describing vigorously gestural painting—Jackson Pollock's action painting, for example, Kandinsky or de Kooning—cannot account for the silent visuality that is maximized in other forms of abstraction. Certainly this would be the case for some works which will be addressed in this chapter, both considering the meditative intensity of Color Field paintings, as well as other works that indicate a withdrawal from linguistic expression. Second, the vital spontaneity in painterly experience, a not-yet-proto-linguistic cognitive vitality, is a visual play not fully accounted for by the notion of constitution and its proto-linguistic gestural tracings. The meditative quality of both kinds of paintings will strain the limits of Merleau-Ponty's model.

Between Writing/Gesture and Silence: Interpreting Cy Twombly and Egon Schiele

Some modern painting evokes or explicitly engages language, in works by many painters in a variety of modern movements. Cubism and Dada both

engage linguistic-readable objects as a part of pictural composition, and these play a central role in the trompe l'œil still life of the nineteenth and twentieth centuries, including Surrealist adaptations of the genre, for instance those by Magritte. A more than occasional integration of language into painting is found in works by Paul Klee, along with such Russian painters as Kasimir Malevich. Yet these paintings also exploit the visual quality of language— letters and words as abstractions. Collaboration between writing and image becomes thematic in shared undertakings of modern poets and painters. For example, Braque illustrated some of Ponge's work, and such modern artists as Picasso, Fernand Léger, and Juan Gris illustrated books of poetry. Many paintings that are evocative of written language or gesture seem not to illus-trate or corroborate but to displace the intent of linguistic meaning, rendering language instead as a property of the visual image. As integrated into pictoral composition, writing often becomes insignificant as language.

Paintings that evoke both language and silence, or a play between them, offer means to test the limits of Merleau-Ponty's phenomenology of painting in its reliance on the linguistic-gestural model. This play in modern art often takes the form of repudiation of writing, whereas Merleau-Ponty's theory re-lies not on a theory of writing but upon the lived-bodily origination of lan-guage in gesture and the expressivity of lived-bodily perception. Yet it is in writing, which assumes a silent life for vision no longer requiring the live voice and the moving hand that inscribed it—thus Blanchot renders thematic how writing expels both author and reader from the literary space—where the resistance to language as expression might be most explicit. Sallis examined Paladino's works for their very capacity to "refuse to display themselves openly to a vision presumed to be continuous with discourse." This refusal is announced in the titles of the paintings: *Silence, I am retiring to paint; Silent red;* and the *EN DO RE* cycle, employing phonemes in a procedure of musical "disentitling" (Sallis 1998, 125).

Other modern works present their own strategies of withdrawal from dis-course or from speaking. Klee's abstract paintings with letters are compelling in this respect, but so are his early notebook experiments that silence the meaning-giving nature of writing. His school notebook sketches of illumi-nated letters, one critic has argued, had already "set up an oppositional rela-tionship between verbal and visual imagery" (Achiele 2002, 117–18). They not only treat a given letter as principally an element of composition, but also effect a discord between the function of the letter for the script and the forms which arise from its visual shape. One such notebook watercolor of 1917 (Ini-tial 1917/11) depicts a profusion of flowery and botanical forms issuing from an ornamental letter (I) at the outset of a sentence describing a lone flower

isolated on a rocky ledge. Thus the visual proliferation contradicts the linguistic meaning of stark isolation. This use of language veers toward abstraction, since the letter becomes principally a shape out of which other shapes emerge, and then initiates a counter-depiction. The ordinary format of the school notebook allows these drawings to suggest a modern form of the monotonous work of the monastic scribe; but they also bring to mind Japanese painting with its graceful brush strokes constituting linguistic characters, prints of which were available to and admired by many modern European artists. Klee's notebook drawings seem to present a productive complication, then decorative erasure, of the gesture of meaningful signification.

In later paintings by Cy Twombly, two of which Philip Fischer examined in a recent study of wonder, there are similar and yet more severe invocations of writing, which nevertheless challenge its ordinary function of meaning. One of these works (*Untitled,* 1970) is composed of a large nearly undifferentiated plane of black-green covered with a white chalky gestural scrolling, giving the impression of blackboard writing, with its entrancing regularity and repetition, on monumental scale. In another (*Il Parnasso,* 1964) are presented sporadic episodes of collision and coagulation of lines of paint. Crossed out words in pencil indicate the Greek figures relevant to the mythical mountain such as Apollo and Sappho. There are also paint splashes like ink, scribbles, and interstitial blankness, as if the writing hand had suddenly and repeatedly aborted its mission. Since the writing is not writing but painting, it is suspended, pulled out of its ordinary function, such that it "will never be altered or opened up to other writing." Contrary to the usual mode of discourse, wherein language begets more language, here the potential utterance is closed off; and in fact this closing off precludes explicit meaning, since the cursivelike lines are illegible, as if not yet productive of readable letters. In both these works there is a fixation of the apparently most fragile writing, respectively, of blackboard chalk and pencil, so that, as Fischer argues, the "most transient of forms" are stabilized. The blackboard painting forces an "interference pattern" between different recognitions of the everyday blackboard object, so familiar to any viewer, and of the monumentality of the art-historical reference (Fischer 1998, 152). This kind of crossed recognition was effected more humbly in Klee's notebooks where the ornamental drawing of a letter both illuminates and contradicts the meaning of the writing it is meant to serve. Whereas Klee is said to have doubled the sign system and thus challenged the viewer "to negotiate two codes of signification" (Aichele 2002, 114), Twombly unravels signification at its most basic level of intelligibility. Heidegger's description of the "totality of equipment" (die Zeugganzheit), noted in earlier chapters, is of use here. Both Klee's notebook and Twombly's blackboard are

the ready-to-hand items that belong to the general context of school, study, and writing implements (Heidegger uses similar examples). Their being-at-hand, however, is interrupted once the function of these everyday writing tools is annulled and the painting's visual surface seems to become entrancing.

Klee's notebook renderings, more modestly, and Twombly's paintings of massive scale equally refer to the communication or intended communication between pupil and teacher; but in each case the pupil's effort of writing or copying writing is thwarted or turns into an ironic exercise. In Twombly there is a palpable resistance to signification. The viewer experiences a reversal of expectations of legibility, since the image gives only the superficial shape of language without its discursive function. The painting surprises by presenting the "puzzle that just where we would ordinarily find writing—that is, words, notes, formulas, diagrams, and problems—we find no words at all, no thoughts, no formulas or notes." In viewing Twombly we move from our impulse to read, an everyday habit of cognizing and communicating, to its "deprivation" and therefore indecipherability—to a visual awakening whereby "the move from reading to seeing has been accomplished" (Fischer 1998, 153). This surprise yields precisely what has been called in the present book an experience of ecstasis, a stepping outside of ordinary modes of experiencing, outside of practical habitual attitudes, in order to reflect on these modes, as a result of which this experience of the visible world becomes quite different from any other. This accords with what Fischer calls the "mysterious wilderness outside the village of the ordinary and the everyday" that emerges with Twombly into the field of vision (155). The coexistence of monumentality and delicacy, of delicacy and movements of ordinary life, is indeed gratifying, but it should also reinvigorate everyday seeing, a feat that seems to have been accomplished with Twombly's work.

Taken together the two works by Twombly described above present an absorbing fascination with pre- and postlinguistic moments of cognitive vitality, pre- and postlinguistic meditations respectively, maintaining as they do an inverted relation to the never-actualized possibility of saying something. The blackboard paintings evoke the school setting; and yet their illegibility—which Fischer overlooks in focusing on the scientific use of the blackboard—easily recalls attempts to write by children who have not yet learned to write. Twombly's painting is evocative not so much of the scientific formulae as it is of preliterate children's as-yet-inept imitations or pretended enactments of writing. One might consider the way cursive handwriting looks to one who cannot *yet* read. Such writing is not expressive; it is pure surface, playfully temporalized delineation of space; it looks mysterious, mystical, desired, en-

veloping, eminently promising, comforting in its regularity, frolicking in its looping curls, and referentially neutral. Anyone who has watched small children draw can confirm their insistence on overlapping and layering, particularly when they are pretending to write. The ecstasis of vision to be described is provoked not only by the transformation from the practicality of reading to the wonder of seeing, of which Fischer gives a phenomenologically sensitive account. A still more elemental stratum of Twombly's work suggests ecstatic sources of child-consciousness, the mode of seeing and intervening upon blank space—blackboard, paper, and the like—that is given free rein in children's play. This recalls Benjamin's interest in children's coloring books where the experience of color is not yet tethered to identification of objects. Here intervening in blank space causes delight long before any meaning to say needs to take expressive hold. This level of child-consciousness is most accessible to the adult consciousness through art—as explored in the literature of Proust and Rilke and in the analyses of Benjamin, Bachelard, and Merleau-Ponty. It is also relevant that Klee studied this proto-ecstasis of child drawings and scribblings with scientific seriousness.

These paintings are not only preliterate but prearticulate since, as Fischer put it, "the work has no parts or sections, no areas or segments" (157). Thus Twombly's painting *Untitled* (1970) does not only not "speak clearly," it also does not divide into segments which could stand in for the parts of language or the tensions of differing tonal positions. At first glance, the painting presents a delighting surface, and then departs in a strange, uncanny way from ordinary linguistic intentionality. But it does not have to be seen, as Fischer would have it, as a "master metaphor" or "as an idea." In overlooking the preliterateness of the painting, Fischer also misses the special correlation between childish delight and the uncanny annulment of language. In his interpretation the entrancing surface becomes explicable as an idea; it becomes conceptual art. The blackboard painting capitalizes on the idea of surprise of collision between two different expectations—what a painting is and what a blackboard is. Consequently, such an idea, as Fischer concedes, can be executed only once with full effect. Thus he describes the seemingly inevitable boredom looking at Twombly's paintings arouses: "Moving quickly in a Twombly retrospective, from one work to the next one, we find works too similar in kind to hold off boredom in exactly that situation where we began by being so taken with the freshness of the idea" (159). Yet where the deeper registers of ecstasis are felt and acknowledged, Twombly's work does not become this kind of conceptual art, an art of a bright idea, but a differentiated region of multifarious echoes between the preliterate, prearticulate imagination and its adult receptivity.

On a Merleau-Pontyian model, Twombly's art would have to be considered an art of gesture, of the moving embodiment of expression given through the quasi-writing hand. But it has been suggested here that the movement in the painting is from a state of adult articulateness back to a primal origin between the birth of perception and the full accomplishment of language. Taking the echoes of child-consciousness into account, even boredom has its place. Doodling, scribbling, and the endless repetitions of practice re-create for the attentive viewer the visual play space of intervention upon blankness that children so enjoy, and which for the mature consciousness presents a locale for attentive, but purposeless, lingering. The revitalization of the factor of nonpurposivity in childhood play, defended in chapter 2 against Freud's determination of its adult telos, is for the adult viewer fascinating, because that kind of boredom, which can be friendly to the childhood imagination and to fancy, is felt as a perhaps distressing shaking out of the more devastating boredom felt in adulthood. The originality of Twombly's paintings is far more nuanced than the immediate but short-lived wonder of a bright idea felt through opposed recognitions of blackboard and painting. While this is opposition is certainly a part of the effect of the painting, the viewer can enter leisurely into the transports they effect through echoes of child-consciousness.

The strange childishness of *Untitled* (1970) is made even stranger and more childish by the painting's larger-than-life size; but this childishness resonates, too, across the earlier post-classical muteness of the Parnassus work. Rather than preliterate, in the painting *Il Parnasso,* completed six years earlier, there is a postliterate experience of the same reversal: reading-turned-seeing. Whereas Raphael's Parnassus painting depicts a grouping of classical figures conversing, gesturing, communicating, embracing, and so on, in Twombly's painting there are no figures, only a few names scratched in pencil among episodes of paint-splashed and smeared color, and then scribbled out. The crossed-out, splotted, and aborted writing in the Parnassus painting evokes a post-writing—indeed coming after the now crossed-out possibilities of Sapphic utterance, superceding mythic figurations of a past poetic language. All the intelligence and poetry of that past and of a (now necessarily scholarly) relation to that past is negated, even playfully mocked, by the childish scribbles, still breaking through the already-developed linguistic cognition suggested by the names of Greek poets and gods. It is consistent with this interpretation that the Parnassus painting was executed first, for what is most remote in the past—our childhood origins as echoed in the blackboard painting—might be farthest from the fixed habits of seeing.

In order to draw out further the inverse relation to utterance and the silence of visual ecstasis, a few more works by Twombly should be considered.

A different but resonant effect is evoked by an earlier work, *Leda and the Swan* of 1962, constructed of oil, pencil, and crayon. Here the story of the seduction of Leda is not softened by the beauty of figuration—the alabaster form of a classically voluptuous Leda and the richly feathered, darkly shadowed, velvety swan, as in Renaissance depictions. In Twombly's Leda, there is no depiction of figures at all, no narrative that could be discerned even through the abstract, vital movement of the intervening lines. Rather, the distressing, and yet not entirely chaotic, conflagration is comprised of diverse sketches and scratchings, scribbles, markings in shades of black, grey, white, and a vibrant red, that seem to invoke both centrifugal and centripetal movement around an unseen because not localizable center of action. The violence, and also intense stimulation, of the painting is created not so much by its vigorous movement, but by the disjointure between the sexual subject-matter of the title—affirmed by the splashes and scratches of blood-like red invoking at once lust, injury, penetration—and the childish form of the markings, indeed of the materials themselves, in particular the red crayon. The painting's size provokes a distressing exhilaration of scale (over 6.3 x 6.6 feet). The image effects another interference pattern between recognitions, a notion that Fischer developed to describe the blackboard work. With this notion it can be said that the classical-mythological reference here provokes an everyday worldly echo of the mythological and art-historical past, for the form of markings made by children writing and drawing with pencils and crayon are common and familiar from everyday life.

Twombly again hints at the potentiality of ecstasis sheltered by the child-consciousness, here in a violent and silencing collision with the drama of adult signification. This interference pattern provokes a transformation of the viewer's gaze from one which, directed by the title, looks for meaning, tries to read the painting; instead of reading the scene we are directed to the drama of pure looking and of meeting an event. This drama of looking is curiously thematized by the only recognizable object in the painting, in its upper-right corner: a small, childish pencil drawing of a four-paned window in outline. This astonishingly quiet, at first perplexing, presence of what seems to suggest objectivity, bluntly, but also mutely, thematizes the experience of viewing the painting itself. The transparent window (since drawn in outline only and reflecting no glare) gives no view to an outside, does not reflect the looker back into its glass (which is not indicated by any sheen or patina), but rather directs the viewer's gaze back onto the paper that shows through, back into the illegible yet provocative spectacle of mute seeing. This small childish window is almost emblematic of the phenomenological reflection upon experience that has been under discussion throughout this book as uniquely invoked

by modern art. One of the most interesting relatives to this aspect of Twombly's work is found in Anselm Kiefer, whose works invite a meditation on violence by a similar snuffing out of language, by illegible markings, in contrast to other readable words, which evoke both historical, post-catastrophic stupor, and residual blood.

These remarks on the Leda painting are intended in part to supplement Fischer's study of Twombly, most instructive in pointing out precisely some ways in which Twombly plays with quotidian experience. But what happens in the Leda painting, as in that of the previously mentioned works which Fischer examines, suggests beyond Fischer's commentary a real drama of nonsignification. Language—in the Leda painting only implied by illegible pencil markings, crayon scratches, and markings-out—is shut down in a revitalization of a different kind of visual experience. This revitalization is dependent on the strange childishness of the seeing it provokes, and the clash between mature, literate consciousness and sources of ecstasis that childhood experience seems to harbor.

This drama of nonsignification is also found in yet another set of Twombly works that are closer than the Leda theme to everyday experiences of utterance. These are two etchings, *Note I* and *Note II* (1967), on orange-buff laid handmade paper, each comprised of a larger field in which a small note is placed slightly above the center. Each note looks and at first glance reads like a small letter, a notation, or a linguistic explanation of something outside the field of the larger background image. Yet any such reference outside the painting—any such linguistic reference, that is, any real functioning of language—is annulled by the illegibility of the lines of writing. From a distance, the paintings look like handwritten notes framed within a larger field; up close it is clear that they do not say anything, that their cursive-like linear and progressive marking only playfully mimics something like writing, as if preliterate children were pretending to write.

There is in the experience of viewing these works a similar reversal of expectations as discussed above. Instead of writing, the viewer is merely seeing; and then instead of merely seeing, the viewer is intensely examining, following-through, looking for clues; and then experiences recognition. This recognition involves the yielding of intentional meaning to the primacy of the mute image, to the quiet patterns of the curling marks and their repose against and on the paper. Recognition returns the revitalized aesthetic of seeing into the context of everyday life which the notes suggest. Twombly's notes are a directive to take note of; but of what? *Note II* presents a more startling reversal of the expectation of reading. It presents a vertical slant contrary to ordinary cursive handwriting. The ovalesque horizontally unfolding curls lean to the

left rather than to the right, and stop midway in the last line, which covers half the space of the others, but not as writing (in Roman letters) would. Rather, the line appears to be inscribed from the right-hand rather than left-hand side, suggesting an undetermined reference to other forms of writing. In the *Notes* the transformation from the immediate impression of a familiar product of ordinary activity—note making on paper—to a visual experience quite unfamiliar, startlingly lovely, and even haunting, is effected by signification's abandonment, an event which seems to be etched into rather than depicted by the image.

The constant vivacity of the elements of Twombly's paintings—their movement in events, episodes, squiggles, curls, progressive oscillating lines, crossings-out, splashes, and the like—seems at odds with the notion of a gathering unconcealment of a singular and deeper origin preceding any consciousness, a notion essential to Heidegger's view that a painting speaks. Yet when these works are understood as echoing the primordial resonances of childhood experience, Heidegger's terminology of manifestation and unconcealment might be appropriate to some extent, if the surfaces of delight that are suggested in children's scribbling are regarded as images in themselves rather than as harboring a concealment that points primarily to the unity of poetry and thinking, that is, to language as the primary manifestation of Being. The tension in these images is not one of *Streit* or antagonistic tension, but of play, even if that play suggests darker, uncanny, or more obscure emotions as recollected in adulthood. This would echo the suggestions of child-consciousness in Rilke's original looking, an experience Rilke attempted to approach in his elegies and novel. While indeed evocative of a deeper and ever-recessive origin, in Twombly an original looking shimmers with the originality of childhood, enframed but also sheltered by a mature aesthetic imagination with which it sometimes clashes. Any origin here is rendered at surface, experienced through the dual register of discord and rediscovery in the image itself.

Having identified the reversals made visual in Twombly's works, the limits of any linguistic model, even one of ontological depth, become apparent. Instead of speaking, a certain silence of language is felt, as seeing takes the place of expressing, gesturing, or naming even in the broadest poetic sense of gathering into unconcealment. It might be argued, in Merleau-Ponty's terms, that the gestural movements of the Twombly works effect a kind of expressive speaking, that the gestures, the traces of the hand, are language in another form, and that therefore the viewer is not directed away from reading altogether but is pressed to read the gesture itself as legible. For Merleau-Ponty the painting, like language, expresses "an event which is taking place" in a "continuous improvisation"; this event has the "right to philosophical status,"

for painting contains a "mute thought" (Merleau-Ponty 1993, 139, 149). This view would be also compatible with Fischer's suggestion that Twombly's image presents an idea. Yet it is not in the gesture, but in the turn to silent seeing, that the ecstasis of these works is experienced.

For Merleau-Ponty the painter always intends to signify something; there is always something the artist has to say and progressively approaches. A painting's visual composition is always a form of language in another sense. While a painting expresses not so much the meaning as the meaning impregnates the painting, this meaning, though never complete, "commands the arrangement of a painting just as imperiously as a syntax or a logic." In Merleau-Ponty's view a painting always says something. Concerning Vermeer's painting, he remarked that the "system of equivalences according to which each of its elements, like a hundred pointers on a hundred dials, marks the same deviation . . . speaks the language of Vermeer." In van Gogh's painting of crows over a field, he saw the artist aiming to tell a truth. Thus he defends not only his view of language as informed by painting, but he also explains why it is legitimate to treat painting as a language (Merleau-Ponty 1993, 94, 149, 92, 93, 98, 112).

In the wake of Merleau-Ponty's theory, philosophers have described paintings as a form of speaking. Schiele's self-portraits have been interpreted, in Silverman's highly sensitive account, as gestures through which "the speaking subject speaks through painting" (Silverman 2000, 132). Painting is speech in a more primordial sense than its referential nature; not in its capacity to illustrate a meaning we already knew, but in expressing something theretofore unsaid, painting makes a "silent world . . . uttered and accessible" (Merleau-Ponty 1993, 88). Language gropes half-blindly toward its meaning and, at the heart of its very structure, lies silence, the difference between signs. Just as painting can express, that is, speak through this muteness, language is ambiguous, speaking through its own silence. The relation of painting to language is not merely analogous; both are forms of primordial or original expression.

All painting thus is regarded as a kind of disclosure through the language of perception and gesture. Cézanne's painting, Schiele's painting, all are already a kind of speech, a kind of inscription of visibility unto the world (Silverman 2002, 132). Interpreting Schiele's self-portraits through Merleau-Pontyian readings by Dufrenne and Lyotard, Silverman affirms that Schiele renders, in fact inscribes, the "lived as seeing, as seen, as speaking, as spoken." With regard to the self-portrait as Saint Sebastian punctured by arrows (a deliberate choice of figure that would need accounting for), Silverman argues that what the artist is saying here does not matter for Schiele—through the gesture—is speaking, expressing, elaborating a gestural space. This careful interpretation

of Schiele respects Merleau-Ponty's view of painting as language. Schiele's painting would then be "a visual language, a language of seeing" (132, 133). While Merleau-Ponty's essay "Indirect Language and the Voices of Silence" presents a significant critique of André Malraux's view of paintings as the voice of silence, for the latter, too, paintings are "significations, they impose a meaning"—through style—"on visual experience" (Malraux 1978, 234). Merleau-Ponty leaves, nevertheless, this aspect of Malraux's theory in tact.

What is useful to the philosopher in Merleau-Ponty's position is that, if painting is essentially signification or speech, and speech is essentially inscription of a "mute thought," its relationship to truth is readable for the philosopher's interpretive or translating description. But if the viewer's full experience of the artwork is considered (of which, it has been pointed out, Merleau-Ponty takes little account; Potts 2003, 105), such a description seems to overlook something essential. The contemplative silence provoked in the ecstatic experience of a painting might, but need not, be one and the same silence ascribable to the condition of possibility of actual communication through words. Because Merleau-Ponty grants a privileged status to language, silence for him is a not-yet spoken, a deferral of speaking, an incipient meaning. In explaining language and painting in terms of common sources in synaesthetic embodied perceptual life and expressive gesture, Merleau-Ponty's theory has no place for nonlinguistic silence. The childish pretend writing evoked by Twombly rather seems to effect a shutting down of saying, a moment of suspension of the logos, whilst following the productive-meditative boredom and delight of childish repetitive gestures. Painting can emit a qualitatively different silence, a singular address to opticality, what Dewey called the "maximum significance" of the particular sense concentrated in a work of art.

Merleau-Ponty's model makes it difficult to address what in painting is an optical address to sight alone. This is due to the nature of his theory of perception, which justifiably relies on the whole sense-complex that surrounds the visual experience. Since visibility is rooted in common materiality the viewer shares with the things of the world, the relation between seeing and touch is essential. As touch is the place of a viewer's participation in the seen world, so is expressive gesture a part of seeing, and this is rendered visible in painting. Moreover, synaesthetic experience has been evoked explicitly by painters since at least the Renaissance, for whom it was desirable to capture in a visual work, for instance, the feel of velvet or the taste of ripe fruit. Modern painters also rely on synaesthetic evocations. Kandinsky, in particular, insisted that a painting should be received with all five senses based on a law of association between musical sound and color, for instance, an association also characteristic of Klee (Kandinsky 1968, 346–49). But this association is not a necessary

condition for a painting, and a phenomenological explanation of this cross-reference would necessarily leave out a description of the supremely and singularly visual vitality of other modern works.

This relative isolation of looking would not refuse overlapping between sight and other senses, but it would suggest interstitial gaps between them. This is what Rilke in his 1919 essay "Ur-geräusch" called "the dark sectors" (die schwarzen Sektoren) in his visual rendering of the five separate regions of sense experience (KA IV, 703). In his essay, Rilke describes the material and visible recordings of sound from a makeshift phonograph constructed in the narrator's science class and the narrator's experiments with other potential translations between the senses. Remarkably, the actualized or potential translation between the palpable or visible and the audible not only suggests an overlapping, but also indicates the abyssal gaps between the senses. Like Merleau-Ponty decades later, Rilke suggests that the regions of sense perception, in order to be translatable, must have a common origin in a subphenomenal unity; but this original unity is never named by Rilke except in the essay's title (which was suggested by a friend in a letter to Rilke) as an original, prephenomenal sound. The dark sectors between the senses, however, can be explored by the poet who is able to draw from all senses, and who conquers some of the unexperiencable inter-phenomenal sectors for the realm of experience. While Rilke's essay has been interpreted as a treatise on synesthesis, the emphasis is in fact on the limits of sensual perception, which divide the senses from each other, and on the insight that the crossing of these boundaries requires a poetic leap. While synesthesis is a part of the experience of paintings—such as when we pucker our lips in seeing Chardin's lemons or salivate at his cherries, or feel the fragile stream of milk poured from a pitcher by Vermeer's model or see the brittleness of an icy window pane—there is another aspect of the visual experience of painting that might be maximized. Although Dewey also accounts for the common sensual origins of opticality—its evocation, for instance, of touch—"the sensible surface of things is never merely a surface" (Dewey 1958, 29)—his notion of maximality of the given sense-experience is helpful. The painting is best understood as painting, in his view, when seen as a made thing purposively designed and designated to be seen.

For Merleau-Ponty, art was most compelling if it evidenced the structure of perception or projected an explicit gesture. Confronted with abstract art, he asked the question: "What does abstract art speak"? in response to which he called it "a negation and refusal of the world" (Merleau-Ponty 1993, 93). Since painting must speak in some way, he saw abstract art as speaking to a

negation of the world of objects, by crossing out its inheritance from percep-
tual experience of things. But this view is not commonly held by abstract
painters. In his theoretical writing, Mark Rothko stated that modern art—
apart from surrealist skepticism—is not a denial but an affirmation of the
world's objectivity, in celebrating the potential unity of the subjective and the
objective (Rothko 2004, 61).

Yet even in paintings that represent a gesture, such as in the self-portraits
of Schiele where the figure upholds his fingers or raises an eyebrow to the
viewer, the tenor can also be read as ironic. The gesture places a distance
between the subject and the viewer as if only to signal difference rather than
to communicate, similar to the reversal of communication in Twombly's use
of writing-like forms. Contrary to the initial glimpse, the viewer feels pushed
away from the figure. The gesture is not meant to tell or say, rather it presents
an ironic consummation of the strangeness and evident pain of self-seeing.
The figure in the apparently gestural space of at least some of Schiele's self-
portraits presents the spectacle and solitude of an aborted communication, a
communication that can be savored in the painting's ominously and erotically
playful surface of shape, figuration, and sharply contrasting color. Though
communicative in a very formal sense, this cannot be confounded with lin-
guistic intentionality, a "meaning to say." While not erased in the self-por-
traits, it is called into question; utterance is only eerily suggested by the
flagrancy of the image qua image.

The tone of Schiele's self-portrait as Saint Sebastian pierced by arrows is
one of uncanniness and distressing irony. Elaine Scarry's investigation of the
body in pain comes to mind; paradoxically, torture hampers the capacity for
speech, perhaps even the structure of intentionality underlying meaning to
say. One could add that sensual pleasure at its height effects the same.
Schiele's self-portrait, for all its ironic and dark playfulness, suggests this kind
of breakdown, similar to the 1911 group of paintings of sunflowers and au-
tumn trees. The figures in these paintings are in a similar state of withdrawal
from communication to the viewer; nonsentient beings presented as if mute.
They render a kind of loneliness of sight, as if seeing were cut off from all
other senses, and the expectations of synesthesia were reversed. In these paint-
ings the breeze made visible in the movement of petals and leaves appears
frozen against an evening light and annuls the expectation of some kind of
bodily echo to be felt between those figures. In the self-portrait, the bodily
individuation, its momentary muteness, is a paralysis of speech ironized by
the ostensible gesture of the figure.

Ecstatic Muteness, or the Beauty of Not Speaking, in Color
Field Painting

In light of the prevailing phenomenology of painting as a kind of language or
speaking, some Color Field paintings should be considered. One painting by
Morris Louis and one by Barnett Newman, both of which amplify the ecstatic
silence of vision indicated by works described above, will suffice to represent
the kind of silence that strains the linguistic models. Louis's painting entitled
"Tet" is composed of veils of blue and blue-green, cascading down the white
canvas in a translucent stain. It is dominated by indeterminate traces of cold
colors, behind which the even colder backdrop of the white canvas glows
through. The image is both gorgeous and bewildering; a lingering look pro-
duces a slow ecstatic removal from the usual structures of visuality, with its
adherence to recognizable shapes and forms and identifiable color. An eviction
of gesture from the surface of the painting makes any painterly hand or ges-
tural movement untraceable.

The painting could be said to effect a reversal of the expectation of speaking
which Merleau-Ponty has ascribed to painting's silent language. The title is
the Hebrew letter "Tet." The letter is a single unit possibly standing in for a
word (title) and thus, as in Klee's visual use of letters, and Paladino's pho-
nemes, it is prevented from meaning anything determinate. But as a Hebrew
letter "Tet" can also refer to a number—in this case 9. Viewing the painting
one can see how Louis, like other Color Field painters (for instance Newman,
Rothko, Frankenthaler, Albers, Still, Olitski, and Noland), aimed for intense
visuality. In various ways these painters evoke "the power of pure color,"
circumventing any possible figuration that would suggest gesture or reference
(Rose 1967, 224).

Louis achieves this through innovations in medium, by expanding the li-
quidity of paint with the aid of a specially formulated substance. The color
then was not so much painted as stained onto his canvas, with the result that
"most of the paintings, despite the brilliance of individual hues, have a somber
resonance, evocative of the earth, despite . . . the diaphanous properties of the
image." He composed his paintings with "overlapping flurries of transparent
color, running in various directions before depositing their color traces on the
parched cloth." Their "interplay of directional tides . . . tremble on the disso-
lution of the surface" wrote one critic, so that "the whole area of the com-
pleted painting is not reducible to smaller components which can be equated
either with signs for known objects or with personal handwriting. . . . The
painting must be seen as a single field, a field not devoid of incident but,
equally, not reducible to a scale of different sized forms and marks" (Alloway

1963, unpaginated manuscript). Like a single letter of the alphabet, the field cannot be reduced to smaller components. Only the veils of color would become jointed segments of articulation; but then they could not be translated into any potential gesture. As a field, the image is strikingly inarticulate in a way unaccounted for by the space of difference between signs; it suggests unrepresentability and indetermination rather than groping toward articulation. A single letter cannot indicate a between of the linguistic silence so thematic in poststructuralist theories of language; yet the painting is related to language only through this absence (here of other letters). Not only does it not render evidence of the synaesthetic or gestural origins of painting, but it erases it; it does not express the body of the painter at work in the world, positioning himself vis-à-vis things, vis-à-vis the canvas. In Louis the "line, in these paintings, is no longer contour, no longer the edge of anything. It has been purged of its figurative character . . . [such that] the illusion established in these paintings is not one of tangibility" as in the lines of Pollock "but of its opposite: the dripped line, in fact the paintings in their entirety, are accessible . . . to eyesight alone, not to touch" (Fried 1967, 13). While it has been said that Jackson Pollock liberated but never abandoned gesture, Louis presented his work as not having been made by gestures of any kind. The waves or, as he regarded them, veils of color are divested of "tactile significance" because the "limits of individual color-configurations are not experienced as though they were the edge of some kind of tangible thing" but as a compelling, unbroken continuity (15). If the silence of language in the poststructuralist sense affirms the discrete differentiation between signs, no such differentiation is possible. The painting is silent in a way that is foreign to articulation (17). In contrast to other kinds of abstract expressionism, here is a totality of surface, of the phenomenon as surface. As Fischer said of Twombly, an image emerges "to bring up again the deep questions of what kind of surface the surface of a painting is" (Fischer 1998, 159).

The hand of the painter seems absent here in the traces, visible in van Gogh's brush strokes, in the unfinalized, multiple lines in Cézanne's apples, in Pollock's gestured splatterings, and in the looping swirls and violent scratches of Twombly's markings. Here the visual image approaches total figurelessness; its maximum significance resides in its opticality alone. Its surface, and so its unconcealment, is a manifestation as self-manifestation, image as surface, a gathering in simplicity that does not harbor the tension of withholding which belongs to materiality of Heidegger's earthiness of an artwork. Louis's later unfurled paintings, in which discernible rivulets are stained like stripes across the canvas, have also been claimed to be unreadable. For the rivulets are "neither line nor shape, they have the self-sufficiency of the first

and the substantiality of the second . . . one cannot even read around, or along, their perimeters. It is as thought they *have* none—or, more accurately, as though even at their broadest they are *all* perimeter, *all* limit. . . . Instead, the eye incorporates each rivulet *whole*" (Fried 1967, 21). Here the quotidian familiarity of the world is eclipsed. This is due not to the absence of recogniz-able figures—to what Merleau-Ponty considered the negation of figures—but to the isolation of the visual sense, the absence of linguistic utterance, synaes-thetic density, and gesture. Thus the severe maximization of experience might bring about a revitalization of looking.

The singularization of the visual aspect in Barnett Newman's work is also what makes everyday vision subject to reflection as its familiar operations do not hold up. Such a reflection is elicited by lingering over Newman's painting "Onement," where unity is issued in planes of color that open out a place of reposed tension between fields zipped, as it were, by an intervening line. New-man spoke of his paintings as concerning the temporality of vision through color. When time is experienced visually, one can see reality in its ordinary spatio-temporal coordinates only with the effort of recovering from what Peter de Bolla has called the "mutism" effected in Newman (de Bolla 2001, 31). For Newman's image exudes a cognitive but inarticulate vitality through visual maximization. In his study de Bolla refers to the vertical planes of red that make a unity in Newman's *Vir Heroicus Sublimis.* Experiencing this painting kindles a sense of serenity in the recognition that "I know things that in other states are not accessible to me as knowledge" (53). But Newman's time is not the time of nature, of the play of light on the surfaces of things. Time here is more mechanical. On the one hand, time is structured by the interventions of lines through what would otherwise be a single plane of color; on the other, this time is so monotonous it cannot be articulated in words that require a beginning and an end. The "time of looking occasioned by color" that de Bolla sees in Newman is a time articulable only in and as reposing fields. Rothko has made images similar in structure and yet differing in tonal and emotional effect, where a rendering of colors into adjacent but also intersaturating bands maximizes their luminosity. Rothko relied on reso-nance between sonorously and so not quite decidably divided planes, on con-trasts of color that are also resonances. Whereas in Twombly's works one can point to pre- or postarticulate muteness, no such identification seems possible here. The ecstasis effected, for example in Rothko's *Red on Red,* is to some significant degree beyond language altogether, a nonlinguistic form of know-ing, a contact with vision in a purity never possible in everyday looking.

Rothko's paintings are, indeed, secretive and withdrawing; the suggestion

of ever-deeper tones receding beyond the visual surface of the luminous plane is unique to Rothko; it is not found in Newman's works, which rely on unity of color. The mysteriousness, the haunting quality, of Louis's paintings derives from a near-total manifestation in opticality. All that recedes is the process by which the work came into being. Seeking to achieve an impression of total visibility, Louis worked on thinning his paint to such an extent that even the canvas became visible, wholly one with the stain, so that one could not even speak of a canvas underneath the paint, leaving the painting devoid of any self-concealment or invisibility (see Greenberg 1967, 81). This total manifestation, this unconcealment without reserve, cannot be described in Heidegger's terms. By the same token, it effects an elusiveness by its irreducibility to any kind of gestural expression such as Merleau-Ponty's model would demand. It is as if the veils of color in Louis were produced not by a human hand but by a magical weather, magical in its accidental creation of stunning visual beauty. This weather is anonymous and impersonal since its effect is felt without evoking intentionality on the part of any causal mechanisms or origins, and its markings are of a total surface. That Louis often refused to sign his canvases, so as to obviate a final decision about which way they were to be hung, contributes to this effect, as it would also reduce the chance that a painting would be seen to have to be read this way or that way, that it would mean something different if seen the way the artist had intended it to be seen. What remains human in the painting is the ecstasis felt in such intensity of vision, the way that looking is so concentrated as to become an experience in itself, to eclipse any possible content.

Both Heidegger and Merleau-Ponty regarded the task of describing a painting as infinite, and admitted the partiality of any interpretation of art. The phenomenologies of Merleau-Ponty and Heidegger provide resources for describing the effect of hovering hesitation in the experience of vision that might be ascribed to these works. There is the invisibility made visible; there is the unconcealment which manifests and yet evades, with or without withholding; there is the exposure of materiality; there is the gathering of time and space into an event. But the limits of treating painting as poetic language or gestural-expressive language are evident whenever painting draws the viewer into what Merleau-Ponty called "the passage toward singularity, at the limit of discourse." For Merleau-Ponty admits that unlike painting, "language is not just the replacement of one meaning by another, but the substitution of equivalent meanings," whereas painting might be "content to sketch out directions, vectors . . . or a tacit meaning on the surface of the world" (Merleau-Ponty 1993, 118). The refusal, annulment, or vironization of synaesthetically suggestive gestures, figuration, symbols, articulations that evoke lan-

guage, and the irreducibility to a gathering-withholding that can be likened to the speech of Being, are suggested by paintings that provoke a silent ecstasis of vision. The paintings described in this chapter open up experiences of frivolity, seriousness, play, delight, monotony, concentration, distress, vitality, serenity, wonder, remembrance, and awe that, insofar as they can be described, require singular characterization; but they all afford an experience of this silent ecstasis. If the vitality of such paintings is drawn from their direct visual contact with the life of mute feeling, the primacy of the visual phenomenon, and its ecstatic silence, can be recognized.

Ecstatic Mimesis in Trompe l'Œil

Cy Twombly's blackboard painting (*Untitled,* 1970) afforded an occasion to consider the experience of visual art as an event between linguistic expression and the strange muteness of seeing. Another aspect of this painting is its simulation of trompe l'œil, a technique that fools the eye by presenting perceptual objects with disconcerting verisimilitude. Twombly's painting, said Fischer, contains a double or opposed recognition: the object is seen both as blackboard and as painting. The incompatibility of this yields a strangeness so promoting of cognitive vitality. True trompe l'œil works cause these recognitions to collapse into a single moment and blot out the recognition as painting. This moment of compression then is realized as perceptual error. This compressed recognition prevents the viewer from grasping the essence of what is seen, the thing in its being or non-being, so that it falls to the subsequent recognition as painting to amend the deception. By putting the veracity of perception in doubt, trompe l'œil paintings enable a departure from everyday seeing and compel the viewer to reconsider the structure of ordinary reality as given in perception and representation. Trompe l'œils typically portray ordinary objects of quotidian use and familiarity that are part of the everyday environment, and expose the everyday experience in its perceptual contingency, its dependence upon fallible perception, and its vulnerability to ecstatic reflection.

A vital aspect of some visual art, mimesis or imitation as conceived in aesthetics, is central to the intensified realism of trompe l'œil paintings, which present quotidian objects in uncanny verisimilitude. The experience of mimesis engendered by trompe l'œil is that of not only delight but uncanniness, disconcert, a stepping outside of prosaic and practical relations to the real, by

virtue of having been fooled into seeing two-dimensional renderings on a flat plane as the things they present. The viewer sees the image-object as if it were the image-subject present to direct perception; and the first moment of encounter with a trompe l'œil painting occurs in an ordinary expectation akin to the natural attitude: one notices ribbons and paper and envelopes and feathers fixed on a board and presumes their objectivity, their being, as what one thinks they are. Then one realizes that these objects, and the board to which they seem to be fastened, are merely presentations of objects, that they have no being apart from their constitutions as image-subjects, from the fact that their material being is supported only by paint and canvas rather than full dimensional substance with its unseen other sides. This realization parallels and enables a phenomenological reflection, departing from the habitual givenness in our relation to things; instead of being there, ready to hand, they become obstinately painterly, merely representations, obstinate as images by being precluded from any potential use or extra-optical enjoyment. This experience provokes reflection about the way objects are constituted through the expectations of perception. The experience of trompe l'œil exposes the viewer to the perceptual constitution of world.

The objects seen in such paintings are often human creations, the equipment that makes up the worldly arrangements of practical life. Modern art contends with the same tradition of playful agitation effected by trompe l'œil as did ancient painters, and trompe l'œil strategies persist within other kinds of painting, as is apparent, for instance, in Twombly and in the surrealist works of René Magritte. Yet in light of the ecstatic quotidian as a persistent theme of modern art and literature, trompe l'œil, in the context of modernism, poses special problems, in particular the significance of the viewer's disconcert. Trompe l'œil highlights mimesis as a problem of subjectivity and decenters the subject in a provocative but also distressing manner.

Philosophical interest in trompe l'œil was renewed by Arthur Danto's critique of an artwork that is curiously related to trompe l'œil, Andy Warhol's *Brillo Box*, a true-to-scale structure made of wood and paint, indistinguishable from a box that would contain a well-known kitchen cleaning implement made of steel wool and soap. In *After the End of Art*, Danto reiterated a position he had long held with respect to Warhol. His argument is contextualized in his presentation of art history as having been eclipsed by the strategies of Pop Art, in particular of Warhol, and the ensuing shift from modern to postmodern art. Danto sees Warhol's presentations of what might be called lowly, commercial objects of quotidian life, such as in a Brillo box, raise new philosophical questions about the ontological status of art. Since the work of art, like the *Brillo Box*, is indistinguishable from the object of the same appear-

ance found on store shelves, the viewer is forced to ask what makes it art—to question, in other words, the boundary between art and nonart, between the artistic imitation of reality and the real itself. In Danto's view, Warhol liberated art from traditional constraints by suggesting that anything can be art. Now that traditional restrictions on art have been overcome, the possibility for a true philosophy of art arises: "The philosophical question about the nature of art, rather, was something that arose within art when artists pressed against boundary after boundary, and found that the boundaries all gave way." What makes art is its being "enfranchised as art" and so, following Hegel, "if you were going to find out what art was, you had to turn from sense experience to thought. You had, in brief, to turn to philosophy." In other words, the *Brillo Box,* and perhaps trompe l'œil in general, presents an occasion to philosophize (Danto 1997, 14–15).

In addition to its particularly postmodern characteristics, the *Brillo Box* recalls strategies of imitation in trompe l'œil paintings. In viewing such works one does not think that the thing is real but, in the most successful cases, one *perceives* it as real. The error lies not in judgment but in perception itself. There are three moments leading to the eventual recognition of the work as artwork, and to reflection on the nature of perception: (1) the initial perception of a thing as belonging to a specific nexus of equipment for quotidian life, as ready-at-hand and available to be integrated into a given action; (2) the recognition of the thing as not an ordinary thing after all but a representation only; this recognition might be accompanied by an experience of pleasure or disorientation, in either case estranging and provocative; and (3) the recognition that the object is not only not what one had perceived it to be, but is also a work of art. If the ontological question about the relation of art and ordinary things is provoked by trompe l'œil, then one can say that this same provocation issues from the structure of representation in *Brillo Box,* which is both a representation of a Brillo box and indistinguishable from the real thing. For the first and second moments the experience of trompe l'œil is identical to that of *Brillo Box.* But in the third moment there is a difference: the trompe l'œil is recognized in its negativity—that it is not what it appears to be— whereas in the case of the Brillo box, negativity is coupled with potential identification: the thing both could be and is not what it appears to be. For the Brillo box in fact could serve its indicated function; it could be ready at hand, and has been curiously present, for notice only by means of its situation within an art context, an artworld. This situation is environmental and experiential: the work is approached in an art gallery (and then museum); viewers are not allowed to touch it but must walk around it at arm's length distance, and so on.

Yet the experience of trompe l'œil resonates in some important ways with
that of the *Brillo Box*. While trompe l'œil has been a relatively disenfranchised
form of painting, Pop Art exploits its lowly or merely commercial subject
matter to the point of glorification (see Huyssen 1989, 57), and so, in spite of
being appropriated by the high culture of museums, was to render untenable
any strict distinction between high and low art. Rather than setting art above
other representational genres in advertising and mass communication, Warhol
and others exploited contemporary images as images, thus as iconographical
rather than referential. Trompe l'œil, as genre painting, has been relegated to
the status of low art since antiquity, for some of the same reasons that Pop
Art is thought to lie beyond the art-historical narrative. Like the *Brillo Box*,
and Marcel Duchamp's *object trouvé* (the urinal as "Fountain" was first exhib-
ited in 1917), trompe l'œil painters present humble, even vulgar, quotidian
objects, rather than grand themes, as their subject matter. Moreover, they
often present representations of representations; the inclusion of other paint-
ings in their paintings, of pictures in books and documents, and later of pho-
tographs contributes to a complex set of mimetic reflections. While Pop Art
has been criticized for reveling in the image as fact, as icon, and for isolating
things from any lived reference, trompe l'œil is criticized for both its com-
monplace subject matter and its method, for the fact that its hyper-realism
has been regarded as a form of deception; and so such works have been found
politically or morally disturbing. If the familiarity of Warhol's subjects—the
Brillo box, the Campbell's soup can, reproduced photographs of Marilyn
Monroe, and the like—engenders their exploitation as image, the subject mat-
ter and the mimetic strategy of trompe l'œil are connected. The everydayness
of trompe l'œil's subject-matter allows it momentarily to be overlooked as art,
thus assisting the illusion when they are taken at first glance as real.

Of interest in this study is not so much the proliferation of levels of repre-
sentation of both kinds of works, but the relationship between the work of
art and the viewer, the de-familiarization engendered by the work of art's
likeness to objects of ordinary reality. In trompe l'œil, as in *Brillo Box*, the
work of art confounds the viewer, challenges the viewing subject's sense of
familiarity with and control of the representational field. The metaphysical
resonances between experiences of trompe l'œil and the Warhol work Danto
champions suggest not only a tradition overcome or broken with by a radically
new development, but the underlying tensions within the history of art as
regards the metaphysical legitimacy of its own form of representation and its
relation to everyday life. The Warhol work presents a commercial object of
mass production. Warhol also reproduces the method of its manufacture, a
factory-like method, and so dismisses any humanist view of the artist as origi-

nal genius, as source of the work. Not incidentally, Baudrillard links Warhol with Baudelaire and his merchandise fetishism (Baudrillard 1989, 175). Both this work and trompe l'œil magnify the significance of mimesis rather than the original genius of the artist through the provocation of ironic reflection. Mimesis challenges the viewing consciousness, alienated from its quotidian familiarity with the appearance of ordinary objects; it also presses for a reexamination of the relationship between expectations of the world and its everydayness. It might then be determined to what extent trompe l'œil and *Brillo Box* provoke an ecstatic relation to everyday perception, and to what extent this can be described within the terminology of mimesis in traditional aesthetic theory.

The Mimetic Tradition in the Philosophy of Art

At least since Kant the relevance of mimesis in theories of art has diminished. In phenomenologically sensitive models, mimesis is regarded as a metaphysical concept that is to be rejected in favor of a deeper structure. Mimesis plays almost no role in accounts of art as ontological unconcealment (Heidegger), as expression of original embodied perception (Merleau-Ponty), or the productive negativity of the imagination transcending the real (Sartre). Yet trompe l'œil necessitates a consideration of the mimetic principle since it seems to directly engage the mimetic instinct Aristotle claimed as inherent in human development. Aristotle's view of mimesis was a response to Plato, who regarded the mimetic or imitative element of art with suspicion. Plato's objections to art were not only political, but also ontological and epistemological. His suspicions were based on the way art, being thrice removed ontologically from the essence of things, (mis)represents being and, potentially, obscures truth. The fact that Plato, the writer, deliberately employs literary mimetic strategies throughout the *Republic,* in telling tales about fictional ideal cities, about the soul, and so forth, does not contradict his claims. For it is clear that mimesis is in some respects an inevitable feature of knowledge and communication—Aristotle argued that it is most natural for human beings to imitate. Mimesis is necessary not only in the ordinary life of the *polis,* but in philosophy as well. Mimesis is part of philosophical discourse, of the discovery of truth through language and dialectical discussion. Yet mimesis, if it is to be related to truth rather than deception, must be regulated by the philosopher (Plato, *The Republic*, 599a).

Artists, on the other hand, mislead us, holds Plato, for they seem to use imitation as an end in itself, and not self-consciously: the imitation of made objects, natural entities, human figures, and the gods in painting, poetry, and

music are employed promiscuously, for pleasure's sake, without respect for truth, without respect for the distinction between appearances and reality. Imitations themselves are inherently deceptive, for in Plato's account they present a likeness of an object that is, in turn, only an instance of an object rather than its essence; and yet such illusions can be taken for reality, such as in the famous story of Zeuxis's painting of grapes in Pliny's *Natural History.* This illusionism situates Plato's ontological objection, of which there are two aspects. First, a painting of a couch or bed, for instance, might make the viewer believe to be perceiving an entity when in fact what is presented is only the likeness of such, as if nature were reflected in a mirror. Imitations deceive, for they "look like they *are;* however, they *are* not in truth" (Plato, *The Republic,* 596e). Second, painting presents as being what in reality is only a partial appearance (one side of a couch), whereas in reality the couch on all its sides is one and the same object. Mimesis, then, interferes with the cognitive conception of identities and generalities, essential not only for discerning what things are, but also for discerning what does not appear to the eye: their essence or form (*eidos*). Three epistemological objections follow: (1) imitators, it seems, have no knowledge of what they imitate; (2) they cannot convey knowledge; (3) their works address the lower part of the soul—the senses rather than the faculty of cognition. The best known of Plato's objections are the political ones; they concern both the content of imitations and their style. What worried Plato politically is most of all the effectiveness of imitations— that, without the governance of reason, they would reach into and agitate the inward places of the soul.

Aristotle treated the problem of mimesis more generously. In *Poetics,* he argues that it is natural for human beings to imitate and to enjoy imitation; and that this is how we learn. This, our natural propensity for and enjoyment of imitation, is the origin of art. Rather than being opposed to truth, art can indeed be philosophical. Because of its mimetic nature, art presents a likeness or representation of what is, without that likeness being equivalent to actuality. There is a difference between what art *presents* and what it *is;* and thus art can, through the difference between the representation itself and what is represented, show us not merely how things are (actuality), but how they might be (possibility or potentiality). Clearly Aristotle indicates a more robust notion of mimesis than mere copying. The difference between actuality and possibility makes poetic art more philosophical than history, which merely represents what has in fact happened. For Aristotle not the form of objects but of life and action—including what could happen—is the highest subject of imitation.

Hegel, too, regarded mimesis as a source for philosophical contemplation;

but for him it was the first step of cognition, for in raising a particular to the level of a generality, an imitated or represented thing has found a passage through the mind. The bison represented on the cave wall at Lascaux is already a primitive form of thinking. But here imitation (Nachahmung) must be differentiated from representation capable of articulating an idea (Idee) in the Hegelian sense. Whereas imitation is a copying of nature's forms, representation is a kind of transubstantiation wherein empirical substance finds a passage through thought and becomes subject. Contrary to Plato's view, art has genuine reality due to this transformation. Through representation, art becomes the medium between the merely external, sensuous, and fleeting reality and the pure thought [zwischen der Natur und endlichen Wirklichkeit und der unendlichen Freiheit des begreifenden Denkens] (Hegel 1976, 19). Thus Hegel took aim at both the Platonic and the Aristotelean notion of imitation as an explanation for what art is. In his view, art does not exist for the purpose of imitating nature, and imitation is not its defining feature. Hegel here understands mimesis as a merely formal way of copying, a rendering of natural forms with the kind of precision we find maximized in trompe l'œil paintings. As such it is a superfluous and, according to Hegel, mediocre labor. Conceived as imitation—"a semblance of reality addressed to one sense only"—all painting can produce is "a mere parody of life" (nur die Heuchelei des Lebens), but no genuine vitality. . As an imitation of nature, art is rather impotent, "a mere worm chasing after an elephant" (Hegel 1993, 47, 48; 1976, 52). The purpose of art, then, must "lie in something different from the purely formal imitation of what we find given, which in any case can bring to birth only *tricks* and not *works* of art" [nur technische Kunst*stücke*, nicht aber Kunst*werke*] (50; 55). While skill in imitation is impressive—Hegel refers to Zeuxis's painting of the grapes at which living doves were said to have pecked (1976, 52)—the significance of art must be defended against the kind of mimetic deceit that had been so troublesome to Plato; what troubles Hegel is also its frivolousness.

Hegel wanted art to be a serious pursuit, one that deserved a scientific treatment. Art should serve as one model for the unification of matter and spirit. He thus raised the philosophical significance of art; while not yet philosophy, art need not be regarded, as in Plato, as antithetical to philosophical truth. Hegel set himself the task of refuting the misconception that art was merely play, distraction, luxury, decoration, foreign to the real and opposed to serious purposes of life. Not only has imitation, since Plato, been regarded as deceptive, and thus corrupting; it has been dismissed as a "frivolous kind of play" (Plato, 602b). Hegel, too, saw imitation as nothing more than a presumptuous sport, yet he still regarded it as essential to art without giving

art either its rules or guiding purpose. Art, in his view, must provoke thinking and ultimately thinking about the nature of art itself, a suggestion adopted later by Danto with respect to modern art. Nevertheless, trompe l'œil has persisted as a mimetic strategy, providing not only a method but art's very subject matter or idea. Trompe l'œil provokes reflection not only on the nature and function of art, according to Danto, but also on the nature of perception and its relationship to recognition and judgment.

Mimetic Strategies and the Metaphysical Significance of Trompe l'Œil

Some examples of the kind of paintings that maximize the mimetic element, those of trompe l'œil to be considered here, force the philosopher of art to reconsider the significance of mimesis as well as the ontological status of the art object and the epistemological position of the viewer; but they also provoke an experience of ecstasis. The idea that trompe l'œil and its effects are principally those of trickery is contested by art theorists (Mastai 1975, 13). However, the French term was originally employed in 1803 in a pejorative sense to signify a kind of painting that aims at supreme fidelity of ordinary natural perception. However, this fidelity is deceptive, since it gives the illusion of something being present while it is only an image. In this ontological misperception, what should be taken *as* something is taken in the mode: *is* something.

Trompe l'œil presents the viewer with an exaggeration or intensification of reality. Trompe l'œil paintings are found in nearly every period of Western art up to and including the present, but have enjoyed special prominence in the seventeenth, late nineteenth, and early twentieth centuries. They present objects—often on a shelf, tacked to a wall, in a cupboard—with no narrative significance, as if they had not been arranged by the painter, as in still life, but are simply stumbled upon in their everyday equipmental nexus, in their *Zeugganzheit* as Heidegger called it. They exemplify what ancient Greek painters of lofty narrative, landscape, historical and other sorts of grand paintings disdainfully referred to as "rhyparography," paintings of sordid subjects—though such painters were, in Greek and Roman antiquity, in fact at least as popular and successful as megalographers (see Mastai 1975, 36–37; Bryson 1990, 136). This suggests that modernity's fascination with the quotidian, with its relation to problems of perception, revives an ancient interest in representation of everyday objects as well as a persistent fascination with the mimetic strategy of trompe l'œil. While the governance of everyday life was of political relevance in antiquity, and the *oikos,* the management of domestic

affairs, required the invention of a new science of economy (see Foucault 1985; Detel 2005, 4–5; 138–40), artistic portrayal of everyday household objects also suggests interest in the mere perception and representation of the everyday, insofar as the trickery of trompe l'œil rests upon the assumption that perception of everyday things is true perception.

While imaging everydayness, the subject matter of trompe l'œil is rendered with such fidelity as to erase all traces of having been painted. Perfection makes these works also highly artificial, which, in turn, seems to mollify the potentially disastrous effects of fooling the onlooker. Samuel van Hoogstraten, a seventeenth-century Dutch trompe l'œil master, wrote that a perfect painting "is like a mirror of Nature, which makes things that are not actually there seem to be there, and deceives in a permitted pleasant and commendable manner" (cited in Leffert 1996, 19). This pleasantness is, however, coupled with disorientation and the provocation of phenomenological questions. What happens within aesthetic cognition when we view such paintings? What is the status of its image object? In trompe l'œil, too, the physiology of visual perception becomes relevant. As one critic describes it, such paintings are thought to "re-create on canvas the retinal image of arranged objects," in which the "selection of detail is governed solely by the invocation of optical criteria, that is, by asking what elements of the object would be registered on the retina of a viewer with normal vision" (Feldman 1967, 155). Vision and the placement of the viewer are important; and so are the features of the painting as physical image. In order for trompe l'œil painting to succeed, certain formal arrangements must be secured, as another critic describes:

> For example, the light source within the painting must match that falling on the picture itself. . . . The size of the images depicted must be identical to the things represented. There can be no evidence of the act of painting; brushwork has to be hidden. Colors and textures must match those of real objects. . . . Shadows must be adroitly handled to give the objects a sense of depth—this, despite the fact that the objects made most easily convincing are . . . as flat as possible, thus closely approximating the painting's actual surface, which is literally without depth. Most important, the space represented must seem contiguous with that in front of the picture: Its space must also appear to be our space. (Leffert 1996, 20–21)

Style and choice of what is to be painted are both governed by the principle of maximum fidelity. The image subjects are, partly in consequence of this principle, rather humble: letters, papers, curtains, and even canvases them-

selves are common objects represented in such paintings, in part because their flatter dimensions can be rendered most believably and fool the viewer into seeing what is in fact not there. But this choice is also guided by the important demand that the virtual space of the canvas must be perceptually one with the lived space of the viewer, and so the objects must look as if they belong to the quotidian context. Trompe l'œil as a genre inevitably overlaps with others, such as still life or architectural illusionism. The latter certainly shares some, though not all, of the features of such paintings as described here. Some paintings, like the illusionistic frescoes of books in carved cabinets painted by Botticelli on the *studiolo* walls of the castle in Gubbio, belong to more than one genre. The earliest example of a two-dimensional trompe l'œil is the Roman mosaic tile (second century C.E., copied from a Greek original of the third or second century B.C.E.) of an unswept floor, which presents a tile floor as if it were littered with the remnants of a feast: fishbones, shrimp's tails, snail shells, pea pods, torn shells of crab legs, nuts, a bird's claw, olive pits, and other such fragments, along with a mouse enjoying the spoils after the hall is vacated (see Mastai 1975, 36; Dars 1979, 9). The most recent examples include works by the American artist Molly Springfield, in depictions of notes and postcards which echo Twombly's notes, and in depictions of matchbooks, packets of artificial sweetener, and other humble objects, as might be emptied onto the kitchen counter from one's pockets.

As opposed to architectural illusionism, which profits from the Renaissance rediscovery of perspective, trompe l'œil in a stricter sense does away with the perspectival horizon. In order to be closer to reality, it must defeat the parallax effect, and so does not continue the (fictional) space receding further into the painting, rather it extends virtually toward and into the viewer's own space. Trompe l'œil is presented with a world of its own, imagistically protruding forward into the space normally occupied by the viewer. But because it belongs to the viewer's space, at least before the deception is noticed, it seems to belong to the lived world, only to later expose that world as indeed admitting parameters and limits, that is, structures that tend to go unnoticed in the natural attitude.

For the deception to succeed, all subjects in the painting must be rendered whole, without being cut off at the edge of the canvas, as is often the case in still life paintings, where tables, shelves, books, vases, or other objects appear only partially, leaving it to the viewer's imagination to fill in what is missing. The 1892 painting *Old Models* by the American painter William Harnett defies the usual arrangement rather deftly: on a painted shelf are lined up a violin, a trumpet hanging from a nail, several books, and a rounded, vase-like mug, as well as sheet music, not flattened, but hanging over the shelf and so protrud-

ing toward the viewer. This painting provides an astonishing likeness of reality, meant perhaps for amusement and pleasure; and yet it is also troublesome in the way it undermines the ordinary certainty about the reliability of sense-experience and of what controls the visual field. The lived space of the quotidian is exposed in its underlying constituted structure, and so it is compromised, no longer natural, and its coordinates are rendered uncertain. What is seen, at first glance, is a shelf holding up objects within easy reach for the beholder to grasp. Then, as the scene is recognized as a mere image, follows the loss of a formerly harmonious lived space the given context of ordinary experience. This loss is, as Baudrillard writes in his study of the genre, "signaled by its worrying strangeness" (1988, 57).

A related effect is achieved in Raphael Peale's (ca. 1822) painting *Venus Rising from the Sea: A Deception (or After the Bath)*. A female nude is almost entirely obscured by a curtain and only her foot and arm are visible, very much like elements in a Romantic painting. The deception might seem to be at first that the woman is obviously not Venus, and she is not rising from the sea but from the bath. She is no goddess, except for a momentary ideation an admiring viewer might have, for the atmosphere is mundane and commonplace. Yet the curtain, which occupies most of the space in the painting, is depicted with astonishing accuracy, hanging from two pins and conjuring up the perception of a real curtain that hides the actual painting. *After the Bath* causes the viewer to do a double take to be certain that the whole image, including the curtain, is in fact painted. This is the deception to which the title refers, the viewer having been doubly deceived. When this has been ascertained, the image still seems broken into two distinct levels of reality, though they occupy a continuous ontological stratum. The curtain recalls an anecdote from Pliny's *Natural History* wherein the painting of Parrhasios, who in competition with Zeuxis, is said to have presented a curtain: when Zeuxis demanded it be opened so that the masterpiece of Parrhasios could be shown, it was revealed that the work, in fact, was the curtain; whereupon Zeuxis had to give up the prize to his rival.

In order to be effective, these paintings must confuse and unsettle: what was at first glance taken to be a real object gives way to the realization that it has been painted. This realization brings about a feeling of uncanniness which, as Freud and Heidegger showed, emerges from the most familiar world. Without this uncanny realization, the effect is incomplete and the skill of the painter cannot be appreciated. This kind of unsettling is, for Plato, morally suspect, associated with the lower part of the human soul—"with the part in us that is far from prudence, and is not comrade and friend for any healthy or true purpose" (Plato, 603a-b). But equally suspect in Plato's eyes is

sense experience of objects in general, since it is on the confusion of the senses that imitation capitalizes. Socrates explains this to Glaucon in the following passage from the *Republic,* apropos imitation in painting and poetry:

> "Now, then, on which one of the parts of the human being does it have the power it has?"
>
> "What sort of part do you mean?"
>
> "This sort. The same magnitude surely doesn't look equal to our sight from near and from far. . . . And the same things look bent and straight when seen in water and out of it, and so both concave and convex, due to the sight's being misled by the colors, and every sort of confusion of this kind is plainly in our soul. And, then, it is because they take advantage of this affection in our nature that shadow painting, and puppeteering, and many other tricks of the kind fall nothing short of wizardry." (Plato, *The Republic,* 602c–d)

Trompe l'œil, however, does not merely fool, despite its (perhaps unfortunate) name. While it "must have been conceived with the specific purpose in mind of convincing visual delusion" (Mastai 1975, 21), it also awakens an uneasy sense of having been fooled, or almost fooled. By unsettling the viewer, the trompe l'œil initiates the work of both the rationalist philosopher, who rejects the senses as well as empirical reality as insufficient sources of knowledge, and of the phenomenologist, who inquires into the constitution of appearances. While the rationalist or Platonist dismisses sense appearances, the phenomenologist regards appearances as indebted to their perceptual constitution in consciousness; and, as in all open-ended constitutions of things within a horizonal world, individual perception can be wrong. Such instances of the unreliability of empirical experience, as presented by Socrates, mark the first step of dialectical awakening. Under the weight of this argument, one is forced to admit that appearances give only a partial, and often confused, account of what things really are. This is precisely why it was important for Plato to use the painter's art as a pedagogical tool in his dialogue; for reflection on painterly mimesis shows the need to improve upon ordinary perception through philosophical study.

Trompe l'œil potentially engenders a philosophical provocation, just as Warhol's *Brillo Box,* according to Danto, provokes the question of the distinction between art and ordinary things. This recognition becomes problematic with trompe l'œil representations of commercial things. Nineteenth-century painters frequently chose as their subject money and stamps, in both cases convincing enough to be employed for functional purposes, and so causing a

potential socio-political disturbance in respect to the *polis* and the *oikos*. Trompe l'œil representations of objects, only meaningful through abstract exchange, prefigured Pop Art's reproductions of images from advertising. But those images, for instance the Campbell's soup image Warhol presented in a variety of ways, become severed from any real reference to the objects they would have advertised in another context. This severance occurs through the scale of their presentation, or through repetition of the image, a technique also used in reproductions of pictures of Marilyn Monroe; this repetition, while not rendering its object anonymous, as Barthes argues, "depersonalizes" the referent (Barthes 1989, 125). But trompe l'œil's mimetic representations of exchange objects remain threateningly within the sphere of function, threatening the difference between legitimate symbols and counterfeit likenesses. If trompe l'œil forces the viewer to think about the nature of perception and of representation, it confirms Plato's political suspicions that illusions might disturb the representational economy and, of course, the political powers it represents.

It is relevant to consider the profound ambivalence, in the wake of Plato, with which trompe l'œil has been regarded. On the one hand, the effect of trompe l'œil is to give what van Hoogstraten called that "pleasant sensation of having been fooled." There is a certain thrill for the viewer in having been fooled, and admiration for the painter who is able to achieve such mimetic likeness. There is the wonder of exposing so directly the problem and possibilities of mimesis. On the other hand, this is troubling: "The veiled threat of trompe l'œil is always the annihilation of the individual viewing subject as universal centre" (Bryson 1990, 144). When the perceptual world is threatened by contingency, the stability of the subject is threatened. The cognitive judgment of the viewer is not so much confounded, as Plato worried, as it is displaced. Even after the initial confusion is overcome by cognitive judgment, the objects of the trompe l'œil remain stubbornly before the eye; the objects presented seem to exist in their own world, indifferent to judgment. Since the interpretation of the painter, a painter's particular style or lyrical reception of the seen world, is wholly subordinated to the effect of realism, it is as if the objects presented had not yet found a passage through mind. Thus the objects in trompe l'œil paintings have a ghostly look about them, the look of pre- or postcognitive vacancy. As a genre, trompe l'œil is "an extremely conventional and metaphysical exercise," according to Baudrillard: "Trompe l'œil is such a highly ritualized form precisely because it is not derived from painting but from metaphysic; as ritual, certain features become utterly characteristic: the vertical field, the absence of a horizon and of any kind of horizontality (utterly different from the still life), a certain oblique light that is unreal . . . the

absence of depth, a certain type of object . . . and of course the realist halluci-
nation that gave it its name" (Baudrillard 1988, 53). The conventional exercise
of trompe l'œil is maintained through its persistent antagonism toward the
space of representation in painting, its persistent provocation of reflection on
the nature of perception, and its unceasing attention to the most ordinary and
familiar objects.

Because its effect profits from a confusion of perception, trompe l'œil must
represent quotidian objects that belong to the expectations of everyday per-
ception. Thus trompe l'œil shares with still life in general a presentation of
things as visual forms, often with little reflection on their historical signifi-
cance and isolated from narrative context. Still life paintings often present
timeless, familiar objects of the basic substrate of human material life, what
George Kubler considered prime objects. Since, he argues, "our perception of
things is a circuit unable to admit a variety of new sensations all at once,"
human invention of forms "has always had to halt at the gate of perception"
(Kubler 1962, 123–24). Thus the forms of everyday things admit a remarkable
stability. In presenting such objects, still life paintings, from the Roman Pom-
peii of antiquity to seventeenth century Spain or the Netherlands, followed
by what Norman Bryson in his still useful study of still life calls a "virtually
indestructible form" (Bryson 1990, 137). Along with natural, perishable ob-
jects like flowers, fruit, or game, these paintings present human-made objects
for domestic use. While some of them are special instruments indicating the
particular interests or wealth of their owners, many are simple vessels, neces-
sary tools of everyday life. Cups and vases and bowls defy historical progress,
since aside from being decorative enhancements they do not significantly
change from culture to culture. "While complicated tools and technologies
are subject to rapid change, simple utensils obey a slow, almost geological
rhythm. In stratum upon stratum, the archaeology of Western sites unearths
endless variations on the same basic ideas, of storage jar, oil-lamp, beaker,
vase" (138–39).

This endless variation on the same utensils is promoted by a certain regu-
larity of quotidian life that underlies all the changes of human historical devel-
opment. For, as Bryson has stated: "Certain distinct forms recommend
themselves as appropriate, where the propriety is not just a matter of bare
function but of a whole network of practical activity, involving all the factors
of suitedness to action, to the body, to cost, to the ease of manufacture, and
to available materials; in short, to an economy of practices which, eliminating
what is not suitable, in the end converge on this given form, which is then
passed on" (137–38). The subject matter of still life, in presenting the persis-
tent forms of basic objects of everyday use, often alongside natural objects

that do not survive except in fossil form, suggests the recurring and ahistorical cycles of natural time rather than human worldly time and historical progress. As painted objects, these everyday items "dictate to matter the forms of their replication . . . and the objects go on existing outside the field of human consciousness, yet with no diminution of the powers stored within them" (144).

This ahistoricity is characteristic of modernist still lifes by Giorgio Morandi, which present basic everyday objects in near-abstract primitive simplicity. Morandi's paintings constitute a useful contrast to trompe l'œil, in that his objects—bottles, jars, vases—promote an inverse relation of visibility to detail. They seem to be exposed in their essence by means of the sparsest rendering and the most subdued coloring; the absence of detail highlights their vital presence. More abstract than realistic, they nevertheless share with trompe l'œil a preference for the forms of basic everyday objects irrespective of narrative significance. While repudiating the photographic detail of trompe l'œil, they nevertheless amplify visual perception, for the object in both Morandi's paintings and those of trompe l'œil artists present seem to exist in self-contained worlds. If the objects of trompe l'œil tend to be curiously everyday, Morandi's objects are resolutely simple. With vacant backgrounds, strictly simplified forms, earthy coloring, and not even the slightest evidence of the presence of human figures, the paintings present perceptual consciousness in transition, emerging into awareness or fading from recognition of objects. The regard is often suspended at the moment when objects are first recognized as discrete entities, in their presignificant objectivity, or seem to be dissipating into dream-like imagination of objects. The equipmental significations of their everydayness are suspended, for the objects no longer signify any current domestic purpose. Like the objects of trompe l'œil, Morandi's forms are more like archaeological discoveries, where the life world that rendered them useful or decorative has become irrelevant. And yet, Morandi's objects do not appear dead at all, despite their title and genre; for they provoke a reflection in seeing that vivifies everyday perception, not by presenting its simulacra, but by concentrating its primal forms.

Objects in trompe l'œil, by contrast, "have the look of dead men's clothes." This criticism was directed at Samuel van Hoogstraten's *Steckbrett* painting of objects fastened behind ribbons on a board: comb, soap, scissors, spectacles, coins, writing quill, shaving implements, sealing wax, letter opener, letter, handkerchief, and the like. Almost a sub-genre of its own, many trompe l'œil paintings present letter boards such as those by Edward Collier (d. ca. 1702), Cornelis Norbertus Gysbrechts (active ca. 1659–78), Wallerand Vaillant (1623–77); Benjamin Henry Latrobe (ca. 1795), and William Harnett, where still

folded, unfolded or torn, wax-stamped, or enveloped and cancelled letters are
tucked behind ribbons along with notes, labels, pages torn from books, prints,
and pictures. This very personal collection, usually marked by the personality
and intimate life of the owner, is threatened with becoming, or already is,
mere debris. This reversion is made explicit in John Frederic Peto's 1894 paint-
ing *Old Scraps,* where a few scraps of letters, labels, tickets, string, torn pages
are tacked up and stuck behind ribbons on a sparsely covered board, the
empty spaces suggesting abandoned use, absence of ownership, an absence
hauntingly echoed in Morandi's sparse presentations of things.

Trompe l'œil paintings can also imitate paintings themselves. As often as
letters, one finds prints and paintings—and later, photographs—among the
subject matter. A manifestation of this trompe l'œil strategy is Mark Tansey's
The Innocent Eye Test (1981), in which a cow gazes at Paulus Potter's painting
of a bull. The best-known of such examples is probably Magritte's surrealist
painting *La Condition Humaine,* in which a painting sits on an easel in front
of an open window, and the painting on the canvas is indistinguishable from
the view, which is, of course, also painted. Only the edge of the canvas and
the dark legs of the easel serve to define a border between one (second-order)
representation—the canvas—and another—the view from the window. It is
as if the artist were warning the viewer that everything that is seen is, after all,
a representation, that there is no pure empirical reality, no original gaze. This
is also suggested in Magritte's *Reproduction Prohibited* (La reproduction inter-
dite), not a trompe l'œil painting proper, for it does not fool the eye, but its
confusion of the visual field is related to trompe l'œil strategies. Here a male
figure faces a mirror with his back to the room; reflected, however, is not the
man's front side and face, as one would expect to be, but a repetition—a re-
presentation—of the figure's backside. Hence the witty title, a prohibition
which the painter takes literally by refusing to reproduce the mirror image
and thus, paradoxically, breaks with (reproducing, instead, the backside). The
painting is both frivolous and seriously metaphysical, both witty and discom-
forting.

Margritte's tactics are prefigured by earlier trompe l'œil works. In 1670
Gysbrechts painted two trompe l'œil paintings of the backs of a canvas, each
stretched across wooden frames held together by (painted) nails and, in one
instance, strung with a hanging wire. These examples are not merely cleverly
deceptive, but also epistemologically confounding; the convincing portrayal
of the canvas' reverse side suggests a refusal to represent anything, a refusal
borrowed by surrealist painters who show the "obverse and the reverse, [who]
undo the evidence of the world" (Baudrillard 1988, 57). Gysbrechts' paintings
show paintings that were apparently hung backwards. But the paintings *are*

what they do not in fact *give:* the painting for which the viewer searches, presumed to be on the other side of the canvas. Were one to turn the painting over to find the real painting, one would find a (real) canvas back directing one back to the painted surface. Still more estranging are clues in the painting of the canvas that direct the viewer back to the painting imagined to be on the other side. In one example a small piece of paper seems stuck to (is painted on) the canvas on which the number 36 is printed, as if the painting imagined to be on the other side of the canvas were indeed inventoried in a collection or presented for sale. The irony is that the painting, since any expected viewing of what should be the painting is thwarted, remains out of reach; it can be neither purchased nor even evaluated, since it cannot be seen.

Other examples of trompe l'œil also prefigure Magritte's surrealist techniques, one by Gysbrechts and the other painting by Antonio Forbera (Fortbras), both entitled *Painter's Easel*, the latter painted in 1696 for Louis XIV of France. This painting of a wooden painter's easel has literally the two-dimensional shape of an easel, which holds up a painting in progress, a red-chalk sketch for the painting, an old print hanging sideways, the painter's palette, brushes, and the back of a canvas frame into which is placed, behind the center brace, another print (both prints are copied from actual existing prints available to the painter). All of this is painted in oil, contrary to the initial presumptions of the viewer. The whole presentation, including the easel, is the artwork; everything is painted, even the easel which is covered in canvas and painted as an easel. The painting in progress on the easel is itself a rather poor copy of *Realm of Flora* by Nicolas Poussin. The self-reflexivity of the painting is heightened by the presentation of copying within the painting itself. One commentator wrote:

> By remembering the original and recognizing a not-so-good copy, by seeing the drawing based on the original serving as the model for the painting in progress, the spectator sees a magical transformation in progress based on an unseen representation (Poussin's original), brought to a midpoint between the nothingness of the drawing paper, the marked surface of the quite detailed sketch, and finally the representation of the representation(s). . . . Thus representations are layered atop representations, and in the process the viewer is delighted and . . . confounded about what has happened in plain view. (Leffert 1992, 29)

The delight and confusion in experiencing such paintings recalls the ecstatic quotidian as explored in modern literature: just when it seems most ordinary,

the everyday experience of looking is interrupted, and there arises a perception wholly other than one expected. This sequence of expectation, interruption, and surprise becomes thematic of modernist presentations of the world. Visual art, since it does not require the linguistic medium, is still more tightly woven to problems of perception. One might, as reported about Fortberas's painting, try to erase the pencil sketch that hangs on the easel. One might send the trompe l'œil stamp off in the post, or exchange the money, as more than one trompe l'œil artist has done. Or one might fill the *Brillo Box* with its appropriate contents and place it back on the shelf, denying its status as art. In any case, the ordinary givenness of everyday reality is disturbed; familiarity hides what in reality might be only representative rather than real actuality. In the viewer affected by trompe l'œil doubt has been implanted.

Trompe l'Œil, the Purpose and the End of Art: Mimetic Gestures in Contemporary Art

What is the purpose of such painting of everyday things? Is it a mere frivolity by the artist at the expense of the viewer's ease? Is such dis-ease morally corrupting, as Plato argued, merely frivolous, as Hegel worried, or philosophically provocative, as Danto claimed? Trompe l'œil has been granted only minor relevance in art history, when it is discussed with seriousness at all. Leffert saw such representations as mere assertions of political power without any wider implications. While the trompe l'œil painting affirms "the power of the artist . . . the genre lays claim to a radically narrow . . . set of insights" (Leffert 1992, 31). Another commentator reduced the significance of trompe l'œil to undermining "the viewer's reliance on the absolute validity of his optical sense" (Feldman 1967, 155). Baudrillard relegated it to a metaphysical exercise. Inasmuch as the trompe l'œil exploits mimesis to its maximum significance, mimicking above all the most quotidian, insignificant objects, it seems to celebrate these insignificant things as images, which disturbs the viewer's expectations of their equipmental being, their usefulness, their purpose, their cognizable essence. Images of objects seem to evade the legislation of a subject that recognizes things according to the function they serve. The experience of having taken them as actual and the subsequent recognition of error not only provoke philosophical reflection on the nature of art in general, as Danto stated about Warhol's art, but a phenomenology of perception and of everydayness. The experience of trompe l'œil does not only provoke conceptual reflection about the ontological definition of art and its place within a Hegelian history of thought; it also points back to the everydayness from

which it had severed the image, and so opens up reflection upon the constitution of that everydayness and the endless possibilities of its negotiation, transformation, and rendering. Trompe l'œil suggests something about everyday visibility itself, as John Berger describes it: "Not to say that *behind* appearances is the truth, the Platonic way. It is very possible that visibility *is* the truth and that what lies outside visibility are only the traces of what has or will become visible" (Berger 1985, 219).

Art not only raises questions about the power of representation and the political and epistemological function of images. While Warhol's works exploit the severance of the images from the everyday world, trompe l'œil renders the quotidian ecstatic, for the viewer becomes gradually aware of the way appearances of the most everyday things are indebted to the structure of perceptual expectation and its built-up habits, and is provoked to question his or her position as a perceptual subject vis-à-vis the seen world. The presentation of everyday things in trompe l'œil suggests that their significance, while dependent upon the assumption of meaning by a practical human subject, always potentially exceeds their practical determination for such a subject. It creates a tension between the useful presence of things for everyday habits and the persistence of their mere visual manifestation, their address to perception. In such paintings, things may seem to take on a life of their own, which, despite the radical visual differences, makes trompe l'œil resonate with some modern forms of still life. While the vitality of primitive forms in Morandi's works suggests the liberation of their emergence as images to a vital consciousness, the strict verisimilitude of trompe l'œil's detail presents a liberated image only by disorienting the viewer's habitual hold on the world of practical things. The experience of both kinds of paintings not only bears analogy to phenomenological reflection but it also provokes and enables it.

According to Baudrillard, a trompe l'œil's presentation of the most mundane objects displaces the subject, for "only isolated objects, abandoned, ghostly in their exinscription of all action and all narrative, could retrace the haunting memory of a lost reality, something like a life anterior to the subject and its coming to consciousness" (1988, 54). Trompe l'œils, he claims, remind the viewer of a world before metaphysics, before the regulation of higher and lower planes of reality, before the ontological determination of the distinction between appearances and what is real. Though philosophically provocative, such paintings are also antiphilosophical since they render the subject's judgment about reality insignificant. Trompe l'œils give the effect "of a slight vertigo—that of some previous life" before metaphysics and any political ordering of representations (56). The mimetic tradition—both in theory and in art-historical practice—is troubled by trompe l'œil's stubbornly ahistorical

exaggeration of what should remain, to use Aristotle's distinctions, the mere method of art, not its subject or theme as well. When mimesis, by exploiting the everydayness of objects, becomes thematic in the experience of painting, the ordinary grasp on the world through perception is disturbed, much as Descartes had aimed to disrupt the apparent self-assuredness of empirical experience. In Baudrillard's view "every composition in trompe l'œil contributes to the effect of loss, a sense of losing hold on the real through the very excess of its appearances" (56). But what Baudrillard overlooks is that initiated in wake of this disturbance of the natural attitude is also a reflection upon both everydayness and the modes by which it is ordinarily seen. The power of artistic representation to initiate such reflection simply by reproducing everyday things in a convincing manner also reminds the viewer of the freedom of consciousness from the very given everydayness the painting represents.

Insofar as it is related to trompe l'œil, Warhol's *Brillo Box* is not purely beyond the pale of history, a pure signification of the end of art history, as Danto claims. It also suggests a residual alignment with the ahistorical substrate of this history—with the time of things, whether primitive handiwork or mass-produced, commercial objects of everyday use, an alignment with a persistent reflection upon the thing as thing, the image as image, art and its reflective distance from everyday perception. Though in radical ways announcing a new era in the history of art, heralding postmodernism in art, it is not unimportant that the *Brillo Box* is, as an ironic mimetic enactment, also prefigured by ancient forms of rhyparography—the depiction of the common, vulgar, or insignificant—and resonates with other post-Renaissance and modern forms of trompe l'œil. Affinities among these works, despite significant differences, suggests the persistence of mimesis as a means to reflect upon phenomena, upon the appearance of the everyday and its vulnerability to transformation. But whereas Baudrillard celebrates the task of Warhol's art object "to deconstruct its traditional aura, its authority and its power of illusion, in order to glow in the pure obscenity of merchandise," and commends the effects of "seduction," he also admits the effects of entropy in the aura of simulacrum (Baudrillard 1989, 177, 185). Warhol's innovations in (in)authenticity wear out with time, while trompe l'œil, though less spectacular, clings to an original power of illusion. Though Baudrillard criticizes its conventionality, seen in its phenomenological provocations, the experience of trompe l'œil affirms art's power of fascination through persistent, even stubborn, attention to the objects of quotidian experience in a mimetic play on perception. One could argue that for all of the ostensible insignificance of mimesis, this painting of the stuff of quotidian life provides not only a philosophical provocation about the nature of art, but a phenomenological provocation

about the nature of experience. In this sense the usefulness of phenomenology in explaining what happens in the mimetic experience is matched by painting's enablement of the recognition of seeming as being. Art then would be not only the subject but the provocation of, and in some sense the condition for, phenomenological reflection.

Beyond trompe l'œil's resonances with modernism, a few examples of mimetic gestures in contemporary art, though removed from trompe l'œil proper, are worth mentioning. Cézanne's paintings, D. H. Lawrence has argued, give the "intuitive feeling that nothing is really statically at rest" (Lawrence 1939, 29–30). To Cézanne, who watched with fascination the lemons in his still-life arrangements shrivel and decompose, there are still responses in the artistic presentation of things. One example is Sam Taylor-Wood's *Still Life 2001,* a digital video film of three minutes forty-four seconds (currently in the Tate Modern, London) which presents the traditional still-life objects decaying before the eyes in hyper-forwarded time. One mass-produced item, the ball-point pen on the wood table, by the end looks more alive than the decomposed fruit, around which flies gather. Through technological mimesis, Taylor creates an uncanny juxtaposition of the life and lifelessness—reflected in the paradox of its very medium, a both moving live and dead recording that plays over and over—that pertains to so much of contemporary everydayness, with living events endlessly reproduced, replayed, such as to deaden reception of them, turning numb. Other works, resonant with Duchamp and Warhol, may serve as emblematic of the fractured quotidian. The Argentinian artist Jorge Macchi's *Untitled 1993* is constructed of a pillow, in its domestic blue stripe and paisley pillowcase, wrapped in a sheet of fractured glass. That its practical use, its relevance for a homey dwelling is obstructed by the glass—a vision that contrasts with modern depictions of bedroom objects in paintings by van Gogh, Edouard Vuillard, Marc Chagall—evokes a sense of loss, but also of disentanglement from a domestic scene. To the most humble quotidian objects of Morandi's still-life paintings, the bottles and jars, there is an echo in Josiah McElheny's work (Museum of Modern Art, New York), composed of mirrored blown glass, aluminum metal display case, and a two-way mirror, among other things, entitled: "Modernity, Mirrored and Reflected Infinitely" (2003). This work seems to play upon mimetic copying by postmodernizing the kind of objects Morandi painted, which already, by calling to mind primitive humanity, seem to break free from their quotidian assignment through the cognitive vitality of consciousness. In McElheny's work, these bottles and jars seem to build up a city, reflected in each round cap of the mirrored glass bottles, and reflected again as a grouping in the

mirror in repetition, in endless recession from the viewer. The real objects and their reflections in the glass are from a distance indistinguishable.

Some postmodern art seems, through mimesis, to memorialize the quotidian as a contingent and ephemeral present. This is effected sometimes within loving, if not also absurd and frivolous, monumentalization of the mundane as, for example, in Cy Twombly's blackboard and note paintings. In some works, the quotidian appears cherished in its very ordinariness, sheltered within the commonness of the familiar. Twombly and other artists display artistic devotion to usually insignificant objects, which inspires a gentle look at quotidian life and, as in Morandi's works, seems unabsorbed by the hyper-intensity and oversaturation of an age of spectacle. Conceptual art also plays with mimesis of the everyday. In Vito Acconci's *Following Piece* (1969), the viewer is instructed to "follow different person every day until person enters private place" and presents the records of twenty-two days in October when this is enacted. Fluxus art made a principle of mimetic contingency by record-ing countless enactments of this kind, often distorting the quotidian in a forced, but sometimes provocative, ecstasis. Cornelia Parker's *Drowned Monu-ments* (1985) installs miniature copies (souvenirs) of famous buildings in a muddy puddle beneath a gutter, where they are huddled together and are enveloped in fog in a mysteriously illogical unity. However, this unity is in danger of being drowned by the puddle, as the title suggests. Joining the iconography of the monumental with the lowly gutter and puddle, seems an absurd resolution to the ancient rivalry between rhyparographers and the megalographers, artists of the lowly and the grand respectively. The reconcilia-tion of the two is also part of the pleasurable frivolity taken in miniatures in general, and the sense of vulnerability to which our monuments, and perhaps all grand human efforts, are exposed.

Like vulnerability, ephemerality has become the principle of much of con-ceptual art. It stimulates theoretical speculation about the constitution of a work (when it is only enacted or exhibited), authenticity of the art object and indistinguishability of subject and object or medium of expression and an idea expressed. All of this is germane to a work that mimics ephemerality as its very medium, namely Felix Gonzalez-Torres's *Untitled (USA Today)* (1990). This work, which risks being dismissed as frivolous, presents a pile of individ-ually wrapped pieces of candy in patriotic colors, stacked up in a corner with an "ideal weight of 300 pounds, dimensions variable." Like the *objet trouvé*, Gonzalez-Torres's work, in which the viewer participates by taking one of the candies, seems too close to everyday life to be art; but that is also the vexing secret of its critique. While an initial look at this work might prompt an immediate dismissal of its radical antimonumentality, its refusal of artistry

in any recognizable sense, the work, nevertheless, elicits questions about the connection between art and quotidian life, oddly mimicked in the gallery or museum situation. In *Untitled (The End)*, equally common items, here a stack of white paper with black border, are in danger of disappearance—since they are to be taken off one by one by viewers—even as they are constantly replaced. The silence of the blank page, the continual but also necessary depletion of the work's corpus, the dispersion of its parts, the index to future but as yet unwritten possibilities of expression, inspires reflection upon the relation between an artwork and the finitude of language. The black borders in this work may also be an intimation of the artist's impending death from AIDS and fear of becoming another silent statistic of disappearance. This sense of disappearance can also imply an antimimetic principle, the sense that images cannot replace what is lost. The mimetic strategies in art may raise the question, not only about what makes art art, as Warhol's work did, but about how art, whatever it is, turns reflection back to everyday life, with its triumphs and troubles, from which it so apparently differs. The seeming triviality of trompe l'œil is much like that of everyday life itself, and yet neither is immune to the questions about being, appearance, and nonbeing, presence and absence of the world and the subject, about plentitude and emptiness, which mimesis inevitably provokes.

Epilogue

The aim of these reflections was not a critique or ethics of the quotidian, such as in the tradition of sociological and Marxist literature, nor were they meant to establish a philosophy of ordinary life. Rather, what has been presented here is an examination of the persistence of reflection on quotidian life as an interimplicating and driving theme in modern art, literature, and in phenomenology. The observation that the quotidian quality of everyday life is suspended when it is noticed, and that this suspension leads to manifold and potentially endless reflections on the nature of being in the world by, first of all, distancing one from familiarity with the world, leads to a special fascination manifested in various forms of ecstasis. These forms have been relevant for and available to several modes of examination. It has been shown that an examining relation to the quotidian characterizes some important strands of modern literature and art that are phenomenologically suggestive, and it sustains a common thread among the diverse phenomenologies of Husserl, Heidegger, Bachelard, Merleau-Ponty, and Sartre. This observation, however modest in itself, has yielded radically imaginative reflections upon the nature of experience.

This study traced some sightings and unfurlings of this reflection, whether delicate and beautiful, alienating, nihilistic or provocative of wonder, vocal or resiliently silent. While philosophers have rightly pointed out its elusiveness, quotidian life is nonetheless a persistent and special subject of modern reflection, whether phenomenological, literary, or artistic. Such reflection has taken up, as discussed in this study, the quotidian experiences of perception, cognition, habitual activities, and expectations of the world, practical objects and the stubborn presence of what are mere things, childhood play and memory,

vision and visibility. While a phenomenological study is helpful in describing poetic and artistic renderings of quotidian life and ecstatic departures from it, it is also indebted to the kinds of reflections that lie outside its scientific or philosophical purview. These are manifested works of literature and art, some of the most phenomenologically suggestive of which have been presented in this study. Yet highlighting the ecstatic relation to quotidian life does not suggest that reflection upon it must stand opposed to it in favor of some stance transcending any everyday appropriation. Rather the inspiration for reflection upon quotidian life has drawn on its very sources, while often, in turn, promising their revitalization.

Yet something might be said further, in an explicitly critical vein, about the relation between these forms of reflection upon quotidian life and life as it is lived. Everyday life is not only in need of being defended as a worthy, reliable structure that grounds our experience and so our understanding of the world, it also needs healing and revitalization, and modern art and literature are, at least to some extent, characterized by a focus on this task, making it not only the task of the critical theorist or social activist but of the creative imagination as well. Rendering explicit this suggestion differentiates the present study from an analytic probe of the elusiveness of the quotidian which relies on the inevitable stability of quotidian life in its ongoing, predictable cadence. While everyday life is necessarily self-restoring, the vitality or entropy of its configurations is a foremost concern in modern reflections on quotidian experience. This is more pressing if the so-called fallenness, the overly abstracting or alienating elements, of modern life in particular, are reflected upon, and where the philosophies most diagnostic of modern fallenness (from Kierkegaard to Nietzsche and Heidegger) have failed to inspire concrete alternatives to its failures or disasters, that is, alternatives that can renew everydayness beyond its "shattering." All have directed us to aesthetic and poetic experience.

There are also specific historical breakdowns of everyday life to which literature and art, at least, have responded. For example, the idea that everyday life was in urgent need of restoration was a major impetus for writers, moved by the Nazi genocide of the European Jews, of what is now called Holocaust literature, which seems in some important ways to break irreparably with modernism, with its residual, though already challenged, faith in the possibilities of a rational world. One theme of Holocaust literature—for instance in the work of Aahron Appelfeld, Miklós Radnóti, Imre Kertész, Primo Levi, Tadeusz Borowski—is the possible or impossible maintenance of quotidian life through, or in the wake of, moral and social catastrophe. What happens not only to everyday experience but also to the ecstasis of elation, wonder, and surprise that nourishes it, when faith in the world has been broken? It is

conceivable that the breakdown of the quotidian, so horribly palpable in Holocaust literature, sends shockwaves, felt receptively or muted by the numbness of forgetting, through many regions of ordinary lived experience. It seems incontestable that the world and our human sense of place within it have been altered since the renderings by Rilke, Proust, and Cézanne, among others that have been presented here. These changes have provoked and still provoke a plethora of responses. Although these shockwaves are difficult to isolate from other causes and strands of the postmodern thoughtscape, in art and literature, as in theories thereof, echoes of a shattered quotidian are sometimes specifically identifiable, even when no reference to it or any other crisis is made. Some questions can be posed about the ecstatic quotidian, in art, literature, and phenomenology, which arises among these shockwaves.

Of course there are other disasters and injustices, although none were carried out with equal systematicness. The collapse of communism exposed the oppressiveness and historical violence of these regimes along with an end to its challenge to capitalism. The threat of nuclear annihilation has not subsided with the end of the cold war; armed conflict is raging in many parts of the world; the results of terrorism and military occupations are grim; the world's most powerful leaders seem to act without regard for human suffering. The natural environment is disastrously endangered from nearly every aspect of human activity. Constant awareness of these situations, among others, may lend a heightened sense of contingency to human existence or provoke a sense of helplessness or alienation. The defense of everyday life would seem, among these concerns, irrelevant or even a luxury. Yet it is, beyond mere survival, also our striving for an everyday flourishing—what Aristotle called "eudaimonia" or happiness—that makes relief from these disasters or impending disasters so exigent.

Phenomenology in Husserl's scientific form is not able to articulate this exigency. What to make of faith in an unshakeable transcendental ego, a reliable structure, a rational logos, at the heart of the life world, as the source of salvation from the ills of civilization? Holocaust literature makes apparent the severity of the cataclysm that occurred at the very origins of the life world. Blanchot contends in L'écriture du désastre (Writing of the Disaster)—a series of fragmentary utterances both evasive of and definitively emerging from reflections on the Holocaust—that the reliance upon a transcendental self, in challenging the originality of the empirical ego, is a "ruse" [une ruse du moi] (Blanchot 1986, 12; 1980, 26). In "Philosophy and the Crisis of European Humanity" Husserl's notion of science as grounded in philosophical self-reflection seemed to him the only solution to "the ruin of a Europe alienated from its rational sense of life, fallen into a barbarian hatred of spirit." A "rebirth of Europe from the spirit of philosophy, through a heroism of rea-

son" still seemed possible to him (Husserl 1965, 192). Husserl thought that the greatest danger for Europe was weariness of the kind of rational self-reflection that had governed philosophy since its Socratic beginnings, and with which it had lost touch; this loss of contact was determined by naturalism and objectivism, by a fallen understanding of the world as subject to reductive and unreflective calculation. Even with this harsh diagnosis, Husserl underestimated the European problem (the essay was delivered as a lecture in Vienna in 1935. Neither the failure of reason alone, nor the oft-diagnosed hysteria of fascism, could explain the magnitude of the ensuing crisis, given its calculated and massively organized projects of annihilation. If phenomenology, for all its transformations and capacities, has not succeeded in renewing the sources of the quotidian life as it is lived, of self-conscious questioning of the origins of experience and meaning, there are other possible sources of renewal. After Auschwitz, some, like the poet Paul Celan, would claim that poetry—insofar as it includes a tentative attitude about truth and self-assertion—is not only possible, but the only possibility. But this reference to the poetic is also insufficient. One can point to the social and ethical insufficiencies of Heidegger's notion of poetic dwelling, whatever its merits for providing an ethics of *Gelassenheit* (by which he means a kind of "letting-be") toward the earth and the natural world. Productive provocations of ecstasis ought to indicate ever-other possibilities of being in the world, which, while transcending the insularity of a Cartesian subjectivity, still echo the deep origins of a common humanity.

Though quotidian life has its cadences, its energies and entropies, art and literature are manifestations of its capacity for self-renewal. Thus they have something to offer in revitalizing capacities for renewing or reinvigorating everyday life. Provocations of ecstasis initiate reflection on the structure of experience, on the place of the human subject vis-à-vis the world, on the habits and structures, through which its familiar configuration holds together. The experience of this reflection varies, of course, generating delight, discovery, remembrance, frivolity, alienation, uncanniness, despair, renewed efforts at self-preservation, or inventiveness. While aesthetic or poetic ecstasis, insofar as it is stimulated by art and literary experience, might nurture this reflection more directly and more vitally than phenomenological or any other philosophical thought proper, alone it is incapable of—and ought not be reduced to the task of—providing solutions. All of these forms of reflection might disclose that quotidian habit, for all its necessity and potential goodness, can comply with failure, and that sedimented expectations and convictions need to be subject to questioning. That "no one line of knowledge, no individual truth must be absolutized" is Husserl's anti-ideological and anti-totalitarian

formula for attempting to swerve from an impending historical disaster (Husserl 1965, 181). This nonabsolutization, rather than defending skepticism or radical relativism, is an appeal to self-reflection and critical self-scrutiny.

Nonabsolutization has certainly been the subject of extended philosophical exploration in the last few decades. It has been asked—importantly, but sometimes so determined by a specific ideology as to expend with more general profundity—to what degree both truth and the quotidian self in its relation to the world are products of power systems and social construction of what Michel Foucault called "discourse." In terms of the present study, the disclosures in art and literature of the nonabsolute, fragile foundations of the structure of the lived world in its ordinary look point to perceptual and reflective origins of experience that, while not immune to social constructions, power, influence, cultural molding, nevertheless seem to harbor an original energy that begets grounded possibilities of self-examination. A retrieval of the aesthetic or poetic is not to replace social, political, and ethical critique by reference to general existential-phenomenological principles; it is not to displace ethics with poetry. In this respect it could be argued that Heidegger's later philosophy, though it advocates poetic dwelling perhaps in attempting to remedy his political errors of the 1930s, loses sight of the communal as well as interior sources of dwelling in the factical life with which his early thought was so concerned. It is also possible that, with the exception of cultural studies, much of postmodern philosophy, with its emphasis on intransigent difference or celebration of simulacra, has, in the main, lost sight of the quotidian sources—sources of stability as well as renewal—out of which a world is ever reconfigured. And cultural studies, insofar as they focus on the individual's participation in systems of power and its reproduction, consumerism and mass consumption, leave other aspects of the individual experience out of consideration, in particular the individual imagination. Foucault's analyses of micro-practices of power in the rituals and arrangements and habits of the everyday, along with a never-finished project of an aesthetics of existence and account of care of the self, seems to balance an absorption in cultural discourse with a reformulation of subjectivity.

Since art and poetry seem to direct the imaginative life back to the vitality of the quotidian and the inexhaustible possibilities for its reconfiguration, a look at contemporary art and literature from the point of view of quotidian life and its revitalization is merited, but only hinted at, in the last chapter of this study. Agnes Heller has stated, in a defense of the relation between art and everyday life, that much "depends, of course, on *which* branches of art reach into the everyday lives of people, just as much depends on the quality of these works of art" (Heller 1984, 55). Formulated in another way, it would

be important to ask, despite the difficulty of judging one's own moment, to what extent contemporary art manages to stimulate reflection on the quotidian in the wake of its having been shattered or in the exigency of its renewal. While one often finds trivial spectacle and temporary shock value, one also finds expressions of the dual possibilities of ecstasis, bewilderment and mystery, critical defamiliarization and gentle astonishment. The most interesting works evidence a striving toward transcendence while refusing any absolute pronouncements of an ideal; one finds exposure of the contingency of quotidian life, or deference to its usually unnoticed majesties. The most compelling experiences of art and literature, and perhaps of philosophical thought, depart from and at the same time reinvigorate the quotidian from which any experience of ecstasis draws its initial vitality.

It might be the case that modern art and literature too can no longer be read without a persistent index to the shattered quotidian, without feeling the shockwaves of the shattering. Kafka's stories are an example of prewar writings that are now impossible to read without discerning some uncanny relationship to an impending catastrophe. But even in later modern works, those surrounding the war years but not directly about them, their implicit confusion or vacancy, their prescient fragility, seem related not only to universal human conditions but also to specific breakdowns of life. Beckett's hollowed-out world of uncertain, uprooted, and decentered characters are now understood in terms of his specific wartime experiences, rather than as ahistorical, general theses on the alienation of universal man. Similar claims have been made here about Robert Frost, the darkness in his work as a consistent motif, a groping for orientation that eludes the earthy resilience that characterized his poetry as ruggedly individual authenticity in commerce with nature. "Back out of all this now too much for us," as his poem "Directive" begins, takes on new meaning in light of these considerations. That is the commencement of the poem, indicating some other source of re-orientation for quotidian life, as the assignment and labor of the imagination. The fact that this poem, like Rilke's writings, those of Proust and Benjamin, and so many modern literary and artistic attempts to revitalize the lived world, draws upon childhood experience, merits reflective pause. The absence of this stratum of human life in the most prominent accounts of everydayness as well as in philosophy in general is, therefore, quite conspicuous, an absence that has begun to be redressed in the present study.

References

Cited translations have sometimes been altered; when no citation is given for the translation, it is the author's. In-text citations are given with date of publication, unless otherwise indicated, as in the case of collected works, which gives volume number. When a single page reference is given for original and translated texts, this refers to the common academic pagination.

Achiele, K. Porter. 2002. *Paul Klee's Pictoral Writing*. Cambridge: Cambridge University Press.

Adams, Robert Martin. 1966. *Nil: Episodes in the Literary Conquest of the Void during the Nineteenth Century*. New York: Oxford University Press.

Adorno, Theodor. 1995. "Kulturkritik und Gesellschaft." Reprinted in *Lyrik nach Auschwitz? Adorno und die Dichter*. Edited by Petra Kiedaisch. Stuttgart: Philipp Reclam.

Agamben, Giorgio. 1999. *The End of the Poem: Studies in Poetic Discourse*. Translated by Daniel Heller-Roazen. Stanford: Stanford University Press.

Alloway, Lawrence. 1963. "Notes on Morris Louis." New York: The Solomon R. Guggenheim Foundation.

Bachelard, Gaston. 1957. *La poétique de l'espace*. Paris: Quadrige/Presses Universitaires de France, 1957.

———. 1960. *La poétique de la reverie*. Paris: Quadrige/Presses Universitaires de France.

———. 1969. *The Poetics of Reverie: Childhood, Language, and the Cosmos*. Translated by Daniel Russell. Boston: Beacon Press.

———. 1994. *The Poetics of Space*. Translated by Maria Jolas. Boston: Beacon Press.

Badt, Kurt. 1965. *The Art of Cézanne*. Berkeley and Los Angeles: University of California Press.

Barthes, Roland. 1965. "Objective Literature: Alain Robbe-Grillet." In *Two Novels by Robbe-Grillet*. Translated by Richard Howard. New York: Grove Press.

———. 1988. "That Old Thing . . . Art." In *Post-Pop Art*. Edited by Paul Taylor. Cambridge, Mass.: MIT Press, 1989.

Baudrillard, Jean. 1988. "The Trompe l'œil." In *Calligram: Essays in New Art History from France*. Edited by Norman Bryson. Cambridge: Cambridge University Press.

———. 1989. "Pop: An Art of Consumption" and "Beyond the Vanishing Point of Art." In *Post-Pop Art*. Edited by Paul Taylor. Cambridge, Mass.: MIT Press.

Beckett, Samuel. 1970. "Proust." In *Collected Works of Samuel Beckett*. New York: Grove Press.

Bell, Clive. 1922. *Since Cézanne*. London: Harcourt Brace.

Benjamin, Walter. 1972. *Gesammelte Schriften*. Edited by Rolf Tiedemann and Hermann Schweppenhäuser. Frankfurt am Main: Suhrkamp Verlag. [Cited in text by volume numbers III/1, IV/1.]

———. 1996. *Selected Writings, 1913–1926*, vol. I. Edited by Marcus Bullock and Michael W. Jennings. Cambridge, Mass.: Belknap Press of Harvard University Press.

———. 2002. *Selected Writings*, vol. III, *1935–1938*. Edited by Howard Eiland and Michael W. Jennings. Cambridge, Mass.: Belknap Press of Harvard University Press.

Berger, John. 1985. *The Sense of Sight*. New York: Vintage Books.

Bergson, Henri. 1944. *Creative Evolution*. Translated by Arthur Mitchell. New York: Modern Library.

———. 1960. *Time and Free Will*. Translated by F. L. Pogson. New York: Harper Torchbooks.

———. 2001. *L'Evolution créatrice*. Paris: Presses Universitaires de France.

———. 1997. *Essai sur les données immédiates de la conscience*. Paris: Presses Universitaires de France.

Bernard, Émile. 1907. "Souvenirs sur Paul Cézanne et lettres inédites." *Mercure de France*, 247 (October 1 and 15): 385–404; 606–27.

Bernstein, Michael André. 1994. *Foregone Conclusions: Against Apocalyptic History*. Berkeley and Los Angeles: University of California Press.

Blanchot, Maurice. 1982. *The Space of Literature*. Translated by Ann Smock. Lincoln: University of Nebraska Press.

———. 1986. *The Writing of the Disaster*. Translated by Ann Smock. Lincoln: University of Nebraska Press.

———. 1980. *L'Écriture du désastre*. Paris: Gallimard.

———. 1955. *L'Espace Littéraire*. 4th ed. Paris: Gallimard.

Brough, John. 1992. "Some Husserlian Comments on Depiction and Art." *American Catholic Philosophical Quarterly* 66 (spring): 241–59.

Bryson, Norman. 1990. *Looking at the Overlooked: Four Essays on Still Life*. Cambridge, Mass.: Harvard University Press.

Busch, Thomas W. 1980. "Sartre's Use of the Reduction." In *Jean-Paul Sartre: Contemporary Approaches to His Philosophy*. Edited by Hugh J. Silverman and Frederick Elliston. Pittsburgh: Duquesne University Press.

Buskirk, Martha. 2003. *The Contingent Object of Contemporary Art*. Cambridge, Mass.: MIT Press.

Celan, Paul. 1995a. *Breathturn* (bilingual edition). Translated by Pierre Joris. Los Angeles: Sun & Moon Press.

———. 1995b. "Der Meridian." Reprinted in *Lyrik nach Auschwitz? Adorno und die Dichter*, Edited by Petra Kiedaisch. Stuttgart: Philipp Reclam.

Cézanne, Paul. 1941. *Letters*, Edited by John Rewald. London: B. Cassirer.

Crowther, Paul. 1988. "Merleau-Ponty: Vision and Painting." *Dialectics and Humanism* 15: 107–18.

Danto, Arthur. 1975. *Jean-Paul Sartre*. New York: Viking Press.

———. 1992. "Trompe l'Œil." *The Nation*, May 4.

———. 1997. *After the End of Art: Contemporary Art and the Pale of History*. Princeton: Princeton University Press.

Dastur, Françoise. 1995. "Imagination and Metaphysics: The Phenomenological 'Delicacy of the Image.'" In *The Path of Archaic Thinking: Unfolding the Work of John Sallis*. Edited by Kenneth Maly. Albany: State University of New York Press.

Dars, Celestine. 1979. *Images of Deception: The Art of Trompe l'Œil*. Oxford: Phaidon Press.

De Bolla, Peter. 2001. *Art Matters*. Cambridge, Mass.: Harvard University Press.

De Kooning, Wilhelm. 1988. *Collected Writings*. Madras, India, and New York: Hanuman Books.

De Man, Paul. 1993. *Romanticism and Contemporary Criticism*. Edited by E. S. Burt, Kevin Nemark, and Andrej Warminski. Baltimore: The Johns Hopkins University Press.

Denis, Maurice. 1910. *Cézanne*, Translated by Roger Fry. *The Burlington Magazine* 16, 82, 83 (January–February): 207–19; 275–80.

Detel, Wolfgang. 2005. *Foucault and Classical Antiquity*. Translated by David Wigg-Wolf. Cambridge: Cambridge University Press.

Du Bos, Charles. 1962. "The Profundity of Proust." In *Proust*. Edited by René Girard. Englewood Cliffs, N.J.: Prentice Hall.

Dewey, John. 1958. *Art as Experience*. New York: Capricorn Books.

Donoghue, Denis. 2000. "Murray Krieger vs. Paul de Man." In *Revenge of the Aesthetic: The Place of Literature in Theory Today*. Edited by Michael P. Clark. Berkeley and Los Angeles: University of California Press.

Drummond, John J. 1988. "Realism vs. Anti-Realism: A Husserlian Contribution." In *Edmund Husserl and the Phenomenological Tradition*. Edited by Robert Sokolowski. Washington, D.C.: Catholic University of America Press.

Düchting, Hajo. 1997. *Paul Klee: Painting Music*. Munich and New York: Prestel Verlag.

Dufrenne, Mikel. 1973. *The Phenomenology of Aesthetic Experience*. Translated by Edward S. Casey et al. Evanston, Ill.: Northwestern University Press.

———. 1993. "Eye and Mind." In the *Merleau-Ponty Aesthetics Reader*. Edited by Galen Johnson. Evanston, Ill.: Northwestern University Press.

Dufresne, Eva Fauconneau. 1982. "Wirklichkeitserfahrung und Bewusstseinsentwicklung in Rilkes *Malte Laurids Brigge* und Sartres *La Nausée*." *Arcadia* 17: 258–73.

Feldman, Edmund Burke. 1967. *Art as Image and Idea*. Englewood Cliffs, N.J.: Prentice-Hall.

Fingerhut, Karl-Heinz. 1970. *Das Kreatürliche im Werke Rainer Maria Rilkes*. Bonn: H. Bouvier und Co. Verlag.

Fischer, Philip. 1998. *Wonder, the Rainbow, and the Aesthetics of Rare Experiences*. Cambridge, Mass.: Harvard University Press.

Fóti, Véronique M. 2000. "The Evidences of Painting: Merleau-Ponty and Contemporary Abstraction." In *Merleau-Ponty: Difference, Materiality, Painting*. Edited by Véronique M Fóti. Amherst, N.Y.: Humanity Books.

Foucault, Michel. 1970. *The Order of Things*. New York: Vintage Books.

———. 1985. *History of Sexuality*, vol. 2: *The Use of Pleasure*. Translated by Robert Hurley. New York: Vintage Books.

Freud, Sigmund. 1969–1975. *Studienausgabe*. Edited by Alexander Mitscherlich, Angela Richards, James Strachey. Frankfurt am Main: S. Fischer.

Fried, Michael. 1967. Introduction to *Morris Louis, 1912–1962*. Boston: Museum of Fine Arts.

Frost, Robert. 1979. *The Poetry of Robert Frost*. New York: Henry Holt/Owl Books.

Gadamer, Hans-Georg. 1994. *Literature and Philosophy in Dialogue: Essays on German Literary Theory*. Translated by Robert H. Paslick. Albany: State University of New York Press.

Gardiner, Michael E. 2000. *Critiques of Everyday Life*. London and New York: Routledge.

Gasquet, Joachim. 1921. *Cézanne*. Paris: Les Editions Bernheim jeune.

Genette, Gérard. 1999. *The Aesthetic Relation*. Translated by G. M. Goshgarian. Ithaca: Cornell University Press.

Gewirth, Alan. 1998. "Clearness and Distinctness in Descartes." In *Descartes*. Edited by John Cottingham. Oxford: Oxford University Press.

Gosetti-Ferencei, Jennifer Anna. 2007. "Interstitial Space in Rilke's Short Prose Works." *The German Quarterly*, 80, no. 2: 302–324.

———. 2004. *Heidegger, Hölderlin, and the Subject of Poetic Language*. New York: Fordham University Press.

Greenberg, Clement. 1960. "Louis and Noland." *Art International* 4, no. 5: 26–29. Reprinted in *Morris Louis, 1912–1962*. Boston: Museum of Fine Arts, 1967.

———. 1963. Introduction to *Three New American Painters: Louis, Noland, Olitski*. Exhibition at the Norman Mackenzie Art Gallery, Regina, Canada. Reprinted in *Morris Louis, 1912–1962*. Boston: Museum of Fine Arts, 1967.

Haar, Michel. 1996. *The Song of the Earth: Heidegger and the Grounds of the History of Being*. Translated by Reginald Lilly. Bloomington: Indiana University Press.

———. 2000. "Painting, Perception, Affectivity." In *Merleau-Ponty: Difference, Materiality. Painting*. Edited by Véronique M Fóti. New York: Humanity Books.

Hamburger, Käte. 1971. "Die phänomenologische Struktur der Dichtung Rilkes." In *Rilke in neuer Sicht*. Edited by Käte Hamburger. Stuttgart: W. Kohlhammer.

———. 1973. *The Logic of Literature*. Translated by Marilynn J. Rose. Bloomington: Indiana University Press.

———. 1988. "Die Kategorie des Raums in Rilkes Lyrik." *Blätter der Rilke-Gesellschaft* 15: 35–42.

Hegel, Georg Wilhelm Friedrich. 1975. *Hegel's Aesthetics: Lectures on Fine Art*. Translated by T. M. Knox. Oxford: Clarendon Press.

———. 1976. *Ästhetik*, vols. 1 and 2, 3rd ed. Berlin and Weimar: Aufbau Verlag.

———. 1993. *Introductory Lectures on Aesthetics*. Translated by Bernard Bosanquet. Edited by Michael Inwood. London: Penguin Books.

Heidegger, Martin. 1964. *Being and Time*. Translated by John Macquarrie and Edward Robinson. New York: HarperCollins.

———. 1971. "Origin of the Work of Art." Reprinted in *Poetry, Language, Thought*. Translated by Albert Hofstadter. New York: Harper & Row.

———. 1977. *Holzwege*, Gesamtausgabe 5. Edited by Friedrich-Wilhelm von Hermann. Frankfurt am Main: Vittorio Klostermann.

———. 1982. *Basic Problems of Phenomenology*. Translated by Albert Hofstadter. Bloomington: Indiana University Press.

———. 1982b. *On the Way to Language*. Translated by Peter D. Hertz. New York: HarperCollins.

———. 1983. *Aus der Erfahrung des Denkens*, Gesamtausgabe 13. Edited by Hermann Heidegger. Frankfurt am Main: Vittorio Klostermann.

———. 1984. *Sein und Zeit*. Tübingen: Max Niemeyer Verlag.

———. 1999. *Ontology or the Hermeneutics of Facticity*. Translated by John van Buren. Bloomington: Indiana University Press.

———. 2001. *Phenomenological Interpretations of Aristotle: Initiation into Phenomenological Research*. Translated by Richard Rojcewicz. Bloomington: Indiana University Press.

———. 2004. *Phenomenology of Religious Life*. Translated by Matthias Fritsch and Jennifer Anna Gosetti-Ferenci. Bloomington: Indiana University Press.

Heller, Agnes. 1984. *Everyday Life.* Translated by G. L. Campbell. London: Routledge and Kegan Paul.

Hofmann, Hans. 1994. *Search for the Real and Other Essays.* Edited by Sara T. Weeks and Bartlett H. Hayes Jr. Cambridge, Mass.: MIT Press.

Hofmannsthal, Hugo von. 1982. *Sämtliche Werke.* Frankfurt am Main: S. Fischer Verlag.

Hölderlin, Friedrich. 1969. *Werke und Briefe,* vols. I and II. Edited by Friedrich Beissner and Jochen Schmidt. Frankfurt am Main: Insel Verlag.

———. 1998. *Theoretische Schriften.* Edited by Johann Kreuzer. Hamburg: Felix Meiner Verlag.

Husserl, Edmund. 1950. *Husserliana. Gesammelte Werke.* The Hague: Martinus Nijhoff.

———. 1970. *The Crisis of European Sciences and Transcendental Phenomenology.* Translated by David Carr. Evanston, Ill.: Northwestern University Press.

———. 1965. *Phenomenology and the Crisis of Philosophy.* Trans. Quentin Lauer. New York: Harper & Row.

———. 1982. *Ideas Pertaining to a Pure Phenomonology and to a Phenomenological Philosophy,* Book 1. Translated by F. Kersten. Dordrecht: Kluwer Academic Publishers.

———. 1994. Briefwechsel, Band VII, Wissenschaftler korrespondenz. Edited by Elisabeth Schuhman and Karl Schuhman. Dordrecht: Kluwer Academic Publishers.

———. 1993. *Cartesian Meditations: An Introduction to Phenomenology.* Translated by Dorion Cairns. Dordrecht: Kluwer Academic Publishers.

Huyssen, Andreas. 1989. "The Cultural Politics of Pop." In *Post-Pop Art.* Edited by Paul Taylor. Cambridge, Mass.: MIT Press.

Iser, Wolfgang. 1978. *The Act of Reading: A Theory of Aesthetic Response.* Baltimore: The Johns Hopkins University Press.

Jayne, Richard. 1972. *The Symbolism of Space and Motion in the Works of Rainer Maria Rilke.* Frankfurt am Main: Athenäum Verlag.

Jephcott, E. F. M. 1972. *Proust and Rilke: The Literature of Expanded Consciousness.* New York: Barnes & Noble Books.

Johnson, Galen. 1993. "Introductions to Merleau-Ponty's Philosophy of Painting." In *The Merleau-Ponty Aesthetics Reader.* Edited by Galen Johnson. Evanston, Ill.: Northwestern University Press.

Kafka, Franz. 1946. *Gesammelte Werke.* Edited by Max Brod. Frankfurt am Main and New York: S. Fischer/Schocken Books.

Kandinsky, Wassily. 1968. "Concrete Art, 1938." In *Theories of Modern Art.* Edited by Herschel B. Chipp. Berkeley and Los Angeles: University of California Press.

Kant, Immanuel. 1987. *Critique of Judgment.* Translated by Werner S. Pluhar. Indianapolis: Hackett.

———. 1993. *Kritik der Urteilskraft.* Hamburg: Felix Meiner Verlag.

Katz, Claire. 2002. "The Significance of Childhood." *International Studies in Philosophy* 34, no. 4: 77–101.

Kearney, Richard. 1987. *Poetics of Imagining: Modern to Post-Modern.* New York: Fordham University Press.

Kohak, Erazim V. 1968. "I, Thou, and It, a Contribution to the Phenomenology of Being in the World." *Philosophy Forum* 1 fall: 36–72.

Krieger, Murray. 1992. *Ekphrasis: The Illusion of the Natural Sign.* Baltimore: The Johns Hopkins University Press.

Kubler, George. 1962. *The Shape of Time.* New Haven: Yale University Press.

Kuhn, Reinhard. 1982. "The Enigmatic Child in Literature." In *The Philosophical Reflection of Man in Literature*. Edited by Anna-Teresa Tymieniecka. Boston: Reidel.

Lancaster, Natasha Heather. 1997. "Freedom at Work: Sartre on Ponge." In *Situating Sartre in Twentieth-Century Thought and Culture*. Edited Jean-François Fourny and Charles D. Minahen. New York: St. Martin's Press.

Lang, Berl. 1990. *The Anatomy of Philosophical Style: Literary Philosophy and the Philosophy of Literature*. Cambridge, Mass.: Basil Blackwell.

———. 2000. *Holocaust Representation: Art Within the Limits of History and Ethics*. Baltimore: The Johns Hopkins University Press.

Langer, Suzanne K. 1942. *Philosophy in a New Key: A Study in the Symbolism of Reason, Rite, and Art*, 3rd ed. Cambridge, Mass.: Harvard University Press.

Lauer, Quentin. 1965. *Phenomenology: Its Genesis and Prospect*. New York: Harper Torchbooks.

Lawrence, D. H. 1929. *The Paintings of D. H. Lawrence*. London: The Mandrake Press.

Lefebvre, Henri. 1984. *Everyday Life in the Modern World*. Translated by S. Rabinovitch. New Brunswick, N.J.: Transaction Publishers.

———. 1991a. *Critique of Everyday Life*, vol. 1. Translated by J. Moore. London: Verso.

———. 1991b. *The Production of Space*. Translated by D. Nicholson-Smith. Oxford: Basil Blackwell.

Leffert, Richadt. 1996. *Art and the Committed Eye: The Cultural Functions of Imagery*. Boulder, Colo.: Westview Press.

Lessing, Gotthold Ephram. 1962. *Laocoön: An Essay on the Limits of Painting and Poetry*, Translated by Edward Allen McCormick. Baltimore: The Johns Hopkins University Press.

———. 1965. *Laokoon*, Edited by Dorothy Reich. Oxford University Press.

Levin, David Michael. 1991. "Visions of Narcissism: Intersubjectivity and the Reversals of Reflection." In *Merleau-Ponty Vivant*. Edited by M. C. Dillon. Albany: State University of New York Press.

Lyon, Laurence Gill. 1978. "Related Images in *Malte Laurids Brigge* and *La Nausée*." *Comparative Literature* 30: 53–71.

Lyotard, Jean-François. 1989. "Philosophy and Painting in the Age of Their Experimentation: Contribution to the Idea of Postmodernity." In *The Lyotard Reader*. Edited by Andrew Benjamin. Cambridge, Mass.: Basil Blackwell.

Macksey, Richard. 1962. "The Architecture of Time: Dialectics and Structure." In *Proust*. Edited by René Girard. Englewood Cliffs, N.J.: Prentice Hall.

Malraux, André. 1978. *The Voices of Silence*. Translated by Stuart Gilbert. Princeton: Princeton University Press.

Mann, Thomas. 1974. "Kinderspiele." In *Dokumente und Untersuchungen: Beiträge zur Thomas-Mann Forschung*. Edited by Hans Wysling. Bern and Munich: Francke.

Mann, Thomas. 1974b. *Gesammelte Werke*. Frankfurt am Main: S. Fischer.

Marquard, Odo. 1991. *In Defense of the Accidental: Philosophical Studies*. Translated by Robert M. Wallace. New York and Oxford: Oxford University Press.

Mastai, Marie-Louise d'Otrange. 1975. *Illusion in Art: Trompe l'œil*. New York: Abaris Books.

Meadows, Patrick. 1997. *Francis Ponge and the Nature of Things: From Ancient Atomism to Modern Poetics*. Lewisburg, Pa.: Bucknell University Press.

Meier-Graefe, Julius. 1927. *Cézanne*. London and New York: Scribner's.

Merleau-Ponty, Maurice. 1960. *Les relations avec autrui chez l'enfant*. Paris: Centre de Documentation Universitaire.

————. 1964. *L'œil et l'esprit*. Paris: Gallimard.

————. 1964b. *Sense and Nonsense*. Translated by Hubert L. Dreyfus and Patricia A. Dreyfus. Evanston, Ill.: Northwestern University Press.

————. 1964c. *The Primacy of Perception*. Edited by James M. Edie. Evanston, Ill.: Northwestern University Press.

————. 1973. *The Prose of the World*. Edited by Claude Lefort. Translated by John O'Neill. Evanston, Ill.: Northwestern University Press.

————. 1989. *Phenomenology of Perception*. Translated by Colin Smith. London: Routledge.

————. 1992. *Texts and Dialogues*. Edited by Hugh J. Silverman and James Barry Jr. Translated by Michael B. Smith et al. Altantic Highlands, N.J.: Humanities Press.

————. 1993. *The Merleau-Ponty Aesthetics Reader: Philosophy and Painting*. Edited by Galen Johnson. Evanston, Ill.: Northwestern University Press.

Morgenstern, Christian. 1992. *Sämtliche Galgenlieder*. Zurich: Manesse Verlag.

Morrissette, Bruce. 1965. "Surfaces and Structures in Robbe-Grillet's Novels" in *Two Novels by Robbe-Grillet*. Translated by Richard Howard. New York: Grove Press.

Murdoch, Iris. 1953. *Sartre, Romantic Rationalist*. New Haven: Yale University Press.

————. 1997. *Existentialists and Mystics*. New York: Allen Lane.

Natanson, Maurice. 1978. "The Arts of Indirection." In *Rhetoric, Philosophy, and Literature: An Exploration*. Edited by Don M. Burks West Lafayette, Ind.: Purdue University Press.

————. 1988. "The Strangeness in the Strangeness: Phenomenology and the Mundane" in *Edmund Husserl and the Phenomenological Tradition*. Edited by Robert Sokolowski. Washington, D.C.: Catholic University of America Press.

Nietzsche, Friedrich. 1968. *The Birth of Tragedy*. In *Basic Writings of Nietzsche*. Edited and translated by Walter Kaufmann. New York: Modern Library.

————. 1990. *Das Hauptwerk,* Band III. Munich: Nymphenburger Verlag.

Nims, John Frederick. 1983. *The Six-Cornered Snowflake and Other Poems*. New York: New Directions.

Novotny, Fritz. 1937. *Cézanne*. New York: Oxford University Press.

Petzet, Heinrich Weigand. 1985. Foreword to *Rilke, Letters on Cézanne*. Translated by Joel Agee. New York: Fromm.

Plato. 1968. *The Republic*. Translated by Allan Bloom. New York: Basic Books. [In text academic pagination cited]

Ponge, Françis. 1948. *Le parti pris des choses*. Paris: Gallimard.

————. 1994. *Selected Poems* (bilingual edition). Translated by C. K. Williams, John Montague, and Margaret Guiton. Edited by Margaret Guiton. Winston-Salem, N.C.: Wake Forest University Press.

Potts, Alex. 2003. "Utterances, Art Works, and Things." In *Art and Thought*. Edited by Dana Arnold and Margaret Iversen. Malden, Mass.: Blackwell Publishing.

Poulet, Georges. 1962. "Proust and Human Time." In *Proust*. Edited by René Girard. Englewood Cliffs, N.J.: Prentice Hall.

Proust, Marcel. 1954. *A la recherche du temps perdu*. Paris: Gallimard.

————. 1989. *Swann's Way*. Translated by C. K. Scott Moncrieff and Terence Kilmartin. New York: Vintage.

Radnóti, Miklós. 1971. *Clouded Sky*. Translated by Stephen Polgar et al. New York: Harper & Row.

Rapp, Carl. 1987. "Philosophy and Poetry: The New Rapprochement." In *Philosophy as Liter-*

ature/Literature as Philosophy. Edited by Donald G. Marshall. Iowa City: University of Iowa Press.

Read, Herbert. 1974. *A Concise History of Modern Painting*. London: Thames & Hudson.

Rilke, Rainer Maria. 1930. *Gesammelte Werke*, vol. 3. Leipzig: Insel Verlag.

———. 1939. *Briefe*, vol. 3, 1907–1914. Edited by Ruth Sieber-Rilke and Carl Sieber. Leipzig: IM Insel-Verlag.

———. 1942. *Sonnets to Orpheus*. Translated by M. D. Herter Norton. New York: W. W. Norton.

———. 1958. *Notebooks of Malte Laurids Brigge*. Translated by M. D. Herter Norton. New York: Capricorn Books.

———. 1996–2001. *Kommentierte Ausgabe in vier Bänden*. Edited by Manfred Engel et al. Frankfurt am Main and Leipzig: Insel Verlag. [Cited in the text as KA with volume number]

———. 1997. *Die Aufzeichnungen des Malte Laurids Brigge*. Edited by Manfred Engel. Stuttgart: Philipp Reclam.

———. 1984. *The Selected Poetry of Rainer Maria Rilke* (bilingual edition). Edited and translated by Stephen Mitchell. New York: Vintage Books.

———. 1985. *Letters on Cézanne*. Translated by Joel Agee. New York: Fromm.

———. 1986. *Selected Poems*. Translated by Albert Ernest Flemming. New York: Methuen.

Rishel, Joseph J. 1996. "A Century of Cézanne Criticism: From 1907 to the Present." In *Cézanne*. Philadelphia: Philadelphia Museum of Art.

Robbe-Grillet, Alain. 1960. *Jealousy*. Translated by Richard Howard. London: John Calder.

———. 1963. *La Jalousie*. Edited by B. G. Garnham. London: Methuen Educational.

———. 1965a. *For a New Novel*. Translated by Richard Howard. Evanston, Ill.: Northwestern University Press.

———. 1965b. *Two Novels by Robbe-Grillet*. Translated by Richard Howard. New York: Grove Press.

Robbins, Daniel. 1963. *Cézanne and Structure in Modern Painting*. New York: Solomon R. Guggenheim Museum.

Robertson, Ritchie. 2002. "Modernism and the Self, 1890–1924." In *German Philosophy and Literature 1700–1900*. Edited by Nicholas Saul. Cambridge: Cambridge University Press.

Rojcewicz, Richard. 1987. "The Structure of Consciousness of the Child." In *Critical and Dialectical Phenomenology*. Edited by Donn Welton and Hugh J. Silverman. Albany: State University of New York Press.

Rose, Barbara. 1967. *American Art Since 1300. A Critical History*. New York: Frederick A. Praeger.

Rosen, Stanley. 2002. *The Elusiveness of the Ordinary: Studies in the Possibility of Philosophy*. New Haven: Yale University Press.

Rothko, Mark. 2004. *The Artist's Reality: Philosophies of Art*. Edited by Christopher Rothko. New Haven: Yale University Press.

Rumold, Inca. 1979. *Die Verwandlung des Ekels: Zur Funktion der Kunst in Rilkes "Laurids Brigge" und Sartres "La Nausée."* Bonn: Broschiert.

Sallis, John. 1998. *Shades of Painting at the Limit*. Bloomington: Indiana University Press.

———. 2000. *The Force of Imagination—The Sense of the Elemental*. Bloomington: Indiana University Press.

Sartre, Jean-Paul. 1948. *Psychology of the Imagination*. Translated by Bernard Frechtman. New York: Philosophical Library.

———. 1938. *La Nausée*. Paris: Gallimard, 8.

———. 1964. *Nausea*. Translated by Lloyd Alexander. New York: New Directions.

———. 1966. *What Is Literature?* New York: Washington Square Press.

———. 1986. *L'Imaginaire*. Paris: Gallimard.

———. 1987. *Transcendence of the Ego: An Existentialist Theory of Consciousness*. Translated by Forrest Williams and Robert Kirkpatrick. New York: Farrar, Straus & Giroux.

Scanlon, John. 1988. "Husserl's *Ideas* and the Natural Concept of the World." In *Edmund Husserl and the Phenomenological Tradition*. Edited by Robert Sokolowski. Washington, D.C.: Catholic University of America Press.

Schapiro, Meyer. 1952. *Paul Cézanne*. New York: Harry N. Abrams.

———. 1968. "The Apples of Cézanne: An Essay on the Meaning of Still-Life." *Art News Annal*. Edited by Thomas B. Hess and John Ashberry, vol. 34, *The Avant-Garde*, New York.

Shiff, Richard. 1984. *Cézanne and the End of Impressionism: A Study of the Theory, Technique, and Critical Evaluation of Modern Art*. Chicago: University of Chicago Press.

Schiller, Friedrich. 1959. *Über Kunst und Wirklichkeit: Schriften und Briefe zur Ästhetik*. Edited by Claus Träger. Leipzig: Philipp Reclam.

Sedlmayr, Hans. 1957. *Art in Crisis: The Lost Center*. Translated by Brian Battershaw. London: Hollis and Carter.

Shklovsky, Victor. 1965. "Art as Technique." In *Russian Formalist Criticism: Four Essays*. Edited and translated by Lee T. Lemon and Marion J. Rees. Lincoln: University of Nebraska Press.

Silverman, Hugh J. 2000. "Traces of the Sublime: Visibility, Expressivity, and the Unconscious." In *Merleau-Ponty: Difference, Materiality, Painting*. Edited by Véronique M. Fóti. Amherst, N.Y.: Humanity Books.

Sini, Carlo. 2002. "Gesture and Word: The Practice of Poetry and the Practice of Philosophy." In *Between Philosophy and Poetry: Writing, Rhythm, History*. Edited by Massimo Verdicchio and Robert W. Burch. New York: Continuum.

Stein, Gertrude. 2002. *Tender Buttons*. Los Angeles: Green Integer.

Ströker, Elizabeth. 1988. "Phenomenology as First Philosophy: Reflections on Husserl." In *Edmund Husserl and the Phenomenological Tradition*. Edited by Robert Sokolowski. Washington, D.C.: Catholic University of America Press.

Taylor, Charles. 1989. *Sources of the Self: The Making of the Modern Identity*. Cambridge, Mass.: Harvard University Press.

Taylor, Paul. 1989. *Post-Pop Art*. Cambridge, Mass.: MIT Press.

Tymieniecka, Anna-Teresa. 1984. "Harmony in Becoming: The Spontaneity of Life and Self-Individualization." In *Phenomenology of Life in a Dialogue Between Chinese and Occidental Philosophy*. Edited by Anna-Teresa Tymieniecka. Dordrecht: D. Reidel.

———. 1988. *Logos and Life: Creative Experience and the Critique of Reason*. Dordrecht: Kluwer Academic Publishers.

Venturi, Lionello. 1936. *Cézanne, son art—son oeuvre*. Paris: P. Rosenberg.

———. 1956. *Four Steps Toward Modern Art: Giorgione, Caravaggio, Manet, Cezanne*. New York: Columbia University Press.

Watson, Steven. 1987. "The Philosopher's Text." In *Philosophy as Literature/Literature as Philosophy*. Edited by Donald G. Marshall. Iowa City: University of Iowa Press.

Williams, Forest. 1954. "Cézanne and French Phenomenology." *Journal of Aesthetic and Art Criticism* 12: 481–92.

———. 1993. "Cézanne, Phenomenology, and Merleau-Ponty." In *The Merleau-Ponty Aesthetics Reader.* Edited by Galen Johnson. Evanston, Ill.: Northwestern University Press.

———. 2002. "Analogical Thinking as a Friend of Interpretive Truth: Reflections Based on Carlo Sini's Images of Truth." In *Between Philosophy and Poetry: Writing, Rhythm, History.* Edited by Massimo Verdicchio and Robert W. Burch. New York: Continuum.

Williams, William Carlos. 1949. *Selected Poems.* New York: New Directions.

Winnicott, D. W. *Playing and Reality.* London and New York: Routledge, 1971, 2005.

Wittgenstein, Ludwig. 1965. *The Blue and Brown Books.* New York: Harper & Row.

———. 1998. *Wittgenstein's Tractatus.* Translated by Daniel Kolak. Mountain View, Calif.: Mayfield.

———. 2001. *Philosophical Investigations/Philosophische Untersuchungen.* German text with English translation by G. E. M. Anscombe, 3rd ed. Malden, Mass., and Oxford: Blackwell, 2001.

Index

3003457R00140

Printed in Great Britain
by Amazon.co.uk, Ltd.,
Marston Gate.